"No one writes like Tom Robbins. . . . Now, in *Tibetan Peach Pie,* his first full-length work of nonfiction, Robbins draws back the veil from his own personal history and offers a lively, impressionistic account of a life well-lived." —*Washington Post*

"Readers will enjoy immersing themselves in [Robbins's] adventuresome life, from his remarkably unsupervised childhood to his free and easy adulthood. *Tibetan Peach Pie* . . . is a welcome antidote to our current era of helicopter parenting and disciplined conformity and rules, rules, rules." —*Richmond Times-Dispatch*

"*Tibetan Peach Pie* is vintage Robbins. It's pyrotechnic in language, labyrinthine in logic, daunting in voice, threaded with his wonderfully esoteric wit. . . . Authentically charming . . . profound." —*Washington Independent Review of Books*

"Fans of Tom Robbins, the person, the novelist, the introspective jokester and the gifted storyteller, will love this book. It truly is a gem." —*Portland Book Review*

"Ever the raconteur, Robbins carries us along a magical wonder tour in this high-flying, Zen koan-like, and cinematic tour of some of the episodes in his journey through space and time. . . . Master storyteller, indeed, Robbins calls us into his tales and with a wink and a nod, never lets us go until we've heard it all." —*Publishers Weekly* (starred review)

tibetan
peach pie

tibetan peach pie

A TRUE ACCOUNT OF AN
IMAGINATIVE LIFE

tom robbins

An Imprint of HarperCollins *Publishers*

HarperCollins books may be purchased for educational, business, or sales promotional use. For information please e-mail the Special Markets Department at SPsales@harpercollins.com.

A hardcover edition of this book was published in 2014 by Ecco, an imprint of HarperCollins Publishers.

FIRST ECCO PAPERBACK EDITION PUBLISHED 2015.

Designed by Suet Yee Chong
Tibetan Dragon Mask by Sim Kay Seng/Shutterstock, Inc.

Library of Congress Cataloging-in-Publication Data has been applied for.

ISBN 978-0-06-226741-2

23 24 25 26 27 LBC 11 10 9 8 7

For my sisters, Rena, Mary, and Marian.
And for my cousins, Martha and June.

His spiritual nature hides beyond countless oblique paths of eroticism, pursuit of the marvelous, and love of mystery.

—ROGER SHATTUCK
(OF GUILLAUME APOLLINAIRE)

It requires a certain kind of mind to see beauty in a hamburger bun.

—RAY KROC
(FOUNDER OF MCDONALD'S)

contents

preface

This is not an autobiography. God forbid! Autobiography is fueled by ego and I could make a long list of persons whose belly buttons I'd rather be contemplating than my own. Anyway, only authors who are household names should write autobiographies, and not only is my name infrequently tumbled in the lapidary of public consciousness, but those rare homes in which it's spoken with any regularity are likely under police surveillance. I've even made an effort to avoid the autobiographical in my novels, wishing neither to shortchange imagination nor use up my life in literature.

I'd like to think *Tibetan Peach Pie* isn't a memoir either, although it waddles and quacks enough like a memoir to be mistaken for one if the light isn't right. What it is more precisely is a sustained narrative composed of the absolutely true stories I've been telling the women in my life -- my wife, my assistant, my fitness trainer, my yoga teacher, my sisters, my agent, et al -- over many years, and which at their insistence I've finally written down. In order to remember events sufficiently, I've had to arrange them in more or less chronological order; which, of course, contributes to the book's resemblance to a memoir, as does the fact that the stories, as I've said, relate my own experiences, encounters, follies, and observations, not those of, say, Abraham Lincoln.

If *Tibetan Peach Pie* doesn't read like a normal memoir, that may be because I haven't exactly led what most normal people would consider a normal life. (My editor claims some of this stuff is so nuts even I couldn't have made it up.) Moreover, my writing style is my

writing style, whether it's in the service of fact or fiction: a pileated woodpecker is a pileated woodpecker no matter if it roosts with the ducks.

Now, despite my contention that the events described herein are "absolutely true," I've never in my life kept anything remotely resembling a journal, so they are at least somewhat subject to the effects of mnemonic erosion, and some folks who were involved at the time may recall them a bit differently. It's the *Rashomon* effect. *C'est la vie.* I do, however, happen to possess a pretty good memory and can at a moment's notice name the lineup of the 1947 Brooklyn Dodgers and all but one or two of my ex-wives.

Whatever it may reveal about me and my personal "monkey dance of life," including how I emerged from a Southern Baptist milieu to write nine offbeat yet popular novels published in more than twenty countries, as well as innumerable pieces for magazines and newspapers, this book also provides (perhaps more importantly) intimate verbal snapshots of, among other settings, Appalachia during the Great Depression, the West Coast during the sixties psychedelic revolution, the studios and bedrooms of bohemian America before technology voted privacy out of office, Timbuktu before Islamic fanatics crashed the party, international roving before "homeland security" threw a wet blanket over travel, and New York publishing before electrons intervened on behalf of the trees.

Oh, about the title: Tibetan peach pie is the pièce de résistance (the Holy Grail, as it were) in an old shaggy dog story, author unknown, that Zen ranch hands may well have told around the chuck wagon; a sort of parable about the wisdom of always aiming for the stars, and the greater wisdom of cheerfully accepting failure if you only reach the moon. I retold an abbreviated version in my second novel, *Even Cowgirls Get the Blues,* back in 1976. Anyone desiring a more comprehensive retelling can write to me at: P.O. Box 338, La Conner, WA, 98257, and sooner or later it will be supplied.

tibetan
peach pie

born thirsty

I was seven or eight months old -- a creeping, crawling carpet crab -- when my father came home for lunch one day and found me covered with blood.

At least, my father, bellowing in horror, believed it was blood. It wasn't. My mother had briefly left me unattended -- always a mistake: even as an adult it's been risky to leave me without supervision -- and in her absence I'd attempted to drink a bottle of mercurochrome, spilling in the process a fair amount of it down the front of my sweet little white flannel baby gown.

One doesn't see mercurochrome much in these days of various antibacterial ointments, but there was a time when it -- cherry red, better smelling and less stinging than iodine -- was widely used to sterilize and succor minor cuts, scrapes and scratches. Why was I drinking it? Someone once commented that I have a great thirst for knowledge, to which I replied, "What the hell? I'll drink *anything*."

As proof, in the months following the mercurochrome fest, I also drank ink (symbolic, perhaps?) and Little Bo Peep Household Ammonia. Ammonia is poisonous, so I doubtlessly swallowed no more than a sip before being repelled by its powerfully astringent aroma. Ah, but the intent was there.

My innate, raging, and indiscriminate thirst nearly came to an end, and my life along with it, at age two.

I'd toddled into the kitchen, lured by the smell of something

sweet, chocolaty, and, yes, liquid. The source of this attractant was a pot of cocoa steaming furiously on the stove. Never one for formalities, I, on tiptoes, reached up, seized the handle, and yanked the boiling pot off the burner, emptying in the action its contents onto my chest.

There was no emergency room: this was Appalachian North Carolina in the middle of the Great Depression. The one and only local doctor washed the burned area -- and then, not too cleverly, tightly bandaged it. A few days later, my mother, concerned by my high fever and obvious pain, removed the dressing. All the flesh on my chest came off along with it. Not merely the skin but the meat.

At the hospital in Statesville, some seventy miles away, I took up residence in an oxygen tent, my mother in a boardinghouse across the street. At one point, the attending physician telephoned Mother to tell her that I was dead. She picked up the phone after the first ring, but no one was on the line. In the meantime, you see, a nurse had run up to the doctor to say she thought she'd detected signs of life, so he'd immediately hung up to investigate.

By the time my frightened mother, alerted by the dropped call and propelled by maternal intuition, rushed into the ward, I was officially relisted on the scroll of the living. Still in critical condition, mind you. But sleeping peacefully. Probably dreaming of my next adventure in drinking.

grub & girls

While my early passion was for beverages of every description, I also exhibited no small fondness for food and for female companionship, lasting appetites whose satisfaction proved only slightly less fraught with danger.

One sunny autumn afternoon in my third year, Mother heard a commotion outside. She opened a window to see me sauntering down the street, blissfully gnawing on a raw cabbage, its head the size of my own. Several yards behind and gaining on me came a vocally irate housewife.

It seems I had appropriated the vegetable from its resting place on the neighbor's screened-in back porch. The volume of the woman's displeasure can be attributed to the fact that in an Appalachian village in 1935, a nice fresh green cabbage was more prized than a kilo of beluga caviar. I was apprehended, of course, and duly punished, though not before I had at least partially pacified my belly lust.

It was not long after the great cabbage heist that the men who worked in my grandfather's nearby cabinet shop (on Sundays Papa rode a mule into the "hollers" to preach the Gospel to tiny congregations of hill folk; during the week he fashioned exquisite pieces of handmade furniture) began complaining that food items were missing from the lunch pails that they customarily left on a bench outside the shop.

The mystery continued for a week or more before one morning

the thief was discovered in a clump of wild rhododendron bushes, chowing down on a bologna sandwich he obviously had not made himself. It's said that "stolen honey is sweetest." I can attest that larceny improves the taste of bologna, as well.

Gastronomic adventures persisted, I suppose, although I was nearly five when one next precipitated public scandal.

It was a summer day, so warm and slow that neither my favorite toys nor the sartorial splendor of my brand-new sun suit (that's what the one-piece, short-legged, sleeveless outfits were called) could enliven the torpor. Eventually, the faint jingling anthem of a distant ice cream cart drifted into my notice, provoking me to slip from our yard and hurry the block and a half to the relatively bustling commercial street (it was high season in a resort town) where I quickly located the source of the entrancing tinkle.

A Popsicle cost a mere five cents, but I possessed not a single coin of the realm. Undeterred, I approached a group of tourists loitering nearby and offered to sell my sun suit. They must have thought it a cute idea because one of them tossed me a nickel.

Instantly, without ceremony, I shed my outfit, handed it over, placed an order with the incredulous pushcart vendor, and strolled home stark buck naked, licking an orange Popsicle with particular satisfaction.

Surely there were familial repercussions -- new sun suits didn't exactly grow on trees -- but any memory of discipline has been successfully suppressed.

My lifelong taste for the company of the opposite sex may first have been demonstrated at age two, when I was spotted in the middle of the main highway leading out of town, hand in hand with my cousin Martha, age one and wearing only a diaper. We were blow-

ing that provincial pop stand, baby! We were on the road! And never mind that Martha could barely put one chubby little foot in front of the other.

Our escape thwarted by meddlesome busybodies, we were driven home in a police car, much to the astonishment of our respective moms.

Cousin Martha grew up to be crowned, in her early twenties, Miss America School Teacher, the most beautiful secondary educator in the land. Me, well, it was hardly the last time I was to leave a town with a pretty young thing in tow, often with only marginally better results.

tommy rotten

Throughout most, maybe all, of my childhood, my mother's pet name for me was Tommy Rotten. I use the term "pet name" advisedly, for though it had been born in perplexity and consternation, it was invariably spoken with affection -- and sometimes actually with a kind of ill-concealed admiration.

Lest anyone be tempted to characterize Tommy Rotten as a prototype of Bart Simpson, let it be known that for all my reckless (and usually hedonistic) mischief, I was as much a Lisa Simpson as a Bart. That is to say, I was cursed with that gene that causes children thusly afflicted to exhibit overt signs of sensitivity, to go around creating stuff (drawing pictures, putting on puppet shows, banging on the piano); and, in extreme cases, to behave as if the thermostats on their imaginations were set permanently on high.

It was almost as if some mad literary fairy, hatched perhaps in a poppy in Oscar Wilde's garden, had tapped me with her wand as I lay in my cradle, because I fell totally in love with books as soon as I knew what books were, and I hadn't been talking in complete sentences for many months before I announced to my parents that I intended to be a writer.

Too impatient to wait until I could spell words and scrawl them on paper, I turned my mother into my private secretary. When the muse bit me, as she did rather frequently, being indifferent to child labor laws, I'd call on Mother to stop whatever she was doing and take dictation. The fact that she was so willing to comply may be attributed to the fact that Mother herself was a frustrated writer. At

eighteen, she'd been offered a scholarship to Columbia University but had been too frightened to move to New York.

It was doubtlessly her sublimated literary ambition that prompted Mother to occasionally change the wording of my dictation, to improve (in her opinion) my prose style. However, I always remembered each and every sentence I'd spoken, and would throw a tantrum until she restored my wording verbatim. When in 1975 I recounted this to Ted Solotaroff, my editor on *Even Cowgirls Get the Blues,* he exclaimed, "My God, Robbins, you haven't changed in forty years!"

In any case, when for my fifth birthday I was given a *Snow White and the Seven Dwarfs* scrapbook, I began filling it not with pasted pictures but my dictated -- and unedited! -- stories. The very first of those stories (the scrapbook still exists) was about a pilot whose plane crashed on a tiny desert island, a barren place whose sole inhabitant was a brown cow with yellow spots. The cow had survived by learning to gastronomically process sand. In time, it taught the pilot to eat sand, as well, and they lived there together, man and bovine, in friendship and good health.

What meaning can we take from this first attempt at literature? That fortune favors those who improvise? That we humans have much to learn from animals? That we should insist on joy in spite of everything? The fact that the pilot didn't rather quickly butcher the cow and commence cooking it up (thereby ensuring his starvation when the meat ran out), was that an object lesson in sustainability; a prophetic fable intended to encourage future generations to seek alternatives to the greedy, thoughtless consumption that one day would threaten to suicide the planet? You'd have had to ask little Tommy Rotten -- and he wasn't talking.

blowing rock mon amour

Noticing that I squinted whenever I scanned the funny papers, my parents fetched me to an optometrist. As a consequence, and much to my embarrassment, I entered first grade wearing a pair of wire-rimmed spectacles. The school year was only a month or so old when Charley, the class roughneck, punched me in the face, shattering my glasses.

Can't imagine what I might have said to provoke the little bastard. At any rate, I was physically unharmed, but the force of the blow sent a shard of glass flying (oh, delicious irony!) into *his*, Charley's, right eye, and it had to be surgically removed.

Take heed, ye foul-spirited critics. Scurrilous attacks have been known to backfire.

As mentioned, I started writing fiction at age five. Hardly an overnight success, however, I didn't get published until I was seven.

I attended a large consolidated school, grades one through twelve in the same three-story building. There was a biweekly school newspaper, edited and almost exclusively written by juniors and seniors. Well, I had recently composed on notebook paper (the *Snow White* scrapbook having long since been filled) a rather melodramatic story featuring a reckless boy, a courageous dog, and a dangerous waterfall; so one day during recess I trudged up to the third-floor newspaper office, slapped the story down on the surprised editor's desk, and said, "Print *this*."

It appeared in the next issue. And I thought, *Hmm. That was easy. Maybe I could do this for a living.*

Flushed, perhaps, by having become a literary lion in the second grade, I proposed marriage. As evidence of my sincerity, I gave my intended a ring, a kitschy little costume trinket with a wobbly glass stone. The ring had cost me twenty-five cents -- and lest anyone think me cheap, please consider that in 1939, a quarter could buy two hamburgers and a hot dog -- with mustard, onions, and relish -- at Bynum's Café (not to mention five new sun suits from Tommy Rotten).

Was it Nancy Lentz to whom I proposed or was it her cousin Toni? I can't remember which, they were both beauties, nor do I recall if she did more than giggle incomprehensibly at my matrimonial gesture. I do remember that it was Gwendolyn Berryman with whom that same year I played one-on-one "post office" (a "letter" was a kiss, a "package" an embrace) in the front seat of the Berryman sedan, parked in our driveway while, oblivious, our moms chatted away in the living room.

What was the source, one might ask, of such overtly romantic impulses in a boy so young? We could do worse than lean on Bob Dylan. Because the answer is, indeed, blowing in the wind. Blowing. Blowing Rock.

Having spent significant and affecting years in each of them, I claim to have five hometowns (and never mind that not one of them would likely lay claim to me). Listed in reverse order, they are: La Conner and Seattle in Washington state; Richmond and Warsaw in Virginia; and Blowing Rock, North Carolina, the town where I was born, the final resting place of my kin, and the site of all the events so far described in this account.

It's a bit of an understatement to say that Blowing Rock is in the mountains. The highest incorporated town east of the Rockies, Blowing Rock is *on* the mountains, atop the mountains. From Blowing Rock, baby, it's all downhill.

The town took its name from a geological formation, an actual rock, an immense cliff of metamorphic gneiss, a jutting promontory that protrudes like God's sore thumb out over the Johns River Gorge more than three thousand feet below. It's possible to rather easily climb out onto the rock, and marvel there at a panoramic view any postcard would die for, though the perch is not for the vertiginous. Okay, but why "Blowing"?

The rocky walls of the gorge form a flume through which silent winds sweep with considerable force, although atop the rock itself it's usually calm. A visitor can toss a handkerchief, a paper cup, or any light object off of the cliff, watch it go spiraling hundreds of feet down down down into the purplish mist far below, until a mysterious current suddenly seizes it, lifts it up up up and blows it back over the head of the tosser, who may then turn, retreat a few yards, and retrieve that which he or she has tossed (hopefully, not his or her cookies). In winter at the Rock, the snow falls upside down.

It's unthinkable that a natural phenomenon of this order, as mystifying as it is spectacular, would not generate local myth. In recent years, the mythology surrounding the Rock has taken on complex cinematic properties, as if rewritten by a Chamber of Commerce booster with a made-for-TV sensibility, but the simpler and somehow sweeter legend I heard as a child went like this:

A Cherokee maiden has received word via the tom-tom telegraph that her lover and husband-to-be has been killed in battle. Inconsolable, the distraught girl goes to the Rock and hurls herself, wailing, into the abyss. Before she hits bottom, however, sympathetic and allknowing wind spirits catch her, bear her aloft, blow her back onto the Rock and into the arms of her approaching lover, who it turns out was only wounded, not slain as the drums reported.

Now, growing up in that landscape and in that narrative (my young pals and I were all over the Rock like ants over a loaf, my imagination swam in the mythology like sperm in a love bath), how could I have *not* succumbed to romanticism?

The dark woods, the singing creeks, the stars just barely out of reach; the great stone ships, their prows pointed eternally at *elsewhere*. Air as clean as freshly laundered bedsheets; owls hooting from hidden linen closets, asking *who, who,* who dares to follow the bear god's spoor down oblique paths where reality is a network of shadows and time is prone to lose its bearings? And scattered everywhere among the pines -- like the topaz droplets of resin that frescoed our bare heels in summer -- were ancient invisible Cherokee kisses, kisses known to have triumphed over death.

When in addition to the natural environment and prevailing folklore, we factor into the equation fairy-tale books with their lovelorn princes and princesses, the chivalrous tales of King Arthur's knights, and the movies in which Tarzan went swinging through the greenery with Jane on his hip, we may arrive at an algorithm that explains why Tommy Rotten gave his heart to Nancy Lentz (or was it Toni?) and his own paleface kisses to Gwendolyn Berryman.

Tarzan movies were indeed screened in Blowing Rock (from the moment I first beheld loinclothed Johnny Weissmuller traversing with a wild yodel the free space between heaven and earth, Jesus was permanently dislodged from his position atop my fiery pantheon), although the films were shown only in summer. Let me explain.

Blowing Rock was a summer resort, and a rather posh one. Lured by the area's beauty and cool mountain air, wealthy families from throughout the Southeast maintained summer residences there. The Cannon textile barons had a huge estate, as did the R. J. Reynolds tobacco clan, and the Coca-Cola Snyders from down in muggy Atlanta. Beginning in early June, our sidewalks sported pedestrians in

tennis whites and gold jewelry, our streets opened their asphalt arms
to European sports cars and luxury sedans. There were boutiques
with flagship stores in West Palm Beach and Boca Raton, a produce
stand that displayed fruits (avocados, papayas, yellow plums) that no
hillbilly could identify let alone afford; and then there was the movie
theater that showed first-run films as soon as they opened in Los An-
geles and New York -- until Labor Day Tuesday, that is, when it went
as dark as the Tomb of the Unknown Gaffer.

It was an annual occurrence. Come June, the merry masquer-
ade began; come September, Appalachian reality settled upon the
community with a mournful sigh. The shops were shuttered, golf
courses deserted, the last fancy auto went Cadillacking down the
mountain and out of town. Even the Louis XVI colors of the au-
tumn leaves failed to paint over the detail that many residents would
have to survive for nine months on what they'd earned in three.
There would now be fatback suppers, rotgut hangovers, malnour-
ished kids, flour-sack fashions, occasional stabbings; and always
outbreaks of measles, whooping cough, scabies, and head lice. And
then . . . and then June would jack out of its box and life would get
healthy and merry again.

Unconsciously, Tommy Rotten learned a great lesson from this sea-
sonal seesaw. As his brain involuntarily traced the arc between the glam-
orous and the drab and back again, he became attuned to the rhythms of
change, to the balance of opposites, to the yang and the yin, to the rise
and fall of the cosmic pumpkin; and he came to take a kind of solace in
the knowledge that paradox is the engine that runs the universe. In the
novels he was to write as an adult, *transformation* (along with liberation
and celebration) was a major theme.

It would be a mistake to suggest that the off-season in Blowing Rock,
for all of its hardships, was devoid of interest. *Au contraire.* Even dur-
ing the long Decembers of the Great Depression, the place exuded

a fascinating flavor. For a boy with a kinetic imagination, it could be nothing short of magical.

Allowed to roam freely in both the streets and the woods, I observed and interacted not only with the wonders of nature but with an assortment of squirrel hunters, rabbit trappers, berry pickers, banjo pickers, moonshiners, tramps, real Gypsies, snake handlers, muleback preachers (like my grandpa), eccentric characters with names such as Pink Baldwin and Junebug Tate, and perhaps most influential, bib-overalled raconteurs, many of whom spun stories as effortlessly and expertly as they spit tobacco juice.

All of this gave me an appetite for enchantment -- and I haven't even mentioned the pastor's little daughters, with whom, at their invitation, I used to play "doctor." In this game, participants took turns being patient and physician. Highly instructive, it was hands-on, anatomically correct, and nobody on either end of the examination table gave a rip about insurance. Harvard Medical School, eat your heart out!

Any consideration of Blowing Rock's influence that fails to mention The Bark is incomplete. A roadhouse on the outskirts of town, The Bark took its name from the unmilled cedar shakes with which it was sided, and its interior was as notorious as its exterior was rustic. Behind that rough facade, customers drank beer and danced, activities that to any good Southern Baptist invoked the Devil himself.

My mother, a stalwart in the church (her father, like my father's father, was a Baptist preacher), taught a Sunday school class for committed Christians in their late teens and early twenties. On Wednesday evenings, the class met at our house. The meetings were part religious, part social; and after prayers, as young Baptists nibbled cookies and sipped punch, gossip (evidently not a sin) would typically bloom. Invariably, someone would blurt out, if it's possible to blurt in a hushed tone, "Mary Jones was seen leaving The Bark Fri-

day night." Or, "Saturday, Daddy saw John Doe's pickup parked at The Bark, and it was there for hours and hours."

These bits of intelligence were always greeted with audible gasps, followed by much wagging of chin and clucking of tongue. If The Bark was forbidden fruit, then the shock, the awe with which they spoke of it, applied a polish, a sheen to its peel that in my imagination (I was eight, nine at the time) glowed like a peach of solid gold. I grew as attracted to that roadhouse as to the jungles of Tarzan and Jane.

On our way to the Rock or one or another of our various woodland hideouts, my buddies and I frequently passed The Bark, and we tended to pause there for long minutes and stare at the place, as if it were an evil castle where a great treasure was stored. Once in a while we'd see gentlemen emerge (after, we knew, a bout of drinking and dancing inside); we'd see some tattooed fellow with a cigar in his teeth, and with what the Sunday school crowd called a "floozy" on his arm; watch the couple straddle a big Harley-Davidson and go roaring out of the red clay parking lot, enveloped in an oxygen of freedom about whose perils and rewards we could scarcely guess. At those moments, all I wanted was to quickly become old enough to drink beer, dance, get tattooed, smoke cigars, ride motorcycles, and have a floozy of my own on my arm.

Eventually I was to accomplish all of those things -- and they proved in no way a disappointment. Who said The Bark was worse than its bite?

crime, art & death

The Hannah brothers, Georgie and Jimmy, were Iraqi Jews, actually born in Baghdad. Their father was a rug merchant who sold fine Oriental carpets in Blowing Rock every summer, in Florida the rest of the year. The day each June when Georgie and Jimmy arrived back in town was for me an occasion more anticipated and more exciting than Christmas. They were my favorite playmates, for their imagination equaled my own. The Hannah brothers excelled at making wooden swords and ray guns, at piecing together the funky costumes (cowboys, Indians, pirates, spacemen, jungle lords, etc.) apparently necessary for acting out our bizarrely improvised versions of recent movie scenes -- as well as at sneaking into matinees at the theater where we studied such scenes far more attentively than we'd ever studied arithmetic.

All summer long we strived to outdo one another with the creativity of our variations on cinematic or comic-book themes, performing in backyards, along mountain trails, on the broken porches of "haunted" houses (daring one another to go inside), around the perimeters of golf courses, and in the gardens of the Mayview Manor Hotel, where we'd sometimes catch glimpses of vacationing celebrities. (We saw Bob Hope there, Jimmy Stewart, and General Eisenhower, but, alas alas, never Johnny Weissmuller.)

When, after Labor Day, Georgie and Jimmy were sadly returned to Sarasota, the limitless galaxy of make-believe all too quickly gave way to the mundane world of school. I still had my reading and writing, however. I also had Johnny Holshauser, a year-round boy,

my next best friend, and -- oh, the shame! -- my partner in actual crime.

One half-warm spring afternoon, Johnny and I were moping about, bored with the accumulated inertia at church and school, despondent over our chronic lack of funds. We had not a dime for a comic book, not a nickel for a candy bar, not even a penny for a gumball -- and at age seven going on eight, attempting to barter our pants for financial gain would have been neither cute nor profitable. All at once, or maybe it unfolded gradually, we had an idea, a strategy, a ploy. It was simple. We'd rob a bank.

Of course, it was hardly an original solution. All through the Great Depression, proactive young fellows with neither money nor prospects had discovered that robbing banks could impact their cash flow in a positive if not always sustainable manner.

Johnny and I each owned a cap pistol that fairly closely resembled an actual handgun. Thus armed, we marched into the Northwestern State Bank on Blowing Rock's main drag, pointed our pieces at an astonished teller, and demanded "a lot of money." Mind you, this was no prank. We were completely serious. Everything went very quiet for a moment or two. Then the shooting began.

At least, we thought it was shooting. In those days there was an item of fireworks called "torpedoes," a misleading name since in size and shape they resembled those gumballs we couldn't afford. They were like dry, gray jawbreakers that when hurled against a hard surface, exploded with a loud report. Obviously unknown to us, the bank had a supply of said torpedoes, and one or more of the employees surreptitiously began throwing them at the marble walls and floor. Johnny bolted for the door, me right behind him, both convinced that bullets were whizzing past our heads.

We hightailed it through town, took a back road up a steepish hill, and barreled into the woods, not stopping until we reached a primitive lean-to, one of our aforementioned hideouts. There, breathless, we collapsed on the pine needles. And waited. Waited. Listen-

ing for sirens or other signals that the police or a posse of vigilantes was on our trail.

Hours passed. Darkness fell. A heavy chill, like an ice-hoofed horse, clattered in and out among the rhododendron and huckleberry bushes. Owls hooted. We heard growling that might have been a bear. A mountain lion. Or the bogeyman. Or our empty stomachs. Finally, unable to stand it another minute, we crept hungrily, nervously, sheepishly, back to our respective homes.

News of the aborted holdup had spread quickly through town that afternoon. Most citizens got a good laugh out of it, though my parents could not be counted among the amused. Following a brief lecture, surely to be continued, I was given toast and milk -- thanks, perhaps, to the Geneva Conventions -- and ordered to bed.

In my room, I lay awake, troubled by guilt, scorched by embarrassment, worried about inevitable repercussions. Yet, with a secret smile, I couldn't help thinking, *If Georgie and Jimmy Hannah had been with us, we could have pulled it off.*

Having in my seventies developed a mild and belated interest in genealogy, I hired a professional to look into my ancestry. To my delight she discovered a few odd nuts (if their names be any clue) dangling from the old family tree. For example, there was Smallwood Marlow, Marvel Greene, Mountain Issac Greene, Nimrod Triplett, Commodore (his name not his rank) Robbins, and most intriguing of all, a woman listed as Elizabeth Gotobed. Most of these splendidly christened individuals resided in North Carolina, though none in Blowing Rock per se.

Daniel Defoe (1660–1731) obviously didn't live in Blowing Rock either, but it turns out that I'm a direct descendant of that luminary. Moved by this newfound knowledge to reread *Robinson Crusoe,* I was dismayed to find that Defoe was an imperialist, a racist, a sexist, and somewhat of a literary hack -- which is to say, in his entire book there

is not one sentence so daring or so beautiful or so funny or so wise that I'd give twenty-five dollars to have written it (a screwy way to judge talent, I agree, but there you have it).

Ultimately, I'm far less enthused about my kinship with Daniel Defoe than with Polly Elrod (1833–1924), my great-grandmother and arguably the first Pop artist in America.

Polly lived within walking distance of Blowing Rock -- if you didn't mind a two-day walk each way. My father, in the company of his own pa, made the hike when he was a boy. The Elrod cabin was way back in the hills, up one of those deep valleys that we hillbillies called "hollers," unreachable except on foot. Daddy and Papa crashed in a hospitable farmer's hayloft their first night on the trail.

A widow by then, Polly and her late husband had built the one-room log cabin themselves. Its most prominent feature was a massive fieldstone fireplace, used for both heating and cooking, that took up one whole wall of the cabin. Now, both Polly and her spouse chewed tobacco. In those days, cured and pressed tobacco meant for chewing came in plugs about the size and shape of a deck of cards. The "chaws" were neither packaged nor wrapped. Brands were distinguished one from another by small tin emblems with prongs on the back, one emblem per plug. The Red Apple emblem was actually shaped like an apple, Red Dog's like a greyhound.

Polly and her husband favored a brand called Red Jay. Its emblem, scarlet with black lettering, was, not surprising, in the shape of a jaybird. Well, Polly, for whatever reason, had taken those emblems and stuck them one by one into the mud chinks between the stones. Over the years -- and she lived to be ninety-one, which allowed for considerable chawing -- literally hundreds of shiny little red tin jaybirds were embedded in the wall.

The overall effect, as my father described it, would have been beyond kitsch and into the realm of the genuinely aesthetic. Here in regular lines, there in purely arbitrary arrangements, the emblems in combination would have generated a kind of optical chatter, a vi-

sual din both restful and jarring. Repetition would have reduced concentration on the individual unit (the miniature Red Jay icon) and increased apprehension of the display as a whole, a kind of three-dimensional wallpaper quite likely as powerful as it was comic and strange.

Was Polly's intent wholly decorative? Was it to create a nostalgic record of those countless hours of chawing? Or was her wall a celebration of the pleasure chawing afforded her in a hardscrabble life whose pleasures would have been scarce and lean? In any case, when I envision that fireplace it is difficult not to think of Andy Warhol's *Two Hundred Campbell's Soup Cans* or *Green Coca-Cola Bottles,* paintings that caused such a stir in the art world in 1962. I'm proud that the blood of Polly Elrod runs in my veins. And I like to fancy that the red corpuscles in that blood resemble little tin jays.

My sister Rena never heard about her great-grandmother's Pop Art masterpiece. For that matter, it's doubtful if she ever heard the legend of the Cherokee princess, although she surely would have loved its happy ending. Rena was a sweet, sunny, towheaded child, whose life revolved mainly around her family of dolls.

It was a lovely May day two months before my seventh birthday when Rena, age four, was taken to Blowing Rock's new clinic to have her tonsils removed. "She'll be home in a day or so," my mother assured me. Rena never came home -- except in a pretty little coffin decorated with cherubs, lined in white satin. She'd been administered an overdose of ether.

To this day, when anyone I love leaves home for longer than a few hours, I'm filled with dread that they will not return.

When Mother became pregnant about a month after Rena's death, she prayed over and over and with much fervor that she'd give birth to twin girls: a single daughter would have invited inevitable comparisons to Rena, and as for another son, I guess one Tommy

Rotten was more than enough for one household. The next March, my twin sisters Mary and Marian were born.

It gives one pause, does it not? You needn't place it in a religious context, we can argue all night about the true identity of its source, but for me, at least, there is no denying the evidence of answered prayer.

Aside from love, which we may assume everybody except heart-numb psychopaths covet in one guise or another, average Christianized Americans (with whom I've a whole abattoir of bones to pick) really desire two things: they want to get rich and they want to go to heaven. (Apparently in that order.) And this despite the fact that their very own Lord and Savior explicitly warned that it's easier for a camel to pass through the eye of a needle than for a rich man to enter the kingdom of heaven.

What's up with that? Do they think Jesus was joking, just kidding around? Or does each would-be wealthy Christian believe that an exception will be made in his or her case; that at heaven's gates his or her accumulation of property and cash will elicit a knowing, sympathetic wink -- as the needle's eye is temporarily widened to let him or her squeeze through?

Rena wouldn't have had that problem. The only possessions she left behind were her dolls -- and the toy tea set with which she entertained them daily.

snakes alive

Pink Baldwin claimed there was a ridge not far from Blowing Rock where huckleberry bushes grew as thick as the whiskers on Santa Claus's chin. There was a problem, however: the ridge was populated almost as thickly with rattlesnakes. When the Baldwin family went berry picking up there, they were obliged to wear lengths of stovepipe over their legs for protection. According to Pink, the sound of rattlesnakes striking those stovepipes resembled rain falling on a tin roof.

My parents, an uncle and aunt of mine, and I were driving on the Mount Mitchell Highway after a scenic picnic lunch atop the highest peak east of the Rockies, when a large diamondback rattlesnake was seen sunning itself in the middle of the road ahead of us. Daddy stopped the car, whereupon I abruptly leaped out for a closer look. Just as swiftly, Daddy followed, grabbed me by the collar and practically threw me back in the car.

My father and uncle, for reasons doubtlessly as primal as they were on that occasion unnecessary -- a response embedded aeons ago in Homo sapiens DNA -- set about to kill the snake. The stones they hurled at it quickly aroused it from its stupor, at which point it fled across the road, racing into the ditch and up a steep embankment, disappearing into the underbrush. Naturally, we thought that was the end of it, and I alone, smarting from my rough treatment and ever ripe for adventure, was disappointed.

A minute later, however, we were in for a surprise. The snake, having turned around in the brush, came racing back down the bank, heading straight for its attackers, rattling furiously. It sounded like the Devil's maracas at carnival time in hell, and it was enough to set father and uncle falling all over themselves to get back in the car. The big viper coiled, jaws agape, fangs glistening, as if daring its tormentors to confront it. Wisely, they declined.

What happened next was that Daddy drove over the angry reptile several times with the car before leaving it for dead. But was it? The whole incident had a kind of supernatural flavor, heightened by the fact that no one, including herpetologists to whom I've since described the encounter, could remember ever hearing of a rattlesnake, once out of danger, deliberately returning to challenge its human enemies. Most experts, frankly, were incredulous.

A few years ago, however, an amateur herpetologist with experience in Appalachia offered what seemed like an even more startling explanation. He suggested that the snake that came charging so fiercely down the embankment was not the same snake that had gone up it.

"Eastern diamondbacks often live in pairs," he said, "especially during mating or brooding season. Could be that either the male or the female took it upon itself to go out of its way to show it wasn't going to tolerate any threat to its mate."

Had the cold-blooded reptile charged down that bank, risks be damned, to avenge the stoning of its partner, to demand satisfaction for the offense and intrusion? Had it died for honor? For *love*? If true, that casts the whole episode in a very different light: no longer just extraordinary and mysterious but romantic. In other words, right up my nothing if not serpentine alley.

My father was helping to string a new electrical line from Lenore up the mountain to Blowing Rock when the right-of-way crew flushed

a good-size rattlesnake from its den. One of the workers pinned down the viper's head with a shovel while a companion yanked out its fangs with his pliers. The agitated but now harmless snake they then stashed in the large wooden toolbox in the bed of their truck.

After work, back at the Lenore inn where the crew was lodged, they dispatched the cook's helper, a colored man, out to the truck to retrieve "a mess of huckleberries" they claimed they'd picked that day. "They're in the toolbox," they told him, expressing a keen desire for huckleberry pancakes.

Much to the amusement of the jokers at the inn, there soon erupted a terrified scream, followed first by the crunch of running feet on the gravel drive, then the flap-flop of loose shoes disappearing down the highway. The poor fellow might have run all the way to Africa for all they knew because he never returned to the inn.

At least that's how the story went. My father was a resolutely honest man, seldom disposed to narrative embellishment, yet it's difficult not to detect in this anecdote, especially its climax, a whiff of the apocryphal. And it's impossible not to detect the odor of racism.

Race, in those days, was hardly in the forefront of Blowing Rock consciousness. Not a single African American lived in the town or its environs. Even the wealthy summer people didn't bring along their black servants when they came for the season, finding it cheaper and less bothersome to hire maids and other help from the local white population. All the blacks in my frame of reference were in the movies; and whether it was a sophisticated dancer such as Bill Robinson (hey, he was cool enough for Shirley Temple), a figure of fun such as Buckwheat in "Our Gang" comedies, or the native tribesmen (so strange, so far away) who shared the jungle with Tarzan, they lacked any relevance in my daily life.

Of course, I'd heard the occasional "N-word," and while I realized it wasn't exactly a compliment, even that epithet could possess a degree of ambiguity to me back then. For example, the time dear Aunt Mary expressed alarm at the way I'd dressed myself that morn-

ing. "Lordy mercy, Tommy! You can't go around wearing red and orange together. Those are nigger colors."

I have no idea how Aunt Mary came by that interesting piece of fashion information, but I do know that more than twenty years later, when I was at a civil rights gathering in defiantly segregationist King William County, Virginia, I noticed that the only person of either race wearing red and orange was me.

On one of our honeymoons, my wife Alexa and I rode elephants from northern Thailand to the border with Burma (for both humanitarian and poetic reasons, let's refuse to call it Myanmar), a trip, at pachyderm pace, of three-plus days. Lumbering along atop an elephant's head is not quite the wild, free, ecstatic experience it appears to be in Tarzan movies or the circus. For one thing, the elephant's hair, though short, is stiff and wiry. One feels as if one's posterior is bouncing on a beanbag chair made of steel wool.

In addition, elephants are given to cooling off (and it was summer in Thailand) by frequently misting themselves with any available water, often from a ditch. The rider, naturally, is sprayed along with his or her mount. It's actually refreshing -- until one begins to notice that the spray contains a certain amount of mucus. An elephant sprays with its trunk, which is, one is eventually reminded, its nose. At the end of each day, my bride and I were covered with a thin, slick coating of elephant snot.

Let's forget viscid nasal secretions, however. I've been talking about snakes, and it happened that one afternoon a very long, very heavy serpent crossed the trail in front of our pachyderm party. One of the elephant drivers chased it down and dispatched it with his machete. We were told it was a *sing* snake. *Sing* is the Thai word for "lion." If you're a consumer of imported beers, you may recall that Thailand's national brand is Singha. "Singha" was the name of a powerful lion figure from Southeast Asian mythology, although the beer,

being a meek Buddhistic brew, seems more representative of bunny rabbits than of the king of beasts. *Sing?* Ha!

At any rate, our guide mentioned that the elephant drivers would be eating the *sing* snake for their dinner, whereupon I insisted that I must have some, as well. So, the men hacked off a chunk about seven inches in length, weighing about half a pound; wrapped it in a banana leaf, and, when we made camp, presented it to our cook.

The cook proceeded to prepare it nicely with sticky rice, bamboo shoots, and, as is the local custom, enough red chili paste to give heartburn to the Human Torch. Having de-snotted ourselves in a river, Alexa and I sat down on a palm log, bowls on our laps, chopsticks in hand, our hospitable palates poised to welcome in a culinary stranger.

Well, I can truthfully note in my résumé that I have dined upon lion snake. But what does lion snake taste like? I have no idea. Definitely not like the proverbial chicken -- unless that chicken had just reentered Earth's atmosphere. Every one of my nine thousand taste buds was preoccupied with trying to protect itself from third-degree burns. For at least an hour after dinner, I felt as if I'd been gargling napalm, and as an antidote, no amount of Singha beer could cut the mustard.

In the African nation of Namibia in 2004, I was struck by a black mamba, one of the world's deadliest reptiles. Compared to a black mamba bite, a rattlesnake bite is little more than a hickey. (Refer to Barbara Kingsolver's splendid novel *The Poisonwood Bible* for a graphic description of the accumulating physical horrors a black mamba victim usually experiences in the fifteen minutes or so between the bite and death.)

Obviously, since I'm writing this account, I wasn't bitten. The strike missed. It missed because the open electric cart in which my guide and I were seated (we had ridden out in the bush to observe up

close and personal a mother and baby rhinoceros) lurched forward inches out of fang range at precisely the right instant. Suffice to say we didn't stick around for a second chance. In black mamba baseball, it's one strike you're out.

The mamba was long, slender, and graceful, and in striking it rose so high it was virtually vertical, as if balanced momentarily on the tip of its tail. It resembled a self-propelled licorice whip from the Marquis de Sade's candy shoppe, a sleek six-foot bold italic exclamation point meant to emphasize a single message: DIE! DIE! DIE!

As thrilled as I was to find the incident in the hours following its agreeable outcome, it was also, believe it or not, to arouse in me a lingering sibilation of romantic nostalgia: the fond memory of another black snake in a very different context from an earlier time.

During my ninth year, when I was in the fourth grade, my father moved us temporarily to Burnsville, North Carolina, likewise a mountain town, though lacking Blowing Rock's altitude, scenic vistas, and seasonal gentrification. Our rented home on the outskirts of Burnsville was adjacent to the grounds of a defunct boarding school. One morning I awoke to a clamor, and from my window observed a multitude of brightly painted trucks and silver trailers filling the weedy campus next door.

As men began to unload heavy rope, wooden poles, and giant rolls of canvas from flatbed lorries and panel vans, I remembered the posters I'd recently seen downtown and realized that a circus was setting up practically in my own backyard! Shaking with excitement, barely taking time to dress (was I wearing red and orange?), I raced out into the vortex of activity intent upon finding a job and seeing the show. I accomplished both, but more importantly, I encountered the flesh-bound instrument of secret wisdom and cosmic love torture who was to animate my fantasies and billow the embers of my yearning for the rest of my life.

Her name was Bobbi. She was eleven -- an "older woman." She had yellow hair that hung down to her waist and wore riding britches

and black patent leather boots, the tops of which very nearly met the end of her tresses. And she had a snake: a pet blacksnake that she carried around the way an ordinary little girl might carry a doll. Bobbi's right arm was tattooed with small scars, souvenirs of the many times the snake had bitten her. (It was an American racer, probably of the rather common *Coluber constrictor* subspecies, and obviously nonpoisonous.)

Bobbi was both the most exotic and romantic creature I'd ever met, a preadolescent living embodiment of Tarzan's Jane; of Sheena, Queen of the Jungle; and though I had no clear notion of it then, of the feminine archetype to whom there clings an air of hidden knowledge, something strangely meaningful, equally nurturing and dangerous.

It was because of Bobbi that at a tender age I became a lifetime member of that exclusive order of men who believe a woman in pink circus tights holds all the secrets of the universe. She was not yet in tights but it was no great stretch to project for her a life in spotlights at the top of the tent, swinging by her hair; or else pirouetting atop the bare back of a prancing stallion in the center ring. As thousands cheered.

Bobbi was of the circus, born and bred. Her father was ringmaster and show manager; her mother -- billed on sideshow banners as "the Indestructible Woman" -- climbed twice daily, scantily clad, into a wooden coffinlike box through which about a dozen heavy swords one by one were driven. Bobbi -- beautiful, fearless, ever dramatic -- was a young goddess of the big top and I simply could not or cannot imagine an adulthood in which, as one of those so-called exotic dancers, she might hootchy her kootchy on a tawdry stage in the armless embrace of a burlesque boa constrictor.

Forget Toni and Nancy, forget Gwendolyn Berryman. Bobbi was on another plane entirely, and I was not so much in love as in awe. It was, of course, unrequited, although she, generally deprived of playmates, seemed fond enough of my company. When I wasn't watering

the llamas, shoveling monkey poop, or performing those other chores in the menagerie tent that was earning me a pass to the main show, Bobbi and I hung out on the lot; and when my duties were done, we'd walk the short distance to my house and play board games or improvise scenes with my toy train set. Out of deference to my mother, the blacksnake would be left behind in its cage.

On the second day (and I'm unsure quite how it transpired), Bobbi's mom and dad came to lunch at our house. It must have seemed a bit surreal, the flamboyant ringmaster and the Indestructible Woman sitting at our dining room table eating soup and discussing the war (Pearl Harbor had been bombed six months earlier) with my parents. Nevertheless, lunch went well, so well in fact that Bobbi's father (surely at his daughter's instigation) invited me to go on the road with the show. And my parents said yes!

I didn't go far. Only to the next stop, some fifty miles away. And after the performances there, after a couple of days of free cotton candy, curious conversations with clowns, and all the monkey manure I could muscle, Daddy drove over, picked me up, and took me home: Mother had been worrying. So much for "running away with the circus."

step right up

No, I didn't run away with it, but it might be fair to say that the circus ran away with me. As a teenager in Virginia, I performed sideshow and menagerie chores for Hunt Brothers, a show with more animals and a larger cast though, sadly, no Bobbi. (Except from afar or in my fantasies I would never see the likes of her again, although as an adult I made the mistake many times of projecting -- unfairly -- her image, her archetype, onto young women who, though lively and eccentric enough, were fundamentally unsuited for the role.) I also worked brief stints as ticket seller and concessionaire on the midways of a number of carnivals and fairs. The moment the first vehicles in a garish caravan began to roll into one of the small Southern towns where we lived, I would be bicycling to the setup lot, looking for a chance, as the showfolk would say, to be "with it," wishing I might leave town in their company.

The attraction for me wasn't so much the fierce individualism and freedom from convention afforded by the transient life -- though the older I got the greater the appeal of the open road -- but rather the sheer exuberant gilding-the-lily poetics of the baroque spectacles themselves, the invitation to bask in the rainbowed prisms of a movable Oz from behind whose spangled curtains genuine wizards seldom failed to emerge.

The circus provided a separate reality, with an emphasis, if truth be told, on *reality*. In the lyrics of a popular song, the term "Barnum & Bailey world" was coined as a synonym for all that is phony and false. Certainly, there was deception, bombast, and ballyhoo aplenty,

and even outright grifting in some of the smaller shows, but ulti-
mately the old-fashioned circus was real to a degree rarely approached
by most modern entertainments, including "reality TV." Those snarl-
ing tigers swiping at a trainer in the center ring were flesh and fang
and claw, not some Pixar animation; those aerialists working without
a net literally risked their lives at every breathtaking performance.
Beauty, novelty, mirth, and danger mingled in real time, real space a
few yards from one's place in the stands; posing the question "Which
is the true phony, Barnum & Bailey or the Hollywood blockbuster;
the Great Wallendas (whose seven-person high-wire pyramid I wit-
nessed shortly before their fatal fall in Detroit), or the preposterous
heroics generated on some studio geek's computer?"

Perpetually in 3-D, with no need for dorky glasses, a circus even
stirred smell into the sensory mix: cardinal aromas of sweat, fear,
sawdust, canvas, greasepaint, spun sugar, frying onions, and the
steaming shit of various and sundry beasts of the world. And resting
like a translucent -- and perhaps transcendent -- cherry atop the ol-
factory omnium-gatherum, the whole overflowing showtime sundae,
was the pure aesthetics and philosophical eloquence -- the poignant
Zen -- of the aerial masters.

When asked by a police magistrate why he famously and illegally
walked a wire between the World Trade Center's twin skyscrapers,
Philippe Petit responded in a manner worthy of a Kyoto sensei: "I
see three oranges, I have to juggle; I see two towers, I have to walk."
Karl Wallenda, when asked why he refused the protection of a net,
replied, "God is my net." And on another occasion, the Wallenda
patriarch quietly declared, "On the wire is living. Everything else is
only waiting."

In some spiritual disciplines such remarks would be recognized
(and venerated) as "crazy wisdom." As from my seat in the pea-
nut gallery I observe daily the wholesale distortion and corruption
of consensual reality by corporate interests, their Madison Avenue
pimps, and their stooges in government, I take a certain refuge in

crazy wisdom, even when (maybe *especially* when) it emanates from avatars in pink circus tights.

Summer lay on the rural Southeast like a sheet of flypaper. Men, dogs, farm animals, commerce, time itself, seemed stuck to the page with a yellowish narcotic glue. Hours, days, weeks dragged by as slowly as a celebrity divorce. Only we kids, with our sandlot ball games, our dips in the river, seemed the least bit animated, but by August, we, too, had surrendered to the torpor, our whoops and wa-hoos gradually softening to a flylike buzz.

Evening thunderstorms, cooling and greening, occasionally en-livened the scene, yet no sooner had the last raindrop plunked, the last lightning bolt kicked its spastic leg, than heat and humidity, ever sure of themselves, once again assumed office, and by midmorning the countryside would have gone back to looking as if it had been fried by Colonel Sanders.

Considering that there was no air-conditioning to evaporate the sweat, considering that there was no television to relieve the tedium; considering that the church, while dominant in the life of the community, was not exactly a barrel of fun; it's hardly sur-prising that when a circus or traveling carnival hit town, a great many residents (one needn't be a hard-core show fan or Bobbi en-thusiast) shared in my delight. Sure, there were a few righteous citizens (Pentecostals or Hard-Shell Baptists) who'd snort, frown, turn their backs, quarantine their children, and take refuge in their clapboard bungalows, praying against the threat of contamination by godless frivolity. But if you'd spy at night from behind the hy-drangea bushes or broken-down clunkers in their yards, you'd catch them at the window, lace curtains pulled slightly aside; ears cocked, nostrils twitching, unable to resist stealing a look, a listen, a sniff at just how gleefully the Devil had transformed an innocent school-yard or disused field.

Well, maybe it was the Devil, maybe it was God, maybe it was
a bunch of otherwise unemployable guys and girls from down in
Florida somewhere, but "transformed" *is* the proper verb. What had
been a dusty, forlorn acre, carpeted in clumps of half-dried grass,
bestrewed with clods, empty beer cans, and tumbling tumbleweeds
of crumpled newspaper; inhabited by shabby sparrows and lazy grass-
hoppers, that unappetizing pasture would have been alchemized in
less than a day; transformed into a strange but beguiling pleasure
park; a rollicking incandescent oasis of otherness, promising rewards
outside the range of normal expectation.

It's no wonder that transformation was to become a fairly promi-
nent theme in my novels. The way that colored lights and bouncy
music, Ferris wheels and performing elephants, could temporarily
turn an empty Virginia field into an encampment of marvels was not
unlike the way an affluent summer migration periodically turned
Blowing Rock, North Carolina, from Dogpatch into Swankville. The
lesson was the same: This program is subject to change -- often unex-
pectedly, sometimes in the batting of an eye. It's the best argument I
know against suicide.

Regularly each July, there was a carnival in Blowing Rock. It was
not, however, a professional touring outfit with thrilling mechanical
rides (Zipper, Loop-the-Loop, Tilt-A-Whirl); or with freak shows,
hootchy-kootchy reviews, and crooked games of strength and skill at
which a hayseed stud might spend half his paycheck trying to win a
twenty-cent plaster Kewpie Doll for a girl in whose pants he may or
may not ever get. No, this was one of those old-fashioned amateur
community carnivals -- in this case thoughtfully organized by the
summer gentry -- to raise money for local charities, of which there
was, in Depression-era Blowing Rock, a fairly considerable need.

Our carnival took place in our park, a pleasant block-long stretch

of trees and grass in the center of town. It was a one-day event but it could generate at least two weeks of excitement. The pony rides were popular with kids, and for a dime you could also take a ride on the municipal fire engine, complete with flashing red lights and sirens; and/or go for a spin in a tiny British sports car (probably a forerunner of the Swatch). There was outdoor bingo (bingo was something of a novelty in a town without a single Roman Catholic), a band concert, a pet show, and a pie-eating contest. There was even a kissing booth, although I was too poor and considered too young (Oh yeah?!) to patronize it. The prime generator of excitement however was the raffle.

For several weeks prior to carnival, raffle prizes were prominently displayed in shop windows downtown. It was shortly before my eighth birthday when, passing such a display, I laid eyes on an object of manifest marvel: a portable radio. This was 1940, mind you, when a portable radio was the size, weight, and general shape of a piece of luggage. Today, you'd be charged thirty-five bucks to carry a radio such as this onto a plane.

This was no cheap plastic ghetto blaster. Not one polymer had been killed or injured in its manufacture. Its frame and handle were made of polished hardwood; its facade, around the speaker, was covered in a tough but tasteful tan fabric resembling a kind of upscale burlap. (Think Louis XIV's personal potato sack.) It was elegant, it was . . . well, mysterious, magical even; and it was *mine*.

That's right, it was mine. Of that I was absolutely sure. All I had to do was to buy a lottery ticket. The problem was that a ticket cost a quarter: five times my weekly allowance.

Day after day, I begged my father for an advance. To no avail. It wasn't that he was stingy. He just wanted to spare me an inevitable disappointment, not to mention the loss of funds. He did the math for me, patiently explaining the odds against a single ticket among so many winning the prize.

I persisted. And I pestered. Finally, on the Saturday of the draw-

ing, Daddy capitulated and took me to the store to buy a ticket. There
were just two left. Fine with me. I only needed one.

That evening, Daddy and I walked the few blocks to the carnival,
me serenely confident, he a trifle sad. Again and again, he cautioned
me against unreasonable expectations. Unreasonable? That argument
made no sense. Fate had promised me that radio.

It was nearly past my bedtime when the drawing for the radio
finally occurred. Our mayor's daughter reached into a top hat, pulled
out a number, and handed it to the emcee to read aloud. The number
was not mine.

If I was shattered, I don't recall. In any case, I hadn't long to react,
because it was quickly announced that the drawn number was that of
the single ticket, the only one, that had not been sold. A second num-
ber was then pulled from the hat. And minutes later, I walked back
home in the soft summer night with my new radio blaring at the end
of my arm, exactly as I'd expected.

In all the years that have slid into the history pit since the 1940
Blowing Rock carnival, I've never won another raffle. Why? Did I
use up a lifetime's allotment of lottery luck on that one classic occa-
sion? Or is it that I've never again entered a contest or game of any
kind with that level of belief? Was it testimony, on a peewee scale, to
the power of *faith*? And did I lose my faith in raffles about the same
time and for approximately the same reasons that I quit believing that
virgins can have babies; or that if I slay only those people the govern-
ment encourages me to slay, I'll be allowed to spend all of eternity in
some vaguely located puffyland sipping milk and honey with a huz-
zahing throng of cheery nonthinkers? (As the painter Ad Reinhardt
said when asked if he was an Abstract Expressionist, "To Heaven --
but not with them guys!")

Saint Paul defined faith as "a belief in things unseen." Well, I
believe in unseen things. Don't you? Love. Electricity. Flatulence.
Moreover, a great many of us seem to experience an innate longing
to interface somehow with powers and forces we sense but can never

fully identify or comprehend: such yearning is the impetus for all spirituality (as opposed to organized religion), and can be intensified and even temporarily actualized under the influence of deep meditation or LSD. If that's faith, Paulie, we'll take a half pound on spec and get back to you Monday. But I digress.

Maybe, on the other hand, I never won another prize because I sold that damn radio ten days later.

My parents questioned why I coveted the radio in the first place. It wasn't as if I listened to a whole lot of music. Neither the Grand Ole Opry nor the Carolina Hayride were my cup of tee-hee (rock and roll hadn't been born yet) and *Captain Midnight* came in just fine on the family console. True enough, but that portable box of tubes and wires was beautiful, it was sophisticated, it was sexy; it was totally, aggressively, unspeakably *cool*. (Not that anybody south of the Harlem jazz scene would have used the word "cool" in that context in 1940.) For more than a week I basked in its consummate coolness. Then one day an encyclopedia salesman came through town.

In addition to the *Encyclopedia Britannica,* the man was peddling six-volume sets of the works of Mark Twain, leather-bound; handsome ten-volume sets of Children's Classics, whose titles included *Fairy and Wonder Tales, Folk Tales and Myths, Tales From Greece and Rome,* and *Animal and Nature Stories;* and a world atlas. Oh, fickle me! In a fickle heartbeat, those books had trumped the once-adored radio, which I then proceeded to sell to a tourist for twenty-eight bucks in order to buy everything except the encyclopedias.

There were no regrets. Evidently, I'd suffered an epiphany: the subconscious realization that when it comes to coolness, nothing the human race has ever invented is more cool than a book. I still believe that today. To quote another famous painter, this time Robert Motherwell, "The best toys are made of paper."

Incidentally, speaking of paper toys, that soon-to-be-tattered atlas became a favorite plaything, another trough at which I might water the wild horses of my imagination. It also had a practical ap-

plication. Not only did I ace geography classes in junior high, years later in taverns I won many a beer betting that Reno, Nevada, was farther west than Los Angeles, and Portland, Oregon, farther north than Portland, Maine. (You can look it up.)

On the blazing, bustling midway of the Northern Neck State Fair (in Warsaw, Virginia), the sideshow barker (now an obsolete term: for years, show people have called them "talkers") was enticing crowds of gawking rubes with ornate, exaggerated descriptions of the oddities and wonders allegedly assembled inside his tent. Among the attractions was a "genuine living" midget, a rosy-faced, tuxedo-attired gentleman of somewhat less than normal height who had joined the talker out front to personally demonstrate that there truly were "startling examples of Mother Nature's cruelties" to be seen inside by those rubes who accepted the invitation to step right up and lay their money down.

Talkers obviously talk, and this one talked so rapidly, so incessantly, that when he died I'm sure they had to beat his tongue to death with a stick. In the midst, however, of explaining that despite the midget's deficiency in stature, he was an intelligent and talented human being (as if to prove the point, the midget lit a cigar), the talker abruptly stopped talking. He stammered a few incoherent words. Then fell mute again.

From the booth where I sold tickets for rides on the Whip, I had a good view of the sideshow tent, and I knew what had silenced the talker. I'd been expecting it.

The tidewater village of Warsaw resembled the mountain village of Blowing Rock in that no persons of color resided there. Unlike Blowing Rock, however, there were scores, perhaps hundreds, of African Americans living in what amounted to rural shanty-towns within a couple miles of the municipal limits. While during the week, a scattering of black faces might be seen in Warsaw --

cleaning women and laborers mostly -- on Saturdays there was an ebony tide. They came into town to shop and to mix and mill, hanging around the Texaco station talking, laughing, drinking soda pop and brown-bagged whiskey, listening to the soul sounds (called "race music" back then) that blared from the countertop radio until the place closed around 11 P.M. The loosey-goosey Texaco station was the only establishment in Warsaw where Jim Crow constraints went unenforced. As a result, its owner, a white man, was a bit of a pariah in town, but that's another story.

Residing somewhere in the unlit, unpaved, hoe-chopped, chigger-scratchy environs of Warsaw was a family of black midgets. There were four, maybe five of them: male and female, siblings possibly, though the precise nature of their kinship was impossible to know. They always came to town together, never singularly, accompanied by several full-size chaperones or protectors, and they didn't come in very often: maybe a half-dozen Saturdays a year. It seems they didn't appreciate being gawked at, which, though understandable, sprinkles a fine pepper of irony over their visit to the Northern Neck State Fair.

Now, let me emphasize that when I say "midgets," I mean *midgets*. I'm talking extreme midgetry. Midgets among midgets. Jaw-dropping diminutive. Seriously, I'll eat this page and wash it down with raw kerosene if any one of Warsaw's little people was so much as a mouse hair taller than Michu, for years a star attraction with Ringling Brothers, billed as "the World's Smallest Man." Michu's height was thirty-three inches.

So, when from my fairground vantage point I witnessed the Warsaw midgets slowly approaching the sideshow tent, I fully anticipated the talker's shock and embarrassment. There he was, raving on in cascading hyperbole about what a rare specimen of humanity his midget was, how privileged were the rubes to behold such a phenomenon, when he -- and eventually the rubes -- caught sight of a whole troupe of beautifully formed chocolate miniatures, not one of

whose head would reach as high as the sideshow midget's nipples.

Was it pure coincidence, were the gods having sport, as is their wont? Or had our midget family planned the whole thing, either as a silent protest against both the commercial exploitation of the physically peculiar and the dishonesty of ballyhoo; or despite their customary shyness, as a prank, an uncharacteristic display of mischief and fun? Had they gone back to their shantytown that night and laughed their tiny butts off?

We'll never know, although the gossip among the midway carnies was that the show boss had followed them home, returning there the next day and the day after, ever sweetening his offer to make the lot of them rich and famous if they'd just sign on with him. To their credit, they did not. Meanwhile, back at the fairgrounds, I watched the talker wax visibly nervous each time he was joined out front by the upstaged fellow some of us had taken to calling "the World's Tallest Midget."

In 1972, an odd little circus rolled into the fishing village of La Conner, Washington, and erected its big top, which was not very big, on what was then a vacant lot in the center of town. Although I can't remember the show's name (a poster in the grocery-store window had only four days earlier announced its arrival), certain other aspects of it are lodged in the folds of my brain like a pressed blossom; still faintly perfumed, still faintly colored, as if reluctant to relinquish its charm. And it did have charm. It was simultaneously the most pathetic and the most engaging circus I've ever known.

To begin with, it traveled with but two live animals. Considering the cruelty to which many circus animals have been subjected, that could be judged two too many, although this unlikely pair -- a half-grown elephant, and an unusually large parrot -- seemed robust.

As for human beings, there were in the entire company exactly seven: four men, three women. Three of the men were roustabouts:

workers who put up the tent and did the heavy lifting. The other man (he might have been the owner) served as ringmaster, played the organ, and at one point performed what passed for a trapeze act. Middle-aged, with a beer belly, he struggled mightily to swing in a complete loop. As he perspired, huffed, puffed, and turned rooster red, my girlfriend and I surely weren't alone in fearing we were about to witness a medical emergency. "The Greatest Heart Attack on Earth." He persisted valiantly, however, and eventually managed to flip all the way over. The applause he received was motivated more by relief than admiration.

Sometimes solo, occasionally in pairs, once in triplicate, the women assumed a variety of roles: acrobats, tumblers, balancers, contortionists, jugglers, elephant trainers, ropedancers, etc. What's interesting is that each time a performer left the tent, she returned with a different name. For one act, a woman might be announced as "the fabulous Madame Yvonne"; the next time she entered the ring she would be "the amazing Madame Dianne." There was Madame Natasha, Madame Sophie, Madame Elena, and so on, as if spectators might actually come to believe there were dozens of them. Each female performer wore multiple identities -- but always the same tights. And virtually every pair of tights had runs in it!

This raises the question: does a woman in pink circus tights hold all the secrets of the universe if her tights have runs in them? The answer I think is emphatically "yes!" -- although I wouldn't go so far as to declare it a prerequisite.

The multitasking and name-changing; the frayed, unraveling tights; the effort and exuberance exhibited in an obviously distressed show whose performances might easily have been perfunctory and forlorn, was endearing enough, but what broke the needle on my charm meter was the grand finale. Picture this:

Spotlit and sparkling, a spinning mirrored disco ball is slowly raised to the top of the darkened tent. As it ascends, a live parrot, twirling round and round, is hanging from the ball by its beak. And

all the while an organ, fully amplified, all stops out, a panting, red-faced ringmaster at its keyboard, is playing "The Impossible Dream." Ta da!

Well, I guess you had to be there. I've attended many a circus, major and minor, in America and abroad; seen many a performance, thrilling and routine, but it is the one just described -- kind of cheesy, sort of dumb, falling so audaciously and yet so sweetly on the far side of reason -- that will forever occupy the center ring in my heart.

Incidentally, the following morning I stopped by the market and asked for the poster, wishing to add it to my meager collection of circus memorabilia. The poster wasn't there. According to a clerk, someone from the show had picked it up earlier so that it could be displayed in another town. Turns out, this circus with one elephant and one parrot also had only one poster.

yes, virginia

A silk scarf is smoothed out upon a flat metal plate. A frying pan is placed atop the scarf. An egg is cracked and dropped in the pan. The egg fries, soon cooked to perfection, although there was no flame and the scarf does not burn or even scorch. My father was among tens of thousands who watched in astonishment this demonstration in one of the science pavilions at the Chicago World's Fair of 1933.

Long after his buddies had left the pavilion, perhaps to check out Sally Rand's scandalous "fan dance," my father lingered behind, observing the confounding demonstration several more times. By the time he got home to Blowing Rock, he'd figured out how it worked.

The device was an early prototype of the microwave oven, though nobody used that term in 1933; and Daddy proceeded to build one just like the one he'd seen in Chicago. Not surprisingly, it attracted attention from miles around. People kept showing up at the electric company offices, pleading to see the trick. Daddy's friends urged him to charge admission, but he declined, having not a grain of greed in his gullet. For his family, he was always a "good provider," as they say, but he had scant interest in money per se. He soon gave the device to an associate, who, charging the curious ten cents apiece to see it in action, enjoyed a nice little sideline before the primitive microwave sputtered one day and ran out of magic. His friend might have persuaded Daddy to rebuild it, but it was summer, hens had quit laying, and the price of eggs was cutting into profits.

George T. Robbins dropped out of school in the eighth grade. At eighteen, he went to work as a lineman, climbing poles for the regional electrical utility. By the time he was fifty, the homemade microwave long since forgotten, he was a division manager for Virginia Electric Power Company. At VEPCO, there were 250 electrical engineers working under him, and colleagues said that he knew all of them. A kind of natural genius in his field (a couple of his inventions remain in use today), he surely would have risen to an even higher executive position were it not for the fact that he talked like a character from the Li'l Abner comic strip. In elocution and grammar, he never transcended his lack of formal education or his hillbilly roots.

For whatever reason, the electrician gene, the carpenter gene, the mechanic gene, all so dominant in my father, are totally recessive in me. My whole life I've been bored to within an inch of rigor mortis by the very sight of a slide rule; likewise a screwdriver, unless, of course, we're talking orange juice and vodka. I have, however, found ways to override my lack of talent for -- and total disinterest in -- the role of handyman.

For example, I once owned a secondhand 1969 Mercury Montego convertible, which, by the time I gave it to a relative, was showing an excess of two hundred thousand miles on its odometer. This car ran like Joan Rivers, on and on, defying detractors, requiring no repairs beyond the cosmetic, leaving newer models in its dust. Its extreme durability I attributed to the fact that in all the years I owned the vehicle, I never looked under its hood. Not even once. Rather, I imagined (and visualized) that in place of an engine, there was a ball of mystic white light under there that kept the car going. And going. And going.

Only recently it occurred to me that I might successfully apply this strategy to my own body. Avoiding intrusive medical tests, and disavowing the presence of oozy organs, fetid tubes, and yards of slimy coils, I've begun to picture my abdominal cavity occupied in-

stead by a single glowing globe, a radiant mandala, a holy pearl of purest ray serene. How's it working? So far so good -- although I haven't yet canceled my health insurance.

Everybody's heard a fish story: two bass on one hook, an ancient trout that outwits generations of anglers, a biblical putz swallowed by a whale, the ubiquitous big one that got away. Ultimately, however, there's only one fish story, as persistent as it is true, and it goes like this: big fish swallow little fish. That's the story behind business in American -- and behind my family's move to Virginia. Northwest Carolina Utilities, the company that lit the lamps in Blowing Rock, was swallowed by the slightly bigger firm that took us to Burnsville; then that one was ingested by East Coast Electric, which moved us to a succession of towns in eastern Virginia; only to be gobbled up in turn by VEPCO, the great white shark that eventually beached my father at its corporate headquarters in Richmond.

Our first stop in Virginia was Urbanna, a fishing village situated where the Rappahannock River, a mile wide near its mouth, empties into Chesapeake Bay. Crabs could be netted inside the town limits, seagulls paraded down Main Street, and the place proved salty in more ways than one. It may be no accident that Urbanna is in the country of Middlesex, accent on the last syllable.

In Urbanna we lived in a grand old house, a colonial brick manor with white columns, solid marble steps, ornate fireplaces, and enough rooms to accommodate Jesus and all twelve apostles, although Judas would have had to sleep on the sun porch. We rented the ground floor and two-thirds of the second. The owner, widow of a sea captain, shared an upstairs apartment with her grown daughter, a young divorcée apparently not thought unattractive by gentlemen callers. Mother was outraged at having come upon the saucy brunette washing the hair of one of her beaux. In retrospect, I'm guessing it was an activity, real or imagined, other than hair washing that upset my

Baptist mom (after all, "cleanliness is next to godliness"). But for years thereafter "shampoo" was associated in my callow consciousness with some sort of wicked pleasure.

As befitting, perhaps, a boy not quite eleven, I personally had only one intimate encounter with the shameless shampooer (destined forever, at least in my mother's mind, to wear a scarlet S on her bodice). She beckoned me into her bedroom one day, saying, a bit cryptically, that she had something interesting to show me. Any ill-formed hopes I might have harbored were abruptly dashed when she lifted not her skirts but the lid of a cardboard box that had arrived, she said, in the morning mail.

She lit a cigarette (doubtlessly another reason why Mother thought her a hussy) and studied my face as I stared, bewildered, at the contents of the package: a big blob of gooey goop. Predominately brown and creamy white, the mess was dotted with nodules of primary color, looking overall as if it could have been the droppings of a mythological bird, some gigantic fruit-eating cross between a pterodactyl and a peacock.

If my thoughts ran toward the ornithological they weren't so far off, because eventually she confided, "It's an egg."

"Huh?"

"An Easter egg."

"It is?"

"It *was*." The dissolute shampooer laughed. Then she explained. For Easter, which was now a month or more in our rearview mirror, a sailor boyfriend stationed in Brooklyn had sent her an especially large candy egg: chocolate on the outside, vanilla cream and candied fruit in its interior. The suitor had neglected to include the state name legibly in the address (this was well before the advent of zip codes) and some myopic postal clerk had directed the package not to Urbanna but to Havana. As in Cuba.

In its weeks of travel -- New York to Havana to Urbanna -- the egg (it was nearly the size of a football) must have encountered suf-

ficient hot weather to rather thoroughly melt it. And with it, I surmised, the sailor's hopes.

If Tommy Rotten longed to stick in his finger and lick it (careful: sublimation is in the mind of the beholder), he refrained; and having now shared her story of a good egg gone bad, this small-town femme fatale indicated that show-and-tell was over. I shambled from her chamber, but in the decades since, I've rarely seen a chocolate egg without entertaining, however briefly, thoughts of life's vagaries, its impermanence. And whenever I've mailed a package to a desirable woman, I've been especially careful to address it correctly.

Urbanna's saltiness was by no means limited to our landlady's sultry daughter. It, oddly enough, flavored even the elementary school, in whose grade five I was enrolled upon our arrival from North Carolina in April. I entered the class just as its teacher was leaving. She had joined the WACs, which in and of itself wasn't strange: America was at war and it was a patriotic thing for an unmarried woman to do. (Evidently, the shampooer was no patriot.) But why would a popular, conscientious teacher choose to bail out on her class with only two months remaining in the school year? Couldn't her enlistment have been delayed until June?

School administrators never said as much, but I had to wonder if the teacher wasn't fired. Why? When I write that she was popular, I'm guilty of understatement. She was, by her pupils, adored, and much of their adoration was due to the freewheeling freedom of expression she not only allowed but encouraged. No subject was taboo in her class, and while pupils lacked the knowledge or experience to discuss anything too explicitly sexual, both their conversation and their papers (the teacher was big on written assignments) were peppered with kiddie innuendo.

For children, a slim though messy line separates the sexual from the scatological, and the themes these Urbanna fifth graders com-

posed were ablaze not only with "hells" and "damns," but "poops" and "pees" and "farts" and "snots," alongside frequent references to "tongue kissing." Once I recovered from the shock, I jumped in with merry abandon, filling my first paper with every penciled profligacy I could imagine while staying true, of course, to the subject at hand (Tommy Rotten had his literary standards).

Alas, the changing of the guard was then under way, and my paper, assigned by the libertine teacher, was graded by her conservative successor. It came back to me so marked with red ink it appeared to be hemorrhaging. It was difficult to look at it and not think of the carnage in Europe. The red *F* it sported was so large and bright it could have been seen by enemy aircraft, even at night. I protested this threat to national security -- and for my trouble, ended up in the principal's office, where I was so shamed I actually cried.

For the fifth grade, the era of official permissiveness was definitely over, although outside of the classroom, "salty" remained the spice du jour. Behind the school building there was an expansive grassy field, extending a great many yards beyond the portion designated as an actual playground. The field ended in swampy woods, and just inside the tree line, invisible from the school proper, was a narrow ravine. Each afternoon at recess, weather allowing, a group of a dozen or more fifth- and sixth-grade boys would disappear into those woods, and not, as one might assume, to smoke cigarettes.

I don't remember if native curiosity prompted me to follow the group one day or if, on the reputation of my notorious heavily censored paper, I was invited along, but I became a willing witness to, though never a participant in, a ritualistic and perhaps atavistic contest. The rules were not complicated: the boys would line up along the brink, open their flies and compete to see who could direct their pee the greatest distance across the gully. Whether lunch money was wagered or it was all for glory I cannot recall, but competition was spirited.

Boys are hopelessly coarse, even disgusting creatures (all too few change with maturity) so recreation such as this shouldn't really surprise anyone. What *is* a bit surprising is that it was a spectator sport -- and the spectators were of that opposite, generally finer-grained sex. It's true: at every recess a small gaggle of girls, no more than four or five, would slip into the woods to watch the proceedings. Invariably, one or more of the boys would beg a girl to give him "luck." The bestowing of luck consisted of the girl touching the boy's penis, a gesture that produced, along with multiple giggles, a junior erection, which could, it seemed, add an appreciable velocity to the lucky boy's urinary propulsion, producing a trajectory that sometimes reached the opposite bank.

Thus are champions -- and legends -- made. Could it have been, I wonder, a similar exhibition that gave McDonald's the idea for its golden arches?

I don't suppose there's a category in Guinness for long-distance urination, though admittedly I've not looked to see. Certainly, this was my one and only encounter with the sport. We moved upriver to Kilmarnock, Virginia, late that summer, so I have no clear idea how the youth of salty Urbanna might have interacted upon attaining puberty; how, if at all, the peeing competitions affected later relationships. Maybe, as she grew older, an Urbanna girl would change a guy's luck by shampooing him.

Despite the brevity of our stay in Urbanna, the place left a mark on me that persists to this day. Fresh from pre–Great Society, pre–network-TV Appalachia, I spoke with an accent that would have made the cast of *The Beverly Hillbillies* sound like the Royal Academy performing *King Lear*. There's no way I can accurately reproduce on paper the way I pronounced, for example, words such as "night" or "ice" or "grass," although I can report that I said "far" for "fire" and

"hain't" for "ain't," which could be a bit confusing since back in Blowing Rock we called a ghost a "haint." Imagine someone exclaiming, "Looky thar in the winder! Hain't that a haint?"

Naturally, the pupils at my new school made fun of the way I talked: kids are blunt in their reaction to deviations from their particular social norms. Alas, I was mocked by Urbanna's adults, as well. Once when Mother sent me to the store to buy a pound of sliced ham for supper, the butcher stared at me incomprehensibly, then demanded I repeat my order again and again. "Slyced hame," I kept saying, pronouncing "ham" as if it rhymed with "came" or "lame." Eventually, my order was filled, though not before I had to point at what I wanted and everyone in the store enjoyed a laugh at my expense.

Spurred by ridicule, I soon commenced to devote much time and effort to altering my manner of speech, practicing off and on throughout the day, laboring to talk as if I were somehow indigenous to tidewater Virginia. The results were not pretty. Sure, "hain't" was no longer in my vocabulary and I could now order flesh of the pig without embarrassment, but overall what happened was that my elocution flattened out permanently into a kind of deflated Okie drawl.

Today, my voice sounds as if it's been strained through Davy Crockett's underwear. While to my mind's ear, I might sound like an Oxford-educated intellectual, I have only to hear myself on tape to realize that in actuality mine is the voice of a can of cheap dog food -- if a can of cheap dog food could speak. It's a Skippy voice. Not even that, a *generic* brand with a plain brown label. Thanks, at least in part, to the jeerers and sneerers of Urbanna, I'm going through life with a voice that might be visualized as something scraped off the kitchen floor of a fast-food restaurant by a pimply teenage dishwasher at closing time on Friday night. Or else that little pile of smashed potato chips left on the rubberized seat cushion of a motorized wheelchair belonging to a 365-pound retired female professional wrestler named Grandma Moses. Or else . . . well, you get the picture.

In one of my early novels, *Even Cowgirls Get the Blues*, the pro-

tagonist, Sissy Hankshaw, is born with abnormally large thumbs. Rather than submit meekly to the deformity, she elects to turn the tables on it, exploit it, have fun with it, make an art of it, ride it all the way to glory. I'm not as wise as Sissy, but I *have* in recent years come to accept my voice, even cheerfully embrace it -- although there are delusional moments (usually while lecturing or reading aloud in public) when I'm still convinced I'm sounding a lot like Jeremy Irons.

There's an area of tidewater Virginia known widely and semiofficially as the Northern Neck. It is, indeed, a "neck" of sorts; which is to say a peninsula: bordered on the south by the Rappahannock River, on the north by the Potomac, terminating at the Chesapeake Bay. There are four counties in the Neck, each just far enough downwind from Washington, D.C., to escape moral contamination.

Kilmarnock is the largest town in the Neck; Warsaw the most vibrant, though "vibrant" may be too fancy a word for any community in this region of farmers and fishermen. Our family alighted on Kilmarnock like flies landing on a horse biscuit, shooed away by the swishing tail of circumstance before we could savor a proper taste. Our home there, for the few months it lasted, was a plain single-story clapboard cottage, bereft of marble, of ornament, of any upper chamber where a sexy Samaritan might assist in the tonsorial hygiene of needy gentlemen.

The house was situated at the far end of town, piney woods behind and on one side of it; on the other side, a vacant field. The only neighbors were across the road and we rarely saw them, so it was months before I learned that my sixth-grade teacher lived there, the very one who slapped my face for "sassy" behavior. (I suspect that I, a devotee of atlases, had corrected her none too diplomatically in front of the class for some shocking display of geographic ignorance, à la Sarah Palin.) Moreover, our house sat back quite a distance from the road, so overall it's fair to say we were a trifle isolated, a fact that

made Mother uneasy, especially since Daddy was usually only home on weekends. No doubt it was due to Mother's nervousness that on weeknights she, my twin sisters (then age four), and I all slept in the same smallish bedroom.

Late one night (it was past my bedtime at any rate), Mother thought she heard a noise outside. When she slipped into the darkened living room to investigate, she saw that a car was parked in our long dirt driveway. Its engine wasn't running and its headlights were off. She watched the car for five or ten minutes. When she returned to our bedroom, she was carrying a butcher knife.

It was a mild Indian summer night (since, technically, Indian summers can only occur after there has been a frost, it was probably toward the end of October) and the bedroom window was raised. The window was, however, permanently screened. Pointing to the window, Mother handed me the knife. In a low voice she instructed me to await her signal. When and if it came, I was to slice open the screen, lower Mary and Marian outside, follow them out, lead them quickly away from the house, and hide.

Zing! Adrenaline shot through me like a crystal meth espresso through a break-dancer. I was scared, to be sure, but equally elated, fairly throbbing with anticipation. I'd been reading *The Three Muske-teers* that same week, and the moment my hand closed around that knife handle I was transformed into d'Artagnan. "All for one and one for all!" I exclaimed, a trifle too loudly to suit Mother's mood.

Before she tiptoed back to the living room, she put a finger to her lips, then gestured for me to rouse my sisters. "There's a bad car in the driveway," I said as I tugged at their bedclothes. "Who in tha car?" mumbled Marian, barely half awake. "Cardinal Richelieu and his lieutenants," I replied, still tugging. They gazed at me without an atom of comprehension.

Herded to a place by the window, the twins, who heretofore had been too sleepy to do more than whimper a little, now commenced to actively whine. "Hush," I cautioned. "There's a car out there full

of escaped maniacs. Do you want them to come kill us and eat our brains?" Evidently, the girls did not. They became ~~unwon~~ ~~until and~~ ~~silent~~, though now they were shaking like cherubs on an ice floe. "Don't worry," I said, "I'll protect you." Cleverly, they responded in Morse code, tapped out with their teeth.

Since I was seven years older than my sisters and a boy to boot, my attitude toward them had naturally been one of indifference. Benign neglect. Now, however, having suddenly been put in charge of their physical survival, I was totally prepared to shepherd them into the forest and shelter them there; to guard those girls all night if necessary. All night? Maybe several nights. Hey, maybe a week! Who knew how long the fiends in that car -- be they slobbering maniacs, a band of robbers, or, more likely, Japanese spies (the war in the Pacific was raging then) -- would occupy our home? At some point, I might have to sneak into the house and cut Mother free of the ropes with which they'd surely bind her, particularly if, while stealthily foraging for food scraps in the garbage can out back, I should detect sounds of torture, a situation that might necessitate hand-to-hand combat.

Armed with a dull kitchen knife and a keen imagination (the wild horse was out of the chute now and good luck to the cowboy who'd try to break it or the rodeo clown who would distract it), I was projecting one heroic scenario after another onto the screen of my mind, reminding myself that I was born for adventure.

It was right about then that Mother returned to announce that the car had started up and driven away. "Maybe they'll come back," I said. Judging from the scowl on Mother's face, she was all too aware of the note of hope in my voice.

Though she never said as much, our intruders probably had been young townspeople in immediate need of a secluded spot to swallow alcoholic libations, each other's saliva, or both. It would be a few years before I learned that illicit drinking and making out were also adventures of a sort, ones for which I had alarmingly more aptitude than for the thwarting of Japanese spies.

fright or lite

One Halloween midnight when my father was in his early twenties, he and some buddies went to the home of a slightly older, recently married friend, quietly dismantled the fellow's new Model T Ford, climbed up and reassembled it piece by piece on the roof of the house. (Cars were not so complicated in those days, but it was still quite a feat.)

The following morning, as the distraught groom was telephoning the Blowing Rock police to report a grand theft auto, a wildly gesticulating neighbor rapped on the window and beckoned him outside. As the men stared up at the shiny black vehicle, perched now like Edgar Allan Poe's nightmare between two chimneys, they could only shake their heads and mutter, "Halloween."

If in their voices there was consternation, there was also resignation and even a poorly disguised trill of admiration: it had been a daring, perfectly executed whopper of a prank on a night consigned to pranksters, a night ruled by the Lord of Misrule, a night when unsettled spirits of the dead squeezed through a crack in the space-time continuum, demanding notice and a bit of mischievous fun, often temporarily occupying the all-too-willing bodies of young Western males.

Nowadays it's Halloween lite, all treats and no tricks, the dead driven back into the underworld by candy companies, liquor stores, Hallmark-card sellers, costume merchants, and understandably concerned owners of vulnerable private properties. Believe me, I'm seldom one to pine for the "good old days," but when I was growing up

much mischief was afoot on October 31, and ol' Jack was alive in the lantern. Privies would be overturned, gates unhinged, penned chickens liberated, tires deflated, doorbells mysteriously rung, lawn shrubbery festooned with toilet paper, homes pelted with eggs; and every shop window in town thickly soaped, generally with pseudocryptic graffiti resembling today's adolescent "tags."

With long roots in antiquity and the human psyche, Halloween was the one night of the year when humanity openly acknowledged universal dread, honoring the departed even as it trembled at the rattle, real or imagined, of their bones; a celebration in which populations came together to sing "Happy Birthday to Death." A Halloween without fear is a Christmas without cheer, an Independence Day without freedom, a luau without aloha, a corrida without *olé*.

By the twentieth century, the old terror, if not erased, had been significantly suppressed; and once-sanctioned communal anarchy reduced to a temporary tolerance of the kind of soft vandalism previously described. And in century 21, the Feast of the Dead is primarily represented by tutu-clad children on tooth-decay missions, by young adults dressed up as cultural icons in the hope they won't be recognized when they make inappropriate sexual advances and/or get falling-down drunk.

Now, as a property owner, not to mention "senior citizen" (talk about a scary epithet), I can't say I'd prefer those Halloweens of yore, yet I can't help but feel that something has been lost: something transformative, something central to our story, something secretly nourishing to the soul. And, to be perfectly honest, I wouldn't mind awakening one November 1 to see my neighbor's Toyota on top of his house.

As a teenager in Warsaw (the Virginia village where I finally got over my homesickness for Blowing Rock), I was to be found every Halloween among the group of boys that gathered after supper in

the center of town, intent on mischief, percolating with an uncon-
scious longing to invoke and flirt with those fearsome forces that
haunt the mortal shadows of being. On the other hand, it may just
have been a bunch of bored kids looking for a break in small-town
routine, looking to cut loose for a night, looking for a little ex-
citement, for kicks. Despite their rowdy nature, these rallies were
fundamentally devoid of malice, were reflective of an actual kind of
innocence; yet, as I can report firsthand, they did not always pro-
duce a happy ending.

As we boys, armed with bars of soap and rolls of bathroom tis-
sue, milled about Warsaw's main intersection, waiting for Clanton's
Drug Store to douse its lights and close for the night (the intersec-
tion's other businesses had gone dark at six), we were inevitably
joined -- or, rather, confronted -- by an adult male in a suit and tie.
That would have been Mr. Willy Jones, the commonwealth attorney
for Richmond County, a jowly, humorless middle-aged man whose
fairly affluent residence was a scant two blocks away. Jones would puff
himself up, survey us disdainfully, and address us in a painfully slow
Southern accent so swimming in hog gravy that it elicited giggles
from us boys, even though all spoke fluent Dixie save I, who, as afore-
mentioned, sounded like an Oklahoma bug doctor trapped under a
spud truck. "I am orderin' y'all," Willy Jones would announce, "to
deesperse this assembly immediately or I will prosecute ever lass one
of y'all to the fullest extent of the law."

Jones's threat would be greeted with hoots and jeers. He would
then repeat it, emphasizing the prosecute part; and gradually, in pairs
or groups of three or four, boys would peel away from the main body,
only to regroup (though we always lost several 'fraidy cats) around the
corner and down the street in front of the B&B poolroom, the only
establishment in town aside from the movie theater and the Negro-
friendly Texaco station to remain open after eight. It was a yearly
ritual: Willy Jones would strike a vocal blow for the rule of law and
the forces of good, then we frankly laughable representatives of the

Dark Side would scatter, later to slip and sneak around the residential streets banging on doors, tipping over garbage cans, wreaking minor havoc. One October 31, however -- it was my senior year in high school -- the routine took an unfortunate left turn, paving the way for the end of Halloween Fright and the advent of Halloween Lite in Warsaw forever.

Wishing perhaps to put some distance between ourselves and Willy Jones (Warsaw's sole cop always seemed to conveniently vanish at Halloween), eight or nine of us found ourselves a half mile or so from the heart of town, out where residences petered out and croplands began. Be it by chance or subliminal design, we were gazing across a field at a large white farmhouse occupied by an unmarried schoolteacher and her bachelor brother. Andrew Garland, a gruff old bird, had retired from surveying to devote all of his time to the farm. His sister, Claude, a severe, stout woman who had been teaching typing, shorthand, and bookkeeping at Warsaw High School since practically the demise of clay tablets, was known to everyone, young and old, as "Miss Claude."

Motivated by no spoken plan, we advanced to within forty feet of Chez Garland, finally pausing beneath a black walnut tree, very tall and likely older than all of us put together. The actual black walnut nut, hard and dense of shell, is contained inside a thick, pulpy husk about the size of a handball: a perfect size, alas, for throwing. As there were walnuts aplenty on the ground, it wasn't long before, silently, spontaneously, our puppet strings pulled perhaps by the spirits of Halloween -- ancient, autumnal, arboreal -- we commenced to hurl the walnuts against the side of the house.

So far so good. We seemed to be successfully creating the very kind of loud, hopefully scary, ultimately harmless racket that was ever our goal on these annual nights of fright. But then . . . But then there was a new sound: a *clink!* followed instantly by a cascade of icy tinkles, as if a cheap music box had imploded inside a freeze locker. The noise was repeated. Over and over. Encore! Encore!

From inside the house, there came a sound disturbingly akin to
a scream. Abruptly, the tinkling stopped. We froze. The night, the
earth, the universe slammed on its brakes. Time sucked on a chlo-
roform Popsicle. We gaped at one another, neither in triumph nor
terror, neither with bravado nor indifference, but with a peculiar kind
of disbelief. Then, like a flock of starlings, we whirled as one and took
off for town.

Our young legs covered a lot of ground quickly, but the news of
our foul deed got there ahead of us. By the time we reached the B&B
poolroom, Lester Scott's father and Bernard Packett's older brother
were already sitting out front in their pickup trucks, engines idling,
and less than a minute later, Lester and Bernard were hauled away.
When we looked up the street and glimpsed Willy Jones conferring
with our local lawman beside his patrol car, the rest of us developed a
sudden yearning for the comforts of hearth and home.

Each upstairs window in the Garland house comprised a dozen
nine-by-eleven-inch panes. How many of these were shattered, I
couldn't say. Reports later ranged from five to twenty-five, depend-
ing on who was talking -- and none of us boys was talking much at
all. The number, however, was not really the issue. The more relevant
question was "Why?"

Cap'n Andrew, as he was called, wasn't the most gregarious of
men, but certainly none among us bore him ill will. As for Miss
Claude, she had a reputation at school as a stern disciplinarian, but
nobody ever called her unfair or unkind. Moreover, not a boy in our
party had taken one of her classes. Her mission for at least two de-
cades had been to prepare local girls for office work, one of the very
few jobs available to young women at that time and in that place.
Had we ever given it a moment's thought, we'd have let out an ec-
static rebel yell that it was the girls, not us, who faced a future of
balancing ledgers and taking dictation.

No, it was neither personal anger nor general resentment of au-
thority that prompted our walnut barrage, nor can it be traced to any

inherent meanness; and let's not get carried away with blaming the demonic agents of Halloween, though our assault never would have occurred on any other day of the year. In the end, I suppose it was the confluence of boredom, hormones, and chance opportunity that led to the broken glass, an impromptu teenage reach for fresh thrills in small-town postwar America.

In any case, for days thereafter, all of Warsaw was abuzz with talk of the Halloween caper. Everywhere, we were regarded with curiosity and/or disgust. Commonwealth Attorney Jones was hell-bent on "prosecutin' ever lass one" of us to the fullest extent of the law. Rumors of impending reform school were widely circulated.

Several of our parents got together and hired a lawyer, and I was among those who were deposed in his office. Eventually, restitution was paid, individual letters of apology written, Miss Claude forgave us, and within a month the evil pumpkins of Halloween had been safely baked into Thanksgiving pies, although there were a few of us who would never quite sponge ol' Jack's tainted smudge from our ledgers.

Now, an octogenarian writer looking back on his life, I find my list of regrets a short one: shorter, no doubt than it has any right to be. Near the top of that list, however, ahead even of a couple of ill-advised marriages, is the part I played in the breaking of Miss Claude's windows. If there is an afterlife, a dimension resembling Judeo-Christian fantasies of heaven, I take some solace in the conviction that the good Miss Claude is busy there, occupied with helping God update His office skills in case He should finally get around to correcting all those obvious mistakes in the Bible.

Apparently, my seasonal interest in the Feast of the Dead mythology was squelched neither by maturity nor middle age (the two being by no means synonymous), because I was a tick past forty on the Halloween when three friends and I ingested a sizable (though less than

heroic) dose of so-called magic mushrooms (*Psilocybe semilanceata*) and set out to make credible contact with the spirit realm.

The most favorable spot for such an encounter (location, location) seemed to be a graveyard, one well away from traffic and city lights. Thus, Pleasant Ridge Cemetery seemed ideal. Several miles from La Conner as the vulture flies, reached only by a two-lane country road, it was unlit, unguarded, reasonably isolated, and regularly enveloped in Pacific Northwest mist. Any bag of bones tempted to rise from the grave could scarcely ask for better conditions.

By the time we reached Pleasant Ridge, the fungous psilocybin had begun to kick in. The caul of civilized conditioning was falling away from our eyes, and our central nervous systems were vibrating at a frequency that seemed to be perfectly synchronized with both the rhythms of wild nature and the music of the spheres. It was the necromantical numina of the netherworld we were courting, however, and they proved to be reluctant guests.

Time is decidedly relative when one is in the thrall of the mushroom elves, but I'm guessing we sat among the tombstones for no more than thirty or forty minutes before concluding that such close proximity was likely inhibitive to the wakeful dead; whereupon we moved across the narrow road and repositioned ourselves inside a thickish grove of alder and second-growth fir. There we not only had a clear view of the cemetery without being intrusive, but were concealed should a car happen by, and moreover, were in a relationship of sorts with the (not-exactly-primeval) forest.

A bank of clouds foreclosed on the moon. Dark pillows smothered the stars. A thin silvery rain began to fall. Still, we sat. We watched. And we giggled. And giggled and giggled. We were cold, wet, scratched by twigs, uncomfortably seated, and in a lonely, spooky place miles from the costume party our peers were enjoying at the tavern in town. So what was so damn funny?

Well . . . everything. Everything! Raindrops running off Roseanna's nose were funny. Victor's fit of sneezing was funny. Aurora's un-

successful attempt to form a coherent sentence was funny. The moss was funny, the ferns were hilarious, every third tree will a stand up comi than. From the perspective afforded by psilocybin's psychoactive alkaloids, existence itself was so amusing it was a wonder any one could take it seriously for half a minute. In our altered state of consciousness we seemed to be fortuitously in tune with those Asian "crazy wisdom" sages who have defined life as "the beautiful joke that is always happening"; with the avatar Ramakrishna who, after achieving ultimate enlightenment, returned to say that what Nirvana most closely resembled was laughter.

Well and good, yet it was our comic sensibility that may well have been the rubber fly in our Halloween ointment, that may have been precisely why we failed to access the Other Side. When we finally gave up and drove back to La Conner, it was starting to occur to us that séance and silliness might not mix, not even in a remote rural graveyard on the thirty-first of October with an elfin choir of sacred toadstools singing in one's blood. Life may be a joke all right, but the dead are not easily amused.

holy tomato!

It was said of Cap'n Andrew Garland, he of the walnutted window-panes, that he walked outside one morning, shook his fist at an uncertain sky, and shouted, "All right, God, I've got You now! If it's sunny I'll get up hay, if it rains I'll plant tomatoes."

Since tomatoes were the principal cash crop in that area of Virginia, and since Christianity played a significant role in nearly every Warsawian's life, it's hardly surprising that the Almighty would be occasionally invoked in a field where the love apples grew. I personally witnessed such an invocation, and a quite effective one, albeit with the opposite intention of the usual agricultural prayer.

In my teens, I lived for two successive summers on a farm owned by the family of a high school buddy, where I, along with a half-dozen other boys, was hired to pick tomatoes. We were paid ten cents per basket for green fruit, five cents for ripe. The green ones were destined for the grocery stores and produce markets of Florida, its growing season being the reverse of our own, and they had to be unblemished and of a particular size, whereas the ripe ones, which we'd haul at night to a local cannery to be turned into juice or sauce, had no such restrictions and thus were far easier to pick. On a good day, a boy might earn four or five bucks, which could light up a good many pinball machines and add any number of comic books and girlie magazines to one's *Librorum Prohibitorum*.

The camaraderie, moreover, though unspoken, was relished by all of us, and we shared a sod-sullied bond strengthened by the perpetual japes and jabs of inane teenage redneck humor. Ah, but as wise

men know, a big front has a big back, and the beefiest backside of this summer job was that on July afternoons it could get hot enough in those low-lying fields to melt the humps off a camel. There were days when the sunshine seemed not only weighty, not only textured, but almost audible: it sounded like drops of oil crackling into combustion, or a bluesman vamping on a harmonica made out of lard. On one of those days, the heat became so unbearable it apparently called for divine intervention.

Lancelot Delano (that was his actual name, though his friends called him "Gumboot") was a tall, gawky youth, strong as a mule but sweet as molasses and just about as slow. Lancelot wasn't really a halfwit, not exactly a simpleton, just . . . well, *slow.* He was related to two of the pickers, and all of us knew him even though he'd kissed school good-bye in the fifth grade and rarely came to town, even for a movie. Gentle and good-natured, he was never ridiculed, but, rather, elicited from his peers a measure of rough affection -- and, one day, the torturously torrid day aforementioned -- a kind of awe.

The temperature flirted with one hundred that afternoon, humidity hard on its heels. We sweated like thawing snowmen, and in our wilting ears heat made a faint fuzzy chirping noise, like the spasms of wounded crickets. Bending over the tomato vines as we worked our way down the rows, we were sinking ever more deeply into a miserable stupor, when suddenly we heard Lancelot Delano's voice, addressing the heavens: "Good Lord, if it's in Thy power," he intoned, "send us that knocking-off shower."

What happened next strains credibility, but I swear to the truth of it. Within fifteen minutes or less, the pale blue sky broke out in bruises, dark tanks of cumulus came rolling in, bucking and heaving like a Russian rodeo. Claws of lightning ripped a turbid bodice, thunder neighed like all the czar's horses. Farmer Packett, our boss, kept glancing up nervously, and by his fourth or fifth glance he had rain in his face.

The downpour didn't last especially long, but afterward condi-

tions in the field were too muddy for effective picking. We happy boys piled into and onto a big farm truck and sped off to the Rappahannock River, where we frolicked in the cool, salty water until suppertime. I'm unsure if any of us questioned our goofy liberator about his cosmic connections, but for weeks thereafter I'd catch boys, including myself, looking at him with something akin to wonder.

On several overheated occasions later in life -- laboring on a construction site, drilling on a military parade ground, trekking in sub-Saharan Africa -- I attempted to duplicate that little meteorological miracle, lifting my eyes and muttering, "Good Lord, if it's in Thy power, send me that knocking-off shower." Nothing happened. Not one drop. I'd lacked both the courage and conviction to speak my prayer aloud; I'd lacked the pure heart and spirit of Warsaw's sweet Sir Lancelot, Saint Gumboot of the Tomatoes.

Summer, tomatoes, religion, the river -- and the actress Natalie Wood -- are all tangled up in the web of my memory. Let me see if I can separate the strands.

Had the summer I turned thirteen been the Kentucky Derby, it could have been won by a hobbyhorse: that's how slowly those months dragged by. Too young for gainful employment, even in a tomato gang, I passed the long, steamy days reading, napping, attending Vacation Bible School (yawn!), composing with my "talking stick" (about which, I'm afraid, I'll have more to say later); impatiently waiting for a Tarzan movie, a circus, or a traveling carnival to find its way to town. Other than that, my primary activity was hiding from Dr. Peters.

Pastor of the Warsaw Baptist Church, Dr. Peters was tall, gaunt, and pale, with a weak damp smile and cold damp palms: shaking his hand was like being forced to grasp the flaccid penis of a hypothermic zombie. And he did always want to shake my hand. Whenever he managed to corner me, that is. I considered Dr. Peters more

creepy than refrigerated possum slobber, an opinion not shared by my mother, who found him John the Baptist incarnate and the ideal shepherd to steer my soul to Jesus.

The two of them, Mother and Dr. Peters, believed that very summer -- the summer when testosterone first barreled into my plasma, piloting a red speedboat and scattering large pieces of childhood in its wake -- to be perfect timing for redeeming Tommy Rotten, and they conspired to facilitate my salvation. At Mother's invitation, the good pastor kept dropping by for a glass of iced tea, intent on engaging me in spiritual conversation. Rather quickly, I developed a sense of his impending arrival and a strategy for avoidance that more often than not consisted of me vanishing into the thicket behind our garage, pretending not to hear my name being called.

A weeklong revival meeting was scheduled for mid-August at our church and on those occasions when I failed to elude him, Dr. Peters would solicit my pledge to come forward during one of the evening services and commit my life to Christ. I wasn't entirely opposed to the idea. While I would have preferred that Jesus be a lot more like Tarzan, I had nevertheless bought into the prevailing view of him as the greatest figure who ever trod the earth, the heroic loving martyr who would return someday to dispense to true believers their personal slices of sky pie. Certainly, I didn't wish to burn, Warsaw's summer was plenty warm for me; and although descriptions of heaven made it sound disturbingly similar to Vacation Bible School, only an imbecile would trade a little boredom for the fires of hell. I convinced myself that I loved Jesus and might be worthy of his love in return -- but why did Dr. Peters have to be the matchmaker?

There was a livelier preacher in the area: a rather flamboyant African American who drove a light blue panel truck upon whose sides were painted in fiery red letters several ominous Bible verses, along with the preacher's name: THE REVEREND EVER READY. This is not a joke.

Every so often, the Reverend Ever Ready would drive up to the

little black-friendly Texaco station, fling open the rear doors of his van, and step aside as six or seven noisy children, all seemingly under the age of ten, swarmed out and began running wildly hither and yon. The good reverend would oversee the filling of his tank, the checking of his motor oil (this was prior to the advent of self-service), then go inside to swill a Coca-Cola, dig some soul tunes, and shoot the breeze with the proprietor. After a quarter hour or so, he'd emerge, and bellow in his powerful pulpit voice, an operatic baritone so volcanic it could be heard blocks away, "All aboard! If you can't get a board, get a plank! If you can't get a plank, get your ass in the truck!" The kids would come racing from all directions and dive for the doors just before he pulled away.

Now, I never heard the gentleman preach: this was racially seg-regated Virginia, remember, and there was nary a white face in his congregation. Nevertheless, had it been the rambunctious Rev. Ever Ready rather than the cadaverish Dr. Peters offering to drive me to Christ, I'd have been considerably more eager to get aboard. To get a plank. To get my ass in the truck.

On a sweltering August night, I sat in a sticky pew, nervously await-ing the call. When it came, I walked to the front of the church (the lights were low, the congregation was softly singing), and along with a handful of other repentants surrendered my life to Yeshua bin Mir-iam, the radical itinerant rabbi known to English-speaking Chris-tians as Christ Jesus. My mother was overjoyed, my father pleased enough, Dr. Peters carved another notch in his pastoral pistol, and I was . . . well, kind of on pins and needles.

What exactly was I expecting? I could not have said with any degree of articulation, I just thought I'd feel somehow *different*. Oh, I felt good about myself, felt a certain sense of accomplishment, felt marginally safer even; but when I awoke the next morning, there was no aura around the objects in my room, no radiance in my mirror, I

was unmotivated to go forth and help the sick and needy (not that I'd had a clue where to begin), and instead of turning for guidance to the family Bible, I found myself reaching for the Hardy Boys mystery novel I'd started a day or two before. *Maybe,* I thought, *nothing has changed because I haven't yet been baptized.*

I didn't have long to wait. Within a fortnight, I was wading fully clad (I argued for old clothes but Mother insisted I don my very best) into the Rappahannock River, in which Dr. Peters stood up to his skinny thighs. When it was my turn, he told me to hold my nose, placed a hand in the small of my back, another behind my head, said a short prayer, and completely immersed me. I waded to shore, soaked, dripping, uncomfortable, but pretty confident that henceforth I would live my life in virtue and light.

Impatiently, I waited to be transported, to be transformed, to be illuminated (whatever that meant precisely). A day passed. Three days. A week. Was my soul so wicked it was beyond redemption? Had they shrunk my favorite pants for nothing? Was I damned? Then it happened: I was struck full force by spiritual lightning.

As it turned out, Dr. Peters had nothing to do with it, Rev. Ever Ready was not even remotely involved, nor had Lord Jesus himself hurled the bolt from above. No, my sudden spiritual awakening was precipitated by Miss Natalie Wood.

Leaving my twin sisters with a sitter one evening, my parents had allowed me to accompany them to a movie in Callao, a town about a dozen miles from Warsaw. The film, entitled *Tomorrow Is Forever,* dealt with the shock, confusion, and heartache that ensues when a soldier, thought to have been killed in battle, returns alive years later (his war-disfigured face unrecognizably altered by plastic surgery), to find that in his absence, his wife and presumed widow has married another man. Natalie Wood, then eight years old and pretty, sweet, and vulnerable, played the adopted daughter of the resurrected man, trying to be brave as her young life is squeezed through one emotional ringer after another.

Okay, it was a Hollywood tear pump, a celluloid onion chopper, yet the film was skillfully executed (Orson Welles had a hand in it), and from young Natalie there rippled echo-circles of such genuine poignancy that they melted the shadow between make-believe and the real world. I doubt that I cried in the theater -- it would have caused me terminal embarrassment -- but on the drive home, as I sat alone in the dark backseat, a few drops leaned their slick bald heads over the window ledge of my tear ducts, glancing around to see if the coast was clear. And then . . . something else happened.

My sorrow unexpectedly widened and deepened, became less focused on the Natalie Wood character, become increasingly comprehensive -- enveloping not only hurt children and suffering innocents everywhere but also Hiroshima victims, Huck Finn's Jim, our neighbor's recently euthanized cat, and so on and so forth. Natalie's character also embodied a stubborn, contagious hopefulness, and in me that hope commenced to expand geometrically, as well, eventually morphing into something akin to universal love.

My scruffy whippersnapper heart opened like a sardine tin, my impressionable kiddish brain sidestepped the domination of cognitive experience; I sensed the world in me and me in the world, felt fundamentally connected, saw the many as all and the all as one; one and all bobbing along forever and ever in an unending, indestructible river of tears and tickles, breath and meat. In this totally unfamiliar oceanic state, momentarily free of self-involvement, conventional knowledge, and pedestrian consciousness, radiating such a vortex of woo-woo love it would have made Saint Francis of Assisi seem like a mink rancher, I finally felt "saved." And while it was not quite the salvation Mother and Dr. Peters had in mind, I was certain it suited God and Jesus just fine. Blessed be Natalie Wood.

School opened in Warsaw that very week, and I, entering eighth grade, was soon caught up in activities curricular and extra that left

scant time to reflect on my cosmic illumination. The clear light slowly faded and I was not to experience anything similar until, decades later, I was introduced to meditation and the psychedelic sacraments. It was hardly the last time, however, that I was affected profoundly by cinema.

A film that comes immediately to mind is François Truffaut's *Shoot the Piano Player*, which I watched alone at a private screening in 1963, having gone to review the movie for the *Seattle Times*. After leaving the theater, I did not -- could not -- speak for three whole days. The unexplained silence caused my baffled wife to flee, moving into a motel until I recovered my voice. Susan never understood and I'm unsure if I can explain it adequately even now, except to say that Truffaut's daring artistry validated unexpectedly yet completely my nascent literary vision, giving me the confidence to bring it, in time, to fruition.

In one amazing scene, a young woman about whom Truffaut has led us to care deeply, is shot by gangsters who are hiding out on a French farm. It's winter, and when the dear girl topples, her body goes sliding slowly, gracefully, on and on, down a long slope covered with snow. Our hearts are breaking over the girl's death, yet the long snowy scene (shot in black and white) is, from an aesthetic perspective, breathtakingly beautiful. The audience is pulled in two directions at once, and it was this dichotomy and others like it in early Truffaut that led me to accept and eventually act upon my own life view, my native hardwired inclination to mix, intermingle -- even fuse -- in my novels the tragic with the comic, the ugly with the beautiful, the romantic with the gritty, fantasy with reality, mythos with logos, the sensible with the goofy, the sacred with the profane. Hidebound critics experience some difficulty with this approach, finding it challenging to comprehend, for example, how writing can be simultaneously ironic and heartfelt, although to the nimble-minded among us it seems every bit as appropriate as it does surprising.

In any case, while *Shoot the Piano Player* may have had the more

obvious effect on my life, it would be wrong to dismiss that awak-
ening precipitated by *Tomorrow Is Forever* and little Natalie Wood.
Natalie, whose birth name, incidentally, was Nikolaevna Zakha-
renko, grew up to be a major Hollywood actress, starring in such
memorable motion pictures as *Splendor in the Grass* and *Rebel Without
a Cause*. According to gossip, she was also quite naughty in her adult
life, though far be it from me to hurl any stones. In an interview, her
friend and fellow actor Dennis Hopper told how Natalie had to be
rushed to a hospital emergency room because during one of their wild
parties she'd had champagne poured on her vagina. Bull! I'm not de-
fending Natalie because once upon a time she brought me closer to
Love and Truth and God, but Hopper was a creative artist who could
sometimes be creative with facts, and I can tell you from personal
experience that champagne, however directly or copiously applied,
causes neither pain nor injury to a woman's treasure, her salty peach,
her rosy aperture, her nether diadem.

While I won't claim that tomatoes have brought me closer to Love
and Truth and God, they have enriched my life on countless occa-
sions, especially when sliced, salted, and laid between two slices of
soft white bread slathered edge to edge with mayonnaise.

My passion for the tomato sandwich, which persists to this day,
blossomed in Warsaw, hardly a coincidence since prior to our set-
tling in Virginia I could be counted among the millions of Ameri-
cans who've never tasted a proper tomato. In the Puget Sound area,
where I now reside, summers aren't hot enough, soil lacks the proper
acid content and holds too much water. As a consequence, the to-
matoes grown here taste only marginally better than soggy Kleenex.
Many other parts of the U.S. also roll out tomatoes consistently
deficient in both flavor and nutrition. In Virginia's Richmond and
Hanover counties, heat, sandy soil, and high pH factors combine
to produce love apples that lend credence to Erica Jong's otherwise

cryptic line, "If a woman wants to be a poet, she must dwell in the house of the tomato."

I cannot speak for female poets, their abodes or their education, but during my summer of avoiding Dr. Peters and embracing Natalie Wood, the two summers I worked in the fields, and many summers thereafter, I did dwell in the house of the tomato sandwich, though it was less a house, I suppose, than a boat: a modest yet spunky little raft in a sea of culinary confusion, defiantly flying a flag foreign to canapé-snapping gourmets and junk-food junkies alike. Long may it wave. On the other hand, maybe my favorite sandwich -- indeed, my all-around, all-time favorite food -- has been less a barge than a temple, say; a shrine, a zendo, a pantheon. If a boy wants to be a writer, must he worship in the church of the tomato?

I would be derelict did I not point out that these days, even in perfectly suited eastern Virginia, it's nearly impossible to find a worthy, healthy, full-flavored, densely pulped, intoxicatingly pungent tomato for sale in any public market. The reason is that our shoddy, fast-buck, rush-to-profit economy encourages growers to pick and ship fruits much too soon. Many people hold to the belief that a tomato, especially if left to rest in a sunny place, will continue to ripen once picked, an assumption that is patently false. A picked tomato may continue to "redden," true enough, but as any plant biologist will tell you, reddening is not the same thing as ripening. Outwardly, a prematurely harvested tomato may be blushing like Natalie Wood in the emergency room (Dennis Hopper's little fantasy), but inwardly its sugaring process -- so essential for flavor -- has come to a screeching halt.

Without apparent guilt or shame, supermarkets from coast to coast regularly post signs reading VINE RIPENED TOMATOES atop produce bins piled high with tomatoes that have never ever experienced the joys of ripening; that, in fact, are hard, usually more pink than red, often streaked with yellow, orange, or even green; and when cut open will reveal pectin deposits of ghostly white. Back

when one of those babies last saw a vine, it might have passed for the viridescent apple of Granny Smith's eye. Merchants who through ignorance, indifference, or outright chicanery untruthfully promise "vine-ripened tomatoes" could and should be prosecuted under truth-in-advertising laws.

Erica Jong is a lusty woman. I can no more believe that she would advise poets to take up residence in some weak, pink, corporate tomato than I, when I opened *Jitterbug Perfume* with the line "The beet is the most intense of vegetables," intended for readers to think of any but the reddest of beets. Being a root vegetable, beets aren't subject to issues of ripening, of course, but still, a *yellow* beet?! Fie on that craven, that fool's gold, that ditzy blonde, that impostor, that stand-in (but never stunt double: if you doubt that red beets do their own stunts, check your toilet bowl the morning after). For intensity, one wants a red beet. For delectability, one wants a tomato, authentically ripe. Apparently, both can be inspirational.

sticks of wonder

By the time I was ten months old, I was both walking and talking. Scarcely taller than a bowling pin, as fair of hair as one of those Aryan tots with whom Hitler and his henchmen loved to pose, clad only in diapers or rompers, I must have cut quite a figure toddling down Blowing Rock's main street beside my mother. Looks, however, weren't the whole of it. Shopkeepers, amused loafers, and other citizens would often fork over pieces of penny candy or even an occasional Popsicle to hear this ambulatory baby speak in complete, if short, sentences. Apparently, it never occurred to anyone that Mother might have been a ventriloquist.

If I was performing like a trained seal, it didn't bother Mother (blinded, perhaps, by her pride in my precocity), and if it twisted my psyche in some lasting way, I've managed to mostly compensate. What it did do was to instill in me at a very early age the knowledge that words have worth, have power; that language can command rewards. And Freud might argue that that was enough to set my course as a writer.

Not so fast, Uncle Sigmund. While the favorable response to my surprisingly articulate jabber could very well have planted the seed from which whole narratives would in a few short years be sprouting -- verbal displays that may indeed have leaned toward attention and approval the way a potted geranium leans toward the sun -- there are also completely private acts of literary creation that seek no audience, deny appreciation, are meant never to be read or heard; and these are not so handily explained. Consider, for example, my "talking stick."

Although this activity began sporadically a year or two earlier, and continued in an abbreviated, more surreptitious fashion for a year or two thereafter, its golden age was my time in Warsaw, roughly between the ages of eleven and sixteen. It involved me making up stories and telling them to myself while I beat the ground with a long stick.

I'd pace, sometimes back and forth, sometimes in circles, speaking all the while in a low voice, or more usually only mouthing the words, but "writing" scenes in my head and tapping them into being. There was nothing especially outlandish about the stories themselves: tales set in jungles and circuses, foreign spy adventures, sports stories (I created a baseball hero named Tex Halo, a quarterback called Skyrocket McNocket), the kind of fantasizing or daydreaming one might expect from a small-town boy. The oddity was in the execution and its persistence -- although it did occur somewhat less frequently after I began dating and playing basketball.

What must poor Mother and Daddy have thought?! Due to the location of our house, it was fairly easy to conceal my stick sessions from neighbors and the street, but from the kitchen window or the back porch my parents had a clear view of their only son talking to himself for hours on end while attacking the earth with a rough length of sapling. Moreover, there were large patches of bare ground here and there where enthusiastic literary composition had annihilated the grass. I was hell on lawns.

I've no idea with what concern, consternation, or wringing of hands they might have discussed my behavior when alone, but to their credit (or was it?) my folks never once ridiculed me, tried to dissuade me, or (to the best of my knowledge) consulted a child psychologist. Neither, however, did they blindly ignore the activity or try to pretend it didn't exist. Rather, they spoke openly about it, casually referring to it from time to time, calling it "Tommy's talking stick" -- their term, not mine -- as if it were a quirk they found interesting, perhaps peculiar, but not disturbing.

Imagine my surprise when, some fifty years later, as I was inattentively listening to a program on the Canadian Broadcasting Company (my focus was on dinner), I overheard the words "talking stick." Startled, I cranked up the sound on the radio. Among certain native tribes in Canada, I soon learned, the tribal storyteller traditionally carried a rod called a "talking stick" with which he beat out cadence as he recited his yarns.

Aha! That was it! What I had been doing as a boy was *drumming*, creating a rhythm for my interior monologues. That could explain why, in my adult writing, in my novels and essays, I've always paid special attention to the rhythm of my sentences, realizing instinctively that people read with their ears as well as their eyes. And now I could at last speak openly, even with a modicum of shy pride, about my eccentric past.

What remains unexplained is why I was moved to intentionally, consistently, secretly (God help me if my peers had found me out!) create those insubstantial narratives in the first place. Putting pencil to paper can be tedious, especially for a youngster, so I may have just hit upon a more active, energetic way to escape boredom while satisfying the commands of an excessive imagination. No matter how drab everyday existence, the talking stick allowed me to actively participate in another, more exciting, reality. In a sense, the talking stick was a joy stick; I had invented my own video game, played according to my own rules, decades before the interactive pixel was as much as a twinkle in some nerd's eye.

In the late 1960s, my girlfriend and I watched a Fellini movie in which the phrase "a life of enchantment" appeared in the English subtitles. Afterward, over beers, Eileen announced that her intention henceforth was to live just such a life, whatever that meant exactly: in the whimsical sixties, goals of that sort were generally taken in stride. In any case, it occurs to me now that "a life of enchantment" was pretty much the very life I, stick in hand, had begun to make for myself as a boy.

Incidentally, you may be relieved to know, when I went away to college I left sticks behind. That era of my life was over. Well, almost. Certainly not a single blade of grass on the campus of Washington and Lee University ever lost its life in the service of my creative imagination. However, there were more than a few times when writing a term paper or an article for the W&L newspaper that I would become so excited in the throes of composition that I'd pace my dorm room while beating on the mattress with a coat hanger. Fortunately, I roomed alone.

flames of fortune

For obvious reasons, no talking stick had accompanied me to Hargrave Military Academy either, which is lucky for the stick considering the fate of the items I did bring along. Before describing that fate, in all of its drama, I should probably explain what I was doing at a military prep school in the first place.

The reason is quite simple: like many if not most of the other cadets at Hargrave, I was sent there because I hadn't distinguished myself in public high school or, rather, had distinguished myself for activities that parents and college admissions offices tend to deem less than desirable.

Commercially, administratively, Warsaw served an assortment of farmers and fishermen, every one of whom resided in the countryside or along the river some miles from town. Warsaw High School served their children, the majority of whom were bused in and out, although it also provided an approximation of education for an assortment of townies, of whom I was one. There were thirty-five seniors (all white, of course) in my graduating class, to give you an idea of the school's size; and of that number, I alone was to earn a college degree, to give you an idea of its academic thunder, although a more revealing fact, perhaps, is that most of Warsaw's teachers hadn't earned degrees either. We were mostly taught by women with but two years of college; women, in some cases, barely older than their pupils -- a proximity not particularly helpful when it came to maintaining order in the classroom.

Serious discipline was left to the principal (a cutup such as I wore

a virtual path to his office), while punishment doled out by teachers was usually limited to assigning extra homework or making a guilty pupil stay after school. The latter justice could only be dispensed to townies, however, because the other pupils, the majority, had buses to catch, and it was not especially feared by us town boys due to the fact that the teacher with whom we would be privately sequestered was likely to be nubile and cute. Teenage boys notice such things.

Having one's face slapped by a teacher was quite rare, but it happened to me in Warsaw as it had, the reader may recall, in Kilmarnock. What offense, what outburst of sass, I committed to inspire this particular corporal retribution I cannot remember, though I'll never forget the aftermath.

Miss Snowden, the history teacher, was probably twenty-four or twenty-five, making her somewhat senior to her associates, though scarcely less attractive: a tall, willowy blonde, whose nickname, we kids somehow discovered and never forgot, was "Choogie." At any rate, I'd just entertained the class with an egregiously inappropriate bon mot at a disruptively inappropriate moment when Miss Snowden choogied over to my desk and . . . *swack!* -- let me have it, slapping me with such force that the ringing in my ears might have called whole populations of the faithful to prayer. She also ordered me to remain after school, a rather severe penalty on this fine spring afternoon when our baseball team (never my sport, baseball) was about to play for a conference championship.

The actual bell rang, students scurried out, some to the bus lot, others to the ball field at the far end of campus. Miss Snowden approached the desk where I sat both cautiously defiant and genuinely contrite: I liked Choogie and lacked the sophistication to try to justify my behavior on the grounds that the comedy that really matters in this world is *always* inappropriate. For a while she just stood there, looming over me in silence. I'd no idea what *she* was thinking, but *I* was thinking that if she slapped me again I was going to tell her about Reggie Sulley.

Reggie Sulley was a punk, a crude, cruel, smirky, dishonest creep (and here in the interest of full disclosure I should report that he and I played the same position on the basketball team, competing with mutual hostility for playing time). It so happened that Sulley and I were also among a small number of students in an unsupervised study period that convened each morning in what was Miss Snowden's homeroom. Like a few teachers and many pupils, Miss Snowden customarily brought her lunch to school in a brown bag. She left the bag on her desk. Well, one day Sulley, in front of the dozen or so study-hall attendees, opened the bag, unwrapped a sandwich, unzipped his fly, and rubbed his penis all over the bread before returning the sandwich to the bag. So stunned were we, boys as well as girls, by the act's audacity, not to mention its perversity, that we never reported it and discussed it only in whispers. Word spread, however, and during lunch period that day Miss Snowden's homeroom was unusually crowded, every eye squeamishly fixed on the teacher as she innocently munched her desecrated tuna-on-rye.

Thankfully, Choogie Snowden did not tempt me to spill those sick beans. Instead of a second slap, she, after staring me down for a while, smiled, shook her blond head, and said something to the effect of "Tommy, you are a piece of work." Then she moved to the door, gesturing for me to follow. That door, near the very front of the school, opened on a long, dimly lit, now-empty hallway that ran the length of the building. Without a word, Miss Snowden inexplicably took my hand. Took my hand! In hers! And hand in hand, like lovers strolling the Boulevard Saint-Germain, we slowly walked the whole length of that hall, at the end of which she pulled away, shooing me outside into sunlight and the noise of the distant ball game.

Let me emphasize that there was nothing the least bit sexual, nothing untoward at all about the incident, yet it was definitely, in its odd way, romantic. It was tender. It was intimate. It was sweet. It was a mingling, however subtle, however cross-generational, of male/ female energies. And whatever its intent, if any, it was effective, be-

cause for the rest of that school year the angels' own butter would not have melted in my mouth, so quiet was I in Miss Snowden's class, so respectful, so appropriately appropriate.

News of my slapped face failed to reach Mother and Daddy, and I never told a single soul, not even my best friend, about the poignant, dreamlike hall-walk with Miss Snowden (it would have felt like a betrayal). However, the negative reviews of my deportment on monthly report cards (a foreshadowing of critiques from the more small-minded members of the literary establishment?), along with the glad tidings (delivered at a PTA meeting) that in the annual popularity poll my schoolmates had voted me "Most Mischievous Boy," caused the parental unit to wonder if a "talking stick" mightn't be the least of reasons for concern about the future of Tommy Rotten. Then, there was the great academic flip-flop of 1948.

At the end of the first semester of my junior year, I bore home a report card resplendent with straight A's: an A (a vowel black in color, according to Arthur Rimbaud) in every subject including algebra. Unfortunately, I couldn't get the report card to its destination without word of its contents being leaked to the crowd of townies in whose company I walked home every day. With scummy Reggie Sulley and tough Lester Scott leading the Greek chorus, I was mocked all the way down the street. They literally jeered me. Even inside the B&B poolroom (an obligatory stop, boys only, after school), the ridicule continued. I was made to feel a sissy, a sycophant, a sellout, an outsider unfit for the company of my proudly anti-intellectual pals.

In truth, I hadn't even studied particularly hard to earn those A's. Well, never mind, I'd show them! I'd set new standards for goofing off. And second semester I flunked every subject including English. Straight F's. For the year, this averaged out to an aggregate C, which meant that I'd passed the grade and hadn't completely torpedoed any chance of college admission, but finding a minimum

of cheer in that, and even less in my having regained my status as a good ol' Warsaw boy, Mother and Daddy began to think seriously about military school.

"The men in the Robbins family mature slowly," my mother said once, referring not only to me but my father and his father -- and she did not mean it as a compliment. Personally, I've found maturity an overrated quality except in wine, for both creative artists and lively people in general have much to gain from facing the world with the unsullied vision, flexible responses, and playful sensibilities of a child. That said, considering Mother's views on the subject, considering her critique of the Robbins male, her choice of Hargrave Military Academy as a suitable repository for yours truly made perfect sense. Hargrave's motto (in those more innocent times) was "Making Men Not Money."

I'd graduated from Warsaw High at age sixteen, looking -- and at times acting -- several years younger. I was a virgin, my success with girls having peaked about a decade earlier back in Blowing Rock; but was no stranger to alcohol, having already discovered the joys, though not yet the perils, of frescoing one's tonsils with the cardinal brush. For some time, I'd been writing a fairly mature sports column for *The Northern Neck News,* a weekly paper serving four Virginia counties, but my abilities as a scribe could not conceal the fact that overall, I presented a measure of challenging grist for the Hargrave Military Academy man-making mill.

Hargrave sat on a hill overlooking the pretty little town of Chatham, in the Piedmont region of Virginia, about a hundred miles from Warsaw. Across a valley, on the other side of Chatham, atop a hill directly opposite Hargrave, sat Chatham Hall, a high-toned private school for "problem girls" (or so it was alleged) from privileged fami-

lies. Equally keen on deportment, the two schools were separated by more than terrain. Fraternization of any kind between Hargrave and Chatham Hall students was strictly, absolutely forbidden.

Cadets presumed to know the nature of the girls' "problem" and fantasized endlessly about exploiting and contributing to it. For their part, the girls surely thought the cadets romantic figures in their dashing uniforms, with their military bearing (so unlike the slouching slobs back home), and air of prospective danger (this even though the rifles we carried, each and every one, had had their firing pins securely removed). The vectors of adolescent sexual longing that crisscrossed that valley must have been so strong, so thick that it's a wonder any bird could fly through it.

The rule was unwritten, unspoken, yet every cadet was aware that to be caught on the Chatham Hall campus was grounds for immediate expulsion. Hormones are stronger than rules, however, and the powerful allure of forbidden fruit has been documented everywhere from Greek myth to hillbilly jukebox, from grand opera to soap opera, from romance comic books to the Book of Genesis. So, each spring, when the sweet silky air was practically a-wiggle with pheromones, when a young man's fancies turn to thoughts of stolen kisses and damp panties, a couple of cadets would sneak onto the greening lawns of that quasi-convent across the valley. Most of the time they escaped detection and retribution, though their forays predictably produced no verifiably amorous results. Then there was the case of Stu Seaworth.

Stu (not his real name) had begun to percolate with joy and promise when his presence in the shadows of a Chatham Hall dormitory was acknowledged by a resident of said dorm. The girl waved to him from a lighted third-story window. Stu waved back. Then the unthinkable happened, the stuff of dreams. As Stu stood there gaping, the girl pulled her sweater over her head. Next, she unhooked her bra and tossed it aside. She allowed Stu a good long look at her little moons before beckoning him to come orbit them. He shrugged,

threw up his hands, became almost frantic with frustration, there being under the circumstances no way to reach her, a moon landing logistically impossible.

Ah, but what was this? The bare-breasted schoolgirl was pointing to a narrow fire escape that ran down the side of the dorm. Stu was a tall lad, yet he could not reach even the bottom rung of that ladder. Not to worry. The siren had disappeared and with her Stu's hopes, but just then the fire escape began to lower. The girl was operating some kind of lever mechanism. When the rungs were low enough, he climbed aboard, shaking with excitement. He was going to heaven on a creaky steel ladder! However, just out of reach of the third floor, the ascent abruptly aborted. In midair now, and at a forty-five-degree angle, the ladder remained -- and remained -- immobile. The lights went off in the siren's room. Stu was stranded. He thought he heard giggles. A chorus of them.

In the desperate jump that followed, Stu shattered his ankle and cracked his femur. He was on crutches when his folks arrived to fetch him home in disgrace one month before he was to graduate.

I never met Stu Seaworth, he'd come and gone the previous year, and for all I know his story could have been embellished or even wholly apocryphal. Still, firmly embedded in Hargrave mythology, it was not without value. It suggested, in an oblique, potentially painful way, a way fraught with consequences, that girlie Chatham Hall -- its mystique, its challenge, its looming presence, its moth-to-candle-flame allure -- might contribute as much as the military school itself when it came to making boys into men.

Upon arrival at Hargrave, I was assigned the oddest, most isolated room in the academy. What was up with that? Had they heard something? Did they fear I might incite rebellion -- or worse, subject innocent cadets to the spectacle of the talking stick?

Tucked away in a remote corner of the third and top floor, the

room was exceptionally large: long and narrow with a slanted ceiling and single small window, giving every appearance of having once been an attic. This room was so far removed from administration offices, from dayroom, classrooms, dining hall, gym, and quadrangle that its occupants had to set a clock to alarm at least five minutes before reveille (the actual bugle call that awoke the rest of the cadet corps) in order to fall out on time for morning formation.

I had two roommates. From Virginia peanut country, there was a mild-mannered boy, bespectacled, still freighting half a load of baby fat, and bearing the almost Faulknerian name of Ollie Hux. In the other bunk, from the Dominican Republic, was a handsome, worldly, self-assured Hargrave veteran named Pelayo Brugál. There were quite a few Hispanic cadets enrolled at the academy, largely from the Caribbean and South America, places where the military in particular and machismo in general were the cat's meow and not a caterwaul less.

Brugál (accent on the last syllable) had seniority among the Hispanics and was their natural leader. He helped them academically, taught new arrivals the ropes. As a result, our big "attic" room was a Hispanic gathering place. Afternoons, it was crowded with boys from Venezuela and Cuba, jabbering away in Spanish, the world's fastest language, seeming to all talk at once. It was like living in a cage full of parrots whose crackers had been laced with crystal meth. I found it agreeably colorful.

For whatever reason, Brugál had not been home in two years, spending his summers at Hargrave. That year (my year), however, he flew down to join his family for the Christmas holidays. With him, he carried two suitcases, one packed with clothing, the other empty.

It so happened that Pelayo's father and uncle owned the largest rum distillery in the Dominican Republic. When Brugál returned to school during the first week of January, the previously empty suitcase was now filled. With bottles of rum. Fine Dominican rum. Rum, the higher life-form that crawled out of the primal ooze of molasses.

Every night after taps, when the academy was quiet and dark, Pelayo would steal to our closet and remove a bottle from the locked bag. He, Ollie Hux, and I would each swallow a nice big slug. It was warming. It was uplifting. It was fraternal. It made for sound sleep and pleasant dreams. Happy, well rested, and maybe a trifle smug, we were willfully oblivious to the certainty that we were flirting with fire. Then, on February 19, the school burned down.

When the fire alarm sounded that night during study hour, I, along with other cadets from that end of the third floor, scampered down the nearest fire escape. Even though we caught a faint whiff of smoke, none of us expected the fire, which started in a teacher's quarters on the floor below, to amount to very much. Believing that we'd rather quickly be back in our rooms, we cheerfully welcomed this unscheduled break from the books. Then we looked up and saw flames. And they appeared to be spreading.

Rescuing the rum was out of the question, but my Warsaw basketball letter jacket was in our room, along with photos of (mostly imaginary) girlfriends, a sweater, and some warm socks: it was fifteen degrees that night and I'd fled in khaki pants, a T-shirt, and bedroom slippers. So, sensing now that the situation might actually turn into something serious, I headed back up the fire escape, and intent on grabbing those items that passed pitifully for my valuables, climbed again through the open window.

On the ground, what had initially been a semifestive atmosphere was digressing into shock and pandemonium. Cadets, faculty, and staff milled about in helpless confusion, awaiting the arrival of Chatham's one fire engine. Nobody saw me return to the burning building, there were no shouts of warning, no hysterical mother wailed, "Fireman, Fireman, save my child!"

Once inside the third-floor hallway, I crashed headlong into a wall of heated smoke. I'd taken only a couple of steps before smoke filled my eyes, my nose, my throat. It felt as if a troop of Girl Scouts were toasting marshmallows in my lungs. (Sure, it could just as well

have been *Boy* Scouts, but even near death I preferred the company of females.) On the verge of losing consciousness, I managed to execute a clumsy about-face and practically somersaulted back through the window. If anyone noticed my descent, coughing and choking, they gave no indication. In minutes, I was just another figure in the crowd, watching with a mixture of fascination, excitement, disbelief, and dismay, the metastasizing flames. Nobody thought to have me treated for smoke inhalation.

Yeah, impulsive Tommy Rotten had been lucky to get out alive, but I was fortunate in another way as well. Inevitably, sooner or later, that secret stash of rum would have been discovered -- it was stupid to think otherwise -- and Pelayo Brugál, Ollie Hux, and I would have been given the ol' spit-shined boot, our names to be chiseled below that of Stu Seaworth in the Hargrave hall of shame. And who can say what trajectory my life might have taken thereafter? No longer admissible to the college of my choice, and at seventeen too young to seek refuge in the army, I . . . well, I like to think I might have followed Brugál down to Santo Domingo, where I would have written a version of *The Rum Diary* years before Hunter S. Thompson. It's debatable whether or not that could be considered a happy ending.

Hargrave rose from the ashes. Like the Phoenix? No, more like the Tucson -- at least for the remainder of that school year. Following a month's suspension, the academy amazingly reopened in March, but with major adjustments. Surrounded by parade grounds, an athletic field, a quadrangle, and an outdoor swimming pool, Hargrave had occupied a single extremely long three-story building, only one end of which had survived the fire. That end contained the gymnasium, now converted to a dining hall, and living quarters for approximately one-third of the cadets. The rest of us were distributed around Chatham in various temporary locations, I being lucky

enough to be included in a group of about twenty that was housed in a downtown hotel.

Because our uniforms had gone up in smoke, we now wore civilian clothes. This spelled a blessed end to daily inspections and gave us a newfound sense of freedom, but failed to adequately conceal our identities as cadets. At the insistence of their parents, if not wholly a matter of personal preference, town girls continued by and large to shun us, and Chatham Hall girls remained as distant as ever, although from our hotel rooms we could spy on them during their weekly visits to the business district to pick up girlie items at the drugstore, etc. They came on foot, always in parties of ten or more, and were as heavily chaperoned as a shipment of weapons-grade plutonium.

We still were subject to curfews and to morning formations (now a rather motley agglomeration), but drilling was suspended for the duration, which oddly enough displeased me. I rather liked to drill and was fairly good at it, having been trained in the Boy Scouts. You see, the adult males who organized and presided over my Scout patrol in Warsaw had seemed less interested in making outdoorsmen of us boys than in teaching us to drill, box, and to properly care for the American flag. I can see now that they were out to mold us into little fascists, and recalling their incessant racist and anti-Semitic remarks, I have a suspicion that at least a couple were members of the Ku Klux Klan. There was more Klan activity in 1940s Virginia than people today realize. In any case, my entire Scout patrol was suspended after some of us were caught drinking cheap wine (ninety-five cents a bottle cheap, paid for with our Scouting dues), and peeking in the windows of comely housewives (in lieu, perhaps, of earning a merit badge for bird-watching).

Hargrave was now half military academy, half civilian prep school, and its postfire year passed unsteadily for everyone involved. It did pass, of course, and at graduation exercises on the final day, I

found myself summoned by name three times to the front of the assembly: once to receive a diploma; once to accept a Quill and Scroll award, given to cadets who had made exceptional contributions to the school newspaper; and lastly to be presented the coveted Senior Essay Medal, which I'd won not for an essay but a short story entitled "Voodoo Moon," about some weird goings-on in the Louisiana swamps. The name of no other graduate was called more than twice that day, most only once, and my triple honors served me particularly well since the previous evening I'd smashed in the right front fender on my father's brand-new Chevrolet sedan, having skidded into a tombstone while joyriding through a local cemetery. Daddy's anger, his disappointment, was naturally, fortunately, tempered somewhat by pride in my achievements. So it was that neither for the first time nor the last my verbal mojo, my knack for the written word, served to save my reckless ass.

now showing: *satori*

Yesterday (18 November 2011), police in Los Angeles announced that after thirty years they were reopening their investigation into the demise of Natalie Wood. She had died in the waters off Santa Catalina Island during or after a party aboard a yacht, and at the time cause of death had been given as drowning while drunk. Now the circumstances were being reexamined and the news prompted my paramour to ask if my long-ago Natalie-inspired spiritual awakening, described earlier in these pages, had been an example of satori. I replied, "Close but no sitar."

It might have been a passable pun except for one cross-cultural flaw: a sitar is an East Indian musical instrument while the term "satori" is Japanese. Usually defined as "sudden enlightenment," satori is how Zen adepts refer to a spontaneous lightning strike of total, all-encompassing understanding. It most often follows many years of study and meditation, although the bolt of unlimited awareness has been known to wallop novices as well. Excluding that Natalie Wood episode, which was emotional and heart-centered, bypassing the intellect, I've experienced satori twice in my life, both times ignited by the most unlikely of sources and neither producing, except in capricious, barely perceptible ways, lasting results.

In 1966, I was renting a spacious apartment -- seven rooms and bath -- for fifty bucks a month. Why so cheap? Situated in an industrial area of Seattle, the apartment occupied the second story above a machine shop. Apparently, few renters considered that a desirable

location. I, on the other hand, found it as appealing as a Manhattan penthouse.

The shop manufactured gears. Gears have to be ground. So, rather than a cacophony of clanking and banging, the noise from below my quarters was a low, slow, steady, grinding hum, not unlike the turning of the screw on a ship. It was soothing, comforting, and even kind of romantic; a perfect sound track for both lovemaking and a good peaceful sleep. On those occasions when the gear works had a rush order that compelled it to grind around the clock, I experienced difficulty in getting out of bed in the morning. I could have blissfully slept all night and all day. And sometimes when I did force myself to arise, I'd walk to the window, half expecting to see expanses of ocean and, in the distance, a silhouette of, say, Tahiti -- or maybe Santa Catalina, whose waters would eventually swallow Natalie Wood.

Nobody wants influenza, but when I was hijacked by a virus in January of '66, I took consolation in the fact that I'd get to recline in my warm bed for several days and be lullabied by the sweet humming of friendly machinery. Moreover, I had a good book to read. *I Lost It at the Movies* was a collection of reviews by legendary film critic Pauline Kael. Ms. Kael was one of those rare critics whose passion for her subject was contagious. Just as Henry Miller's writing on Matisse was evocative and enrapturing to the point where it could make the reader willing to walk ten miles naked through a shit storm if there was a chance at the end to view a painting by Matisse, so reading Pauline Kael gave one a raging appetite for movies. It's a credit to the virus that I managed to resist for four days before abandoning my sickbed to head to a theater.

In those premall, premultiplex, pre-Netflix days (I didn't own a television), first-run movie theaters tended to be clustered in city centers. Thus, I slid behind the wheel of my decrepit Plymouth Valiant (it was nearly as infirm as I) and set out for downtown Seattle. It was winter, as I said, and I hadn't driven far along Elliott Way before running head-on into a full-fledged blizzard. Snowfall of this magni-

tude is rare in Seattle, whose winters are typically mild and rainy, but this baby might have sent Admiral Byrd into an early retirement. Snow was blowing directly into my windshield, reducing visibility, though it was early afternoon, to practically zero. Except for roiling snowflakes, I could see nothing beyond the hood of my car.

There used to be a driving range and putting green on Elliott Way, advertised by an elevated sign depicting a large white golfball. The painted golfball was outlined in three-dimensional white neon. As I crept along, squinting into an animated curtain of swirling, spinning snowflakes, there unexpectedly appeared in this dynamic white vortex a glowing white circle. A seed, a cell, a head, a halo, a tondo, a corona, a bodily orifice, a zodiac wheel, the sun, the earth, the moon, the eye, and the egg; the unbroken cycle of life, the continuity of consciousness, the mysterious silver flower of the soul: that neon golfball was all of those things and none of them; and as I glimpsed it suspended and radiating within an energized field of sparkling flakes, white on white, I suddenly understood everything.

Everything! I saw how the universe worked, how it was put together -- on every level, macrocosmic and microcosmic. For as long as it lasted, and it was over I'm guessing in a dozen seconds (in that state time was elastic/geologic), I was witness to an indissolvable totality of reality, a gestalt which normally our monkey minds split into convenient fragments. The rigid fetters that bind us to simplistic dispositions, absurd rationalizations, self-destructive ideologies, and divisive worldviews were severed and I was a free spirit in the oneness of the whole enchilada, seeing the world -- material and immaterial -- for the all-inclusive miracle it is: not a continuous undifferentiated glob of stuff, mind you, but more like a great spiraling web whose interconnected threads are beaded with pulsing blips that as much as anything else resemble notes of music. I'm all too aware of how woo-woo this sounds, but it was as real as a stubbed toe and as lucid as a page in Hemingway.

Had I been Asian and of a certain temperament, I suppose I

would have repaired to a Zendo, an ashram, or a wilderness cave to meditate upon my neon golfball satori for the rest of my life, striving to integrate it somehow into my daily existence. Instead, although shaken, galvanized, and fairly splish-splashing in a fading aura of awe, I just motored on through the subsiding snow squall and went to a Hollywood movie.

The film, incidentally, was *The Group*. It chronicled on-screen the lives and loves of a bevy of Vassar girls. Pauline Kael would later dismiss it as "carelessly busy."

Although there are legions of us stray cats for whom libraries, bookshops, and movie theaters have served as temples, cathedrals, or sacred groves, it's still embarrassing to have to admit that, excluding certain LSD epiphanies, the primary, most affecting "metaphysical" (for want of a less suspect term) experiences in my life have each one been connected in some way to movies. First there was the Johnny Weissmuller Tarzan who supplanted Jesus in my pantheon of heroes; next came the floodtide of love and empathy raised by the young Natalie Wood; then there was the powerful creative breakthrough precipitated by *Shoot the Piano Player,* followed by the snowy golfball satori that occurred as I drove and was driven to see a film. And finally -- the butter on the box of transcendental popcorn -- my second and only other satori actually transpired inside a movie house.

The year was 1991, the venue was the Neptune Theater in Seattle's University District. The film was *The Fisher King,* starring Robin Williams. Based loosely on the Percival story from the Arthurian legends, Williams plays Parry, a man broken financially, physically, and mentally. Homeless, Parry has been given shelter in the basement of a New York tenement building; and in that dusty, low-ceilinged space, zigzagged with furnace ducts, electrical wiring, and water pipes, he has set up an altar, a small shrine.

Neatly arranged in the shrine are such religious paraphernalia as

incense and incense burners, prayer beads, votive candles, and representations of Asian deities, including the Buddha. It's all quite tidy and earnestly, if naively, reverential; but if alert, one notices among the holy relics two little plastic packets of soy sauce, the sort typically included in your take-out order from a Chinese restaurant. Nothing is made of this in the movie, it's just a fleeting image; maybe a throwaway sight gag, maybe an offhanded clue to Parry's mental state. For me, however, it was an unbidden, instantaneous round-trip ticket to satori.

It probably can't be explained to either the reader's satisfaction or my own, but let me suggest that the juxtaposition of the nobly devotional and the petty functional, of the high-minded and the banal, served to attract the flash of ultimate cognition the way a metal rod set atop a barn can attract lightning. Of course, for a strike to occur, conditions in both cases must be favorable.

The glue that holds the natural world together appears to be a harmonious balance of opposites: day and night, light and dark, winter and summer, liquid and solid, acidic and alkaline, male and female, wave and trough, proton and electron, etc. There prevails in our reality an explicit duality that represents an implicit unity (the "oneness" about which I've previously babbled), and the line of separation between those things just named is as thin as it is necessary: yang rubs up against yin, yin against yang, distinct but mutually supportive.

The line separating tragedy from comedy is broader, deeper, more jagged, although neither as fixed nor as problematic as the one between life and death; and it's those more glaring oppositions, including desire versus rejection, success versus failure, and especially, "good" versus "evil" that generally engage practitioners of the narrative arts. From my perspective, however, the most fascinating and perhaps most significant of all interfaces is the one that separates yet connects the ridiculous and the sublime. The surprisingly narrow borderline between things holy and things profane, between prayer

and laughter, between a Leonardo chalice and Warhol soup can, be-
tween the Clear Light and the joke, provides a zone of meaning as
exhilarating as it is heretical: a whisper of psychic release so acutely
yet weirdly portentous it just might offer a clue to the mystery of
being. Or at least help one understand what ol' Nietzsche was getting
at in *Jenseits von Gut und Böse*.

I hasten to emphasize that no thoughts of that sort occurred to
me at the time. Not one. I simply glimpsed the stupid little packs of
inferior soy sauce sitting at the divine feet of the Buddha and sud-
denly felt giddy, felt in instant total harmony with that Indian swami
who defined life as "the beautiful joke that is always happening." The
roof had been blown off of the cellblock of consensual reality and I
was escaping, climbing toward the stars, trailing tatters of abandoned
orthodoxy, surfing a tide of higher wisdom that is forever off-limits to
the sober and the prudent. Figuratively speaking, obviously: I hadn't
spilled a drop of my Pepsi.

washington, lee & wolfe

Since 1985, Washington and Lee University, a private liberal arts college in Lexington, Virginia, has been coeducational, but when I studied there in the 1950s, the only breasts on campus belonged to the law school's hot librarian (thanks to whom that library was filled to capacity every evening) and a couple of carbo-enhanced mammoths who played offensive line for the football team. W&L had been exclusively male since its founding in 1749, and its male students have themselves been rather exclusive since the academically rigorous school was and remains highly selective: only 15 percent of applicants were admitted for the year 2012–2013.

Some considered W&L, known as "the Princeton of the South," a sort of finishing school for Southern gentlemen, a notion reinforced by the college's famous honor system, still in effect, and its strict insistence on conventional dress, a rule only recently modified in deference to the widespread contemporary predilection for informality. "Conventional dress" meant that we students were required to wear coat and tie at all times, on campus and off, except when participating in sports -- which may account for the fact that I spent such an inordinate amount of my time playing basketball.

Since the majority of W&L students were from affluent families, many of those suits and coats were well made and handsome. One student, however, stood out among all others in terms of sartorial splendor. It wasn't that his threads were more expensive, more finely tailored than those of fellow classmen, but that they were chosen --

and worn -- with such panache, such dash. This dandy, who on warm days appeared in dazzling white suits with flowery pocket squares, was, among other things (he epitomized the "big man on campus"), sports editor of the semiweekly school newspaper, for which I, a freshman, was a cub sports reporter.

The paper was called the *Ring-tum Phi* (why, I never learned: W&L men were inclined that way), although it was referred to informally as "the Ring Dang Doo," a slang term for "penis" (they were inclined that way as well); and the sports editor, my boss, was T. K. Wolfe III. In less than two decades, he would be known to the English-speaking world as Tom Wolfe, one of the most innovative journalists in the history of the craft, a flamboyant but sharp-eyed stylist who, along with Hunter S. Thompson, blasted open the long-standing wall between reporter and subject, creating on the page an intimacy and immediacy that put culture and counterculture in bold relief, filling semi-anthropological magazine articles with the rococo popcorn of amplified observation.

Tom Wolfe has also enjoyed a measure of success as a novelist, although his fiction suffers from the very characteristics that made his sixties and seventies journalism so vital: his flawless ear for jargon and meticulous eye for detail. His approach to fiction, he has admitted, is that of the nineteenth-century novelists, which implies a verbatim translation of life, but as W. Somerset Maugham once put it, "Realism too often produces novels that are drab and dull," going on to assert that the fiction that really matters is make-believe, dealing not in truths per se but in effects. Wolfe either doesn't possess or chooses not to indulge the most precious and effective potion in a novelist's pharmacopeia: imagination. Again, I digress.

I recollect seeing Wolfe at the offices of the *Ring-tum Phi*, sitting with his smart white shoes propped up on a desk, a flop of fine barley-colored hair drooping over his right eye, reading half aloud a long epic poem he'd just composed about the foibles of the Southern Athletic Conference. He was both elegant and eloquent, and I was

suitably impressed. If he spoke to me, an awkward underling, even once during that year I don't recall it, but thirty-three years later we did share a short but, I think, agreeable exchange.

It was at the conclusion of *Esquire* magazine's gala fiftieth anniversary dinner at the Four Seasons restaurant in New York. I found myself standing behind Wolfe at the coat-check counter. It had been a splendid event (both Wolfe and I were regular contributors to *Esquire*), the room luminous with luminaries, and now we were collecting our wraps. At W&L, Wolfe had been a starting pitcher on the baseball team (I told you he was a big man on campus), and later, before he became a media star, pitched for a season in the semiprofessional Sertoma League in Richmond, his hometown. I knew this because I had to monitor local baseball during my stint on the sports rewrite desk of the *Richmond Times-Dispatch*. Before Wolfe could retrieve his cashmere topcoat, I leaned forward and asked quietly near his ear, "What exactly was your record in the Sertoma League? Was it eight-and-five or five-and-eight?"

When he whirled to face me, looking not merely surprised but incredulous, I introduced myself and tendered an explanation. Wolfe shook my hand heartily, then proceeded to tell me that whenever and wherever he spoke on college campuses, students would invariably ask if he knew Tom Robbins. Now, he said, while no less perplexed, he could at least answer that we'd met. He seemed genuinely pleased.

Any satisfaction I might have taken from this warm and ego-bolstering exchange was immediately chilled when I turned to find William F. Buckley, emperor penguin of the American right, sneering at me with the horror and revulsion he would have displayed had he come upon a bedbug lounging in his satin sheets, reserving particular odium for my ruffled pink shirt and my bow tie with colored sequins. I guess you can't please everyone.

For all of his talent, all of his glamour, T. K. Wolfe III wasn't the only interesting student at W&L that year. There was Glenn Allen Scott, who introduced me to the writings of Henry Miller (at the time almost impossible to find in the puritanical U.S.), and who while an undergraduate published a novel that *Newsweek* compared to F. Scott Fitzgerald's first book, *This Side of Paradise*.

There was Walt Michaels, a genuine gentleman athlete with whom I was conversing in the Lexington post office at the moment he tore open an envelope informing him he'd been selected to play in the National Football League. Michaels did play, and later coached for many years the New York Jets.

There was David Gale, who dropped out of school in the middle of his freshman year to go sail a sloop around the world with Captain Dod Orsborne, an intrepid adventurer whose autobiographical *Master of the "Girl Pat"* had enlivened my fantasy life as a teenager. (In my late twenties, I became romantically involved with a young married woman named Patricia whose husband, poor devil, I would unkindly refer to as "master of the girl Pat." She never understood the reference, and anyway, shame on me.)

And speaking of Pats, super-evangelist Pat Robertson was a member of W&L's class of 1950, but while he would go on to contribute mightily to both the commercialization of Christianity and the dumbing down of America, his talents for those black arts hadn't announced themselves in college. At W&L, Robertson was a nonentity, though in retrospect it seems hardly possible that an ego that immense would have gone unnoticed.

Overall, I'd say that the fellow student whom I'd found most intriguing was a guy whose name long ago vanished down one of my synaptic ferret holes. All I remember of him, and what fascinated me at the time, was that he was expelled for stealing record albums from a Lexington music store -- and he didn't own a phonograph. He seemed content to stack the albums (he was quite prolific) in a corner

of his dorm room. Upon his expulsion, it was learned that he'd studied all semester for a Spanish exam -- and he didn't take Spanish

When my geology professor announced that at our next meeting we'd be going on a field trip, I was pleased: it would be a relief to get out of his stuffy classroom. When he advised us to wear old clothes, pleasure escalated: it would be an even greater relief to officially dispense with coat and tie. And when he told us to bring along flashlights if we possessed them, the outing seemed to promise a modicum of actual excitement, though admittedly it's a bit of a stretch to think of excitement and geology in the same context. Thoreau advised, "Distrust any enterprise that requires new clothes." An enterprise that requires old clothes (it usually means manual labor or rough recreation) should raise eyebrows, as well. In this case, I got more excitement than I'd bargained for.

The class assembled in front of Doremus Gymnasium, crossed after roll call the footbridge to the athletic field, traversed the gridiron, jumped a narrow creek (some of us more nimbly than others), made its way through a stand of light woods, and commenced to climb one of the rambling green and rocky hills that surround the Shenandoah Valley and the town of Lexington. We paused occasionally to examine fossils -- trilobites and brachiopods mostly -- embedded in rock outcroppings, amazed by concrete evidence that the entire Appalachian mountain range had at one time been under the sea. We'd tramped a couple of miles when the professor abruptly halted at a place where two rocks, each about the size of a Volkswagen Bug, abutted. (It could have been a fender bender in Düsseldorf. Or Bedrock.) Between the stone VWs, partially obscured by weeds and a scramble of broken rock, was an opening. A hole. A hole in the ground. Beaming now, the professor disclosed that this unlikely hole was the entrance to a natural cave. Activating his flash-

light and instructing the rest of us to line up single file and follow, he dropped to his knees and disappeared down the shaft like some rabbitless Alice who didn't mind muddying a pinafore.

Terrestrial cavities known as "solution caves" -- formed when subterranean limestone is dissolved by acids occurring naturally in groundwater -- are numerous in hilly western Virginia. The most celebrated, Luray Caverns, has been commercialized, its spectacular system of colored stalactites and stalagmites (some people can actually remember which is which), its columns, curtains, mirrored pools, etc. attracting fifty thousand visitors annually. Electrically lit, its gentrified entrance is surrounded by such man-made formations as a snack bar, a souvenir shop, and a parking lot. Neither outside nor inside did our field-trip cave bear noticeable resemblance to Luray.

The going was pretty easy at first. The depression sloped gradually, gently downward. It was wide enough not to feel pathologically oppressive, and entertained sufficient weak sunlight to make flashlights temporarily unnecessary. Although we couldn't stand upright, we could hunker down and duckwalk, and oxygen seemed in generous supply. After fifteen feet or so, however, the cave became darker, more narrow, and we -- single file of course -- were forced to crawl on hands and knees. Claiming that there was a "marvelous room" ahead, the professor urged us on.

So, on we crawled, following erratically bouncing flashlight beams along a skinny passageway as damp as a sink and as dark as the inside of Groucho Marx's dog. On and on. Until abruptly there was a chain-reaction pileup of sorts as our chthonian conga line hit a wall, an apparent dead end. Not to worry. The "room" was just on the other side, our leader told us, but to enter it, we had to follow him down a second hole.

This opening was tight. Very tight. Each of us (we were twenty in number, more or less) had to literally *squeeze* feetfirst through the portal, then slide down into the chamber which proved to be about the size (height and breadth) of a traditional kitchen; that is to say,

while it was considerably smaller than the great halls of the Luray Caverns, from a spatial perspective a Thanksgiving dinner could conceivably have been prepared therein, providing, of course, that Julia Child wasn't doing the cooking. The cave continued for more than a mile, according to our instructor, but this room was as far as our party was going, and it was here that he would deliver his lecture. Once everyone was inside.

Ah, but only about two-thirds of us were so far in the room, and it appeared that the others might not be joining us there. It likewise appeared that we might not be leaving. They were stranded outside the room, we were stranded inside it. Both parties trapped. Trapped by Howie.

As a small child, I referred to my rear end as my "bumptaratum." The origin of the word was a mystery to Mother and Daddy, and I suspect to me, as well. Maybe it was from a language I'd spoken in a previous incarnation. Or in a parallel universe. Investigation has failed to find the word in any tongue spoken on the planet today. At any rate, Howie's most distinguishing feature was his backside. He was a big fellow overall, though not dramatically so, *except* between his waist and his thighs, which is to say, that his gluteus was maximus. So protuberant was his posterior that it simply would not fit through the vertical opening. It, in fact, became wedged in the passage, and the more he struggled the more firmly it lodged. There he was, legs dangling at eye level on one side, my side, of the opening, his upper body flailing on the other side; students of Geology 101 trapped at both ends, and all I could think was, *I'm gonna die down in this black hole because of Howie's bumptaratum.*

(Note: Although having in my young adult years become an ardent admirer if not a literal connoisseur of the female derriere, I can assure you that I never once, neither vocally nor in my private thoughts, referred to a woman's anatomical assets as a bumptaratum: as much as it may have amused and puzzled my mother when I was three and four, the word is silly, cartoonish, and anything but sexy.

On the other hand, if any human rump of my acquaintance deserved the bumptaratum label, it was Howie's. Nonetheless, why the epithet would reassert itself in my consciousness after so long a time and in such a precarious situation, I cannot say. Perhaps it was my brain's attempt at gallows humor.)

In truth, we were in no clear and present danger of death. The seven or eight students above Howie could have returned to the surface and gone for help, though it would have meant crawling backward for forty or fifty yards, there being inadequate space to turn fully around; while those of us below Howie could have, as a last resort I suppose, followed the cave to the place where it terminated on a bluff above the Maury River, but as aforementioned, that terminus was a good (make that "bad") mile away, a twisty route fraught with mazes and cul-de-sacs. Meanwhile, claustrophobia, which had been skulking around the perimeters of our party from the outset, now commenced to pull down its plastic bags over first one head and then another. There were no signs of outright panic, but I could hear guys inhaling abnormally, as if to hoard precious oxygen; and when a flashlight ray happened to sweep over a face, the expression illuminated there was one of classic unease.

An experienced spelunker, the professor himself sounded calm enough as after surveying the state of affairs, he called for a show of pocketknives. Pocketknives? Was he kidding? These were W&L men. These men were, for the most part, sons of doctors, lawyers, and captains of industry; men who drove British sports cars between campus and their fraternity houses, men who'd studied Greek and Latin at high-toned New England boarding schools, men who named their newspaper the *Ring-tum Phi*. There wasn't a pocketknife in the bunch. (My own trusty blade had been confiscated at Hargrave for reasons that are now unclear.)

So . . . we dug Howie free with our bare hands. Fortunately, the walls that confined the bulbous bumptaratum were mostly clay, studded here and there with limestone shale: hard, yes, but sufficiently

pliable when gouged and clawed by desperate hands. It took at least a quarter hour of vigorous quarrying, several broken fingernails, and doubtlessly an incipient blister or two, but eventually we volunteer diggers clawed out just enough wiggle room for escape, and Howie dropped down into our midst like a space capsule home from the moon. We couldn't make out his expression in the subterranean gloom but he had to have known that he was destined to become the butt of numerous butt jokes.

Ever professional, our geologist proceeded to deliver his intended talk on cave formation, although all of us suspected it was an abbreviated version. Then, dirty, tired, and anxious, the lot of us made for the surface, and I was hardly alone in making sure I stayed upward of Howie. Blue sky, when finally glimpsed, had seldom looked so sweet. We did not exit through the gift shop.

As part of the university's physical education program, all W&L sophomores were given golf lessons. Behind the grandstand, those in my class gathered three times a week to practice the proper holding of a club, the addressing of the ball, and the swing with its all-important follow-through. In order to earn credit for the course, each of us, at the conclusion of these lessons, was obliged on his own to go actually play nine holes of golf at Lexington's public links. However, on the final day of lessons, the instructor placed a plastic water pail approximately twenty yards from where we'd assembled, and brandishing a seven iron, announced that the student who, with said iron, landed his chip shot closest to the pail would be excused from playing the obligatory round. Okay, fair enough.

My turn. I addressed the ball. I swung. The ball was launched. The ball sailed. The ball looped. The ball came down. In the bucket. Not merely close to but . . . *in* the bucket! I kid you not. It was pure luck, of course, or divine intervention (the gods are always watching, and sometimes, usually when we least expect it, they smile on

us, they grin and make it possible for us to pull something grand or goofy or both out of our bumptaratums). In any event, nodding at the future golfers, I laid down my club that fine spring afternoon and never picked one up again.

In one of my novels, I have a character say, "Golf is basketball for people who can't jump and chess for people who can't think." That wasn't very cute of me, especially since I have two good friends, a successful film director and a brilliant painter, who are fairly passionate about the game. My antipathy for golf is no doubt due to a certain prejudice against the men most often associated with amateur golfing: country-club types who use the links to make contacts, seal deals, swap information, and in general advance business careers without seeming to be conducting business; and, more recently in our social history, the kind of blue-collar round-the-clock sports nuts who consider the Super Bowl the crowning achievement of Western civilization, and for whom golf, unlike hockey, say, or football, is an opportunity to participate personally in a sport in which "real athletes" also perform. In both cases, these duffers delude themselves into believing they're actually getting exercise, and in both cases, when push comes to shove, they'd rather be playing golf than having sex with their wives.

It's been said that golf is a Zen activity. I'd argue that if golfers were practicing Zen, they wouldn't keep score. Or ever get angry when they blow a shot. But what do I know? If you recall, I owe my personal enlightenment to a neon golf ball.

the right snuff

Obviously, I didn't learn to play golf at Washington and Lee, but what, then, *did* I learn prior to dropping out at the end of my sopho-more year? (Rumor has it that I was expelled from a fraternity -- some say the university -- for throwing biscuits at my house mother, but in fact, while there was a dining room food fight that got a trifle out of hand, I wasn't expelled for my role therein, merely reprimanded.) Let me see: I learned that Henry Miller could write incandescent circles around the dullards we studied in lit. class (Andrew Marvell is *not* marvelous); I learned to read German (not simply newspapers but Rainer Maria Rilke and Thomas Mann); learned that wearing a coat and tie could be advantageous when hitchhiking; and, well, learned to drink bourbon, although in retrospect I could have learned that back in Blowing Rock from my old granny.

Sophronia Ann Robbins, known for miles around as "Aunt Phro-nie" or simply "Granny," was a mountain woman right out of central casting. Tall and gaunt, her igloo white hair pulled back in a severe bun, she wore actual bonnets, high-top shoes, ankle-length gingham dresses that she made herself; kept a cow she milked every morning, churning her own butter; kept hogs she butchered in the fall, making not only sausage and liver mush from the flesh but rendering pig fat with lye in a huge cast-iron cauldron to produce the soap with which she laundered the family's clothes, and with which, not suffering fools gladly, she would threaten to wash out the sassy mouths of her grandkids. (Once she scolded Cousin Martha and me that we weren't

fit to lick a dog's ass, pronouncing "ass" as "ice" -- and suggesting that she could use some oral soaping herself.)

Granny carded raw wool, spun it, and fashioned quilts prized by summer people and locals alike, some examples of them ending up in galleries and museums devoted to Appalachian folk art. I wasn't privy to the information as a child, but she was also a healer and practicing midwife of some repute: a newspaper once called her "the Florence Nightingale of the Mountains." A lovely tribute, though it's difficult to picture the saintly nurse Nightingale dipping snuff and downing bourbon.

In her last twenty years -- and despite or because of a life of hard work she lived to be ninety-two -- Granny was rarely seen without a birch twig protruding from her lips (the little sticks were used to tamp the snuff and when a snuff stick became frayed and drooped at an angle, it could be mistaken for the unlit fuse on a granny bomb). On the floor beside her old hickory rocking chair, a Maxwell House coffee can served as a spittoon, and evenings a tumbler of Four Roses straight Kentucky bourbon was ever within easy access.

My mother and my paternal grandmother had never gotten along, and that nightly glass of Four Roses became the target of Mother's most poisonous rays of disdain. Never mind that Granny Robbins was a Bible-reading lifelong Southern Baptist widow of a part-time preacher. In Mother's view, one could not possibly be a Christian and partake of whiskey, not even for medicinal purposes, as was Granny's claim. Mother found Christianity -- even common decency -- and alcohol -- even in small amounts -- to be mutually exclusive.

Following my two years at W&L, I worked briefly in the mail room of a Richmond insurance company. It was a large firm, and on the last workday prior to Christmas break, there was a party in every department. As I went from floor to floor collecting outgoing mail, I would be offered at each stop a cup of cheer. Uncharacteristically prudent, I accepted but a swallow of spiked eggnog here, a sip of cheap

champagne there, and when at the end of the day I rode a Trailways bus (I didn't own a car) from Richmond to my parents' new home in nearby Colonial Heights, I remained by most standards sober. I did, however, smell faintly of booze, and that yeasty perfume was the stench of hell to Mother's olfactory receptors.

Backing me into a corner beside the gaily decorated tree, she declared through teeth clenched so tight they could snap a bone in half that should I ever again attempt to enter her house with alcohol on my breath, her door would be closed to me forever. Forever!

That struck me as kind of cold. About as cold, in fact, as an assassin's ice pick. The bartender in a Skid Road joint I, ever the romantic, frequented during my first months in Seattle, would say politely to an intoxicated customer he was asking to leave, "See ya later when you're straighter." Hello? A drunk in a dive is treated with a measure of respect and the promise of future congeniality, while a mother threatens to permanently disown her firstborn, her only son, should his exhalations suggest that he might have entertained a discreet swallow of wine?

I was hurt by that and held it against her much as she held against me my determination to see for myself what lies beyond dogma's cinder-block walls. It was not until many years later, a full decade after her death in 1992, that I learned with a jolt what accounted for her rigid, relentless, and fierce opposition to adult beverages.

An elderly aunt, helping my sisters and me with some genealogical research, finally spilled the terrible beans. During an incident in which alcohol played a prominent role, my mother, then eighteen, had shot and killed her beloved older brother.

At twenty-eight, Conley Robinson was a successful, apparently charismatic Charlotte attorney. Although he'd yet to run for office, he was considered a rising star in North Carolina politics, and some thought he was being groomed for the governor's mansion. Mother's childhood had not been easy. Unloved and slighted by her stepmother (her biological mother had died when Mother was

eight), ignored by a timorous and distracted father (another Baptist preacher), she turned for warmth to Conley, the family member she most respected and adored. In the interval between high school graduation and starting nursing training, she moved in with Conley and his wife, helping to care for the couple's infant son.

One evening after working late, Conley stopped by a party at a social club, where he proceeded to get rather thoroughly plastered. When he arrived home, an argument ensued and Conley commenced, first verbally then physically, to abuse his wife. At one point, for reasons known only to a certain species of American male, he felt compelled to interject into the disagreement that metallic expression of the testosteronic imperative, a handgun. By then, Mother, awakened by the commotion, had come to the wife's aid, and in the struggle that followed, Conley was shot dead.

Arrested, Mother spent at least one night in jail, though the shooting was eventually ruled either accidental or self-defense: details remain spotty. It was all the information I needed, however, to place my mother's zero tolerance policy toward alcohol in a more forgiving perspective. How she must have suffered with that secret her entire adult life, taking refuge in the Bible and decaffeinated coffee. I'd like to think that had I known the truth, I might have been a kinder, more loving person. If only we knew the Truth, mightn't we all?

Unless they've enjoyed an unusually close relationship, men do not regularly dream of their grandmothers, so it's hardly unusual that Granny Robbins has appeared in my dreams only once as best I can recall. Dreams swim up and down my subconscious fish ladder in great profusion every single night, yet no matter how lurid, enchanting, or disturbing, they seem to vanish completely and permanently within hours if not minutes after waking. The dream in which Granny plays a role, however, I still clearly remember even though it occurred in my late teens. It remains one of the two or three most

vivid, memorable and perhaps significant dreams of my long somnolent career.

It unfolded like this: I am a passenger on a large wooden raft that is slowly ascending up to and beyond the clouds. There are thirty or forty other people aboard, but the raft is by no means crowded. The people, all strangers to me, are friendly and cheerful, not in the least perturbed by the altitude or the absence of guardrails or seats; they're just sociably milling about, a few listening to an old upright piano that's being plunked at one end of the otherwise bare raft. At some point it becomes clear to me that the raft is on its way to heaven.

In the dream, I haven't died nor have the other passengers been resurrected from their graves. It's just Judgment Day, apparently, and we collection of living souls, presumably as a reward for our piety, have been provided free transportation to God's promised paradise. Nobody is singing hymns or shouting hallelujah, there are no blaring trumpets, no posse of angels riding shotgun, it's all rather low-key, but there is little doubt that the lot of us are glory-bound for the kingdom on high. Then, a funny thing happens: I fall off the raft.

It's kind of a shock but it isn't scary, because rather than tumbling head over heels, I fall slowly, gracefully. I'm worried about hitting the ground, naturally, but eventually find myself gliding and realize that I'm lying belly-down on a sled, a children's sled, my own private Rosebud. The sled lands gently on a steep snow-covered road in Blowing Rock, a hill familiar to me as it's right around the corner from the Robbins family homestead. The snow peters out, the sled continuing to coast over gravel and dirt for a few more yards before coming to rest. I stand up. It's very, very quiet. Not a person is in evidence -- which makes perfect sense: it's Judgment Day and the entire population has been airlifted to heaven or jerked down to hell, depending on their résumés.

Feeling like humanity's lonely orphan, unsure what to do next, I turn the corner and walk down deserted Rainey Street. Then I see her! Granny Robbins, in her long granny dress and Frankenstein

shoes, is standing in the expansive front yard next to her prize hydrangea bush, matter-of-factly raking leaves. So what if it's Judgment Day? She's got chores to do. As I walk up and greet her, the dream abruptly ends.

Now, I've never attempted to analyze that dream, never consulted a Jungian psychologist or one of the popular dream manuals. I'm unconvinced, in fact, that dreams have a lot of meaning. When we fall asleep, our mind is relieved of duty, it goes on recess, takes a play period, starts looking around for recreation. In that playful mode it snatches up images, figures, and locales from our memory vault and rearranges them, often randomly, usually out of context, for its own amusement or stimulation, trying different incongruous combinations just to observe the results. Your memory bank is your sleeping mind's toy box. Sometimes these art projects, these little private movies and impromptu skits, require themes to legitimize them, so the mind will seize on our current worries or deep-seated fears for subject matter, and because our mind isn't completely confined to our brain but extends, abridged, throughout our organism, biological urges (say we're hungry, horny, or have to pee) will sometimes intrude upon the dream show, adding a touch of stark reality to what is essentially a surreal production.

Okay, but having said all that, I'm left with the still-lucid recollection of that particular dream, puzzled why it, among tens of thousands of other dreams, would have made such a lasting impression that sometimes even now "during the solemnity of midnight when every bosom is at rest except that of love and sorrow" (as they characterized insomnia in more poetic times), I'll picture Granny and me alone on Judgment Day and wonder if there is some wider meaning there, some cryptic message from a hidden dimension, from the Other, from the Over Self. Or if it was simply that heaven didn't want us and hell was afraid we'd take over.

cry for funny

The evening of my twenty-first birthday found me not in a festive bar enjoying the first legal cocktail of my shiny new adulthood, but perched instead in saggy underwear atop an olive-green footlocker shining ill-fitting new black shoes to a gloss lustrous enough to satisfy the perverse demands of a uniformed sadist who'd be in my face berating me ere the cock crowed thrice on the morrow. No, a bar it surely was not, yet there was live musical entertainment of a sort, and in a peculiar sense it affected my life in ways beyond the reach of any lounge singer in any gin joint this side of Casablanca.

Two weeks earlier, I had enlisted in the United States Air Force. Why? -- one might fairly ask. Well, for precisely the same reason that 90 percent of all enlistees join the military, which is to say, I was at a point in my life when I didn't know what else to do.

Professional patriots, religious demigods, and politicians of all stripes are wont to shine the shoes of their public image by periodic references to "the heroic men and women who sacrifice so much in order to keep America safe and preserve our freedom." There may have been a few times in our nation's history when such tribute was accurate and deserved (in the days and weeks following the attacks on Pearl Harbor and the World Trade Center, for example), but I have to say that during four years in the air force, including posting at an army base in Korea; and during numerous conversations with both veterans and those on active duty, I never once heard a serviceman or -woman claim that he or she had joined up in order to preserve American values and keep their countrymen free. By and

large, young people have enlisted in order to escape boredom, finan-
cial difficulties, bad relationships, and general stagnation.

The travel and adventure promised (and, yes, often delivered) by
the military is not a component of basic training. From the hour one
lands in boot camp all thoughts of future fun and past attachments
are pounded out of one's consciousness; one is locked in a perpetual
present designed to purge one of any trace of individuality and ex-
tract from one any erg of energy with which one might presume to
resist. Talk about a makeover! It can leave the new recruit feeling
exhausted, beaten down, lost, apprehensive, and that he's probably
made a terrible mistake. That, as a matter of fact, fairly accurately
describes the state most of my platoon mates and I would be in when,
slumped on our footlockers at Sampson Air Force Base, New York,
buffing our ugly brogans and dreading the too-soon-upon-us dawn,
we'd be treated to the aforementioned "musical entertainment."

Almost to a man, the two dozen or so recruits in our platoon
had lived their entire lives in the racially segregated South, only to
find themselves now in a freshly integrated military, spending days
and nights in close company and on equal footing with members
of a familiar yet alien race. There were only three or four blacks
in our unit and the attitude of the white guys seemed one of pas-
sive curiosity rather than hostility or resentment, although frankly
we were all too tired and distracted to give racial differences much
thought. There was at least one prominent difference, however, and
it asserted itself in a manner whose benefits the Pentagon could not
have foreseen.

We honkies would be sitting there by our bunks, shining and
whining, enveloped in a forlorn funk, when down the center aisle
would come one of the black guys on his way to the latrine, the water
fountain, or the bulletin board; and he'd be all grinning and relaxed,
just snapping his fingers, shaking his booty, and, *singing;* not show-
ing off, mind you, or seeking attention, just unself-consciously lost in
the music he was hearing in his head and his heart, a music that toil

and trouble could not silence -- and perhaps made necessary. It never failed to lift our spirits or send us to bed in a ꙮꙮꙮꙮꙮ ꙮꙮꙮꙮꙮ I ꙮꙮꙮꙮ this not to perpetuate the myth of racial specializations -- the musicality of African Americans doubtlessly owes far more to environment than to genetics -- but it's impossible to recall those moments in my barracks without thinking of the Revue Nègre, Sidney Bechet, Josephine Baker et al, and how expatriate black American jazzmen put a smile back on the sad face of a Europe chronically depressed in the years after World War I.

Two centuries earlier, America itself began to be slowly uplifted by a people they had enslaved. Our nation was settled, remember, by emotionally constipated Puritans and purse-lipped prudes; expanded by brutish fortune hunters with a taste for hardtack and genocide. It would be insensitive to say in regard to something as evil as slavery that it's an ill wind that blows no good, but it's a fact that in addition to their other contributions, former African slaves managed over time to bring joy to a dour, priggish population which danced, when it deigned to dance at all, with heavy feet and a guilty conscience.

In any event, that experience in air force boot camp stayed with me, doubtlessly affecting in some way my unpopular stance as an integrationist in 1950s Richmond.

By the way, I alone among the white recruits actually recognized those songs that the black recruits were singing. There was a catchy one whose refrain went, "Ain't that crazy, crazy, crazy?" A question apropos to so many situations in life. And there was "Work with Me, Annie," whose lyrics had almost as many lives as a cat. Etta James recorded a supposedly cleaned-up version called "Roll With Me, Henry," but even that proved too risqué for white radio. Eventually, Georgia Gibbs scored one of the very first hits in the new genre of rock and roll with a further sanitized version entitled "Dance with Me, Henry." Needless to say, the original song's sequel, "Annie Had a Baby," was too earthy -- and too scary -- to be even considered for Caucasian transliteration.

How did blue-eyed Tommy Rotten happen to know those songs? Why, I'd heard them back in Warsaw at that little black-friendly Texaco station where the radio on the counter was always tuned to minority broadcasts from D.C. and Baltimore. Kid pops into a gas station to play the pinball machine and is subliminally radicalized. Ain't that crazy, crazy, crazy?

By 1953, the Korean War had wound down, but conscription remained in effect and I was about to be drafted into the army, a prospect that held a minimum of charm for me since I fancied neither shooting nor being shot. The air force seemed a more peaceable alternative, and I wasn't strongly averse to enlisting for the reason I stated earlier: I was bereft of appealing options.

In the year after severing ties with W&L (I didn't hate the place, it just wasn't the best fit for someone with my funky orientations and anarchic aesthetic), I'd done a bit of pre-beatnik hitchhiking (even writing a few pre-beatnik poems), labored briefly in the mail room of the Life Insurance Company of Virginia; and worked construction helping build and maintain electrical power plants and substations. I actually enjoyed construction, primarily for the camaraderie.

My fellow workers, though uneducated and unsophisticated, were funnier than a ruptured pipeline of laughing gas, offering witty and often insightful commentary on nearly every misstep, local and national, in life's passing parade. Not one of them gave a braised pig's knuckle that I could read Rilke in German, but they were loyal, stand-up guys who respected the fact that I'd dabbled in higher education, and who, I knew, always had my back. Going to work each morning was akin to attending a staff meeting of the *Harvard Lampoon,* if there were Harvard men who could keep you in stitches while threading pipe expertly or digging a ditch.

Enjoyable it might have been, but as I possess less mechanical aptitude than a rheumatoid squirrel monkey, my future in the con-

struction trade was limited at best. Oh, and lest I forget, there was one other sharp stick prodding me toward enlistment: I'd recently gotten married.

The summer I turned twenty, I'd lost my virginity to a fetching, likewise virginal, Warsaw girl three years my junior. It being the 1950s, and it being rural Virginia, and we, Peggy and I, being middle class; well, in that time and under those circumstances, the popping of the cherry more often than not led to the popping of the question. Granted, I'd been a nonconformist practically since birth, but in this case I don't know if I was rebelling against convention or bowing to it; yet for whatever reason, the prospect of a teenage wedding (and this was years before Chuck Berry sang about one) struck me as kind of cool, kind of wild.

I definitely wasn't driven by conscience, by the shameful feeling that my wonton lust had soiled an innocent flower. Peggy wasn't pregnant, and the truth is, she craved sexual intercourse as fervently as I. I'd say she craved it even more, except that such a claim would likely annoy Terry Gross.

Ms. Gross, of course, is the host of *Fresh Air,* the fine interview program on National Public Radio. The time I was a guest on the show, she seemed incredulous if not outright indignant when she asked if I really believed that women are more interested in sex than men are, as I'd had a character say in my novel *Skinny Legs and All.* I replied, "I don't know but that's what my women friends tell me."

It was an honest answer, if a trifle incomplete. I should have said, ". . . that's what my *married* women friends tell me." As we've established in these pages, the second his biological urge is satisfied, many a husband is mentally if not physically out the door, lugging his bag of clubs. Especially if a ray of daylight persists in the sky. And when he yells "Fore!" you can bet your bottom credit card he isn't crying out for more foreplay.

On a humid, blustery day (it was typhoon season) in the autumn of 1954, I landed in Japan. Two nights later, I landed again -- this time without benefit of aircraft. The second landing, though unaffected by storm winds, was rougher, more perilous than the first. Let me explain.

While awaiting transport to various assigned installations in Korea, hundreds of us airmen were temporarily quartered in what amounted to a tent city, although the structures weren't tents in the usual sense in that their bottom halves were wooden and seemingly permanent. From a height of about six feet upward, they were canvas, a heavy olive-drab tarpaulin material. Each unit slept twenty airmen, the cots lined up in two rows of ten with an aisle down the center. There were scores, maybe hundreds, of these half tents, and they all looked exactly alike. Only an identification number at each entrance distinguished one from all the others, but the numbers could be difficult to read in the dark.

Somewhere in the midst of Tent City, next to the huge mess hall, there was a canteen, the Pentagon being ever thoughtful when it comes to providing its troops with easy access to beer. By my second night in Japan, I was already so in love with the country (despite having thus far experienced precious little of it) that I downed an imprudent amount of suds, toasting my good fortune in finding myself in such an ancient and fascinating culture. At closing time, I went weaving back to my tent, where I quickly fell asleep, dreaming no doubt of geishas and Mount Fuji, in scenes resembling wood-block prints.

At some point during the night, a full bladder awakened me. I arose, located the latrine building, and proceeded to off-load my cargo. Now, my cot was immediately inside the entrance of my assigned tent, very first bunk on the right. Upon my return, I threw myself down on what I believed to be my mattress -- only to land right on top of a sleeping man. The man screamed. Literally screamed. He believed, I'm sure, that he was being attacked by a Communist, or worse, was the victim of an attempted homosexual rape.

I pulled myself off him as quickly as I could manage it, being somewhat entangled in the man's flailing arms and legs. Once free, I raced in a panic to the tent next door, which, luckily, proved to be the correct one, and dived into bed with my shoes on. There was some commotion outside, but it soon died down, and once my heart quit pounding and my breathing slowed, I quietly laughed myself to sleep.

At breakfast the next morning, I turned my head and discreetly chuckled again when I heard airmen asking, "Did you hear what happened to Sergeant Johansson last night?"

Later that day, just outside his tent, I came upon Sergeant Johansson himself. A gruff, tough-looking fellow in his thirties, he outranked me by three stripes and outweighed me by at least thirty pounds of what looked to be more muscle than fat. Walking ever so nonchalantly past him, I had no trouble suppressing even the faintest sign of amusement, though there definitely was a big red Japanese sun of a smile on the face behind my face.

In Korea, my assignment was to teach members of the South Korean air force the techniques of weather observation, including registering prevailing atmospheric conditions and encrypting, decoding, and plotting on maps meteorological data transmitted via shortwave radio from various observation sites around western Asia. To prepare me for this duty, the U.S. Air Force had sent me to its school near Chicago, where my classmates and I took two years of college meteorology in four months, attending classes eight hours a day, six days a week. This saturation process is called a "crash program," and I can testify that it is a highly effective way to learn a subject.

I had arrived in Illinois in the middle of a program, so my future weather classmates and I had to wait eight weeks for the next program to begin. To keep us occupied, useful, and out of mischief in the interval, our commanding officer made certain we were available daily for either mess hall duty (KP) or something called "base

beautification," this latter consisting of tasks ranging from scouring every inch of the sprawling base for cigarette butts and other litter to raking leaves, heaving sacks of compost, and planting shrubbery. Base beautification could be sweaty physical labor or it could be a piddly existential bore. And while in both cases it was preferable to KP (The horror! The horror!), it was hardly the sort of mindless grunt work we'd envisioned we'd be performing when we eschewed the army for the air force. Guys were always faking toothaches or upset stomachs, or inventing other lame excuses to get out of it. To that end I hit upon a novel tactic that in certain circles might be regarded as brilliant.

When our unit would report to a noncommissioned officer in charge of a particular base beautification project, each of us, individually, would be required to sign his name on a duty roster. At noon, we'd break for lunch, after which there'd be a roll call to assure that every one of us had returned to work as ordered. At no point in this operation were IDs checked. So one morning I signed the roster not as Thomas E. Robbins but as "R. M. Rilke," betting that not one of the authorities involved would have heard of the Austrian poet. After lunch, I slipped away to the base theater and watched a matinee.

The following day, at my unit's early-morning formation, nobody noticed the twinkle in my eye when our own NCO ordered "Airman Rilke" to report to the orderly room, presumably to defend his unexcused absence from base beautification. Perfect! And the next time we future weathermen were assigned to a laborious beautification detail, I signed in as "Feodor Dostoyevsky." After lunch, I traipsed over to the gym and shot baskets, knowing that I might have to bite my tongue to keep from snickering at the way our sergeant would pronounce "Dostoyevsky" the following morning. I only regretted that I couldn't be privy to the consternation "Rilke" and "Dostoyevsky" surely must have caused in our orderly room.

Not wishing to arouse suspicion. I skipped a day or two now and then and returned to the shovel and the rake, but over the following

weeks "Alexander Pope," "Leo Tolstoy," and "Oscar Wilde" were all cited for being AWOL from base beautification -- while I passed sweet afternoons seeing the latest Hollywood films and improving my jump shot. Who says a literary education doesn't have practical applications?

Any American air force pilot, having been alerted in a weather brief ing to the presence of a storm system in his flight path, would take pains to circumnavigate it. South Korean pilots, on the other hand, being fatalistic both by temperament and religious training, would just fly right into the storm.

At least that was the case in the 1950s. With that stoic approach to aviation prevalent in their officers, my students could be forgiven for caring no more about meteorology than kittens might care about string theory.

Nevertheless, we had to go through the motions, which we did in rotating eight-hour shifts: day, swing, and midnight (weather doesn't sleep). The question soon became, "What to do," my students and I, "to keep from boring each other to transcultural tears?" I'm unsure whose idea it was, but for a while -- in between recording and transmitting temperatures, dew points, and wind directions -- the locals amused themselves by teaching me to swear in Korean. More than a half century later, I still remember those naughty words, which is a trifle odd as I've had scant opportunity to put them into practice and have been known to criticize profanity as representing a paucity of vocabulary and destitution of wit.

Eventually, however, we discovered a diversion that was not only mutually satisfying but profitable. Moreover, it struck a symbolic blow against Cold War communism, being a working example of capitalistic principles on a democratically fundamental plane. We took up black marketing.

The PX at K-2 Air Force Base occupied a Quonset hut set on

treeless, ever-brown land, presenting a rigidly militaristic demeanor
to the world: no nonsense, no frills. Inside, though, it offered for sale
at discount prices a fair number of the familiar items that average
Americans considered essential to their pursuit of happiness if not
their actual survival. These would include Camel, Pall Mall, Kool,
and Marlboro cigarettes. Regulations permitted each airman on K-2
to purchase two cartons of cigarettes a month, a rule irrelevant in my
case since I didn't smoke. Well, one day a student named Kim (come
to think of it, each and every one of my students was named Kim; in
fact, I believe every man, woman, and child in Korea was named Kim
in 1955, and that may still be the case for all I know); this particular
Kim fellow came to me and very shyly suggested that were I to pro-
vide him with a carton of Marlboros, he would pay me more than
twice the price charged by the PX.

Now, I'm not much of a businessman -- life is entirely too short
to be used up in shallow pursuit of monetary favor -- but this transac-
tion sounded easy enough and, hey, this Kim, though not uniquely
christened, was a good-natured soul who'd giggled like a schoolgirl
when instructing me how to say "motherfucker" in his native tongue.

Let's not drag this out. Soon I was supplying Kim with not only
my two monthly cartons but cigarettes I'd purchased at face value
from other nonsmokers in my outfit. Before long, we were dealing in
toilet articles as well. They, in fact, commanded a better price than
the smokes. Bear in mind that South Korea at that time was an im-
poverished, war-torn country with nothing remotely resembling a
modern manufacturing sector, and from its sheer volume, it was ob-
vious that the stuff I sold to Kim was being resold to a third party or
parties.

Conducting business at the weather station would have been
risky for us both, so I'd conceal the merchandise in a laundry bag and
schlep it to a rendezvous at a Korean civilian laundry located some
twenty or thirty yards down the unpaved road that led in and out of
K-2. Most of the airmen had their clothes washed there, and guards

at the gate didn't notice that I seemed to be soiling my duds at many times the rate of the average airman.

I suppose I should emphasize that this enterprise was wee potatoes. Bantam feed. A mafia don wouldn't have wiped his wife's poodle's butt on it. But entertainment was cheap in those postwar years in Asia, and my illicit earnings, meager as they were, afforded me excellent sukiyaki dinners, Kabuki performances, and lovely female companionship when I would travel to Japan on leave. It wasn't until near the end of my tour of duty that I learned that most of our contraband, especially the toilet articles, was ending up behind the bamboo curtain in what was then Red China. Brand me a traitor if you must, but I figure that for eight or nine months I was supplying Mao Zedong with his Colgate toothpaste.

In the weather observers' barracks at K-2, a poker game was almost always in progress. One of the most ardent poker players was an affable, roughhewn Southern lad named Jody. Between weather station duty and incessantly chasing a royal flush, Jody hadn't time for much else, including writing to his girlfriend back in North Carolina, so he offered me five bucks (his luck had been good that week) if I'd write to Sue Ellen in his stead.

Since my interest in cards has been pretty much limited to wild cards (figuratively speaking), I rarely sat at the poker table, preferring to spend my leisure hours at the service club, flirting with bargirls and drinking beer; or, when in the barracks, pursuing my newfound interest in Japanese aesthetics, including trying to understand and assimilate such concepts as *wabi-sabi* (the art of finding beauty in things that are imperfect, incomplete, humble, or unconventional), a practice, with its undertones of "crazy wisdom," that continues to absorb me today. However, a young American male can only *wabi* so much *sabi*, and my rinky-dink black-market ring wasn't time-consuming, so I consented to write to the fair Sue Ellen on Jody's

behalf -- on one condition: he must sign and post the epistle without reading it. He agreed.

Refraining from waxing so poetic as to arouse her suspicion, I told Sue Ellen how much I (Jody) loved and missed her, but that I (Jody) was proud to be serving my country so that American values might endure. Skipping any reference to poker, I included a few lines about the base and work, but they struck me as dull. I felt that the letter could use a bit of color, some tidbit to intrigue and delight.

Inspired, I added that I had recently captured a snake and was keeping it in my laundry bag as a pet. It was pretty, I wrote, a cousin of the North Carolina king snake, and that I fed it mice I trapped in a nearby rice paddy, as well as eggs pilfered from the mess hall. Then, as a final romantic touch, I wrote that I (again, Jody) had named the snake "Sue Ellen" in her honor.

He never heard from her again.

Although he whined a few times about a broken heart, Jody soon quickly lost himself -- and Sue Ellen -- in the shuffling and dealing; whereas I felt I'd done a good deed, saving a fellow airman perhaps from marriage to an unimaginative, not to mention unappreciative, wife.

For several weeks, I was detached to a joint armed forces communications center in downtown Taegu, third largest city in South Korea. It was a wonderful deployment in that I got to walk to work every morning through narrow streets paved with stone and raucous with life, a sensorium of undulating exotica. Everywhere there was the rattling of carts, some pulled by shaggy ponies, most by old bearded papa-sans in baggy white britches and stovepipe hats. Pushing aside rice-paper screens, extended families poured from single-story houses, the women in long, very high-waisted skirts and tight-fitting brocade jackets worn under a looser jacket of quilted cotton. (Bargirls and prostitutes, of which there were great numbers in Taegu, wore

Western-style dresses -- usually gifts from GI boyfriends who ordered them from Sears catalogs -- but these larks of the night seldom ventured out before noon.)

My nose, even my eyes, filled with smoke from hibachi pots, with the pungent breath of kimchi crocks, and with the sweet-sour redolence of unidentifiable spices, lotions, tonics, oils, dyes, and bodily effluvia: strange smells to complement the strange language whose stick-figure letters jitterbugged on wooden and paper signs in every direction and whose intonations burst in the air around me like invisible cannonades.

Some mornings early on in my deployment, I'd get lost in the alleys and teeming jingle-jangle of it all, and not knowing how to ask directions, would wander in the multitudes until I saw a particular little bridge or an old car without wheels and realized that's where I must turn left and climb the hill to the communications center. More often than not, I was late for work. As I said, it was wonderful.

On that assignment, I was quartered on an army post, there being no air force presence in the city, and commuting from K-2 would have been a hassle even though it was no more than ten or twelve miles away: too many pushcarts, bicycles, and pedestrians jamming the road. Nights, when I wasn't on the futon of some cute bargirl, I slept in transit quarters, located on the second floor of a large, ugly, gray stone building, a relic of the Japanese occupation (1910–1945). I shared those temporary quarters -- a long, cold room with about thirty bunks, most of them empty -- with members of the U.S. Army all-Korea boxing team.

Having each won a Korean Command championship in his weight division, the boxers were training to fight the Japanese Command champs, the winners of those bouts then traveling to Germany to take on the top army pugilists in Europe. Trained by an Italian American with a Bronx accent as heavy as a subway car, these guys took their conditioning seriously, some of them perhaps dreaming of a professional prizefighting career once they were discharged from

the army. They were good roommates, however, funny and friendly
and always trying hard not to wake skinny, noncombatant me when
they arose at 5 A.M. to do their roadwork.

Sharing quarters with the military boxers made me feel as if I
were living in the pages of *From Here to Eternity*, the monumental
opus by James Jones that critics unfortunately and in some cases no
doubt snobbishly never mention when listing contenders for the title
of "Great American Novel." But, then, writing fiction is not a boxing
tournament, is it? Hemingway and Norman Mailer might have dis-
agreed, but there is no heavyweight champion of literature.

Very late one night, well past the Cinderella curfew, our peace-
ful quarters were invaded by about ten young greenhorn privates, not
long in the army and fresh off the troopship from the U.S. Some-
where in their journey from the port of Inchon to Taegu, they'd man-
aged to consume a large quantity of beer, and they were as loud and
stupid as nineteen-year-olds can be when inexperienced with the ca-
prices of ethyl alcohol. Add to that the giddiness they surely felt at
being left temporarily unsupervised in, for the first time in their lives,
a foreign land, and you have a recipe for elevated levels of obnoxious-
ness. Their horselaughs, their drunken vulgarity, their banging about,
their smartass retorts when asked politely to quiet down and switch
off the lights, failed to enchant the awakened boxers, whose arduous
workday on the road and in the gym would commence with the pink
prickling of dawn.

As the juvenile jackassery continued, I, beneath my government-
issue blankets, chuckled softly. One needn't be prescient to know how
this was going to end.

It ended quickly. With no wasted motion, boxers slipped out of
bed, slowly crossed the room, and WHUMP! WHOOSH! SUR-
PRISE! Single well-placed punches to the midsection let the air
out of three or four of the raucous rookies with a sound like that
of exploding tires. Deflated, the brats fell backward against their
astounded comrades or onto their clattering bunks. Then, piñatas

smashed, fiesta canceled, lights summarily extinguished, the new-
comers briefly grumbled under their breath and passed out while the
former went back to dreaming of title fights, flashbulbs, tabloid head-
lines, and million-dollar purses, or at least how their fists were going
to get them the hell out of Korea. And I, for the second time since
arriving in Asia, laughed myself to sleep.

There was something else besides Sears catalog fashions that distin-
guished Taegu bargirls and set them apart from their more virtu-
ous peers: namely their breath. These enterprising ladies, unlike their
fellow countrymen young and old, one and all, did not eat kimchi.
Their abstention was a dietary sacrifice of enormous proportions,
yet entirely necessary if they wished to socialize with American ser-
vicemen, which is to say, if they wished to prosper financially.

Kimchi has been called the national condiment or side dish of
Korea, but it's considerably more than that. It's a defining character-
istic, more gastronomically representative of Korea than salsa is of
Mexico or garlic of Italy. Though less so today than in past periods
when money and meat were scarce, kimchi has been a Korean way
of life.

Traditionally, kimchi was napa cabbage that, seasoned with hot
chilies and garlic and soaked in brine, was buried in an earthenware
crock for several months or until fermentation occurred. There are
variations in which radishes, turnips, and/or cucumbers are added to
the cabbage, but the fermentation is essential -- and the effect is the
same: after one has eaten kimchi, one's breath could run a train. It
could also run off any GI, marine, or airman -- no matter how roman-
tically inclined, how fervently propelled forward by testosterone --
who happened to find his olfactory receptors enveloped in an alien
halitosis so powerful it could pour a tank of herbicide on the reddest
rose of passion.

Kissing a kimchi eater is one thing, eating kimchi is another,

and while I was not all together unlike my fellow servicemen in my
aversion to the former, I came to join the ranks of the latter, intro-
duced at my insistence to the indomitable dish by a darling girl who
called herself "Sally" (odds are her real name was Kim), and whose
warnings I ignored, creating some displeasure at the weather station
since my entire supply of Listerine mouthwash was being funneled to
Chairman Mao.

I continue to eat kimchi today, albeit by necessity the made-
in-America version. American kimchi? Indeed, it's possible to find
refrigerated jars of the stuff in a fair number of U.S. supermarkets
and specialty food stores, especially on the West Coast; and while it
can add piquancy to tuna sandwiches or bowls of pork with steamed
rice, it's pretty much a pale shadow of the authentic Korean prod-
uct. The problem is that here the ingredients have rarely been fer-
mented. It's possible today to ferment cabbage without burying it in
the ground all winter (a Vietnamese woman in La Conner, Wash-
ington, made me some in her garage: moonshine kimchi), but in
deference to Yankee sensibilities, most preserved cabbage in this
country (in Japan, as well) is actually pickled rather than fermented.
I call it "kimchi lite."

Kimchi lite is to authentic Korean kimchi what a lapdog is to a
timber wolf, what a billiards game is to a rugby match, what Dis-
neyland is to Burning Man, what a golf cart is to a hot-rod Lincoln,
what the Mormon Tabernacle Choir is to the Rolling Stones, what
a sparkler is to a thunder cracker, what Curious George is to King
Kong, what . . . well, you get the picture. Kimchi lite can enliven a
tuna sandwich but hard-core Korean kimchi rocks the world.

"You eat kimchi," Sally warned me, "you wife-san no like you. She
catchy catchy 'nother man." The petite bargirl had laughed uproari-
ously when I swallowed my first bite of kimchi. ("I cry for funny," she
gasped), but she was seriously prophetic in regard to my wife, although

Peggy's animosity had zero to do with Korean cuisine. Or with Korean bargirls, for that matter. We were drifting -- no, motorboating apart before I'd gone abroad.

Romantic love is ambulatory by nature, and it must be anchored in strata more stable than lust if it's to last. Marital disintegration is accelerated when only one, or neither, party is grounded and growing, or growing at different rates or in different directions. As I became increasingly interested in cultural matters, matters of the mind and spirit, my teenage bride waxed more and more materialistic. Peggy was thoroughly unimpressed when I won an air force short-story contest; I quietly scoffed at her fashion magazines, her fascination with the financial potential of Florida real estate. (I'd been stationed at a base outside of Orlando, tracking potential hurricanes.) The sporadic letters she'd sent me in Korea were approximately as affectionate as a foreclosure notice. Written with a blunt instrument. Dipped in zombie blood.

Returning home aboard a troopship bound for Seattle, I'd scored a gig as editor of the ship's newspaper (a thin mimeographed rag distributed daily), thereby avoiding both KP and nightly internment down in the fart-infested rat warrens where troops were stacked like cordwood: I instead shared a comfortable cabin with a trio of medics. Under the nom de plume "Figmo Fosdick," I also wrote a satirical humor column called *Shipboard Confidential*, which, though popular with the troops, frequently put me at odds with the paper's adviser, a Roman Catholic chaplin who possessed the purplish physiognomy and perpetually petulant pucker of the overly zealous censor. I wouldn't insinuate that the good priest ever touched a choirboy, but he certainly molested my prose.

At any rate, I had little time for contemplation during the crossing, so when after a fortnight we docked in Seattle, I elected to take a Greyhound bus to Virginia, thereby saving airfare and giving myself four uninterrupted days on the road to ponder my situation.

Prior to my deployment to Asia, Peggy had been my one and only

sexual partner. Now I'd rolled on the futon with five Korean girls --
Kim, Kim, Kim, Kim, and Sally -- and an extremely lovely Japanese
woman named Reiko. I'd "sown my wild oats," to borrow that dated
agrarian phrase, and was thinking that I was now ready to "settle
down," to employ another grandpa expression, with Peggy and our
son Rip (born just before I shipped out to Korea), and "build a life"
(the clichés just kept on rolling). Moreover, when I finally arrived in
Richmond, I took one look at Peggy and fell in love with her all over
again. Alas, the feelings were less than mutual.

The frigidity of my welcome would have inspired the hardiest
Eskimo to huddle with the sled dogs. Peggy had been strewing some
feral cereal of her own it seems, and was, in fact, pregnant with an-
other man's child. Deserved or not, the rejection ripped through my
heart like a rusty can opener, wounding me so deeply that for years
thereafter it would pop up like a jeering jack in my dreams.

You see, at that juncture in my life I wasn't evolved enough to
understand the fluid nature of romantic love (its indifference to
human cravings for permanence and certainty); its uncivilized, undo-
mesticated nature (less like a pretty melody than a foxish barking at
the moon), or, more importantly perhaps, that it's a *privilege* to love
someone, to truly love them; and while it's paradisiacal if she or he
loves you back, it's unfair to demand or expect reciprocity. We should
consider ourselves lucky, honored, blessed that we possess the capac-
ity to feel tenderness of such magnitude and be grateful even when
that love is not returned. Love is the only game in which we win even
when we lose.

Hmmm. That last sentence reminds me of my gallbladder.

In 2006, an ultrasound exam discovered enough stones in my
gallbladder to pave a Zen walkway. A few weeks later, I had the rock-
strewn organ removed. The surgery went well, but I was kept in the
hospital overnight. I was also pumped full of happy juice. The drug's
identity I do not know, but with it singing in my veins, pushing my

mental pedal to the metal, I was merrily awake all night long, during which time I wrote an entire self-help book in my head.

I'm neither kidding nor exaggerating. Hour after hour, paragraph after paragraph, page after page, chapter after chapter, I composed an entire self-help book. Toward dawn, I finally fell asleep, however, and when they woke me several hours later, the only part of the book I could recall was its title: *How to Lose Every Hand and Still Come Out a Winner.*

That's correct: *How to Lose Every Hand and Still Come Out a Winner.* If only I could have remembered the accompanying text, there is no doubt whatsoever that the book would have sold twenty million copies and placed me in the company of mega-motivator *Tony* Robbins. Maybe that's why I forgot it.

god bless bohemia

Upon returning from overseas in 1955, I stumbled into an America I had barely known existed, a country within a country; or more precisely, a state within a state; a state of being that is usually referred to as "bohemia," although it has nothing to do with Czechoslovakia, and of which I have remained to this day a denizen. ("Citizen" is too licit a word, and anyway, when necessary I've managed to keep one foot in mainstream bourgeois society, which is to say, in enemy territory.)

Now, I'd checked out Greenwich Village in the months before my juvenile marriage, but the place had seemed more foreign to me then than Japan or Korea; and having no guide, no interpreter, no valid passport, nor even a proper frame of reference, I wasn't merely an outsider, I was like a deaf man at the opera or a blind man at the circus. Ironically, it was my estranged wife who introduced me to what would in a few years be labeled (and often libeled) as the "counterculture." A materialist Peggy might have been, but she was also a party girl, and in conservative Richmond it was the bohemian artists and intellectuals, genuine or fake, who hosted -- informally, of course -- the liveliest and most frequent soirees.

There's an area of urban Richmond known as the Fan District, a charming neighborhood, by and large, and home to the largest concentration of artists and arty hangers-on between New York and New Orleans. (Of the Fan I'll have more stories to tell later: I came to live there in 1957 after my discharge from the air force.) Peggy was taking lessons in ballroom dancing, and it was a gay dance in-

structor named Chubby, though he was as skinny as a chopstick, who initiated her into the Fan party scene. On my second night back, following my cross-country bus ride, Peggy let me tag along to a gathering at a painting studio. Within an hour, she'd disappeared, and I did not see her again that evening, but the sting of being abandoned was lessened considerably by my acute fascination with the odd new world into which I'd been dumped. It was bohemia, baby, and while I wasn't exactly wonder-struck, I was undeniably captivated.

In Japan, I'd marveled at wood-block prints, but until that evening in Richmond, I'd seen modern paintings only in reproductions, and not many of those. A Hokusai print is exquisite in its draftsmanship and poignant in the way it penetrates and distills the very essence of nature, but such refinement can be drowned out by the sheer bravura of a big modern canvas, especially one upon which the paint is so fresh it's sticky to the touch; and in that Fan studio I was surrounded by actual original paintings, some hanging, a couple half finished on easels, some propped against the walls. From that night on, the mingled aroma of oil paint and turpentine, with its hint of mystery, its suggestion of activities unfolding outside the realm of normal expectations, has been an intoxicating perfume to me.

Furnished with three rickety wooden chairs and a stained sofa that had seen too much and forgotten too little, the studio's main room, uncarpeted and spattered with paint of various hues, was the epicenter of the party. There, the motley-garbed guests -- not one in a military uniform or "conventional dress" à la W&L -- sipped beer and cheap red wine (marijuana would not infiltrate Richmond for another decade) while listening to an LP recording of a singer with a voice so wretched I thought it must be some kind of joke. (The singer's name was Billie Holiday, and before my leave was up, having probably heard her a dozen more times, I was so completely crazy about her I'd purchased one of her albums, even though, like the

shoplifter at W&L, I didn't own a record player: for me, disorientation has all too often been the beginning of love.)

The party was only moderately noisy, although the buzz of otherwise serious conversation would periodically be interrupted by shouted non sequiturs, proclamations of a bizarre, surrealistic nature, followed by appreciative chuckling. Between the mad poetic outbursts, ideas were being tumbled like gemstones in a lapidary, discussion salted with names such as Freud, Picasso, and Stravinsky. Since in air force barracks guys talked mainly about cars, sports teams, and girlfriends -- in that order -- this dialogue was a refreshment to me, a tonic; and when I overheard Henry Miller mentioned, I jumped in with a few comments of my own.

Almost nobody else present had actually read Miller (the Grove Press paperback edition of *Tropic of Cancer* wouldn't be published until 1961), and my firsthand observations made enough of an impression that when on the following evening, sans Peggy, I knocked on the studio door, I was recognized and admitted. Welcome to bohemia, Tommy Rotten.

I spent the last three weeks of my leave in that milieu, most particularly with the two painters who lived and worked in the studio I now visited daily, a larger-than-life pair named William Fletcher Jones and William Philip Kendrick, and with whom I would establish lasting friendships.

Jones looked like Dylan Thomas with a receding hairline and an exceeding waistline. A big brooding hulk, he would puff his jowls malevolently and bulge his hyperthyroid eyes until he resembled a hippopotamus rising from the ooze, then unfold his meaty lips to emit one of those nervous little nearly silent giggles with which certain jazz drummers vent their ecstasy at the terminus of an especially complicated riff. The giggles customarily followed some nonsensical -- obtuse, at any rate -- remark about life or art, though for Jones the line between the two was virtually nonexistent. He was to become rather well known for semiabstract

cityscapes, charged with tension and electricity and executed in brilliant, juicy hues, although at the time he was painting courting lovers, realistic couples in every aspect except for their heads, which were featureless eggs.

As for Kendrick, whom his friends called "B.K.," he was obsessed with the image of the dancer Nijinsky in the role of Petrouchka, the brokenhearted clown who for one shining moment sat upon the golden throne of God, a subject he has painted literally hundreds of times. B.K. was (and is) himself a clown, albeit a shy one: at odd moments he would jump up, click his heels together, and pirouette in a silly little dance, at the conclusion of which he would glance about the room with an anxious smile, like a child half expecting to be punished for inappropriate exuberance. Indeed, his round face almost perpetually exhibited the wide-eyed gaze and surprised smile of an astonished child, one who might have had his blindfold removed to find himself in a castle filled with ice cream, puppies, and toys.

B.K.'s sensitive baby face was all the more incongruous in that he was a state champion weight lifter, bulky muscles like hibernating armadillos concealed in the folds of his baggy duds. When ten years later we would move to New York together (I detoured to Richmond to pick him up on my way from Seattle), he would cadge drinks for us by walking the length of cocktail bars on his hands, somehow managing not to tip over any of the beverages resting thereupon. A one-hand stand on a bar stool was almost always good for a rum-and-Coke or a pint of Guinness, which we'd divide into two smaller glasses. It was in token repayment for this procurement that I partially dedicated my first novel to him in 1971.

At this writing, B.K. is well past eighty and we've been pals for more than half a century, a friendship that some may find a bit . . . well, bohemian; considering, as I eventually learned, that it was B.K. who had impregnated my wife when I was in Korea.

One morning when I was six, I awoke to find it spring. When I'd fallen asleep it was winter still, but sometime during the night, like a tipsy debutante sneaking home late from a ball, her hair undone, her green gown billowing, a song in her heart and a dreamy yet defiant smile on her face, spring had returned to Blowing Rock.

I'd been sick for nearly a week with the flu, and my mother, ever the nurse, thought I needed at least one more day in bed. Maybe, but when I saw through my bedroom window that the world outside had come alive, that it had taken on an insect quality, everywhere buzzing and budding, I wanted to claim a place in the sun. So, I opened the window (my room was on the first floor), jumped outside, and to Mother's horror, went running, cavorting, and cartwheeling around and around the yard in my underwear.

For those high jinks, I paid with a scolding, a denial of promised ice cream, and an extra day in bed under observation to assure that my little escapade hadn't brought on pneumonia. It was totally worth it.

My encounter with bohemia and the bohemians was to have a similar effect on me. Herbert Gold, the San Francisco author, wrote this: "In all the interstices of a society that still requires art, imagination, laziness, adventure, and possibility unwilled by family and employment, the bohemian unpacks his tender roots." Is not Gold's expression "tender roots" suggestive of spring?

From the stuffy sickroom of button-downed 1950s America, a vanilla-flavored, beige-draped decade whose lodestar was the pine-scented patio candle, I looked out on what appeared to be a kind of behavioral springtime -- a metaphoric season of irrepressible renewal; fertile and wild and green and free -- and felt an urge to go running around in it in my underwear. Alas, barely had its first robin chirped before my bohemian spring was replaced by regimental winter. Leave having expired, I now reported for duty to a base outside Omaha, Nebraska, where for the next twenty months I would work three stories underground in a theoretically nuclear bombproof building, a Cold War fortress without a single window to jump out of.

Offutt Air Force Base, Nebraska, is headquarters of the Strategic Air Command, whose mission during Cold War tensions was to be poised and prepared for Hot War every minute of every day. At all times, day and night, weekends and holidays (including the alleged birthday of "the Prince of Peace") there were SAC bombers in the air, each freighting a payload of atom bombs, their crews awaiting the signal to proceed to a selected target and blow it into radioactive dust. Once the U.S. president had hung up the iconic red telephone, the next call, the order from Washington to let the hell begin, would be answered in the building where I worked.

There would be any number of potential targets blinking on the giant electric wall maps inside the SAC nerve center, and among the factors involved in determining which one or ones to actually bomb would be the prevailing flying conditions in the vicinity of each site. Pilots would need to know what the weather would be like in obscure corners of the Eastern Bloc, and it was up to my Special Weather Intelligence unit to supply them with the most recent information. If, for example, a cold front with heavy snow appeared to be moving in on a missile base near Cheboksary, reducing visibility, a strike might be diverted to a submarine station at Sevastopol, where winds were favorable and the ceiling high.

How would we know? Meteorological espionage. Clandestine ham-radio operators in inner Outer Mongolia or some Podunk part of Pskov would transmit -- in code -- the amount and type of cloud cover, wind speed and direction, temperature, dew point, barometric pressure, and ground-level visibility (how, or if, they were compensated for this secret and certainly dangerous work, nobody ever said) to us boys at Offutt; where we would then decode it, encrypt it in a code of our own, and plot the numbers and symbols with fountain pens onto paper maps. From that information, our forecasters would

connect the dots to develop a pretty good picture of present and near-future atmospheric conditions throughout the Soviet Union and beyond. All that was missing was a jolly TV pitchman to advise the husbands of Nizhny Novgorod that "Tuesday might be a good day to dust off those golf clubs."

Despite the high security and overtones of high drama (Dr. Strangelove would have felt right at home there), my work in Special Weather Intelligence was for the most part as routine as it was cloistered: as I've said, much of my time was spent in a bunker deep underground. An escape hatch, however, like bohemia itself, can be a state of mind, and in the midst of SAC's ongoing dress rehearsals for nuclear war, surrounded by Nebraska's ubiquitous feedlots and cornfields, there did exist opportunities to unpack one's "tender roots."

Back in Richmond during my leave, B.K. -- the painter–weight lifter–bashful clown -- had given me, offhandedly, an introductory course in art history. As we strolled the cobblestone alleys of the Fan District, drank beer at Eton's on Grace Street, or leafed through coffee-table books and art magazines at his studio, B.K. prattled on and on about Rembrandt, Cézanne, Caravaggio, et al, seeming at times to be astounded that such men had actually existed. Though he particularly liked recounting gossip, probably fictionalized, about the artists' personal lives, B.K. also had been able to explain to my satisfaction the differences between Analytic and Synthetic Cubism, and how the Impressionists were able to lead the viewer into mixing color in his or her own eye. Not long after arriving in Nebraska I discovered to my delight that Omaha's Joslyn Museum was home to an impressive collection of everything from ancient Greek pottery to Renaissance masterworks (Titian, El Greco) to Impressionist gems by Pissarro, Monet, and Renoir.

After I had purchased my first car -- it cost fifty bucks, worth every nickel -- I took to spending free days wandering the Joslyn galleries, where, among other things, I tried to reconcile Renoir's plump

and rosy, wine-warmed wenches with the graceful if sinister beauty of the B-47 bombers nurtured and nourished at my air force base, eventually concluding that anything that says yes to life (a Renoir) is automatically saying no to war, regardless of how attractively its weapons and justifications may be packaged. Thus, like those bohemians with whom he was feeling a growing kinship, Airman Second Class Tommy Rotten woke up one morning to find himself once and for all a pacifist.

There was also music in Nebraska. Specifically, there was jazz, long the official sound track to all things bohemian in America, except for the years roughly between 1962 and 1980, when rock and roll ruled the waves. (Thelonious Monk's "'Round Midnight" is modern bohemia's national anthem.) More specifically, there was the incongruously named New York Jazz Workshop, an ensemble whose founding members each had at one time played with big-name jazzmen in Manhattan, so the name was not entirely presumptuous. Headquartered in Omaha, the New York Jazz Workshop (very contemporary, very cool) traveled all over the Midwest, playing mostly college venues, but every Sunday afternoon it held forth in Omaha's Red Lion Lounge -- and every Sunday afternoon when I wasn't down in the bowels of the earth, plotting weather maps, I was at the Red Lion at a table near the bandstand.

It was my disorienting relationship with Billie Holiday (first mocking, then adoring) that had yanked me through jazz's swinging door (another boon from that transformative leave in Richmond), and by my second year in Omaha, I'd become so immersed in the medium -- in its audacious bending of notes, yo-yoing of pitches, and rainbowing of rhythms as it determinedly explored new ways to play and hear music -- that I naively presumed myself qualified to write something about it. When word reached me that the New York Jazz Workshop was in the process of recording an album, I sat at the little

government-issue desk in my barracks and penned what I presumed to be liner notes.

The next Sunday, at the Red Lion, I handed the pages to the group's ostensible leader. Apparently, he perused my notes, and favorably so, during intermission because after the break he read aloud what I'd written, verbatim, over the bandstand microphone. The audience applauded. The musicians applauded. The jazzmen I'd been applauding every Sunday for a year or more were now applauding *me*. It's hard to describe the elation I felt. Vaulted to a peak of pleasure, my heart took a drum solo worthy of Joe Morello.

Several years passed before it dawned on me that they were applauding my use of language, itself rather audacious, rather than my woefully inadequate knowledge of jazz. Nevertheless, that experience was a pivot point for me. After a lengthy absence, I began to write again, and shortly before leaving Offutt and the military, I entered and won another air force short-story contest. This story concerned a man who first psychologically and then physically turns into a mosquito. A month or so later, I submitted it to *Weird Tales* magazine -- and received my first ever rejection slip.

Incidentally, I've been fortunate enough to garner only one other rejection notice in my literary careen (a term I prefer to "career"). It arrived the following year in response to a poem I'd submitted to the *New Yorker*. As I recall, the poem went something like this:

> *At the bat of your lashes peacocks preen.*
> *Peacocks preen, elephants remember,*
> *camels go for days without water,*
> *and dinosaurs of all types become extinct.*

Although I've never pretended to be a poet, I'm still on the fence about whether or not the *New Yorker* poetry editor made the right decision.

My first car, that fifty-dollar hummer, was a 1947 Kaiser. A what? Yeah, a Kaiser, a six-cylinder fully (mine seemed to hit on no more than three) manufactured near Detroit between 1945 and 1953. It looked like the illegitimate child of a sperm whale and a pizza oven, and was built so low to the ground you actually had to step down to get into it: it was not unlike entering a sunken living room or boarding one of those Tunnel of Love boats at an amusement park.

At the time, I was dating a cute little WAF, and when I say "little" I'm not being colloquial: measuring just four feet eleven inches, it's surprising Bunnie was allowed in the air force. When she sat beside me in that low-riding Kaiser nobody could tell she was in the car. From outside, you couldn't even see the top of her head. As a consequence, rumor spread through my squadron that "Robbins drives around all over Omaha yakking to himself." It's fortunate, I guess, that they were unaware of my history with the talking stick.

If that rumor contributed to the fact that I was the only airman in my unit not to receive a reenlistment lecture, I couldn't say. There were, however, reasons why my extended military service went unsolicited. I was good at my job, always arrived on time, and despite a couple of citations for refusing to wear a hat (I felt like a Tijuana bus driver in those low-class lids), I presented a clean, neat, pleasant countenance to my comrades and superiors. True, but a cheerful, generally compliant disposition apparently could not disguise the irrepressible bohemian vapors that now wafted from the pits of my flesh, effluvia interpreted by some as passive insubordination and others as covert anti-authoritarianism. It didn't help matters that names such as Freud, Picasso, and Stravinsky were occasionally popping up in my conversation. It wasn't normal. It wasn't American. It wasn't *right*.

Charges of "intellectual snobbery" escalated after I innocently asked a sergeant which he considered worse, conspicuous consumption or conspicuous nonconsumption. (I'd been reading Margaret Mead.) From the way the guy waxed livid with hostility, one would have thought I'd inquired if he believed Uncle Sam was a lesbian.

On the other hand, I may not have received a reenlistment sales pitch because it was so obviously a waste of time, and never mind that the prospect of wasting time has rarely if ever stopped anybody in the military. At any rate, the air force awarded me an honorable discharge (poor compensation for the fact that I'd received only two promotions in four years); I shipped my belongings to my parents' address, sold the Kaiser to a junkyard for fifteen bucks, shook hands with my buddies, kissed the little WAF good-bye, and hitchhiked back to Richmond, perhaps passing on the road Neal Cassady or Jack Kerouac, an exciting and soon-to-be-famous new breed of bohemians.

If I, indeed, crossed paths with representatives of the Beat Generation while thumbing from Nebraska to Virginia, I failed to recognize them as such. I did, however, encounter an old gentleman whom the Beats might well have found worthy of praise.

On a chilly morning (despite it being early June) in eastern Kentucky, I was stranded on the outskirts of a small city, stranded because it was Saturday and all the traffic was heading *into* town so that the coal miners, moonshiners, hardscrabble farmers and their families could attend to their Saturday shopping (a weekly ritual), while I was heading in the opposite direction. Pickup after pickup passed me by, the cab of each one crowded past the point of legality with parents, grandparents, and perhaps other kin; the truck beds full of children, bundled against the fresh mountain air. More often than not, drivers honked at me and their children waved. Occasionally, one of the kids would shout, "Hey, soldier boy!" Although I was officially now a civilian, I was wearing my uniform because it helped in getting rides.

The friendly reception warmed my heart -- these were in a sense my people -- but the rest of me was becoming chilled to the marrow. Eventually, I turned on a numb heel and took temporary refuge in an unpainted old general store a short way down the road. General stores, all but extinct now, differed from today's convenience stores in that they stocked considerably less junk food, considerably more household staples. This one in Kentucky sold everything from sacks of potatoes to gallons of kerosene, from flour and school notebooks to mousetraps and sugar. I bought a Milky Way candy bar and was eating it beside the potbellied stove when the aforementioned elderly gentleman walked in.

If central casting had been searching for a man to play opposite Granny Robbins, this was their guy. Tall, lean, stubble-faced, and gray, he was clad in faded bib overalls and actually carried a squirrel rifle. He was chewing a "chaw of 'backy," and, as he possessed a deficit of teeth, tobacco juice dribbled in brown rivulets down his chin. When he shuffled up to the counter, the clerk smiled hospitably, and asked, "How are you today, Uncle Ben?" Whereupon Uncle Ben replied, "'Bout dead, thank ye."

There was not a spot of self-pity in his answer, not a hint of despair, and while there was a detectable twinkle in his eye, it was the glow of equanimity not the glint of irony. Throughout the history of Zen, there's been an emphasis on the impermanent nature of all life, all things, and though I surely don't wish to portray Uncle Ben as some kind of camouflaged Zen master, there was in his tone and his being a good-natured, slightly amused acceptance of inevitable impermanence.

It was the briefest of moments and more than five decades have passed, yet I've obviously never forgotten Uncle Ben because when I'm laid up with the flu or some other affliction and a friend calls to ask how I am, I automatically answer, with an appropriate twang, "'Bout dead, thank ye." It never fails to make me feel better.

fan man

Few readers will have heard of Richmond Professional Institute. Even before RPI locked arms with the Medical College of Virginia in 1968 to become the vastly larger, more comprehensive Virginia Commonwealth University, it wasn't widely known, though it was Harvard, Stanford, Oxford, and the Sorbonne rolled into one for aspiring artists in the southeastern U.S.; and in many ways it was the ideal school for incipient bohemians looking for a friendly academic environment in which to unpack those tender roots.

First of all, it was an urban college, its campus brick, stone, and asphalt; nary a blade of grass to remind a student of suburbia, small-town repression, or cornball life back on the farm. Most of its classes were taught (many still are) in former private homes, grand old three-story houses resplendent with ornate staircases, cupolas, balconies, and bay windows convenient for checking to see if the Yankees were coming. Secondly, it was a professional school, which is to say there were no required courses in English, math, or a foreign language. From day one a freshman was immersed in his or her chosen field -- and frequently that field was art, drama, or music. Degrees were offered in advertising and retailing, in journalism and fashion design, and its department of social work had a wide reputation, but it was its curriculum in the arts that gave RPI its flavor, a flavor unsuited to everyone's palate in Richmond, one of the most proper, conservative cities in America.

RPI did not field a football team, not a single fraternity or sorority Greeked up the place, and it should go without saying that there

was no dress code: "conventional dress" at RPI meant whatever the alley cat dragged in, and the *La Bohème* chic on display invited the city's gentry and good ol' boys alike to deride the school as a haven for degenerates of every persuasion. That characterization, as exaggerated as it was, only made the place dearer to the hearts of many students, for little encourages a bohemian more than to be misunderstood and maligned by squares. RPI had suited William Fletcher Jones and B.K., both alumni, and it was to suit me, as well, when I enrolled there soon after leaving the air force.

RPI's student newspaper was called the *Proscript*, and I never knew what that meant either, although the name somehow made more sense than the *Ring-tum Phi*. In any case, I became editor in chief of the *Proscript*, and wrote a weekly column I entitled *Walks on the Wild Side* as a kind of tribute to Nelson Algren, arguably the greatest American novelist of the twentieth century. Like each and every Virginia school, private or public, RPI, for all of its air of nonconformity, was racially segregated. As protest, I and two of my fellow staffers on the *Proscript*, Pat Thomas and Ginger Foxwell, went to great lengths to sneak integrationist messages into the paper, and while some of them were so clever as to be almost entirely esoteric, we were nearly always caught.

As a result of this subversion, I was reprimanded with a C in journalism, which though it torpedoed my "straight A" average, didn't ruin my chances in the job market. In fact, for most of my senior year I worked a full forty-hour week on the sports desk of the *Richmond Times-Dispatch*, the state's leading daily paper. Like all morning papers, the *Times-Dispatch* was produced at night. I worked from four in the afternoon until midnight, which is how I managed to carry an eighteen-hour class load despite full employment. It was a bit of a strain, however, and I was as happy as any kid in junior high when the school year finally ended.

Commencement exercises at RPI were slated for 10 A.M., and due to my schedule, I was of a mind to skip the ceremony, reason-

ing that I could profit more from sleep than walking across a stage for a perfunctory handshake and a parchment diploma. My pal Ginger Foxwell objected. She wanted like-minded company at the event. And when I claimed that I simply wouldn't wake up in time to dress and make it to the civic auditorium (whose name, believe it or not, was the Mosque), she countered that she would send a friend by my apartment to rouse me and drive me to commencement. Sure enough, at nine-fifteen or thereabouts on the fateful day, there was a rapping, a tapping at my chamber door, and though Edgar Allan Poe had once called Richmond home, I was pretty sure it wasn't a raven. Indeed, the figure my bleary eye saw through the peephole was a bird of quite a different feather.

Patricia was radical Ginger's unlikely best friend, a married woman from suburbia. I'd met -- and been beguiled by -- her a month earlier when, after accepting a ride home from a party (I'd yet to replace the Kaiser), I'd ended up in the backseat beside her as the driver took his passengers on an inebriated joyride up and down the streets of the Fan. Patricia and I had chatted jovially, perhaps to conceal nervousness at the insane way the driver was taking corners, and when the car finally squealed to a stop at my address, we'd impulsively, unexpectedly kissed. It was intended to be casual, just a sociable good-night buss -- but then the world might be a different place had Madame Curie discovered a new method for making cheese fondue rather than a recipe for radioactivity.

At the meeting of our lips, peacocks went into hiding, elephants suffered memory loss, camels developed a maddening thirst, and dinosaurs long thought to be extinct turned up on the evening news.

It could not have lasted for more than four or five seconds, yet this commingling of mouth meat, this musical clink of enamel against enamel, this slippery friction (for some reason always as startling as it is intimate) that occurs when tongues collide (surprise!) was epic, mythic, even biblical in its scope. A person could imagine seas parting, bushes burning, angels hovering, milk and honey flowing

from a stone; imagine wheeling chariots, strikes of ancient lightning, and the lamb lying down with the lion in a field of crimson poppies. Those kissing such a kiss, transformed momentarily into a hairy god and a naked nymph slurping nectar from the same full cup, could imagine it lasting forty days and forty nights, though as indicated, it was over so quickly that the parties kissing could not be wholly certain it ever happened.

Now, weeks later, here Patricia stood in my doorway, dolled up in her go-to-commencement finery and wearing a smile that managed to be simultaneously timid, awkward, and seductive. In the time that elapsed as we stared at one another there, I could have received a half-dozen diplomas, a haircut, and a citation for loitering. Then, our heads bobbed toward one another, back and forth, like wary pigeons pecking at an ear of corn, until after a couple of near misses we connected and kissed for the second time that spring.

Patricia had married at sixteen, and now at twenty-two had three lovely children and a nice home in a lower-middle-class suburb. She also had a hole somewhere inside, down which a significant, formative, irreplaceable chunk of her young life had gone missing. Of course, in retrospect, that sounds like I'm making excuses for her. As for my own part in this, I must confess that when Moses threw that stone tablet at me -- the one in which the Seventh Commandment had been plainly etched -- I ducked and it sailed out the window.

Oh, I felt pangs of guilt all right, but I'd recently taken to reading Zen texts and while reading Zen is akin to reading swimming (in both cases one must eventually toss aside books and just leap off the dock), I was learning the wisdom of living in the moment. Moreover, in my moment of wavering hesitation, I could hear ol' Billy Blake shouting all the way from the eighteenth century, "Kiss the joy as it flies."

Suffice to say, I never made it to my college commencement. Due to graduate with honors, I chose dishonor instead, earning a postgraduate degree in adultery. *Summa cum lotta.*

The "Fan" in Fan District refers neither to the manufacture of those rotary appliances used to circulate air in enclosed architectural spaces nor to the handheld accessories whose primary function it is to cool down, and conceal the facial twitches of, overheated dowagers. Rather, it's named for the way streets fan out in a radiating semicircle from Monroe Park, a green if soot-peppered oasis in the urban center of Richmond. It's an old neighborhood in, by American standards, an old city, though one sumptuous with block after block of beautifully restored town houses, and enlivened by the student population of Virginia Commonwealth University (formerly RPI), along with the sort of shops and watering holes that cater to students; as well as to the artists, gays, and bohemians who have both enriched and stigmatized the area for decades.

When I think of the Fan, which I seem to persist in doing, I think primarily of its alleys. As charming as are its leafy streets, lined with renovated homes and almost audibly tramped by the ghost boots of long-dead Confederate officers, it is the alleyways dividing those streets that are responsible for the romance in my Richmond reveries. The images and moods most associated with the word "alley" -- narrow, secluded, gritty, generally unlit, and often dangerous passageways populated by emaciated tomcats, garbage trucks, and thugs -- do not entirely apply to the alleys of the Fan, which to this day are simultaneously inviting and forbidding, elegant and squalid, ominous and suffused with grace.

What one notices first about alleys in the Fan is that they're cobblestoned, an antiquated method of paving that grants them a quaint old European quality -- and when moonlit, an illusion of being studded with golden marshmallows (giving rise to thoughts of sweet-potato pudding -- or Oz). Next, if the season is right, one is likely to discover how sensuous, coquettish even, an alley can be, for these Fan

alleys are lined with fragrant honeysuckle, climbing roses, dogwood, lush magnolia, and showy va-va-vooms of violet wisteria: sufficient allure to distract the eye from rubbish cans and the nose from spots recently favored for baptism by urine.

Further, what makes the Fan alleys unusual if not unique are the little two-story carriage houses one passes every twenty yards or so along one's route. In the nineteenth and early twentieth centuries, gentry kept their buggies and horses on the ground floors of these adjunct buildings, while the upper floors were living quarters for servants. Nowadays, the ground floors typically garage bicycles and sports cars, while those above are rented out as studios for painters, sculptors, poets, and musicians.

The alleys become all the more interesting after nightfall, when they softly resonate with stray disembodied fragments of music (live or recorded), intellectual discourse, dog-bark, couple-squabble, and woo-pitch, not to mention the even less tangible secrets that seem to seep from the shadowed crannies, the walled gardens, and the back bedrooms of the decorous houses that face city streets with feigned nonchalance, as if oblivious of, or at least indifferent to, the eccentric little rivers of alley life -- incongruously cultured, intermittently raw, and potentially threatening -- that course stealthily behind them.

On many a hot, sticky summer night, when a restless Richmond felt like the interior of a napalmed watermelon, I'd leave work at midnight and walk the alleys of the Fan until dawn, half expecting Patricia's armed husband to leap out at me from every spooky nook. On my nights off (Tuesdays and Wednesdays), I'd hang out at Eton's, playing Ella Fitzgerald's recording of "But Not for Me" (my God, what an elegantly poignant tour de force!: it makes self-pity sound like a refined condition, makes the lovelorn feel like a noble tragic hero rather than a poor dejected sap), over and over on the jukebox until closing time (also midnight); then commence my cobblestone ramble, occasionally with fellow alley enthusiasts for company.

At some point in late 1959, Eton's abruptly fell out of favor (maybe

it had just become too fashionable) and the hip scene (except for the gay boys) moved almost en masse diagonally across Grace Street to the Village Inn, a funkier joint run by amiable Greeks who made fine submarine sandwiches and had never heard of Ella Fitzgerald. (The Village also had a jukebox, of course, but the record selection, lacking the advantages of superior gay taste, was less sophisticated, its amplification poor, and it quietly starved to death for lack of quarters.) My friend B.K. was now renting studio space atop a carriage house in the alley directly behind the Village, and it was in that studio that "the Baboon Family" gave its one and only, though locally legendary, performance.

It was on a Wednesday evening in 1961 that B.K., his diminutive powder keg of a girlfriend, Mary Lou Davis, and I were moping around in his studio, bored, broke, and feeling in sore need of alcoholic stimulation. It wasn't long before the solution became obvious. We stripped naked, painted our buttocks liberally with red acrylic, and climbed up in the carriage house's large wooden rafters -- after first having torn pages from B.K.'s sketchbook to make hasty flyers (*See the Baboon Family, 10 o'clock, Admission 25 Cents*), which we persuaded a passerby, a good-natured acquaintance, to distribute in the Village.

Word spread. By ten-fifteen a sizable crowd had climbed the outside stairs to gawk at the red-assed "baboons" who, gibbering, grunting, and scratching themselves, were cavorting among the exposed beams overhead. The problem next became how to get people to leave. It's tiring being a faux baboon.

After an almost excruciatingly long time, however, the novelty (I hesitate to say "excitement") wore off. Spectators, many muttering and shaking their heads, filtered back to their booths, bar stools, and beers; and B.K., Mary Lou, and I descended, finding more quarters in our admission jar than the Village jukebox swallowed in an average month. After washing off our bumptaratums and getting dressed, we were able to go buy a bottle of cheap champagne, which we sipped

in a celebratory mood, like actors toasting their success after opening night of a hit Broadway show.

Maybe it's not unusual that a struggling artist and an aspiring writer who'd yet to find his literary voice would paint their butts red and cavort nude in public, but why, you might wonder, would a nice young Southern girl participate in such a shameless display? Well, you would have had to have known Mary Lou Davis (aka the Human Wrecking Ball) -- and had you lived in the Fan District in the last half of the twentieth century, you very well might have known her.

Mary Lou looked harmless enough. She was petite, as I've said, and rather attractive (long brown hair, fiercely expressive eyes, slender waist, and one of those up/down, up/down seesaw rumps from the Marilyn Monroe Memorial Playground); although in middle age she came to physically resemble the nickname she earned by her propensity for breaking up marriages, friendships, bank accounts, and attempts at serious conversation. The real surprise, I suppose, is not that she would grow over time to look like a wrecking ball but that, after numerous suicide attempts, accidental overdoses, falls, catfights, screaming scenes, and brushes with the law, including six months behind bars (Mary Lou wasn't just a drama queen, she was a drama empress, a tumultuous Cleopatra barging down a Nile of trouble), she actually survived to reach middle age. She didn't live past it.

In any case, she was a reasonably cute young thing from a respectable family down in slow little peanut-flavored South Hill, Virginia, when she arrived in Richmond to enter nursing training at Stuart Circle Hospital. It didn't take her very long (it must have been some perverse kind of homing instinct) to discover the Fan District, however, and then it was good-bye bedpan hello bedlam. Late one afternoon not long after moving to the Fan, she strode into Eton's, placed her hands on her hips, looked around the crowded room and

asked, loud enough to be heard over the chatter and the jukebox, "Anybody here want to fuck?"

To appreciate the full impact of that brazen invitation, the reader must realize that in the fifties the so called f-bomb really did have an explosive quality, and it was never, ever detonated in public. I mean, there were elements in America still reeling from Clark Gable's having uttered "damn" at the conclusion of *Gone With the Wind*. Nowadays, "fuck" reverberates quadraphonically in every multiplex in every mall in the land, and supremely untalented comedians compensate for lack of wit by using the word at least four times per punch line, all of this thoroughly robbing the once-forbidden expression of its deliciously nasty sexual power. Prior to Mary Lou, I had never heard a female say "fuck," even in private, and I was twenty-six or twenty-seven at the time.

Well, for a long full minute, it was as if a paralyzing gas had enveloped Eton's. Nobody moved, nobody spoke. Then, the gay men commenced to titter, and the straight guys -- those unaccompanied by girlfriends or wives -- started to steal looks at one another in a peculiar, nervous, searching way as if to see who, if any, among them would answer or at least nod in the affirmative and make to accompany Mary Lou out the door. I'm unsure if anyone did. At least not immediately.

My own reaction was to fish some quarters from my pocket, go to the jukebox and play "But Not for Me" three or four times in a row. That, I suppose, was my answer to Mary Lou's shocking solicitation. She, definitely, was not for me. When I was working construction, one of the older workers (they were inclined to give me advice) imparted this bit of wisdom: "Your ideal woman, the one you'll wanna hold on to, is the one who's a perfect lady in your living room and an outright slut in your bedroom." Whatever the reader may think of this sagacity, of its political correctness, I must confess it resonated with me. In Asia, even the bargirls I hung with were demure when in public, and the contrast between their outward modesty and

the manner in which I knew they'd behave once the shoji screen slid closed and the futon unrolled, was a torch to the fuse of my libido. For some of us, I guess, primness with the veiled promise of wantonness is just about irresistible.

No, I never found Mary Lou the least bit sexually desirable, not even when she was stark naked (of course the fact that her rear end was brake-light red at the time and she was gibber-jabbering like an agitated ape possibly contributed to my chaste response); but as a friend -- and we did become quite friendly -- she could be as entertaining as she was challenging. After she broke up B.K.'s marriage (she was a dedicated home wrecker but, hey, every girl needs a hobby), the three of us would go to lengths to keep ourselves amused in fusty old Richmond, for there were nights when even the Fan District was steeped in ennui.

One of our routines developed after B.K. came into possession of some theatrical greasepaint, including professional-quality clown white. We'd make ourselves up to a level that would have passed inspection at the Ringling Brothers Clown College. Then, dressed in our everyday clothes, usually sweaters and jeans, we'd go downtown to the Trailways or Greyhound bus station, find seats in the waiting room -- sometimes together, three in a row, sometimes widely separated -- and sit there nonchalantly reading a magazine or newspaper. That is, we'd pretend to read while keeping an eye on people in the crowd (a lot of folks still traveled by bus at the end of the 1950s) to gauge their reaction, a response that varied from open delight to feigned indifference, though the most common reaction was bewilderment. And while I didn't share Mary Lou's devilish glee in fostering confusion, I must confess that I've long tended to regard the interruption of complacency as a kind of public service.

Ah, but then one night at Trailways when the three of us were sitting side by side faking interest in the pages of the *Times-Dispatch*

(the paper for which I worked five nights a week), we couldn't help but notice a tall, lean, cheaply dressed, youngish man (probably in his mid to late twenties) staring at us with shy curiosity. B.K. beckoned him closer and asked in his clownish singsong voice if the fellow would like to join the circus. The man's blue eyes widened, he chuckled and shook his head, less in dismissal than in disbelief. Whereupon Mary Lou, for whom lying came as naturally as breathing, said, "We're serious. Come along and join up with the circus."

He hesitated, as if trying to comprehend. Then he said, "Just a minute," and as he walked away, limping slightly, still shaking his head, I was thinking how much he looked like one of the poor migrant farm workers from *The Grapes of Wrath;* like a young Henry Fonda, beaten down yet somehow hopeful. He left the waiting room and went outside to the loading platform. A few minutes later, he returned accompanied by his young wife -- pretty in a washed-out, equally downtrodden way, barely filling out an obviously homemade cotton dress -- and two small, skinny children. They made straight for us, us with our zany Bozo faces, stopped, smiled tentatively, bashfully, and indicated they were prepared to follow us wherever we might lead them, as if a job with our nonexistent circus was the answer to their desperate prayers.

The three of us rose slowly, dropped our newspapers, mumbled something as incoherent as it was inadequate, and sheepishly made for the front exit. On the way back to the Fan, nobody spoke. I'd never seen B.K. so close to tears. Even Mary Lou, whose heart was so hard you could have drilled holes in it and used it for a bowling ball, was subdued. I tried to offer something philosophical, but the words stuck in my throat. It was as if we were in mourning, perhaps for our own sensitivity. At the studio we quietly scrubbed our faces clean with a force that came close to self-flagellation. And we never played bus station clowns again.

By 1960, Richmond's Village Inn was starting to earn a nationwide word-of-mouth reputation as one of the alcohol-vending establish ments (the Seven Seas in New Orleans, the Blue Moon in Seattle, the Cedar Tavern in New York, and Vesuvio in San Francisco were other examples) where gigless be-boppers, itinerant artists, nonacademic poets, freelance photographers, practicing existentialists, self-proclaimed revolutionaries, dharma drifters, "angel-headed hipsters," full-time eccentrics, and newly christened beatniks of varying plumage could expect to be tolerated by management and welcomed by regular patrons (many of them students with fake IDs), ever eager for fresh stories from the American road, an exchange of intellectual ideas; and maybe, just maybe, someone new and exciting to sleep with.

Richmond was hardly a destination city, however, nor was it strategically located along the great Kerouacian highway, the well-thumbed route between New York and Denver, Denver and San Francisco. Moreover, the Fan District was essentially a small island -- Fan(tasy) Island -- of cool in an ultraconventional right-wing ocean. And there was one other reason why the Village Inn was relegated to a relatively minor role in the spiritual/sexual/social transformation that commenced to sweep over the United States in the late middle of the century: namely, like all licensed venues in Virginia, it had to turn off the beer taps and evict its customers at midnight (hard liquor couldn't be served in a Virginia restaurant at any hour).

For the Village's youthful patrons, though, the Cinderella curfew did not necessarily mean the cessation of merriment, particularly not on Friday or Saturday nights. When the public gathering ended, the private fun began. The scene would simply move to a volunteer's apartment; or, occasionally, to the roof of a commercial building to which one of the revelers had semi-legal access. It generally worked out well, although there were a number of times when the police showed up uninvited, intent on keeping somebody's grandpa's idea of the peace. Oddly, police raids seemed always to occur at a party at

which Mary Lou was in attendance. There were cynics who actually suspected her of tipping off the cops, and I must admit she seemed strangely excited, even elated when news of some such raid would make the papers, particularly if she was mentioned by name. If there was anything Mary Lou loved more than chaos, it was attention.

Unlike the typical post-adolescent soirée, where making out or striving to make out was the primary objective, those Fan after-hours parties had a more creative focus in that they often revolved around a group activity I called "the Language Wheel" (a conceptual image I fished from the deepest well of Indo-European mythology) although nobody actually referred to it by that name or by any name at all.

With neither a leader nor a discernible signal, a number of people would at some point sit on the floor in a circle. Then, drumming on bottles or cans -- occasionally on an actual bongo -- while Paul Miller blew short trills on his flute, participants would take turns improvising lines of poetry. The painter William Fletcher Jones would usually start it off, intoning dramatically, slowly, solemnly, "The old man came over the hill with a sack of goodies on his back," a favorite line of his; then the person next to him might add, " . . . ever aware of the little plastic lobsters of sectarian constipation snapping at his heels." And so it would go, around and around the circle, line after line; some clever, some funny, a few genuinely poetic, most trite, and all too many resembling the babble escaping through the bars of a madhouse window on the night of a full moon; around and around until the "poets" ran out of beer or inspiration or consciousness, whichever came first.

(Sociologists should note that these high jinks occurred several years before marijuana, let alone psychedelics, became available in Richmond.)

It's just as well that I can't recall any of my own contributions to the Language Wheel, although I did participate despite my inconvenient hours of gainful employment. Between eleven-thirty and twelve

on a Saturday night, a friend would go to the telephone booth just inside the Village's entrance and ring up the newsroom at the *Times-Dispatch*. When he or she had me on the phone, I'd be informed of the location of that night's party, and usually I'd head directly to that address as soon as I got off work. Over time, those parties all have run together in my memory, but two do remain distinct.

One summer night, just as a Language Wheel was getting under way on a rooftop on Grace Street, a great Southern storm rolled in. Saw blades of lightning stabbed the heavens with the mania of a serial killer, followed by Wagnerian crashes of thunder. Those in the wheel exchanged cautious looks but nobody wanted to be the first to break the circle. Then the charcoal belly of the sky split open and from the gash there gushed torrents of rain. In a matter of seconds everyone was drenched, yet the circle refused to break, proving perhaps that poets, even inept amateur poets, are tougher than the athletes who play professional baseball.

Eventually, however, the improvised lines of free verse became essentially inaudible, sounding as if they were being delivered underwater. By irritated dolphins. When a mouth opened to speak a line, one could almost see bubbles escaping, and Paul's flute seemed to be imitating a faulty pump in a swimming pool. But I'm pleased to report that it wasn't until the storm had passed that we fools sloshed off to our respective flats, dorm rooms, and rented carriage houses in various parts of the Fan, leaving behind the beer cans and bottles on which we'd drummed our own silly little bohemian thunder.

Then there was the time someone called me at the paper earlier than usual to disclose that that night's party was already under way at a private residence in Windsor Farms, an ultra-tony suburban neighborhood in Richmond's upscale far West End. This wasn't entirely unprecedented. Occasionally a lawyer, surgeon, or corporate

executive -- someone who ought to know better -- would invite a few colorful crazies from the Village to one of their parties, thinking that their regular guests might find the infidels amusing. They usually came to regret the impulse, especially after their home was invaded by maybe twenty thirsty hipsters when they'd been expecting six or seven.

This particular party was on its last legs when I finally arrived at the house, a lovely white brick Tudor, a style much favored by Richmond's anglophilic elite. My friends, I was told, were all out on the patio. I thought I detected the sounds of a Language Wheel in progress there, but was in no rush to find out, being not merely sober but hungry enough to eat one of the gold-framed fox-hunting prints off of the living room wall. Into the deserted dining room I went, directed by raw instinct. Sure enough, a big bowl of creamy dip sat there on the dining room table, but, alas, the rest of the hors d'oeuvres had all been consumed. Not one cracker or chip remained, let alone a carrot stick or stalk of celery. Still, that dip looked mighty tasty. If only . . .

There was one other item on the table. Right in the center, a single medium-size chrysanthemum blossom of exceptional hue floated in a porcelain saucer. I recalled then that in Japan chrysanthemum flowers were not only eaten but considered a delicacy. I hesitated, but not for long. Snatching up the blossom, I plunged it in the dip and took a bite. Umm? Not bad. I repeated the process and was on my third chomp when I heard footsteps. The host was entering the room.

Instinctively, I hid the ragged remains of the blossom behind my back. The host gasped. "Where's my mum?" he demanded of no one in particular. Perhaps he was appealing to angels on high. I shook my head and as I did so he noticed the several petals now clinging to my dip-smeared lips.

That chrysanthemum, I was soon to learn, had won first prize in the annual prestigious Richmond Flower Show that very afternoon: it was a blue ribbon champion of which the man was inordinately

proud. The way he carried on, I might just as well have eaten his wife
and kids.

I left without saying good-bye.

Although it was at the opposite end of the social spectrum from the
Village Inn; at the opposite end, in fact, from just about any spectrum
one might suggest, there was in the Fan another dispenser of liquid
refreshment (or so it seemed) that sued for my attention. I dubbed the
place "Il Palazzo della Contessa di Pepsi," but it displayed no name
outside or in, and was overall so nondescript that there were times
when I doubted its existence.

It was the lone commercial establishment on a quiet, shady resi-
dential block a fair distance west of RPI and the Village, and thus
largely unknown to both students and bohemians. Its clientele? I'm
not certain who were its customers, if any, for while it appeared to be
in business, it was so marginally so that its identity as a "commercial
establishment" is subject to question. Occupying a storefront on the
ground floor of an old town house, long since converted to rental
apartments, there was, as I've indicated, neither signage nor any other
reference to the merchandise for sale therein.

The proprietor of the store, my "contessa," was an elderly woman,
though not so elderly, so frail, or so obviously batty that I might
blame dementia for the fact that she chose to sell nothing at all except
Pepsi-Cola. And the bottles of Pepsi, of which there were a great
number, weren't even refrigerated. This was not a place where on a
sultry Richmond day you could pop in for a cold pop. Yet cases and
six-packs of Pepsi, stacked high and frosted only with dust, lined the
walls on either side, while individual bottles (never a can) marked
time on shelves behind the equally dusty counter.

Adding to the intrigue were the shop's hours. The contessa (the
sobriquet was mildly sarcastic, for she was plain in dress and de-
meanor) elected -- for reasons I assume known to her alone -- to

open her doors from 10:17 to 11:53 in the morning, 2:36 to 4:41 in the afternoon. I may not have the numbers precisely correct, but you got the idea. The hours were odd. Very odd. And they were strict. You couldn't show up at, say, 4:42 P.M. and expect to gain admittance let alone a warm cola.

That I never asked the old lady to explain her strange hours or her singular choice of merchandise was due primarily to my reluctance to dispel the mystery. Einstein equated the mysterious with the beautiful, and while the nameless and dingy little Pepsi outlet did not exactly embody an exquisite equation addressing relativity or the secret origins of the universe, it did direct one's attention to both the mysterious, ambiguous nature of "time" and our heavy-handed and somewhat arbitrary efforts to force logical order upon it. If the shop's contents were monotonous, were static, its uneven, seemingly illogical hours of accessibility (which were subject to change without notice) had a way of mocking our notions of both harmony and permanence. The store seemed simultaneously fixed and boundless: it silently accentuated the conflict between measured time and the unaccountable infinite.

Okay, okay. Admittedly, I'd been reading the Surrealists that year and also had recently fallen rather madly in love with the avant-gardists of la belle époque, so it's probably not wholly exceptional that I would take satisfaction in the manner in which the dusty little Pepsi store seemed to quietly push back the frontiers of logical reality -- which may explain why, whenever I passed the place on foot or in a vehicle, the words that would come unbidden to mind were those of the poets laureate of the subconscious, the radical bards of the imaginative absolute. And why, for years thereafter, when friends asked why I always ordered a Pepsi instead of a Coke, I tended to smile nostalgically and quote André Breton: "I prefer red like the egg when it is green."

People rarely asked me twice.

love It & leave it

If charm were a bathtub, Richmond could have floated a hundred rubber duckies and still had room for half the Royal Navy. With its antebellum architecture, its broad boulevards (a noted European critic once wrote that Richmond's Monument Avenue was "the most beautiful street in America"); with its heroic statues, its blossoms, its birds, its boughs, its high-tea manners and grits-and-sorghum hospitality; with its cautiously frisky, intoxicating springs; and its horsey, gilt-edged falls, Richmond was a study in slowly barbecued, lightly salted grace. Ah, but a big front has a big back, and Richmond had a dark side wider and muddier than the James River that cuts through the city with a bourbon track.

Never mind the annual Tobacco Festival that marshaled lavish floats, dozens of marching bands, and a court of competing beauty queens to celebrate -- yes, celebrate! -- a smelly, highly addictive substance responsible for millions of deaths the world over. And never mind the Civil War Centennial, a fête that was to last precisely as long as the horrific conflict itself, and that would make no effort to conceal -- nor spare any expense to demonstrate -- Richmond's pride in having served as the capital of the Confederacy during the most shameful period of America's history. I'm inclined to set aside those commemorations, and the bloody war and the killer weed that inspired them, to focus on a livelier, more persistent skeleton clacking its bones in Richmond's charming closet.

There are historians who will point out that some good did result from the Civil War (abolition of slavery for example); and apologists

who laud with some justification tobacco's prominent role in the economic rise of our young nation. There can be no plea, however, on behalf of racism, no defense that isn't as evil as the attitudes and policies of racism itself. And here let me emphasize that I bring up the subject not to jab a stick in Richmond's once-blind eye, an orb that while still not 20/20 perhaps, can nowadays distinguish a fellow human being from an inferior subspecies and behave accordingly; but, rather, because Richmond's racism colors (if that's not a poor choice of verbs) the two wiggy but consequential stories I wish next to tell.

On my writing room wall there hangs a poster so faded and worn it might have once hung in the men's toilet at the Crazy Horse Saloon. It depicts a caricature of a horned beast and reads like this: *The Rhinoceros Coffee House Presents Tom Robbins / Poetry Reading & Lectures on Alley Culture / Set to Jazz (Paul Miller's Primitive Four) / 18 Jan. 1961 / 9:00 / 538 Harrison.* I'm unsure why that old poster has remained in my possession all these years when I've lost so many other doubtlessly more valuable souvenirs and mementos along the way. Yet here it hangs, and from it hangs a tale.

The Rhinoceros was opened a half block from the Village Inn by a couple of acquaintances cashing in -- though God knows it made precious little money -- on the beatnik coffeehouse fad that had begun a few years earlier in San Francisco. Well, you couldn't have a real beatnik coffeehouse without beatnik poets, and since Ferlinghetti and Ginsberg were permanently occupied elsewhere, I volunteered to substitute, hastily composing a sheaf of poetic rants specifically for the occasion. (As that editor at the *New Yorker* would attest, I would have had to be as mad as an outhouse rat to fancy myself a true poet.)

While in the course of my reading I confessed my love of the city, I also employed twenty-three shades of satire and twenty-four of hyperbole to box Richmond's pretty pink ears, box it for its To-

bacco Festival, its upcoming Civil War Centennial, its affected an-glophilia, and, most resoundingly, its racism. Amateurish though my poems surely were, my metaphors were inventive, my imagery out-landish and funny, and those in the small audience seemed receptive enough -- with one notable exception. In the middle of one of my rampaging verses, a young woman got up and stalked out, not un-obtrusively, mind you: she was in a huff and made certain everyone knew it.

I recognized the woman, I'd seen her in the Village a time or two, although we'd never met. She was difficult to ignore, frankly, being tall, blond, shapely, and as creamy as a hot vanilla sundae. Her name was Susan Bush (no relation to that nefarious gang down in Texas), and she resided not in the helter-skelter Fan but the formal West End, the daughter of one of those aristocratic old Virginia families that had lost its wealth but not its conceits. She worked for a broker-age firm and her friends (and presumably her lovers) were stockbro-kers, bankers, and lawyers; all very Episcopalian and unwilling to let you forget that their colonial ancestors had settled Jamestown and established grand plantations while yours were digging potatoes be-hind some thatched-roof hovel in the old country.

When she dropped into the Village, regulars believed Susan to be slumming, and to a certain extent that was true, but nobody much minded because she was affable, respectful, could hold her alcohol, and, as no male with sufficient testosterone to sprout a single whisker would have failed to notice, beautiful.

Nine months passed before I saw Susan again. It was an unsea-sonably warm day in October and I'd gone down to the financial district to argue with my landlords. In Richmond, it was rare to rent an apartment from an on-site owner, a tenant almost always had to go through a rental agency, usually part of a large real estate firm and not given to taking the tenant's side in any dispute. Whatever our disagreement, my meeting with the landlords had not gone in my favor that day. Overheated by both the dialogue and the weather, I

ducked into the closest grill and ordered a beer. I was standing at the bar trying to lower my temperature with a frosty Pabst Blue Ribbon when who should walk in, having just gotten off work nearby, but Susan Bush. I don't know if she recognized me at first, but within seconds, perhaps by chance, she was right next to me at the bar. We faced one another. She graced me with about 70 percent of a smile. And I proceeded to let her have it.

I mean I really lit into her. I told her that her dramatic exit from the Rhinoceros was not merely rude, not simply crass, but indicative of a level of insensitivity exceeded only by her shallowness and ignorance. I informed her that had she the intellectual wherewithal to distinguish shit from Shinola, she would have realized that I only criticized Richmond because the place was important to me. "Why would I have gone to all that trouble," I asked, "to illuminate Richmond's faults if I didn't love the city and desperately yearn for it to conduct itself in a more enlightened manner?"

Finally, having exhausted my allotment of bile, I stepped back and took a long slow draft of beer. Susan just stood there. She stood there silently, looking at me with considerable focus and intensity, staring as if she were trying to memorize and catalog every pore in the face of someone who had just called her a clueless philistine. Then, after at least a full minute, she revived her 70 percent yet somehow now more creamy smile, and asked softly, intently, without a squib of sarcasm or trace of tease, "Will you marry me?"

I may have been stunned, but I wasn't totally speechless. "Yes," I said.

And the next day, we drove to North Carolina, where there was no waiting period for a license, and were married there.

Lest the reader judge me madder than that outhouse rat's hallucinating aunt (the old garbage-dump rat who thinks she's Minnie Mouse), let me hasten to supply a bit of backstory.

For nearly a year, I'd been dating an RPI art student named Lynda Pleet. Lynda was smart, confident, a talented painter, and movie-star gorgeous. She also resided in a women's dormitory and she was Jewish, two conditions that conspired to keep us apart.

Her dorm imposed a strict 10 P.M. curfew on its residents. It was boosted to eleven on Fridays and Saturdays but that extra hour was irrelevant since I worked until midnight except on Tuesdays and Wednesdays, and Lynda had a studio class until 9 P.M. on Tuesdays. Essentially, we had a Wednesday kind of love. Sure, we could see one another on Saturday and Sunday mornings, but these were not exactly hours suited to romance; and it was as much the result of our conflicting schedules as the moral temper of the 1950s that physically our relationship hadn't progressed beyond heavy petting in the front seat of my recently purchased Plymouth Valiant.

Lynda's parents had thought I was cool -- until they learned we were serious about one another, at which point, not fancying a goy in their woodpile, they pressured her to start seeing nice Jewish boys. She eventually settled on one, and though she contended that he was but a beard, a decoy, a front, the guy -- having a more conventional schedule than my own -- was soon seeing more of her than I was.

Somehow Lynda had injured her knee, and during the period between the end of spring semester and the beginning of summer school, when RPI was closed for two weeks, she entered the Medical College of Virginia to have the leg surgically repaired. In those days, hospitals maintained very strict visiting hours, and since her family and/or her substitute boyfriend were always in her room during the allotted time for visitation, it sorely tested my ingenuity to find a way to see her there. As fortune would have it, however, a friend of B.K.'s was an intern at MCV, and we convinced him to loan me his white coat and stethoscope for a few hours.

Late that evening I drove to MCV, ducked into a lobby restroom, removed the coat from my shopping bag and put it on. It proved about two sizes too large, but *c'est la vie:* the mission was a go. I hung the

stethoscope around my neck and walked nonchalantly to the elevator. Several people were in the elevator but, luckily, they appeared to be mere staffers: maintenance men, dietitians, lab technicians, and the like. Nevertheless, I averted my eyes, staring at the floor as if contemplating an emergency colonoscopy I'd been summoned to perform.

I got off -- alone -- on the fourth floor and set out at a brisk pace for Lynda's private room, where we might anticipate some hours of quality time together in an intimate setting. And, hey, the fact that I was quite literally "playing doctor" served to invoke enough intriguing possibilities (*Grey's Anatomy* meets the *Kama Sutra*) to propel me ever faster down that long, empty corridor.

Just before I reached Lynda's door, alas, a nurse came around the corner: a uniformed, middle-aged, stern-faced nurse. Her comfortable white shoes practically screeched to a halt. Why was she blocking my passage? Why was she staring me up and down? Maybe it was the baggy coat, so ill-fitting it suggested a horse blanket draped over a poodle. Or maybe it was the fact that at twenty-eight going on twenty-nine, I still looked about nineteen.

In any case, I concluded that an imminent discussion of my medical credentials was likely not in my best interest. The entrance to a stairwell happened to be but a few yards to my left, and propelled now by panic, I dashed for it and ran down three flights, removing my coat as I fled, although the stethoscope was still swinging wildly from my neck like a mutant Nagasaki whip snake when I barged panting into the lobby. Miraculously, I managed to get out of the hospital before an alarm could sound.

I relate this story not to embarrass Lynda Pleet or whatever nice (and lucky) Jewish boy she may have wed in my stead, but rather to convey the state of my frustration -- the depth, breadth, and length of it -- on that fateful day when I ran into Susan Bush at the financial district watering hole. The fact that I answered in the affirmative when a virtual stranger, a woman to whom I'd never been introduced, proposed marriage to me is both an indication of the size of that

frustration and an illustration in action of two basic philosophical principles that came to guide my life.

(1) When a situation has become too frustrating, a quandary too persistently insolvable; when dealing with the issue is generating chronic discontent, infringing on freedom, and inhibiting growth, it may be time to quit beating one's head against the wall, reach for a big fat stick of metaphoric dynamite, light the fuse, and blast the whole unhappy business nine miles past oblivion.

(2) After making an extreme effort, after pulling out all the stops, one is still unable to score Tibetan peach pie, take it as a signal to relax, grin, pick up a fork, and go for a slice of the apple.

Anyway, when the smoke cleared, when the ash settled, when the pie plate was washed and put away, Lynda seemed as relieved as I that our personal production of *Romeo and Juliet* had closed its run, though she might have preferred a more conventional ending (minus, of course, the double suicide).

Returning to the matter of racism, I should confess that I have had little or no interest in race per se. My activities on behalf of civil rights were motivated less by a blanket admiration for darkly pigmented peoples than by an innate hatred of injustice. Whenever groups or individuals are subjected to hurtful unfairness, my stomach tends to roil and my blood to boil in reaction. Suffice to say there was a considerable amount of roiling and boiling going on in my corporeal being as I interacted with the South in general and Virginia in particular, 1957–1962, but it was a goofy integrationist accident rather than an overt act of protest that set into motion the events that made inevitable my departure from Richmond as the cannon boom of Civil War enactments echoed all around me.

In most respects, the *Times-Dispatch* was an excellent newspaper, which is to say its writing and editing adhered to the highest journalistic standards, and this despite the fact that the large dictionary

that sat atop a pedestal in the center of the newsroom, serving reporters and copy editors alike, was so out-of-date it defined uranium as "a worthless mineral." Editorially, the *T-D* was likewise antiquated in the sense that it reflected the long standing temperament and ideology of its statewide readership, an audience so conservative it considered Unitarians a satanic cult and the consumption of Russian dressing an act of treason. On its editorial page the *T-D* was an outspoken advocate of "separate but equal" rights, a gloss for "let the black bastards get their own damn buses"; while in its news columns no African American was ever mentioned by name unless he or she had committed an offense, and even then, no matter how sensational or newsworthy the crime, photographs of the colored perpetrator never seemed to make it into the paper.

On the *T-D*'s copy desk where I worked, my liberal sentiments were well known, earning me the cute nickname of "Nigger Lover." This epithet, however, was never vitriolic or hurled in disgust or anger. My coworkers, a sharp-witted, sharp-tongued, crusty crew of grammar guards, were just genuinely puzzled as to how an educated, clean-cut, Southern white boy (whose exploits in the Fan amused and titillated them) could have formed such heretical, unnatural opinions, and they chided me for my misguided views in an easygoing, jocular manner.

Their pet name might have been spoken with a drop more venom had they known that on Tuesday nights in 1961 I attended biracial meetings in the Unitarian church on Grove Avenue, and occasionally joined the group when, at some physical risk, it ventured into King William County to teach clandestine classes to African-American pupils. Rather than obey a federal order to integrate, King William had shut down all of its public schools, black and white. White kids were being tutored in "private schools" that met in church basements (Praise blue-eyed Jesus!), so our group was striving to provide a similar educational service at a black church out in the tick-infested sticks between the hamster-size hamlets of King William and Aylett. The

subject I volunteered to teach was geography, it having been of keen interest to me ever since I acquired that world atlas at age seven, but for which these black kids had no more regard than did their Caucasian counterparts, which was approximately the same regard in which they might hold a fat fly sunbathing on a horse turd.

At any rate, my newspaper colleagues knew nothing of my Tuesday subversion (Wednesdays were reserved for Lynda Pleet). I respected and enjoyed them despite their prejudices, and I liked the work, especially writing headlines, a word game of sorts that vaguely resembles playing Scrabble. One of my nightly duties on the copy desk was to edit the Earl Wilson syndicated celebrity gossip column. Wilson was based in New York and his column, *It Happened Last Night*, consisted of tidbits, meant to be provocative or revealing, about Broadway and Hollywood stars, especially those Wilson or his secret agents would observe misbehaving or celebrating some new deal at Manhattan nightclubs. Part of my job was to select a photo of a mentioned celebrity, which could be inserted into each column.

Well, one night Wilson happened to mention the great Louis Armstrong for one reason or another, and without a second thought I went into our "morgue," selected a suitable picture of Mr. Armstrong from the photo files, had our staff artist reduce it to the proper size, and stuck it in Wilson's column. I went to sleep that night as sweetly innocent as a newborn turtle.

I was still in my little shell when, reporting for work the next afternoon, I was summoned to the managing editor's office, an unexpected invitation I could not easily refuse. It turned out, on the surface at least, to be a cordial meeting. John H. Colburn held up the page of the paper on which Armstrong's beaming face appeared. He confided that there had been a lot of grumbling from readers about the picture. I expressed genuine surprise -- didn't *everybody*, except maybe the Grand Dragon of the Ku Klux Klan, love ol' Satchmo? -- and Mr. Colburn smiled and sent me back to the copy desk, apparently writing it off as an honest mistake.

On the copy desk I was regarded as the resident Asian expert, due to my interest in that region. There was major fighting in Laos at the time and the *T-D* had been giving it front-page coverage, but the editors were starting to have second thoughts about that level of attention, so I was assigned to telephone Richmond residents at random and ask the question "Do you know where Laos is?" Few did. My favorite response was, "He don't live here. Try across the street." The survey should have been both entertaining and disheartening to a geography buff, but all the while, in the cellar of my cerebellum, I was continuing to stew over the Louie Armstrong incident. A couple of weeks later, Earl Wilson mentioned a black woman -- I believe it was Pearl Bailey -- and I decided to test the waters.

It was on a Monday that I inserted the picture of Pearl into Wilson's column. Returning to work Thursday afternoon, I'd scarcely hung up my coat and loosened my tie before I was again summoned to the boss's office, where this time the atmosphere was about as jovial as dawn on death row. It seemed that the *T-D* switchboard had been lit up like the diamond counter at a Dubai convenience store. Irate callers were demanding to know what that "uppity nigger wench's" picture was doing in their morning newspaper, and Mr. Colburn had a fistful of letters posing the same burning question.

Some subscribers complained that upon seeing Pearl Bailey's picture they'd been unable to finish their breakfast, and despite being on the hot seat, I had to smile at the thought of outraged readers cursing the newspaper and shoving aside their uneaten flapjacks, only to glance up to see a big mammy in a do-rag checking them out from a box of Aunt Jemima's pancake mix.

While I wasn't threatened with immediate dismissal over my indiscretion -- after all, the *T-D* had no official directive prohibiting the publication of likenesses of "uppity nigger wenches" -- it was made pristinely clear that were I to repeat my recent errors in judgment, I'd find myself writing obituaries for a weekly rag in Ice Worm, Alaska.

Less than a month later, Earl Wilson had reason to refer to Sammy Davis Jr. Talk about uppity! Davis had recently had the audacity to marry a white woman, the sexy blond Swedish actress May Britt, an act that landed him number one with a bullet at the top of every racist's hate chart. I thought long, I thought hard. Little devils wrestled with little angels in the innermost chambers of my conscience. The devils cheated, of course, although where my conscience was concerned they were also more familiar with the terrain.

I got up from my seat at the copy desk, crossed the newsroom to the managing editor's office and gave two weeks' notice. "I've decided to do postgraduate work at the Far East Institute at the University of Washington," I said. This was a move I'd actually been contemplating ever since my impulsive marriage to the stranger, Susan Bush. Accepting my resignation, Mr. Colburn shook my hand and wished me success -- whereupon I returned to my post and proceeded to make certain that the ultra-uppity face of Sammy Davis Jr. appeared in every edition of the next morning's *Times-Dispatch*.

I laughed myself to sleep that night. And two weeks later, I packed up my instant wife, her two-and-a-half-year-old daughter, and our belongings, and drove to Seattle.

The day before I left Richmond (January 2, 1962), I dropped in at the Village Inn for a farewell beer, shaking hands with Stavros "Steve" Dikos, the burly, curly-haired, ever-kindly owner, thanking him for maintaining and overseeing so compassionately what many might regard as a kind of wildlife preserve. The wildlife itself took turns, some a trifle enviously, wishing me luck on the road. I even received a catlike nod from "Mona Lisa," a woman of a certain age who sat nightly at the counter chain-smoking, sipping industrial wine, and never speaking to anyone, just staring straight ahead with a faint, enigmatic smile, as if she and she alone knew when the Other Shoe would drop.

And speaking of enigmas, I'd earlier that day stopped by Il Palazzo della Contessa di Pepsi, wanting one last visit to prove to myself that the place existed outside of my imagination. Naturally, it was closed.

During my residency on this planet, I've had only one other encounter with an approach to retail merchandising quite as inexplicably single-minded as the Fan District Pepsi store. It occurred in Gibsonton, Florida, a small town southeast of Tampa that is winter quarters for approximately thirty traveling carnivals. Throughout the late 1980s and most of the nineties, I visited Gibsonton once or twice a year looking for canvas sideshow banners to add to my collection (good ones were hard to find since nowadays banners are made so cheaply they're usually in a state of ruin after only one season); hanging out in the Show Town Bar, whose walls were adorned with photos of freaks and performers (they've now been moved to a newly built carnival museum); and generally absorbing the town's peculiar ambience.

For a few years, the mayor of Gibsonton was the Human Torso, a woman born without arms or legs. To sign official documents, Mayor Torso grasped the pen between her teeth. Whether or not she was married to a giant as was rumored I couldn't say, though it was not unusual to see a man, or men, more than eight feet tall about town, and there were plenty of tiny people on the scene as well. However, Gibsonton's most famous resident, as even the most casual reader of supermarket tabloids may recall, was the Lobster Boy, the victim in a lurid murder case in 1992.

A rare congenital deformity had left the Lobster Boy with fingers and toes fused tightly together in a manner that resembled large claws. Depicted on banners as an actual, regular-size lobster with a human head, lolling on a seaside rock to the stunned amazement of bikini-clad bathing beauties, he was able -- in the days before political correctness roamed the earth -- to turn his misfortune into a fairly lucrative sideshow career. Walking with difficulty, he spent

much of his time offstage confined to a wheelchair. He was seated in that chair watching TV when he was shot in the head by an eighteen year old Gibsonton neighbor, hired for the job by Mrs. Lobster Boy, who in court (her trial ran concurrently with the O. J. Simpson trial and was far more interesting) offered a spousal abuse defense. She claimed that every time she squeezed past his chair (they lived in a trailer where space was tight), he would reach out and pinch her with his "claws."

Let's try not to picture the act of conception, but the Lobster Boy fathered four children, two of whom, a boy and a girl, inherited his deformity, becoming part of a living sideshow tableau, the Lobster Family. Another son, adopted and anatomically normal, is, to the best of my knowledge, still performing on midways, ballyhooed as the Human Blockhead. In his act, he hammers nails and shoves ice picks up his nose. I guess showbiz just gets in one's blood. In any case, the people who knew the Lobster Boy regarded him a cruelly mean alcoholic and few mourned his violent demise. Still, he was a major midway attraction for many years and I hope they at least thought to embalm him in melted butter.

Considering Gibsonton's oddities and wonders, it shouldn't be surprising that my wife Alexa and I were intrigued when on one of our visits there we came upon a crude handmade sign announcing a yard sale. We set out immediately for the address, and while we were to find no quaint or colorful carnival memorabilia, the yard sale did provide, in its quirky brand-name exclusivity, an experience reminiscent of Richmond's Pepsi-only store.

The "yard" proved to be a vacant lot adjoining a gas station. Upon it were three long banquet tables. The tables were separated by enough distance that there appeared to be no connection between them or to the lone individuals who stood behind each table. Actually, only two were standing, the third person was not built to be comfortable for long in an upright position. From a sturdy chair, she confided to Alexa that she had been billed as "the Ton of Fun" in a

carnival sideshow before an illness caused her to lose more than two hundred pounds. She was still about as big around as the average kitchen refrigerator, though no longer so fat that rubes would fork over cash money to ogle her blubber. The woman's table was piled high with Butterfinger candy bars. Only Butterfingers. Hundreds of them. Hundreds! In bulk. For sale. We had to wonder if she was liquidating her personal stash.

Another table was equally loaded down with new blue cotton work shirts, all from the same manufacturer, Girbaud. On the third table there was nothing but stacks and stacks and stacks of Metamucil.

And there, folks, you have your yard sale: a specific brand of work shirt, candy bar, and popular over-the-counter laxative, each in massive quantities. Readers of my novels can be forgiven if they think I'm making this up, but Alexa is my witness, and if I exaggerate may the Human Blockhead pound frozen Butterfingers up my nostrils.

roll over, rossini

The very first time I attended a concert by a symphony orchestra, it was in order to review the performance for a leading metropolitan daily newspaper. The first time I ever went to the opera, it was for the very same reason. And in both instances, my critiques were published, presented to the public as if they were the reasoned and insightful opinions of an experienced musical authority. I suppose I owe it to readers, especially any who unlike me are classically cultured enough to tell *spezzati* from spaghetti, to explain how this charade came about.

When you blow up a major life situation, as I did on two fronts before leaving Richmond, the explosion can leave a hole in your psyche. Nature abhors a vacuum, however, and over time the crater is almost certain to fill in with new wisdom -- or fresh folly. Sometimes it can be a challenge to tell the difference. For example, my metamorphosis into a critic, indeed my first thirty months in Seattle overall, was a mingle of transformative revelations and screwball circumstances.

Susan, little Kendall, and I had arrived in Seattle on a Friday afternoon following a cross-country drive that lacked only a team of sled dogs to successfully re-create a scene from *Nanook of the North*. From western Pennsylvania to eastern Montana, Old Man Winter had a stick up his butt, punishing animal, vegetable, and mineral alike (cars count as "mineral," don't they?) with lashing winds, deadly low temperatures, and a great suffocation of snow. Unaccustomed to driving on ice, I braked abruptly at the lone stoplight in Perham,

Minnesota, and went skidding into the rear of a farm truck. The truck shrugged it off and the damage to our Valiant was largely cosmetic, but the collision caused an air vent under our dashboard to stick open, permitting swirling snow, mile after mile, to blow up my pant leg. By the time we'd traversed North Dakota, the family jewels were so frozen they wouldn't have looked out of place on Michelangelo's marble statue of David.

Eastern Washington, while considerably more benign, was nevertheless chilly, its brown fields lightly dusted with snow, but once we crossed the Cascades and began our descent into Seattle, there'd been a dramatic shift, meteorologically and chromatically. It was like being gulped down the open throat of an emerald. A famous Italian journalist once began her interview with Muammar Gaddafi by asking the Libyan dictator if he had a favorite color, to which Gaddafi replied, "Green, green, green, green, green, green, green . . ." on and on, over and over, for nearly five minutes, she said, before she could get him to stop. The interviewer thought he was crazed but I think he was channeling Seattle.

Seattle, the mild green queen: wet and willing, cedar-scented, and crowned with slough grass, her toadstool scepter tilted toward Asia, her face turned ever upward in the rain; the sovereign who washes her hands more persistently than the most fastidious proctologist. These days, Seattle is not radically dissimilar to other large cities in California or back east, but in 1962 it was a magical metropolis, wrested from moss, mildew, and mud; animated more by chain saw and chi than by commerce and chutzpah; and although I would miss Richmond and miss aspects of it still, I was thrilled to the bone to have landed into this clam-chawed outpost where one might mix metaphors with impunity, bathed in oyster light beneath skies that resembled bad banana baby food. That darkening afternoon, watching Seattle's hills begin to sparkle as if mounds of damp silage were being set upon by a trillion amorous fireflies blinking Morse code haikus that no Virginia cockroach could appreciate or

understand, my heart informed my head that I had found my new home.

We'd traveled that northern route across the U.S., so fraught with wintry perils, neither out of innocence nor a craving for adventure but because I simply couldn't afford the extra fuel required to take a warmer, drier southern route. As it was, I'd arrived in Seattle with only a hundred dollars in my wallet, three bodies to feed and house, and no clear prospect for fattening the kitty.

Barely had we entered the city, however, when, driving along Boren Avenue, precise destination unknown, I glanced up a side street and spotted a "For Rent" sign on a 1930s-era brick building. I made a quick right turn, parked on the northwest corner of James and Minor, went inside and handed over eighty-five dollars for the first month's rent of a clean, roomy apartment. The landlord was Japanese American, which I took as a favorable -- even exciting -- omen, since, if truth be told, its connections and relative proximity to Japan were the reasons I'd sought out Seattle in the first place.

With the remaining fifteen bucks, I walked to a little corner market and stocked up on cheap, filling foods such as rice, beans, cereal, and a few decidedly non-Zen items like Dinty Moore beef stew. For a celebration, I splurged (it cost a whole ninety-nine cents) on a six-pack of beer. For several minutes, I studied the labels on Olympia and Rainier, debating which local brand to test-drive. Eventually, influenced by its label alone, I selected Olympia. It was the wrong choice. Everything else, however -- for days, weeks, and months -- was to go so miraculously well that events seemed choreographed by the gods.

The next morning, armed with a gracious letter of recommendation, believe it or not, from John H. Colburn of the *Times-Dispatch,* I found my way to the offices of the *Seattle Times.* Even though it was a Saturday, I chanced that there might be someone in the newsroom with sufficient authority to answer my inquiry about the possibility of a part-time job. I was received by none other than managing editor Henry McLeod, who, after studying the letter (it evidently made no

mention of Sammy Davis Jr.), informed me that an assistant features editor at the *Times* was about to depart for Europe on a six-month sabbatical and as yet no replacement had been hired. I started to work at the *Times* on Tuesday.

One of my assignments in the features department was to edit the daily advice column, *Dear Abby*. When its author, Abigail Van Buren, would visit a city whose paper carried *Dear Abby*, it was her habit to drop by that paper's newsroom to pay respects. At the *Seattle Times*, she specifically requested to meet the person responsible for the headlines on her columns therein, as they were, she said, most unlike the *Dear Abby* headlines in any other paper (and there were scores of them) that published her. I believe she used the adjective "colorful." Thus it was that I came to shake the hand of the woman who'd comforted more brokenhearted lovers than all of the booze in all of the gin joints this side of Casablanca. In our brief conversation, though, I neglected to ask Abby what I might do about my new wife, to whom I was experiencing greater difficulty adjusting than to my new city.

The features department was located next to the much smaller arts and entertainment department, and toward the end of my projected six-month stint at the *Times*, I had an unobstructed view of a parade of little blue-haired ladies in tennis shoes coming by to interview for the recently vacated art critic position. It was a freelance position, actually, the *Times* art critic was not on staff, and as I watched the dilettantes and Sunday watercolorists sashay in and out, I remember thinking that visual art in Seattle was about to be smothered with a perfumed hankie. The threat had nothing to do with gender, mind you (women such as Barbara Rose, Lucy R. Lippard, and Rosalind E. Krauss were already among the most illuminating modernist critics in the business), but, rather, that these would-be arbiters of taste gave off a vibe clearly indicating an approach that would be reactive rather than analytical; that when evaluating art they'd consistently favor the traditional over the unfamiliar, the pretty over the rigorous,

the decorative over the expressive, the fully clothed over the naked, the prudent over the bold.

At some point in the lamentation, it also occurred to me that once I started grad school -- I'd been accepted by the University of Washington -- I'd still need to augment the modest salary Susan was commanding from the brokerage firm where she'd just been hired. So, bending once again to impulse, and maybe even imagining myself a knight on a white donkey, I gathered a sampling of the art reviews I'd written for the *Proscript* at RPI, strolled into the office next door and plopped them down on the desk of arts and entertainment editor Louis R. Guzzo. "Why not me?" I asked.

Why not, indeed? A month or so later, after giving myself a crash course in Northwest art history (it helped a bit that we'd discussed painters Mark Tobey and Morris Graves in my aesthetic classes at RPI), I was being paid to look at paintings and sculptures, to think seriously about them, and propagate my opinions thereof, never mind that those opinions were only intermittently supported by deep knowledge or keen insight.

Soon there was another development. Lou Guzzo's right-hand man, the assistant arts and entertainment editor, left for greener pastures (though what besides Gaddafi's mania could be greener than Seattle?), and I was offered the job. I would be expected, in addition to my art beat, to attend and review those cultural events that were deemed not blue chip or mainstream enough to warrant Guzzo's attention; to cover, for example, the UW drama department, various hootenannies, traveling ice shows, pop music, and foreign films. How cool was that?! I set about convincing myself (foolishly, as it turned out) that I could handle the load and still become fluent in Japanese.

Naturally, I accepted the offer. To be a reviewer, even for B-list events, on just about any newspaper is a dream job, and I'd sometimes fantasized about it when reviewing student plays and musical theater at RPI. Now I'd fallen into it like a drunk hobo falling into a vat of champagne. In fact, so many things had fallen into place, one

after the other, in the nine months since I'd left Richmond that I
began to suspect that Satchmo, Sammy, and Pearl Bailey, never mind
the gods, were watching over me, moving the pieces.

And then . . . and then there was another unexpected development. (Was Pearl Bailey practicing voodoo?) My unsturdy shoulder
had been to the arts wheel a scant few weeks when Lou Guzzo was
hospitalized with a hemorrhaging ulcer. He'd come close to dying
(easy with those pins, Pearl!), and wouldn't return to work for nearly
two months, during which time I, a raw rookie, *was* the arts and
entertainment department of the *Seattle Times*, B-list *and* A-list,
the whole enchilada: talk about a baptism by fire! And that, patient
reader, is how Tommy Rotten came to publish authoritative critiques
of the first opera and the first symphony concert he'd ever in his life
attended.

For its mid-winter concert, my symphonic cherry popper, the Seattle
Symphony, had announced a Rossini program. It was a vaguely familiar name, Rossini, but I could no more have identified one of his
compositions -- What? Rossini wrote the *William Tell* Overture? I
would have sworn that was Tonto -- than I could have named the
stars in the Crab Nebula. Nothing to do but head to the downtown
branch of the public library and look him up. (Yes, the library: in
1962, "google" was the word for something obnoxious that clowns
did with their eyes.)

There was a picture of Gioachino Rossini in a music encyclopedia, and I was immediately struck by how closely the composer
resembled movie actor Robert Mitchum. They each, Rossini and
Mitchum, projected an air of dreamy menace, primarily due to their
heavy lids. "Bedroom eyes," some might describe them, although in
Mitchum's case it was rumored that he looked perpetually sleepy because he was perpetually stoned, an opinion advanced by Hollywood
gossipmongers after the actor was busted for smoking pot. There was

no mention in Rossini's biography of the composer having suffered a similar invasion of his privacy, but he was widely known as a "gour mand," a polite French word for someone with the chronic munchies, and it's easy to envision him raiding the pantry late at night in search of chocolate chip cookies. Moreover, Rossini had a reputation as a cynical wit and for hiding behind a mask of indifference, both characteristic of the film noir sensibility for which Mitchum was longtime poster boy. For composing the Stabat Mater, the ten-part work the Seattle Symphony performed that snowy evening, Rossini had received from his patron a gold, diamond-encrusted snuffbox (Really? "Snuff"?) and the music itself is as dark and expressionist as the best film noir, except for one quartet part that is strangely almost danceable.

Okay, I may have been reaching, but what else could I do? At the end of the concert I rushed back to the office and pecked out for the next day's paper my assigned review, but because the musical knowledge I'd suddenly acquired in my library research was hardly adequate to fill the allotted space, I padded the critique with a few comparisons of Rossini and Robert Mitchum, their personas and their work, on a variety of fronts, real and imagined. Mostly imagined. Then I waited.

I waited for the reaction -- but there was none. Not a single symphony buff threatened to cancel her subscription, and although Rossini's Stabat Mater was based on a Roman Catholic poem about Mary's grief for Jesus, not one irate Christian petitioned to have me crucified. Curious. Especially so because my art reviews, which were a tad more conventional and a lot more knowledgeable, were generating considerable feedback. At any rate I decided to take silence as an affirmation, and thus encouraged, in my virgin review of an opera (I've forgotten which one) a couple of weeks later, I hinted that the performance would have been more riveting, more relevant had the chorus worn black leather jackets, the soprano been a biker chick, and the basso profundo a Hells Angel on speed. Impressed by the

music but bored by the opera's stuffy, stilted ambience, I seem to re-
call expressing regret there hadn't been Harley-Davidsons onstage.

Doubtlessly influenced both by my recent purchase of a motor-
cycle and my abiding admiration for *The Threepenny Opera* (when I'd
seen the über-edgy show in New York in 1961, it had knocked my
socks off and fanned searing anti-establishment flames in my heart --
though, of course, by traditional standards the *Threepenny* is an opera
in name only), this review, like the Rossini, provoked not even the
mildest public rebuke. Mind you, I wasn't actively soliciting punish-
ment: I, a thin-skinned Cancerian, harbor not one masochistic cell in
my body. My critiques were unorthodox simply because when con-
fronted by my supreme ignorance of the subjects I was obliged to
evaluate, I had little choice but to play the one wild ace that was
always up my sleeve: my imagination.

My next symphony review, one in which I riffed on a piece by the
Brazilian Villa-Lobos, liberally sprinkling my article with phrases
such as "dense underbrush," "hot oozing rhythms," "predatory jungle
cries," and "sophisticated savagery," also failed to elicit reader fury:
nary a hot oozing letter or a predatory phone call. I did, however,
receive soon afterward an invitation to a private afternoon cocktail
party at the home of Milton Katims, the esteemed conductor of the
Seattle Symphony orchestra. What the . . . ?

The Katims occupied a large, low, modern ranch-style house in an
upscale neighborhood. I drove around the block two times before
parking and wouldn't have stopped at all had not Susan insisted.
My friends in Seattle were scruffy bohemians who frequented the
Blue Moon Tavern, but Susan, pining for her Virginia royalist mi-
lieu, could scarcely wait to rub shoulders once again with gentry, and
never mind that she knew even less about classical music than I.

From the moment I'd opened the invitation, I smelled a rat, al-
beit a rat with a dab of Chanel No. 5 behind its ears. Surely it was

a setup. Once Maestro Katims and his high-toned pals had me cornered in unfamiliar territory, a couple of cocktails under my belt, I'd be grilled, exposed, shamed, ridiculed, and diced into pieces small enough to fit on a canapé. Susan disagreed or didn't care. She pestered, cajoled, and finally -- as some women do so effectively -- loosened my resolve with the vaginal wrench.

A uniformed maid admitted us. The clink of glassware and chirp of lighthearted conversation reverberated off elegantly simple furnishings, mostly in beige and white. Near the center of the living room sat a grand piano the size of a gunboat. By the time I'd downed my second cocktail, I could picture it steaming into Havana's harbor, firing a barrage of Beethoven and Brahms at the Plaza de la Revolución. While Susan mingled, drinking too much and bragging dishonestly about her family back in Richmond, I adopted a nonchalant yet defiant stance on the starboard side of the piano, yet not so close to it that a guest might inquire if I might play.

Before long, the distinguished maestro himself came over, pumped my hand, smiling all the while, and confessed that he and other members of the symphonic and operatic circles had wished to meet the person responsible for those "uh, most unusual reviews" in the *Times*. I believe he used the adjective "colorful." Never in his career had Katims read anything quite like them, he confessed. It occurred to me then that the culturati were not so much angered or disgusted by me, not so much contemptuous as they were . . . well, *dumbfounded;* that they suspected, bless them, that perhaps I was less an ignoramus than some kind of loose cannon.

Great! I decided that it would be to my advantage to assume the role. The previous day, I'd heard on the radio that a woman in Issaquah, a suburb of Seattle, had been arrested for telling fortunes without a license, so when a member of the opera board asked my favorite opera, I avoided the trap by going on at some length about a libretto I was writing entitled *The Gypsy of Issaquah*, improvising a melodramatic plot on the spot. You must admit it had an operatic ring.

And when another doyenne inquired more innocently if I had a favorite cocktail, I answered, "Oh, definitely the gin greasy." She looked blank. "It's Beefeater and mayonnaise," I explained. After that, I was pretty much left alone.

The "gin greasy" was no joke. It's an actual drink. Or it was. Once. Briefly. It did attempt a comeback but, for better or worse, did not succeed.

One Wednesday night, after having dropped Lynda at her dorm just ahead of curfew, I was sitting in my Fan district apartment quietly listening to Billie Holiday or Chet Baker when a couple of friends came to the door, bearing a bottle of Beefeater. I welcomed them enthusiastically, then -- since none of us was attracted to drinking gin straight -- went in search of something to mix with it.

Upon peering in my refrigerator, Sherlock Holmes would have instantly surmised that (a) I was a bachelor, (b) was less than affluent, and (c) had very specific tastes. The contents of said appliance consisted almost exclusively of ingredients for the swift preparation of my favorite repast: the tomato sandwich. In addition to several tomatoes, a loaf of Wonder Bread, and three (yes, three) jars of Hellman's mayonnaise, there was in the refrigerator only peanut butter, cottage cheese, and the blueberry pancake syrup that I occasionally drizzled over my breakfast toast. Hmmm? After serious consultation, the three of us were forced to agree that as mixer for the Beefeater, fruit syrup was the logical choice. You yourself may have concurred.

Well, it was awful! Truly terrible. Please, take the advice of one who has gone where no man has gone before him: never pour your gin -- cheap or expensive -- into blueberry pancake syrup, not unless you're consumed with self-hatred, have had your taste buds surgically removed, or are a candidate for the title of Epicurean Jackass of the Month.

Okay, back to the drawing board. "How about," I ventured, only

half in jest, "the mayonnaise?" It made sense. After all there are few edible substances on this earth that mayonnaise cannot improve. I believed that then and I believe it now. My companions were understandably skeptical, yet no one moved to interfere when I loaded a heaping tablespoon of Hellman's into the blender, then added three jiggers of gin.

Once blended, the mixture resembled a young bride's failed attempt at béarnaise sauce: pale yellow, thin, and runny, like the contents of a zombie's chamber pot. I filled, in the absence of cocktail glasses, a trio of paper cups with the stuff. Collectively, we closed our eyes and sipped. Then, sipped again. It wasn't bad. Not bad at all. Even my friends, who lacked the wisdom to recognize that mayonnaise (invented by wanton nymphs who once frolicked in a grotto on the slopes of Mount Olympus) is the true and authentic food of the gods, even my pals had to concede that the gin greasy (as we'd dubbed it) was entirely drinkable -- although it may have only been in comparison to the blueberry-pancake-syrup martini. In any case, we finished off the entire bottle of Beefeater that way and felt the better for it.

Despite its favorable impression, twenty-five years were to slide by before another gin greasy glazed my palate, this time with a less favorable reception. One afternoon in the late 1980s, I was sitting with Curt Boozer in the bar at Cafe Sport, a restaurant in Seattle's Pike Place Market, when something prompted me to mention the curious cocktail. Curt, the son of pro basketball star Bob Boozer, hadn't exactly led a sheltered life, but he looked incredulous as I recounted my gin greasy adventure. When I persisted in extolling the concoction's virtues, however, he became not merely convinced but intrigued, eventually insisting that we consume one then and there.

The bartender was not receptive. He thought we were just being alcohol silly, and anyway, there was no mayonnaise at his station. De-

termined now, we appealed to our waitress. Coleen was a stand-up girl and she knew Curt and me fairly well, as we both dined at the Sport two or three times a week and were generous tippers. When she found a free moment, Coleen went to the kitchen, fetched a small bowl of mayonnaise, presented it to the bartender, who then, scowling all the while, mixed the drinks according to my instructions.

When Coleen brought the finished product to our booth, one glance told me these were not the storied gin greasies of my youth. This version was less yellow than green. Green, green, green, green: did the barman think us supporters of Muammar Gaddafi? It just wasn't right.

Curt was puzzled by my hesitation. He was starting to suspect I'd been pulling his leg all along. So, with my credibility on the line, I toasted him, and we each took a swallow. Then we made a face that would have fit right in on the facade of Notre-Dame. Come back, blueberry pancake syrup, all is forgiven!

It turned out that the only mayonnaise in Cafe Sport's kitchen was herbed mayonnaise. Herbed! Laced with tarragon and basil and God knows what other pungent weed. I can't say whether the nymphs on Mount Olympus would have been appalled, but it took a while for Curt to trust me again, for me to trust Cafe Sport, and as for another entry in the Gin Greasy Diaries, well, that seems to have been indefinitely postponed.

jiminy critic

When at age five I announced my intention to be a writer, I had not the skinniest notion that that job description might include writing art criticism. Yet here I was in my early thirties writing critiques instead of literature, which is to say, producing carob instead of chocolate -- or, worse, itch power instead of lubricant. On the other hand, because I'd yet to find my literary voice, my personal style, or my subject, functioning as a critic on a regular basis served to sharpen my wits, deepen my insight, and steel me to face looming deadlines without a twitch or a flinch. Moreover, I was consistently in close contact with creative minds.

Some of those minds, naturally, were more advanced, more original, more possessed than others, and I made it my mission to separate, to the best of my ability, tough minds from the weak, the driven from the lazy, the radiant from the dull. This had never been done in Seattle before, and there was considerable brush (no pun intended) in the so-called art world to clear away, a number of undeserved reputations to bolster or deflate; an approach, of course, that endeared me to some quarters, made me a pariah -- and a target -- in others.

Not surprisingly, I was attracted to the unconventional, and when I was moved by some radically inventive work, I was reckless enough to climb out on a limb and sing its praises, even when there was a posse down below shaking the tree. Never, however, was this a question of my taste being superior -- or inferior -- to that of others in the art community. To respond to art in a meaningful way, notions of "taste" must be set aside or tossed out the window. Taste becomes

legitimately operational only when expressing preference between works of relatively equal aesthetic weight. To prefer Matisse to Picasso, for example, can be a valid expression of taste, but to prefer Thomas Kinkade to Picasso isn't taste at all, it's aesthetic vulgarity. (Please feel free to shake my tree.)

When the assistant director of the Seattle Art Museum labeled me "a Hell's Angel," I took it as a compliment, thinking it was because of my two-fisted, impolite treatment of certain sacred cows and venerated charlatans, but it turned out that it was my practice of arriving at museum exhibitions aboard my black Jawa motorcycle that offended his effete sensibilities. The wife of the director of said museum did at one point attempt to take out a full-page ad in the *Times* to denounce me, but the paper, to its credit, refused to accept it, an act of loyalty that cost it a hunk of money.

To be embraced by some, despised by others, is usually the mark of an effective critic. I cannot pretend, however, that I excelled at my job. Oh, I could "stir up the animals," as H. L. Mencken liked to put it, but at deconstructing a painting from an informed, formalistic perspective, I was barely competent -- at least during my tenure at the *Times,* getting by primarily because I was good with words and didactic enough to provoke strong reader reaction. I worked very hard at getting better, however, studying, reading, looking, pondering, developing a larger vocabulary, and a wider frame of reference; and by 1966, when I was reviewing for *Seattle* magazine and occasionally, for national publications such as *Art in America,* and *Artforum,* even writing catalog essays for the Seattle Art Museum (now under a new, less antiquarian, regime), I'd become astute enough to sleep with a clear conscience.

Eventually, in 1967, at age thirty-five, it would be art criticism that would pry open the door and nudge me out permanently onto the shining yet slippery path of literary fiction. In the meantime, it was

to have an unexpected and ultimately benevolent impact on my marital situation. To wit: Susan and I spent the majority of our social life in the company of artists. Over time, she observed that even the best, most successful of these artists were, in private, ordinary flawed human beings; that they put on their jeans one leg at a time, as the saying goes. So Susan, her reason increasingly fuzzed by alcohol, decided -- and declared -- that she, too, was an artist. If so-and-so could do it, him with his foibles and problems, so could she. I have through the years witnessed more than one example of this particular delusion. Sure, the greatest geniuses pee and poop just like the rest of us, but that in no way suggests that we are even remotely their creative equal, except perhaps in the confines of the toilet.

Energized by her demons, the paintings Susan commenced to sporadically produce possessed a certain raw, primitive power. They were haunted much as she was haunted, but were totally devoid of the slightest trace of technique or discipline. She entered one of these sloppy monstrosities in a show I was jurying, entered not in the amateur category but the professional, and let me know that if her painting wasn't accepted for exhibition, I would suffer consequences.

Heck, I was already suffering consequences. Kendall, as well. Susan had become increasingly abusive, sometimes physically, to us both. But now I saw her sudden transmutation into a "professional artist" as a solution. Gradually, more slowly than I would have liked, I was able to convince her that if she were truly a painter, she would have a painting studio. Moreover, that she needed her own living space where she might be alone to commune with her muse, free from the distractions and domestic duties that shackle the bourgeois housewife.

Pearl Bailey must have been watching over me still, because I found a tiny, inexpensive, two-room house on a lot with some apple trees (an urban cabin, really) close enough to our Ballard District apartment so that Susan wouldn't feel that she was deserting Kendall (though ten or so years later, they were to become irreconcilably es-

tranged), and helped her move in. It wasn't long before she was living there full-time, drinking heavily and occasionally attacking a picture plane like some distaff van Gogh with 90 percent less talent and 50 percent more ear; while Kendall, now age four, and I reveled in our freedom.

I bought the little girl white sandals and frilly white dresses with sashes, and thus attired, she became quite a sight around town, perched on the back of my black motorcycle, as we roared off to art openings, concerts, and film premieres. We also accompanied friends on rain-forest camping trips and nature hikes, and today she remembers those days as the happiest of her childhood. Although Susan, with whom I never again cohabited once I managed to ease her out, refused to allow me to adopt the child (claiming in one drunken rant that I wasn't living "a realistic existence"), I'm proud to receive a Father's Day card from Kendall each and every year.

I recount that experience because some unhappy reader -- who knows, maybe even you? -- may at some point desperately require advice in developing an exit (or eviction) strategy, and alas, Abigail Van Buren is dead. Should the mate with whom you share living quarters become, as sometimes happens, intolerable, and you are all too aware that you can neither move out nor force him or her to decamp without precipitating hellish, gut-ripping, guilt-ridden, tear-splattered scenes, why not appeal to the party's unrealized (and doubtlessly unrealistic) creative urges? Praise their artistic potential, challenge them to follow their dream, assuring them that fame and fortune await if only they could acquire the necessary solitude, the private space in which their caged bird might take wing. Come on, it's worth a try. It worked for me.

white rabbits

Yep, I'd married a stranger, quit my job, moved three thousand miles from home, dropped out of graduate school, and stumbled into a career as an art critic; but those changes, which most of us would consider fairly significant, weren't a poot in a plastic poke compared to the permutation, the alchemical alteration, the reorientation I would undergo while sitting quietly in an armchair one July afternoon in 1964. I'm not exaggerating. In fact, the hyperbole does not exist that would do it justice.

It wasn't one but a succession of white rabbits popping up first here, then there, that would eventually lead me down the hole into Wonderland. The first of these oracular bunnies had caught my eye when one Saturday some artists invited me to accompany them up in the mountains on a chanterelle hunt. Chanterelle? Sounded like the stage name of a chanteuse in a Parisian nightclub. I was pretty sure no sexy French singer was lost in the Cascades, but what, then, was a chanterelle? A mushroom. It turned out to be a damn mushroom.

Down South where I hailed from, folks did not waste a perfectly fine autumn afternoon tramping over hill and dale looking for wild mushrooms. *Au contraire*. Whenever one of my people chanced upon a mushroom, they'd mutter "Toadstool" under their breath and kick the thing through the goalposts of oblivion as if it were one of Satan's fumbled footballs.

The mushroom is an object of mystery, blooming in thick fogs of superstition, its roots reaching into the deepest cellars of the human unconscious. On one level, it has a reputation as an aphrodisiac, both

its image and its many names in many languages soaked with erotic meaning. Throughout the world, the mushroom has been employed as a symbol for phallus, vagina, and the sex act itself. Conversely (or maybe not), it has been chosen since primitive times to represent evil and death. Standard equipment for poisoners, a necessary accessory for the well-appointed witch, dark is the hue of fungoid repute.

Culturally, racially, we tend to be either mycophobic or myco-philic: we adore mushrooms or detest them, there's scant middle ground. The most avid lovers of fungi are the Indo-Europeans, that vast body of peoples that stretches from China across the states of the former Soviet Union to the fringes of Central Europe. The French and Italians are myco-bigoted, limiting their fondness to a few fa-miliar varieties, falsely regarding all others as toxic or unfit; while Greeks, Celts, and Anglo-Saxons have traditionally placed mush-rooms in the category they reserve for spiders, bats, bohemians, and things that creep in the night.

I, being genetically Anglo-Saxon and bohemian by tempera-ment, found the prospect of hunting, picking, and eating wild mushrooms sketchy if not repulsive, yet also marginally fascinating in that it flickered with the allure of forbidden fruit. So, mildly hesi-tant, I agreed to join the search for Mademoiselle Chanterelle, never dreaming that I would, in the process, be glimpsing the first of those white rabbits destined to lead me through a gash in the fabric of consensual reality.

There are white and off-white mushrooms, but the chanterelle itself is not one of them; this baby is the color of egg yolks, ruffled like an Elizabethan collar, and shaped like a miniature trumpet. In the Douglas-fir forests of the lower Cascades they sprout in profuse patches, or they did before so much of our woodlands were leveled by timber barons. In the fall of 1962, the woods were less ravaged than today, however, and spread out, we moved among the towering firs as if through the chambers of an ancient temple, involuntarily respect-ful to the point of reverence; uncharacteristically hushed until one of

us would come upon a bristling horn section of chanterelles, silent as if waiting for some elfin conductor to raise his baton; whereupon the spotter would let go a half whoop and our party would set upon the saffron trumpets, baskets at the ready.

The sheer novelty, the mystique if you will, of picking wild mushrooms with culinary intent proved captivating to this Southern boy who, growing up, had been warned to never so much as touch a feral fungus. The genes in my old hunter-gatherer DNA were reignited. Even when our baskets were loaded, I didn't want to leave the woods. Driving downriver to La Conner whence we'd come, I felt like an aborigine being forced off his ancestral lands.

Ah, but the good times weren't over yet. In the old La Conner farmhouse where my friends lived, we washed the duff and fir needles off the chanterelles, dipped a quantity of them in a thin batter and fried them in butter. Another batch, once cleaned, were chopped, sautéed in butter seasoned with paprika, then simmered for a few minutes in sour cream and served over toast. Chanterelle meat proved thick and firm, and although a wee bit peppery, tasted rather like . . . you guessed it: chicken. I imagined a hen fattened on nettles and apricots.

These days, when chanterelles, morels, portobellos, and other undomesticated mushrooms may be found on the menus of a great many upscale restaurants; and in season, piled in the bins of better supermarkets, it may be hard to understand what a thrill, what an outlandish oddity was my personal introduction to mushrooming in a society still fraught with fungophobia. (Sir Arthur Conan Doyle spoke for most of the Anglo-Saxon population when he labeled mushrooms as "foul pustules" and a "filthy crop," a prejudice hardly weakened by the general who described the detonation of the first atomic bomb at Los Alamos in 1945 as having formed a "mushroom-shaped" cloud. Mom! Dad! Bud! Sis! Duck and cover! The mushroom is coming!) Ah, but I was hooked, becoming henceforth an avid mycophile.

La Conner, the picturesque fishing village and longtime artist

community where, eight years later, I would settle down (if that's not too wimpy a phrase), made an excellent home base for mushroom expeditions. From there, friends and I motored into the Cascades all that autumn in search of oyster mushrooms, king boletus, matsutake, and more chanterelles; invaded foothill pastures (sometimes just ahead of an irate farmer or an irate bull) to gather any one of several tasty agaricus species. Winter shut us down, but come late March we turned our attention to the morel, one of the most prized and savory of all wild mushrooms despite its uncanny resemblance to the withered gray penis of a thousand-year-old mummy. We searched, we picked, we cooked, we ate.

Spring mushrooms fancy summer no more than the fall varieties like winter, so by mid-May of 1964 I'd put away my basket temporarily and shifted my gastronomic focus to tamer fruit, knowing that in a couple of months my father would be shipping me tomatoes from his Virginia garden. It was about that time, however, that someone happened to mention an article in a recent *Life* magazine that went into some detail about a different sort of mushroom, a variety that illuminated not the palate but the mind.

Curious, I tracked down that issue of *Life*, opened it to the article in question, and *whoosh!* Up jumped another charismatic cottontail, this one smaller, quicker, more furtive yet somehow more portentous than its predecessors; and I sensed that were I to run after it (speaking metaphorically, of course), it would lead me to a hole, a burrow, a shaft, an underground portal that opened upon some secret cockeyed world that though hidden, lay not far -- not far at all -- from where I sat reading a popular mainstream magazine.

Life was mainstream all right: mainstream, popular, corporate, and slick. Yet there's reason to believe that *Life* has probably "turned on," if I may use that phrase in its street slang context, more individual Americans than *High Times*, the *Berkeley Barb*, and all other coun-

terculture periodicals combined. Had Ken Kesey opened Electric Kool-Aid stands on every college campus in the country, it would have made a lesser contribution than *Life* to the creation of that era of unprecedented foment we like to call "the sixties." The pages I read in *Life* that day definitely catapulted me onto psychedelica's helical trajectory and I've met a number of other (often influential) people for whom that same article was the starting point of a personal magical mystery tour, a bunny trail Frost scarcely could have imagined when he spoke of "the road less traveled."

The article detailed the experiences of one R. Gordon Wasson, a successful Wall Street financier whose passionate interest in mycology led him to the mountains above Oaxaca, where in the hut of a *bruja* he ate a sacramental serving of teonanácatl, the so-called sacred mushroom of indigenous Mexicans. Wasson described a cascading ecstasy that lasted for hours, as well as "wakeful dreaming," which is to say, though he was at all times fully conscious and intellectually astute, he entertained incredibly vivid visions of, among other things, radiant beings, luminous extradimensional landscapes, and melting castles encrusted with precious jewels. The *bruja* told Wasson that while white men talked *to* God, the Oaxacan Indians talked *with* God, back and forth, and that the mushroom was the conduit that made such a two-way conversation possible.

My reaction to Wasson's account was immediate and pronounced: I wanted to experience teonanácatl for myself and, by God, I wanted it sooner rather than later! But why?

That's a fair question. Why? It couldn't be categorized simply as thrill seeking. As a boy, I'd fantasized about a life of romantic adventure but that was unrealistic kid stuff; influenced by movies and books and, moreover, of a wholly external nature, vastly different from Wasson's internal expedition. I suppose there could have been an element of the romantic in my desire for the Mexican mushroom, an adult equivalent of stowing away on a smuggler's sloop or running away with the circus, although in retrospect I think it was something

more universally felt if less commonly expressed: a vague yet poignant desire to experience, up close and personal, the fundamental essence of reality, the "which of which there is no whicher," the ghost in the machine. I guess I wanted to break into that melting gemstone castle and see if there was somebody -- or some *thing* -- in there who actually knew which came first, the chicken or the egg.

Off and on, for several years, I'd been reading Zen, I'd flirted with Tantric Hinduism, I'd surfed the smaller swells of Sufism, and tried to get down with the Tao. It was all very eye-opening and inspirational, and while Asian mysticism is an easy target for the sneers of secular cynics and sectarian dogmatists alike, it's far more compatible with modern science than the misinterpreted Levantine myths, ecclesiastical fairy tales, pious platitudes, and near-desperate wishful thinking I'd been fed in Southern Baptist Sunday School. The wisdom in those spiritual texts was obvious, yet I'd integrated it into my daily life with but minimal success. From a practical point of view, it was like trying to teach a monkey to play chess.

I wasn't unhappy exactly. I had an interesting job, sufficient material comfort, and a congenitally comic sensibility: a lens of levity that not even a neurotic alcoholic wife could fog. Still, something was lacking. Mysticism was too abstract, too remote to warmly embrace; art too concrete, too accessible to resonate for very long in those areas of the brain beyond the optic nerve. In that nondescript period between the end of the beige fifties and the beginning of the Day-Glo sixties, I found myself drifting unfulfilled in an ocean of circumstance. Perhaps I was simply itching to move farther outside the realm of normal expectations, thereby insulating myself from the temptations of bourgeois compromise. Maybe I wanted bliss, wanted freedom, wanted deeper meaning, wanted to experience what Surrealist poets meant when they rhapsodized about the Absolute. Maybe I, too, wanted a tête-à-tête with a supreme being. Or maybe I was just terminally curious. Whatever it was I wanted or imagined I wanted, I intuited, thanks to *Life* magazine, that there was some

fungus down in ol' Mexico that could very well hold the key to the only treasure -- aside from love, of course -- that really mattered.

What did I do then but pick up the phone and call the botany department at the University of Washington. I asked to speak with Dr. D. F. Stuntz, the resident mycology expert (I'd seen his name in a field guide), and when I had him on the line I, after identifying myself, came right out and asked if he could help me obtain some hallucinogenic mushrooms. Talk about naïveté! Even in 1963 this was naive. Not particularly amused, Dr. Stuntz curtly suggested I talk to Dr. Varro Tyler in the UW pharmacology department. So I rang him up, too.

With a chuckle, Tyler informed me that while he knew of Wasson's exploits and was aware of mushrooms with similar psychotropic properties that grew here in the Pacific Northwest (Wow! No kidding?), this was not his area of interest. Before hanging up, however, Dr. Tyler gave me the name and number of an academic colleague, I'll call him Jim, who had conducted a bit of research in the psychotropic field.

So I rang up this fellow Jim, who proved to be not only a medical doctor with a PhD in pharmacology, he, as luck would have it, was also a Sunday painter and an avid follower of my art column in the *Times*. Jim suggested we meet for lunch. Later that week, over platters of pasta, we discussed art and philosophy for a couple of hours before getting down to the business of teonanácatl and its gringo cousins. When I inquired if he knew how I might acquire some, Jim smiled and said, "You don't want mushrooms."

"Oh, but I do. I really do."

"No," he said. "Mushrooms aren't trustworthy. The amount of psychoactive properties varies from season to season, locale to locale, even mushroom to mushroom. Two mushrooms growing side by side will often contain different amounts of the mind-affecting agent. It's impossible to gauge a proper dosage." He paused, registering my disappointment. "There's something much cleaner, safer, more reliable,

and equally effective. Actually, it's even more effective, if that's where you want to go." He paused again. My forkful of tiramisu froze in midair. "It's called," he said, "lysergic acid diethylamide-25."

I'd never heard of LSD, but the moment Jim spoke those words, a white rabbit the size of a TV preacher's Cadillac and as preposterous as a unicorn flashed by the restaurant window and vanished down a rain-swept street.

It should go without saying that I was eager to try this LSD stuff. Jim, however, was cautious. "Let's have lunch again in a week," he said, then maddeningly turned the conversation back to art. It turned out he wanted to get to know me better, wanted further assurance that I was psychologically stable enough to handle the drug. So, a week later we lunched again, and this time he went into deeper detail about the substance, describing the reactions of the several graduate students to whom he'd administered it in a laboratory setting. He was curious, I think, to see how a subject might respond in a more relaxed, sensually stimulating environment. In any case, by the time we'd finished dessert, Jim, convinced now of my relative sanity, agreed to guide me on a trip the following Tuesday, the day of the week on which I normally made the rounds of the art galleries and thus wasn't expected at the newspaper.

Jim kept a painting studio in a Wallingford District storefront, and it was there on a quiet street (mixed commercial and residential), that we met. It was 9 A.M. but I'd been awake since six, freighting a load of nervous anticipation. I should make it clear that I'd never smoked marijuana, never been "high" on anything. I'd been intoxicated, of course, but while to this day there are ignorant parties who equate being high with drunkenness, the two conditions are diametrically opposed, the one opening up consciousness the way fifteenth-century explorers opened up new worlds, the other shutting it down like a bankrupt pawnshop. At any rate, I showed up that morning at

Jim's studio with an empty stomach (it's best that way); dressed, as usual in those days, in faded blue jeans and a nice Italian dress shirt, or as one friend put it, "cowboy below the waist, banker above."

I took a seat in an old overstuffed chair. Jim handed me a cup of water and three small round blue pills (little bluebirds of happiness): three hundred micrograms of pure Sandoz lysergic acid, right off the plane from the manufacturer in Switzerland. Ceremoniously, for drama's sake, I swallowed them down and tried to make myself comfortable. In the next eight hours, I would get up from that armchair only once, and that walk to the toilet was like an only slightly condensed version of Homer's *Odyssey*. It would prove to be the most rewarding day of my life, the one day I would not trade for any other.

For the first thirty or forty minutes, nothing happened. *Nada.* Feeling no different than when I awoke that morning, I began to prepare myself for an anticlimax. LSD, this batch at least, was a dud! But then a slow, gentle wave of something like electrical current began washing over me. And . . . huh? What was this? The natural patterns on the unpainted pinewood wall had transformed themselves into an array, a procession, of tiny Mayan and Aztec figures, the kind one sees in any book on pre-Columbian culture, the kind that adorned pottery, stone pillars, and those manuscripts that managed to escape the bonfires of rampaging Spanish priests: brilliantly colored, oddly geometrical, adorned with quetzal plumes, carrying serpent staffs, daggers, and feathered fans, as if on their way to lunar rituals at Chichen Itza. (Which came first, the chichen or the itza?)

I stared transfixed as their numbers multiplied along the wall. Eventually, though, deciding I'd had enough of them, I closed my eyes. Behind my lids, the Mayan figures just kept on coming. Okay then. All right. This was it. Move over Alice, baby. I was down the rabbit hole at last.

acid reflux

It's important to note that those teeming pre-Columbian figures were as close as I would come that day to a hallucination, and even that vision really couldn't be considered hallucinatory because never for one second did I believe that it was real. Like R. Gordon Wasson's in Oaxaca, my rational mind was fully operative throughout the experience.

Yes, things got weird, but I was aware always that the weirdness was a product of the drug and would in time subside; not that I was in any great hurry to return to the "real" world. For that matter, in a state where Einstein's theorems were as concrete, as present and obvious as the chair I sat upon, temporal terms such as "hurry" had little meaning. At the end of what for Jim was a long day, I was convinced I'd only been sitting there for a couple of hours. I was on molecular time, cosmic time, not clock time. My system was in harmony with star systems, with the systems of orbiting particles in an indole ring.

It has occurred to me that the so-called hallucinations commonly associated with psychedelic ingestion are in fact diversionary tactics on the part of the ultraconservative human DNA, whose primary objective is always preservation of the species. (From the DNA perspective, every man is but an ambulatory seed package, every woman a walking egg carton.) When subjected to LSD, there is a portion of our brain that, failing to scare us into a "bad trip," will then roll out amazing fractal 3-D cartoons, hoping that by sufficiently entertaining us, it can divert us from the existential truths the fungoid alkaloids seem mysteriously designed to uncover. For

its narrow interests, our DNA puts on a show, hoping to head off a psychic jailbreak.

As for the nature of those truths, the revelations that scare the pants off of the fusty DNA, they may vary slightly from individual to individual, although in almost every instance they possess overtones that can best be described as oceanic, often suggesting some merging of spirituality and theoretical physics. I must confess, therefore, that I cannot fault the late Bill Hicks, who said that on LSD he perceived that "all matter is condensed energy, we are all one consciousness, there's no such thing as death, life is only a dream, and we're the imagination of ourselves."

Let's not be too quick to jeer Hicks's choice of words. The psychedelic experience is, I'm afraid, fundamentally resistant to ordinary verbal description, so much so that even a professional novelist can scarcely write about it without swathing his observations in the purple cloak of woo-woo. With that in mind, I shall now attempt to relate with as much reportorial objectivity as possible a taste of the highly subjective and "curiouser and curiouser" business that came my way that day in the storefront studio.

Jim had requested that I bring along my favorite record album, hoping, I assume, to gauge my reaction to familiar music under unfamiliar conditions. The record (vinyl LP, naturally) I selected was *Concert by the Sea,* by jazz pianist Erroll Garner. About midway through our session, Jim put it on the phonograph. I hated it. The tunes I'd previously so admired sounded clunky, harsh, and arbitrary to me now, and Garner's once-charming habit of grunting while he played was like noises funneled in from an overheated barnyard. If, however, the experiment was a crude failure on a sonic level, visually it led to one of the richest, most astounding experiences of my life.

Visually? Yes, because as the record played I could *see* the sound waves emanating from the speakers. It's well known that psychedelics enhance visual acuity, but even so I might admit that I was feeling the sonic vibrations rather than literally seeing them -- except for one sig-

nificant detail: there was a vase of fresh daisies on the coffee table in front of my chair, and I most unmistakably could see the daisy leaves swaying -- almost imperceptibly yet nonetheless gently swaying -- in those sound waves. That, however, was merely the preamble.

There was also a bowl of ripe plums on the coffee table, and earlier (it could have been thirty minutes earlier, three minutes, or three hours), I'd stared at a plum (for what could have been thirty minutes, three minutes, or three hours), discovering that the purple plum skin was in actuality a subtle chromatic interplay of red, blue, pink, magenta, maroon, sapphire, indigo, russet, rose, carmine, ultramarine, lapis lazuli, and even gold: my art-critic nomenclature called to the fore. Beneath its skin, I felt I could detect, having now the time/no-time for limitless concentration, the marvelously engineered intricacy of pulp, juice, and pit; could detect the interplay of acids, salts, and sugars as they coursed (never static) through the fruit flesh at speeds far too slow for a normal eye, even with instrumentation, to detect. For an undetermined while, I'd been awash in pure plumness. But now, led there by discernible jazz waves, my attention shifted to the daisies.

It's a fact that the crown of the common daisy forms a perfect logarithmic spiral. Mentally noting, perhaps, that both our DNA and our Milky Way galaxy are likewise spiral or helical in shape, I began to trace with my eyes the spiral arms of one daisy's crown, starting with the outermost arm; slowly, slowly moving along the curved plane toward the generation point, the end, the center. And here, I must warn you, is where the woo-woo kicks in with both fairy slippers. When my eyes reached the end/beginning of the spiral, reached the very most pinpoint center of the yellow crown, I abruptly went inside the daisy! That is, my consciousness entered the daisy. Obviously, my cowboy/banker body remained slouched in the armchair, but for an indeterminate number of seconds or even minutes, my entire conscious being was literally -- *literally* -- inside that flower.

I've seldom told this story, all too aware that even a friendly listener was likely to judge me either dishonest or nuts. Those I have

trusted to accept the account at face value have invariably asked, "What was it like in there? Inside a daisy?" My answer, "Like a cathedral made of mathematics and honey." Ambiguous, I know, but that's the best I can do. I cautioned you, remember, that the psychedelic experience does not readily lend itself to verbal communication. It was voluminous in there, a kind of parallel universe flooded with sweet golden light enlivened by vaporous progressions of abstract symbols that seemed to assign numerical value to the various magnitudes, tones, and patterns of chi, the energy that courses through all living things. See what I mean? A cathedral made of mathematics and honey seems to best sum it up.

At any rate, a physical description is not what really matters here. The important thing is the knowledge I took away from the event, namely the realization that every daisy that exists -- every single daisy in every single field -- has an identity just as strong as my own! I assure you a revelation such as that cannot help but change one's life. It altered my view of the natural world and my place within it, top to bottom, and for weeks thereafter I could not see a daisy in a window box or someone's yard without getting tears in my eyes. The reader is free, of course, to ridicule, scoff, or try to explain it away, but that's my story and I'm sticking to it. As the old coots down in Appalachia used to say, "You can burn me for a fool but you won't get no ashes."

Growing up, I was freaked out by eternity. Early on, my good Baptist mother had briefed me on heaven, emphasizing how those good enough to land there would be there forever, that their lives in heaven would never come to an end. Never? Not ever, not even after a thousand billion years? I couldn't wrap my mind around it. The prospect of extreme longevity was attractive, but the notion that eternity had no stopping point -- that it never ever, ever, ever, *ever* ended! -- struck me somehow as horrific. I used to lie awake at night fretting about

it. And for naughty Tommy Rotten, the information that time was equally interminable in hell was hardly any comfort.

Under the influence of LSD that sunny July day, I finally lost my terror of the eternal. In a state during which time for me flowed either in more than one direction or not at all, I was hit by the realization that in eternity there *is* no time: it isn't a matter of perpetual duration, time simply does not exist there, it was never there in the first place (so, naturally, concepts such as "never," and "first," and past-tense verbs like "was," make no sense in the context of eternity, where it is always the present). Zen places great emphasis on living in the present moment. On acid, it was demonstrated to me that the present moment and eternity are one and the same, whether or not there is any such place as heaven. This all sounds quite sophomoric when I write it down, but that doesn't negate the fact that LSD served to relieve me of a lifelong secret sense of dread.

Carl Oglesby, the former Berkeley political activist, has said that "Acid is such an immediate, powerful, and explicit transformation that it draws a line right across your life: before LSD and after LSD." He is doubtlessly correct, although in my case, neither transformation nor that line of separation would have been evident to an outside observer, at least for a few years.

When I walked out of Jim's studio that afternoon, feeling finally "born again" -- a sensation that had so disappointingly eluded me upon my baptism in the Rappahannock River twenty years earlier -- I remember thinking that if President Kennedy and Nikita Khrushchev were to sit down and take LSD together, the Cold War would end overnight. So many others were to have a similar reaction to LSD that we may conclude that it was acid that fueled the massive antiwar movement a bit later in the decade. In mid-1964, however, the peace movement was still only a throb in some old Quaker's pulse, and I'd been a confirmed pacifist for years before encountering white rabbits and little blue pills.

Outwardly, my life appeared unchanged, I wrote my reviews,

cared for Kendall, dressed in the same style and ate the same foods, although I developed a sudden distaste for alcoholic beverages which struck me now as crude, even barbaric; an insult to the senses and the mind, a toxin that inflated the ego and elongated its tentacles, whereas LSD produced the opposite, ecstatically liberating effect. I also found that reading had become unsatisfying, for no words, however artful, on any printed page seemed to do justice to what I now regarded as the "real" real world.

If editors at the *Times* detected any post-acid changes in me -- the fascinated way I looked now at patterns and colors, for example, as if seeing them with freshly minted eyes -- they didn't let on; and as for Susan, she was too busy drinking to notice that I was not. Anyway, I only saw Susan when she dropped by to check on Kendall or get laid. (There are limits to abstinence.) At one point, I ordered a box of peyote buttons from the Smith Cactus Ranch in Arizona (it was perfectly legal then), thinking that if Susan and I took a mind trip together, the insights afforded might curb her boozing, help her understand me, even repair our marriage.

After drying the green cacti buttons for a fortnight over a space heater, I ground them up, filled horse capsules with the powder, and with as much pseudo-Navajo ritual as I could stomach, swallowed five capsules, forcing five more each on Susan and John, a friend from the Blue Moon who'd showed up unexpectedly. The peyote proved even harder to stomach than my improvised Navajo mumbo jumbo, but once the cramps and nausea subsided, I commenced to ride a muddy surge of organic visions: dense, earthy, primitive, and chthonian as opposed to the exquisite Escher-like morphology of LSD. I felt simultaneously sick and elated. Susan and John, on the other hand, were sick, uncomfortable, and bored, and after a couple hours of this, they repaired to a neighborhood tavern to drink beer, John, too, being a faithful fan of fermentation.

At one point later in the evening, the Coyote-directed mind movies having mostly tapered off, I decided to walk to the tavern

and check on Susan and John. I'd been concerned that their behavior, modified by the peyote, might have gotten them in some sort of trouble. It was a Saturday night, the tavern jam-packed, every booth, every bar stool occupied. When I walked in the door, all conversation in the place abruptly ceased and every eye turned on me. Mind you, there was nothing the least bit unusual about my clothes or haircut, I had no facial hair and wasn't wearing shades, yet everybody was gaping at me as if I were an alien dropped in from Outer Mongolia. Or Venus.

When I reached the table where Susan and John had spent most of the evening, as if peyote were naught but an annoying gastric upset that could be relieved with beer, they regarded me with alarm. "You better get out of here," they stage-whispered in unison. I was baffled. "There's light shooting out of your eyes," confided Susan. And John added, "Man, you look like you're fuckin' on fire!"

I took the hint, retreating from the place with as little fanfare as a man on fire could manage. When I checked myself out in the bathroom mirror upon rushing home, however, I detected no sign of flame or smoke. Writing the experience off to some weird mischief perpetrated by Mescalito, the Native American peyote spirit (from whom we get the pharmaceutical term "mescaline"), I went to bed and dreamed vividly of arroyos, Hopi tricksters, and jade-headed sidewinders. I'd pretty much squeegeed the whole episode from my memory when, about three months later, perfectly straight, I encountered Mescalito in person -- in the form of a redheaded wino.

the redheaded wino

Happily, I did not turn out to be one of those people who allowed psychedelics to become the center of their universe, although I certainly could understand and even sympathize with their obsession. In the year following my day down the infinite rabbit hole, the excursion was seldom far from my mind. The reflections were entirely positive, the musings burnished with optimism, yet that year was the most lost and lonely period of my entire life. I was at sea, tossed about almost incessantly between intimacy and isolation.

I say "intimacy" because, operating on daisy consciousness, as it were, I felt connected to the natural world and its myriad manifestations in the most personal, caring, comprehending, and bedazzled way. On the other hand, there was nobody to whom I might explain, let alone with whom I could share, such feelings. Oh sure, the Pacific Northwest was crawling with nature lovers, but they didn't make the connections between the neurons in their brains and the photosynthesis in their gardens; they climbed rocks but never heard geology humming (humming Earth's sidereal earth song), it rarely occurred to them that perhaps we really *are* just some butterfly's dream. They genuinely appreciated the perceived world yet remained oblivious to the worlds within worlds within worlds . . . ad infinitum.

The problem was that I didn't know a single other soul who'd taken LSD. For propriety reasons, Jim hadn't introduced me to any of his lab rats, and at that time the public -- in Seattle, even the hip public -- was securely unacquainted with the awe-inspiring, life-changing alkaloid synthesized from a fungus that grows on barley

and wheat. To be sure, *Life* magazine (who else?!) had recently run a lengthy article about LSD (maybe unwittingly, maybe not, *Life*'s publisher Henry R. Luce was America's first Pied Piper of psychedelica), but acid trips were not a subject of discussion at the Blue Moon or anywhere else in town. Lacking confederates, I felt I'd become a minority of one; a nation, a race unto myself.

Thus isolated, I commenced to entertain thoughts of emigration. Secretly, I pined to go in search of my new kin, to mingle somewhere with others similarly mutated. I could sense that they were out there (was I channeling Leary and Alpert?), I just didn't know where to find them. This reclusion wasn't all bad, actually. While my acidified self lacked positive reinforcement, it also was not subjected to the enormous negativity that LSD would generate in years to come; the overwhelming hostility, most of it ill-informed if not outright mendacious, from quarters both official and haphazard; from everyone in fact who maintains a vested interest in a suspect status quo.

I'd prefer to deal with this subject more matter-of-factly, as did Apple's legendary Steve Jobs when he told his biographer, "Taking LSD was one of the two or three most important things I've done in my life." The most successful, innovative, influential entrepreneur and businessman of modern times went on to credit LSD with helping to shape his sense of integrated systems and product design, and let it go at that. My mission here, however, has been to try to describe as accurately as possible the state I was in when my path crossed that of the Redheaded Wino.

It was a Friday, payday at the *Seattle Times*. The *Times* was located at Fairview and John, the same address it occupied until quite recently. After collecting my paycheck at the personnel window, I hoofed a few blocks up Fairview to the nearest bank. Once I'd exchanged check for cash, I headed right back to the newspaper, where my daily duties included a midmorning trip to the composing room to oversee

the makeover of the entertainment pages for the second edition. It was nearly eleven, deadline for the makeover (the *Times was an after noon paper*), and I was practically sprinting down Fairview, both the tail of my tweedy sports coat and my carefully knotted tie flapping crazily in the slipstream, my facial expression doubtlessly a stern mixture of fretfulness and determination. That's when I became aware of a slowly approaching figure, a man who looked out of place in that quiet, sparsely populated neighborhood.

Despite the mild weather, the guy was buttoned up in a heavy, olive-drab overcoat, the kind assigned to soldiers in the First World War, and although he was tall, the old army-surplus coat was so long on him its hem kissed the pavement. His high-top shoes were battered, as was his face, a countenance wreathed with unkempt red hair and peppered with a heavy red stubble. His was not a cultivated beard, it just appeared he hadn't shaved in four or five days. Everything about him, in fact, suggested a man -- a derelict, a wino -- who'd been on a bender, although if he were hungover it hadn't darkened his mood, for he was cheerfully singing, singing out loud.

He wasn't busking, mind you, not performing, just unselfconsciously caroling an unrecognizable tune as he shambled up the street. When we got within about ten paces of one another, he broke off his song. He stopped in his tracks. I could tell he was fixed on me, had been for nearly a block, and I was sure he was about to hit me up for some of my payday cash. Instead, as I passed, he looked me over head to toe with bloodshot but piercing eyes and laughed out loud. Laughed right in my face. It was a mocking laugh, imperious even; spiked with the cheap gin of cruelty, but diluted with a splash of amusement, garnished with a sprig of pity; and he soaked me with it, as if he'd emptied a rotgut punch bowl over my head.

He was looking through me like I was a plate-glass window, reading me like a Las Vegas billboard. His gawk was virtually audible. "You think you're a special case," it seemed to say. "You think you're liberated, enlightened, evolved or something, but just look at

you: young man in a hurry, busting his nuts to please a corporate boss; ambitious and uptight, one more teeny replaceable cog in the money machine, dressed like a high school civics teacher, frowning like you lost your smile in a card game you know was rigged from the start. Get your pathetic ass on down the street, you're spraying worry and discontent the way a skunk sprays stink."

Thus spake the Redheaded Wino.

I did keep walking. What else could I do? Just before I reached the *Times*, I pivoted to see if he might be following. And he wasn't there! Probably he'd only turned the corner, but I had the impression that he'd vanished in a puff of smoke. In fact, to this day I sometimes wonder if he'd ever been there at all, if he hadn't been an apparition, a manifestation of Mescalito projected by some cactus-juiced, acid-etched circuit in the recesses of my cerebellum; the one area, perhaps, where neither conscience nor delusion has a place to hide.

In any event, I went home later that afternoon and brooded. All weekend, I brooded and stewed, tossing in a clothes dryer of self-examination. The *Seattle Times* was no sweatshop, no earth-raping multinational combine, no soulless bank. It was in truth a fine place to work, a public service staffed with intelligent reporters, witty columnists, and responsible editors who went out of their way to be fair to readers and subordinates alike. Still . . . still, that carrot-topped wraith, real or imagined, had hit me where it hurt; had with one sulfuric laugh shattered my mask and spoiled my act as a regular guy.

Monday morning I called in well. Three weeks later, I moved to New York. I should have gone to San Francisco.

Romancing the language wheel

I should have gone to San Francisco. If my objective had been to connect with like-minded people, to fraternize, perhaps on a regular basis, with other travelers home from the rabbit hole, moving to New York was a mistake.

Granted, there were individuals in Manhattan who'd taken or were taking psychedelics, but few in number, they flew well below the radar; and even though I lived just up the street from the iconic Peace Eye Bookstore, where I mingled with luminaries of the Beat Generation and befriended Allen Ginsberg, I never established contact with my presumed kin; whereas in San Francisco in late 1964 there was an infestation of white rabbits and they were multiplying like . . . well, like rabbits. A radical new music (a mixture of surfer rock, Southern blues, Berlin music hall, and Indian raga), with far-out lyrics was spilling into the streets around Haight and Ashbury, the city's younger citizens were dressing as if every day was Mardi Gras, and *Chronicle* columnist Herb Caen would soon be coining the term "hippie." An incandescent acid rain was sprinkling San Francisco, but Tommy Rotten, oblivious, had fled the thin gray rains of Seattle for the dirty snows of New York. He hadn't heard the California weather report.

As I look back now, I see that my ignorance had been a stroke of luck. In San Francisco I could have been sucked into the developing psychedelic scene (a *scene*, man); could have been caught up in the looming politics of ecstasy, another sixties comet chasing its

own bright tail. Aside from my conviction that for maximum benefit, the forbidden fruits of LSD are best savored in solitude, the psychedelic experience, as I said, was emphatically nonverbal, and after more than a year during which I was as suspicious of verbiage as of a bigmouthed car salesman with dyed blond hair and three ex-wives, I was, secluded in my New York tenement, beginning slowly to fall in love again with wood pulp and ink. I don't think they were reading all that much in the Haight.

At age five I'd hitched my little red wagon to the Language Wheel, that disk of verbiage that came rolling out of the grunting and growling mud of prehistory, accumulating variations and refinements beyond number as it rolled headlong into literacy, and -- when greased with imagination -- into poetry, into theater, ballads, sutras, and rants. LSD's preliterate/postliterate juggernaut had run me off the road. I'd believed myself stranded there, but now Hermann Hesse had driven up in a vintage Mercedes tow truck, its radio blaring Mozart, and winched my wagon out of the ditch, demonstrating in *Steppenwolf* that modern narrative fiction indeed *could* transcend bourgeois preoccupations, and with both an enlightening and an entertaining panache, as playful as it is deadly serious, bind spirit to matter and insinuate for readers those hidden worlds within our world. *Das ist gut.*

I checked my load. The cargo appeared intact. Transformation, liberation, and celebration; exotica and erotica; novelty, beauty, mischief, and mirth: the goods I'd been hauling around for damn near three decades, all present and accounted for. If anything, psychedelics had cleaned them up a bit, given them a shine. This was encouraging, but having yet to find a literary voice of my own, and not wishing to imitate Hesse (or, for that matter, anybody else), I was to bide my time for nearly three more years before I trusted the muse enough to start my first novel.

In the meantime, however, like a lapsed believer returning to the

fold, I commenced to reaffirm my devotion to language, that magical honeycomb of words into which human reality is forever dissolving and from which it continually reemerges, having invented itself anew. The adjective in the lotus. The jewel in the inkwell. A blue dolphin leaping from a sink of dirty dishes.

manhattan transfer

Whether the Protestant ethic, so called, is a self-imposed affliction, a hobble, a governor, a kind of chastity belt that limits full enjoyment of life; or, instead, is an indicator of trustworthy character, fidelity, and good moral health, well, that may be a subject for debate. In any case, I myself seem to have been tainted -- or blessed -- with that set of values at an early age and to this day have failed to completely outgrow that aspect of it that applies to conscientious work habits. Thus, though I'd landed in New York with enough savings to keep me gainfully unemployed for approximately a year (considering that my rent on East Tenth Street was $51.50 a month and I knew how to eat for a buck or two a day), my ethic demanded that I put my nose to the grindstone, although, naturally, not just any grindstone would do.

The task I set for myself to justify a Manhattan sabbatical was to write a book, specifically (having not yet found my fiction voice) a dual biography of two power-packed maverick painters, Jackson Pollock and Chaim Soutine, comparing their lives and their art. Although no critic had ever made the comparison (and still have not as far as I know), the connection struck me as obvious. Soutine (1893–1943) was a scrawny slum-dog savant from Eastern Europe, Pollock (1912–1956) a brawny cowboyish genius out of Cody, Wyoming, and the two never met; Soutine's paintings featured representational content, Pollock's major works were wholly abstract; yet there were striking similarities in their approach to life and art, and I maintain that Soutine, whose paintings we know Pollock saw at a New York

gallery in 1936 and '37, was the American dripmaster's single biggest influence.

Soutine was arguably the first representational painter to completely reject Renaissance perspective in favor of an overall emphasis that, devoid of a recessed background or central focal point, made each and every square inch of the picture plane as important as any other. Emphasis was uniformly insistent from framing edge to framing edge, as it was soon to be in a Pollock, though Soutine's dense, dark passages of pigment lurched at the viewer in a kind of visual attack, whereas Pollock's roiling constellations swirled all about an onlooker like debris in a polychrome tornado.

Almost supernaturally connected to their primal unconscious, operating at a pitch next to madness, both men lived turbulent, Dionysian lives rife with instances of bizarre behavior; tortured by rejection, disoriented by success. But this is neither the time nor place to get into all that. Here it's sufficient to say I spent my days in New York researching Pollock and Soutine, including numerous interviews with people who'd known them well, and while I never got around to writing that book (the Dionysus in my own unconscious began to demand my attention elsewhere), the experience was worth more than a dozen seminars at any graduate school in the land.

The eminent émigré sculptor Jacques Lipchitz had known Soutine in Paris, when he, Soutine, lived coatless and shoeless in bedbug-bitten squalor. That is, until the morning an American collector dropped by his smelly rooms and bought sixty paintings in a single francflinging swoop, whereupon the always idiosyncratic Soutine ran into the street, hailed a taxi, and ordered the driver to take him to the French Riviera, two hundred miles away. From that day on, Soutine never cleaned his brushes. When he'd finished for the moment with a particular color, he'd toss the brush over his shoulder and grab a new one from the basketful he'd purchased.

I interviewed Lipchitz at his large studio in Hastings-on-Hudson, high above the river, where, as he was confirming that Soutine, like Pollock, was more interested in the *activity* of painting (for both it was an act of concentrated frenzy) than in the finished product, I found myself becoming more interested in Lipchitz's right leg than in his stories.

For working, Lipchitz wore loose-fitting cotton pants, one leg of which had now hitched up to reveal a surprising expanse of bare flesh. The man's exposed appendage was penguin white, smooth as an egg, and as devoid of hair as a baseball bat. Not a filament, not a whisper of fuzz marred that pristine surface. Neither were there scars, pimples, or evidence of the bulging veins common in men of his age. It was as if he had sculpted his own leg, carving it from a single slab of purest white marble. I couldn't help but wonder if he might have done something similar with his genitals. What an outbreak of penis envy that could have touched off at the gym!

Then, when he told me that each week Soutine, a Jew, would consult a nun at a convent on the outskirts of Paris regarding her secret remedy for the prevention of baldness, I wondered if Lipchitz had gotten hold of the good sister's potion and was trying it out on his leg. I mean, he did keep stealing glances at the limb, as if expecting that at any moment a hidden follicle might dilate there and give birth to a perky thread.

Lipchitz was as kind and informative as he was, of course, talented, and even at the time I felt ashamed that I was allowing my imagination to run away with the poor man's leg.

At the time of his death in a Long Island car crash, Jackson Pollock's closest friends had been Barnett Newman and Tony Smith. In my several separate interviews with the two artists, I learned that they had a significant connection that preceded their friendship with Pollock. In his twenties, Newman had left his father's business, intent on

becoming a painter, and to that end, he enrolled in an art academy on Eighth Street in Greenwich Village. His primary instructor there was Tony Smith.

At one point, Newman, recently married, invited Smith to his apartment to dine with him and his wife. Smith accepted, and they partook of a fine dinner, served on a mammoth old but elegant table. Upon their marriage, the newlywed Newmans' families had furnished the flat for them, filling it with pieces that had been in their respective well-to-do households for decades. The various tables, chairs, chests, and stands, even the bedstead, were as thick, heavy, dark, and imposing as one of Soutine's looming canvases.

After dinner, Newman confided to his teacher his ambition to become not merely a successful painter but a painter of consequence. He asked Smith for advice on how to further that goal. Put on the spot, Smith was silent for an uncomfortable minute or two. Then, looking around, he said, "The first thing you need to do is get rid of all this middle-class Jewish furniture." He turned and left.

Two weeks later, Smith was surprised when Newman once again invited him to dinner. Tony didn't tell me why he accepted. Maybe he was tired of eating out, maybe he liked Annie Newman's home cooking. In any case, he returned to the apartment, where his astonishment instantly multiplied by a factor of ten. All of the furniture, every single stick of it, was gone. Dinner was served atop a packing crate. They ate squatting on the floor.

Smith was starting to think this guy was serious. He wasn't just another dilettante, he meant business. So, when Newman, at the end of the evening, asked again what he could do to make a contribution to the ongoing mainstream of modernism, Smith replied, "Men know a lot about horizontals. They don't know much at all about verticals."

He left it at that, but it was all Barnett Newman needed. Newman went on to build a financially and critically successful career exploring the effects on the eye and the mind of strategically (but seldom

predictably) placed vertical bars, shafts, or splinters set tantalizingly close to the edges of vast fields of solid color. Far from the autocratic arrangements of traditional painting, in which the viewer's eye is compelled to focus on one or more images of the painter's choosing, any of Newman's giant canvases issues an invitation -- or a challenge -- for the spectator himself to make what he would of a vertical entity in an expanse of *real* -- as opposed to pictorial/illusional -- space. There is no narrative, there is no seduction or pretty plea, there is only a platform from which we can "feel" elementary verticality as it asserts itself convincingly if unexpectedly against a flat ground.

It's unfortunate that Tony Smith isn't around and in a position to advise the human race on verticality because as we continue to procreate like adolescent fruit flies, our affection for the horizontal -- for industrial, residential, and even agricultural sprawl -- is destroying the earth and the Earth. Visionary architects contemplate structures so tall their tops would actually be in orbit, a park on one floor, hospitals, public libraries, sports arenas, and department stores on others: an entire city inside a single building. And think of vertical farms: towering hydroponic greenhouses each producing more corn, more tomatoes than a million acres currently devoid of wildlife and trees, poisoned by chemicals and greed. If we don't go up we may go down.

That's the value of artists, isn't it? Even when they aren't aware of it, they're dreaming our dreams for us.

All things considered, I've learned more from talking to painters than talking to writers. Not that painters are smarter than writers, such is seldom the case, but in conversation writers are inclined to waste an inordinate amount of time either bragging or bellyaching about reviews and royalties, complaining about their publishers, or dissing other authors. Painters, being equally insecure, can likewise come across as boring and bitchy -- it's tough being creative in a materialistic society -- but since they labor not in vineyards of verbiage but upon

ice floes of visual images, they tend to function with fewer inhibitions than the wordsmiths when it comes to vocally exploring and expressing ideas. Since no one judges their speech, comparing it to their written work, they don't feel so acutely the weight of language.

The painter Morris Graves, for example, verged on nonliterary eloquence when he told me about being awakened before dawn one morning in India by a strange, beautiful, hypnotic sound, a kind of marvelous chanting. At breakfast, he learned that in that village, as in some others in India, the men and boys have gone out each morning since prehistory to chant the sun up. "Cynics scoff," said Graves with a smile, "but the villagers point out that in all the millennia that they've been chanting, the sun has never failed to rise."

When NASA scientists invited the mystical painter to Cape Kennedy to advise them on matters about which they were becoming increasingly uneasy -- areas where astronomy, theoretical physics, and higher mathematics seemed to be inescapably crossing the line into the province of metaphysics -- Graves told them about the Indian chanters, suggesting that NASA might do well to incorporate a similarly reverential, less brutal attitude toward space exploration. Graves found many scientists receptive, even agreeing when he argued that to truly "conquer" space, men need to travel inward as well as outward, and do so with the same focus, seriousness, effort, courage, and determination they would devote to searching for life on Mars or establishing a colony on the moon.

Graves was a master at turning things inward. In what I'd intended to be a hard-nosed interview on the question of form versus formlessness in modern painting, he eventually had me on the floor of his studio tossing Chinese coins, consulting the *I Ching*. It wasn't an easy sell. By that time in my life, I'd reached the conclusion that Asian spiritual texts were probably best left to spiritual Asians. The Bible is an Eastern book, pure and simple, and when one considers the many messes, psychological and material, we in the West have made in its name, one shudders to think of what harm might be un-

leashed from similar misinterpretations (most due to ignorance, others calculated and insidious) of *The Bhagavad Gita, The Rig Veda,* or *The Tibetan Book of the Dead.*

I knew that the *I Ching* was oracular, a book of divination whose system of hexagrams, refined in China over a period of three thousand years, was centered on the concept of the dynamic balance of opposites throughout the universe, and the notion that all events, personal and cultural, unfold somewhat predictably in a matrix of perpetual change. I was hospitable to that concept and curious about its practical application, but I insisted on keeping the same distance from the *I Ching* that I might keep from a guru's ashram or an encampment of Gypsies. Morris Graves was, next to Allen Ginsberg, the most charismatic human being I've ever met, the sort of man who, if he said, "Come with me," you'd grab your coat and go because you'd know that wherever he led you, it would be more interesting than where you'd been at the time.

Thus it was that at Graves's urging I capitulated, posed a question (a rather general one about how to proceed on my life's journey) and set about tossing the coins (yarrow stalks, the preferred method, being unavailable). I can't remember the English name of the hexagram I received as my answer, but I've never forgotten the explanation of the hexagram, its verbal direction. It was composed in formal prose, stilted, and a little aloof, perhaps as befitting an ancient oracle, but it boiled down to this: "Be careful what goes into your mouth and what comes out of it."

The advice was so good -- so simple, wise, and encompassing -- that I've never felt the need to consult the *I Ching* again. It was quite likely the best advice I've ever received. I can't help but wonder what my life would have been like if I'd actually followed it.

Gray, chilling, pappy, and blah, Manhattan in March of 1965 had resembled a bowl of leftover mush, the one that, if you remember the

fairy tale, caused Mama Bear to exclaim, "This porridge is too fuck-
ing cold!" Then one Sunday near the end of the month, New Yorkers
awoke to a morning as sweet and fine and budding with optimism
as Goldilocks's training bra. Like some silent yet amplified public-
address announcement, the sun called people into the streets, where
they were so surprised by the absence of snow and snot that they
actually smiled at one another. By Southern California standards, not
to mention Hawaii's, the day wasn't really all that warm, but it was
a change, a definite improvement, and the response was widely mo-
bilizing.

That afternoon, my girlfriend Eileen and I strolled over to Wash-
ington Square in Greenwich Village. The change in weather had
turned the park into some kind of walk-through jukebox. Every few
feet, it seemed there was another impromptu source of live music.
There were, as usual, the young aspiring folkies armed with cheap
guitars or harmonicas, who stationed themselves here and there in
Washington Square on any good day; but that Sunday there also were
small rock groups, jazz trios, elderly classical violinists sawing away
in front of actual music stands, and men from Russia or the Middle
East, individually or in pairs, playing exotic tunes that neither Eileen
nor I recognized on instruments we could not identify. A few of the
musicians were busking, boxes at their feet into which passersby were
invited to toss monetary tokens of appreciation, but most seemed to
be playing for the sheer joy of it; a multicultural, nonjudgmental pre-
cursor of *American Idol;* and even as ominous clouds -- darker, more
imposing than Papa Bear's big brown butt -- lumbered in from the
Atlantic, the dozens of mini-concerts continued, as if music alone
could hold the new spring in place and keep a resurgence of winter
at bay.

Then (it must have been between three and four o'clock) there
came a noise -- distant at first, but rapidly drawing closer, louder,
and louder yet -- a sound so potently primal that it resonated not
only in the ear but in the gut, in the spine, the groin, and the heart.

It was like an excerpt from an opera performed on the Fifth Day of Creation, before the existence of man and woman, when Jehovah was still up to his armpits in stardust, leaving Lucifer, his baton a twisted rod made of snakeroot and mud, to direct the chorus.

One by one at first, then all at once, every singer's song trailed off, every instrument squeaked to a halt. It had quickly become apparent that the sonar interruption was coming from above, and as if yanked by marionette strings, all heads tilted upward, lifting to see a jackknife of wild geese scratching God's secret name in the sky.

I'd no idea the migratory path of Canadian honkers traversed New York City. It could have been an aberration, the geese diverted by a storm or an unusually voluminous release of chemical steam from a refinery near the Jersey Shore, but whatever the reason, the mighty wedge passed directly over us, northward bound, flying so low above the city it was a marvel that it didn't crash headlong into an observation deck or a mogul's penthouse.

For some in the square, the native-born Manhattanites, it was probably the most direct contact they'd ever had with wild nature. Even transplants from places such as Idaho or Arkansas were visibly surprised, delighted, and moved. And just before the great birds vanished in the distance, just as their primordial barking faded away, the entire population of the park -- musicians, tourists, winos, dog walkers, workers enjoying their Sunday holiday, everybody -- erupted into spontaneous applause.

And then . . . and then at that exact moment -- and I swear I'm not making this up -- the sky split open as if from cesarean surgery, as if ripped by the knife blade of geese, and there was a cloudburst of typhoon proportions. Soaking, blinding, the rain spilled on us in such volumes that within minutes every living soul had fled the park. Even pigeons took shelter. Washington Square was totally emptied. It would take more than a deluge, however; more than the river of time itself, to wash away the magic, the winged reminder that there are wonders in play on this planet whose eerie beauty urban man,

with all his ingenuity, all his ambition, all his vanity, can never ever quite match. Not Soutine, not Pollock, not even Graves, who came as close as any artist has to concretizing in paint the hair-raising yet somehow nurturing music of the wild.

I'd been in the Big Apple less than ninety days when I joined New York Filmmakers' Cinematheque. It was a relatively new organization, just starting to gain traction, and it didn't matter that I had no intention of making films, I had credentials as a critic (albeit in faraway Seattle), and since the objective of the Cinematheque was to promote experimental artists and their work, the group welcomed any and all support. For my part I'd had a keen interest in noncommercial movies since being introduced to "An Andalusian Dog," the shocking 1929 collaboration between Luis Buñuel and Salvador Dalí, at a University of Washington screening the previous year.

One night each month, I believe it was the first Thursday, the Cinematheque would show recently completed films or work-in-progress by such underground directors as Jack Smith, Stan Brakhage, and Jonas Mekas. For members only, the screenings were at midnight at the New Yorker Theatre on upper Fifth Avenue, and I was a dedicated attendee; dedicated, perhaps, to a degree that verged on the obsessive if not the silly. What follows are two cases in point.

The vast majority of underground films were short, seldom exceeding fifteen or twenty minutes. Andy Warhol's movies were the exception -- epic in length if minimalistic in content -- so when it was announced that the premiere of Warhol's latest effort would run a mere ninety minutes (his aptly named *Sleep*, the previous year, had run six hours), Cinematheqies took heart. Moreover, the subject of the new film, its "star," was the erudite Henry Geldzahler, a highly influential museum curator and gadfly in the NY art world, and legion were those who courted his favor.

A nearly full house gathered to watch *Henry Geldzahler*, in which

the curator was filmed sitting in an easy chair in what appeared to be a sunlit Hamptons beach house, smoking a cigar. And that was it. For an hour and a half. The camera was stationary throughout. There were no close-ups, no long shots, no fades or dissolves and no sound track. Except for the arm that held the cigar, Geldzahler was motionless. After about thirty or forty minutes of this, I overheard grumbling. Several people seated near me got up and left. Reminding myself that in Zen it is said, "If something is boring for five minutes, try it for ten; if it's boring for ten, try it for fifteen," and so on, I was determined to stick it out. For this, I was rewarded.

In an otherwise static film, a couple of things were happening that held my attention. First, Geldzahler, as time went on, was growing obviously, genuinely uncomfortable. He neither spoke nor signaled, and made no move to rise, but his increasingly annoyed expression and rigid body language were those of a man who could barely wait for this experiment to end; and since this sentiment was shared by many, if not most, in the theater, it created in an odd, serendipitous way that sense of audience identification for which great actors and writers so often strive.

Then, there was the lengthening ash on the cigar. If puffed gently and undisturbed, a well-made, slow-burning cigar tends to hold its ash, and this fat stogie, doubtlessly of Cuban origin, burned on and on (on and on), its ash intact. As the ash grew longer, it became, for me at any rate, not just the focal point of the film but riveting.

Next to Geldzahler's chair was a freestanding ashtray, the kind one used to see in hotel lobbies, and on several occasions later in the film Henry reached down and made as if to knock the ash off into the tray -- only to pull the cigar back at the last second, and take another puff. Each time he did this, tension escalated. Gradually, the suspense became as great as anything in a Hollywood thriller. The fate of that long cigar ash -- Would Henry ever flick it? Why didn't it just fall off on its own? -- was comparable to the fate of an imperiled Jimmy Stewart or Tippi Hedren in the most spellbinding Hitchcock

masterpiece. I was breathing hard and, metaphorically at least, on the edge of my seat. And when at long last the orb could defy gravity no more, its tumble was cathartic, the release very nearly orgasmic.

The film ended. The houselights came up. And I was simultaneously flabbergasted and embarrassed to see that as near as I could tell there was not another soul in the theater! I alone had stuck it out.

Speed-walking for the exit at a pace that suggested the place was on fire, I was convinced that anyone who happened to see me would conclude one of the following: (1) I was the coolest, most Zen dude in town; (2) I was a poser, a phony out to prove that I alone possessed the sensitivity and intelligence to comprehend the meaning of such a challenging film; or (3) I was a naive sucker from the sticks whom the crafty Warhol had succeeded in duping.

On another first Thursday, a month or two later, I attended an opening at a major art gallery, where I chanced to meet a beautiful British film actress, young but already well known. I won't identify her as she is alive and still acting, often appearing in TV miniseries from the UK as well as episodes of *Masterpiece Theater*. Our conversation was going so well that we elected to continue it elsewhere, and did so in the bar of her uptown hotel. After two or three drinks, she squeezed my hand, looked meaningfully into my eyes, and invited me up to her room. I glanced at my watch. Oh no! It was well past eleven and the Cinematheque film program would be starting at midnight. Stammering that I was duty bound to go watch some important underground movies, I kissed her on the cheek and fled to the New Yorker.

Now, my all-time favorite accolade from a book reviewer was when Fernanda Pivano, Italy's best-known critic, wrote in a leading Italian newspaper that "Tom Robbins is the most dangerous writer in the world." I never read my reviews, even in English, but others sometimes pass choice bits along, so when I had occasion to meet the legendary Signora Pivano at a reception in Milan, I asked her what she meant by that wonderfully flattering remark. She replied,

"Because you are saying zat love is zee only thing that matters and everything else eese a beeg joke." Well, being uncertain, frankly, that *is* what I'd been saying, I changed the subject and inquired about her recent public denial that she'd ever gone to bed with Ernest Hemingway, whom she'd shown around Italy in the thirties.

"Why didn't you sleep with Hemingway?" I inquired.

Signora Pivano sighed, closed her large brown eyes, shook her gray head, and answered in slow, heavily accented English, "I was a fool."

Okay, back to the New York Cinematheque. Why did I choose to go watch a bunch of jerky, esoteric, often self-indulgent 16mm movies rather than sleep with the sexy British actress? Move over, Fernanda, there's room for two fools on your bus.

So many times and with such vigor did Eileen and I kiss during our months of cohabitation in New York that the sheer number of our kisses would have confounded Carl Sagan; while our osculatory energy, if converted to electricity, might have illuminated Times Square and half of Coney Island. Our mingling of mouth meat, Eileen's and mine, was so persistent, so manifold that it's impossible now to single out any of our individual smooches for special attention, which may account for the fact that the only kisses that do stand out, the only two I actually remember from that period, were brief, dry, and devoid of passion (and thus could not have involved Eileen). One was the previously described dumb, wimpy peck of rejection I planted on the cheek of that British actress. The other was bestowed on me by Allen Ginsberg, the only man who's ever succeeded in kissing me on the lips.

It was a wintry day in 1965, and Ginsberg and I sported snowflakes in our hair and beards as we paraded in front of the Women's Detention Center on West Tenth Street, Greenwich Village. The march, the first of its kind and none too large, had been organized

by "Lemar" (Legalize Marijuana) to protest that the prison was crowded with females of all ages whose sole criminal act was the private, orderly, nonviolent inhalation of tiny plumes of smoke given off by a smoldering weed. From time to time, a girl would appear at a barred window to signal gratitude and encouragement before being ordered -- or dragged -- away.

Amidst the swirling snowflakes, like the orbs of mad polar bears, flashbulbs incessantly popped and glowed. Obviously, all those cameras weren't being aimed by the media. Some in our group estimated that at least a half-dozen law enforcement agencies had representatives on the scene. Perhaps to inspire fear and promote intimidation, the various city, state, and federal agents made no effort to hide either their presence or their documentation, and I, for one, was growing increasingly nervous.

My anxiety must have shown in my expression, maybe in my body language as well, because at one point Ginsberg laid a gentle hand on my shoulder and said, "Don't worry about it." He recognized my callow face from Lemar meetings at the Peace Eye Bookstore, though at that time had not learned my name. "Don't worry about it," he repeated, nodding at our swarm of paparazzi. "In the long run, these fuzzy shots in some cop's folder will do you more honor than your face on the cover of *Newsweek* or *Time*." Then he kissed me lightly, exerting scant more pressure than a snowflake.

My immediate reaction I don't recall, but on many occasions in years to come I would silently thank him for the perspective: a lesson in attitude made all the more indelible by the kiss.

Such was his calling, I suppose. A hot-wired sutra slinger, a Vendantic versifier, a Wurlitzer of howling meat drunk on holy quarters, Ginsberg -- invoking the eternal within the ephemeral; wholeheartedly celebrating paradox and confusion as the fundamental fluids in which the human condition hangs suspended (thereby refining our base dissatisfactions into the more luminous chemistry of acceptance, compassion, goofiness, and grief) -- Ginsberg had the

capacity to cast a net of enchantment around nearly everything in life, from a busted dusty sunflower to a potential bust by the morality police.

Not long ago, the United States Postal Service issued a series of stamps honoring the greatest modern American poets. The face of Allen Ginsberg was not among them. It figures, doesn't it?

Eileen and I fled New York in the middle of the night. Our hasty exit, however, was neither as dramatic nor as nefarious as it sounds.

Eileen Halpin, short, brown of hair and feisty of spirit, with soulful eyes and a mouth so sensual it could prompt the pope to dive headfirst off his balcony, was a student in the art department at the University of Washington. We had met in August of '64 just weeks prior to my departure for New York, when I was still under the sway of the Redheaded Wino, and spent three or four lovely sleepless nights together before I left Seattle. I never expected to see her again, but once I'd settled in what New Yorkers were just beginning to call the "East Village" (having dropped off Susan and Kendall in Richmond and picked up B.K., who found lodging in the tenement house next to mine), Eileen and I commenced a correspondence perfumed with such mutual attraction that not much more than a month had passed before I was meeting her train at Grand Central station.

Ever spunky and independent, Eileen wasted little time in landing a job waitressing at Café Renzi, a popular Greenwich Village coffeehouse, just down the street from where a kid named Bob Dylan was starting to flex his adenoids. Although her earnings were small, they augmented my savings, subsidizing to some extent my research. By late June '65, however, those savings were so depleted that coffeehouse tips were insufficient to prop them up. And then there was the matter of Ken Kesey and the weather . . .

June was pistol-whipping Manhattan with a dead flounder; the

air thick with heat, humidity, hydrocarbons, and the near-evil ef-
fluvia of rotting garbage. Our apartment lacked air-conditioning or
even a fan, so to keep cool in the evenings we'd crawl through a win-
dow and sit on the fire escape. When Eileen was at work, I'd read out
there, straining my eyes in the stray glare of a streetlight. As chance
would have it, the novel I'd begun reading that summer was Kesey's
Sometimes a Great Notion, which, set in the Pacific Northwest, was
sodden with images of green moss, green ferns, green cedars and firs,
cool green drizzle, and cold green rivers: such a saturation of green-
ness that it would have sent an ol' desert rat like Gaddafi into shock,
causing him to chant "beige, beige, beige, beige, beige . . ."

One midnight (I'd been splashing in Kesey puddles and, not
coincidentally, it was only days before July's rent was due), Eileen
returned from Café Renzi to find me packing my bags. "Get your
darling stuff together, little darlin'," I said. "We're betraying New
York 'ere the cock crows thrice." Our landlord's real estate office was
on the ground floor of our building and it would be up and run-
ning by nine. By the time it opened, Eileen and I and our belongings
were crammed in the trusty old Valiant, putting across western New
Jersey. As we'd crossed the Hudson, I'd waved au revoir and "later,
man," to the ghosts of Soutine and Pollock, thanking them for their
nine months of service to my Protestant ethic.

There'd been another motivation for escaping New York. The area
around Tompkins Square Park where we lived had for many de-
cades been a neighborhood of Polish and Ukrainian immigrants. By
the early sixties, however, it had become increasingly populated by
Puerto Ricans (soon they'd be displaced by hippies, but that was yet
to come), and at night, young Hispanic gangs dominated street life.
Incidents of violence were fairly rare, though the nocturnal preva-
lence of knots of young Latin males on corners or on tenement steps
created a certain sense of wariness and unease. Walking home late

from Stanley's Bar on Avenue B, I was always alert for trouble, a tiny bit on edge even when accompanied by a muscleman like B.K.

The two rival gangs in our hood were "the 12th St. Boys" and "the Dutchmen." Why a group of tough teens from Puerto Rico would choose to identify with cheese-making, ice-skating, Northern European windmill keepers, I was never to fathom, but I did learn other things about these Latino Dutchmen and I learned them first-hand.

The competing gangs staked out and defined their territory by chalking their names on every available wall. One afternoon as I was walking up East Tenth Street, I witnessed just such a verbal flag-planting by a party of so-called Dutchmen, observing that they, as usual, were misspelling their own sacred name. The leader of this contingent had just written D*U*C*H*M*E*N" on a brick facade and stepped back to admire his handiwork when -- motivated by an uncontrollable editorial impulse, a force that had operated in my life since early childhood -- I walked over, demanded the chalk (the gangster was too stunned or, smelling blood, too amused to refuse), seized it and inserted a big chalky capital *T*. "There," I said, "that's how you spell it. D*U**T*C*H*M*E*N."

It was only then, as I handed back the chalk, that the utter reck-lessness of my impromptu pedagogery hit me. *Good God, Tom, what have you done!* As I prepared to sprint for my life, pursued by a pack of urban wolves, the boys nodded. They smiled. They muttered their thanks in Spanish and in English. And I walked away unscathed, resisting any impulse to accelerate my pace or glance back over my shoulder. It had turned out well, after all. It had. But it wasn't over.

These gangbangers (ages fourteen through eighteen) had a lot of time on their hands. As they loitered in doorways or in nooks of Tompkins Square, they talked. They conversed for hours, day and night, and as I was to learn, they argued; argued about an amazingly wide range of subjects: not merely sports and pop culture, but current events, history, geography, and nature (including human and animal

sexuality). You can see where this is going. I, the gringo who had the education to correct their spelling and the cojones to scribble their name (illegally, of course) on a wall, became their trusted arbiter. From that day on, I scarcely could pass a group of Dutchmen without being called upon to settle some debate.

It was kind of flattering, kind of cool, being an oracle to a gang in the mean streets of New York, but I sensed that my position as a one-man ambulatory search engine could only lead to no good. What if an argument grew overly heated and I sided with some younger, weaker member or members rather than the leader of the pack? What if they were to discover that unwittingly or to hide my ignorance I'd given them wrong information? What if the 12th St. Boys had their own mentor, a retired professor or something, and he were to challenge me to a dramatic *High Noon* erudition face-off? This was before the National Rifle Association helped assure that any hotheaded punk in America could access a handgun, but it was rumored that each and every one of these gangsters carried switchblades. I couldn't very well avoid the Dutchmen or resign my position. The situation wasn't exactly urgent, but it did serve as an added incentive to, as Mark Twain, put it, "light out for the territories."

We not only lit out, we slept out. Financially stressed, we eschewed commercial accommodations, electing to sleep in parks, fields, or, one night in Minnesota, a wrecking yard where the Valiant did not look out of place among the corpses of broken cars. It was summer, nights were balmy, so camping out under the stars should have been pleasant. And it was except for one small fly swimming backstrokes in the ointment: we had but a single sleeping bag.

Each night, a road-worn Eileen would slither into the bag. Then, like stuffing a one-pound sausage casing with two pounds of pork, I'd force my way in beside her, grunting, twisting, and squirming. Once both were sufficiently encased, neither could move. Unable to

turn over, flex, or shift positions in any manner, we were plastered against one another, my face to the back of her head because if face-to-face we would have spent the night inhaling each other's exhalations. Sexual intercourse, naturally, was out of the question. Not even Houdini could have pulled it off, except perhaps if his partner were a yoga instructor. We felt like an Egyptian two-pack in that damn bag: King Tut and his sister Tutti.

In western Montana, as a setting sun turned a placid river into peach juice, we spotted a motel whose clean white cabins were advertised at four bucks a night. Needing a shower, needing to reconfigure our alignment of intimacy, needing to rest muscles sore from reclining on hard earth -- and figuring that with a big push we could reach Seattle by the following evening -- we splurged.

Scrubbed until we glistened like Liberace's incisors, we approached the white cloud of a bed with an almost giddy combination of exhaustion and anticipation, feelings that intensified when we noticed that it was one of those newly fashionable "Magic Fingers" massage beds. Once activated by coins in a slot, such a bed would come to life, slowly undulating up and down, side to side, gently kneading the supine bodies of its occupant or occupants. Great! Wonderful! It was an unexpected answer to a couple of weary road warriors' unspoken prayers.

Well, it might have been bad karma for running out on a lease, it might have been long-distance Puerto Rican Dutchman voodoo, it might have been just one more little joke on the part of the gods (we really shouldn't begrudge them their fun), but our bed, which was supposed to jiggle for about twenty blissful minutes, got in a groove and wouldn't stop. It wouldn't stop! It was as if the thing had been programmed by Bill Haley and Little Richard -- "shake, rattle, and roll" -- or James Bond's favorite bartender.

After more than an hour of constant jiggling, massaged within an inch of our lives, we were at the point of bailing out and attempting to sleep on the floor (in retrospect, that junkyard turf didn't seem

so bad) when it finally occurred to our numb brains that the manic mechanical masseuse was an electrical device, and thus tethered to a power source. Like a rodeo rider dismounting a bronco, I tumbled off the mattress, crawled around on the floor until I found a cord, traced it to its plug, and disconnected it. The bed shuddered and fell idle. "Wahoo!" I shouted. By the time this cowboy was back in the sheets, Eileen was already asleep.

the letter

When had it begun, my fantasy of the golden letter? It was probably in my late teens or early twenties that I first became inexplicably possessed of the notion that one day the mailman would deliver a letter to my door that would dramatically alter my life. For the better, I should add: this conviction was in no way a premonition of misfortune or sorrow. In fact, in my daydream the letter was surrounded by a kind of golden aura.

It was sometime in 1966 that I opened my street-side mailbox to find an envelope with the words "Doubleday & Co." in the return address. Hmmm? Was that a flicker of gold I detected? Impatient, a teeny bit atingle, I read its contents on my way up the stairs to my aforementioned apartment above the machine shop. A fellow named Luther Nichols and claiming to be the West Coast editor of the famed Doubleday publishing house had written to inform me that he would be in Seattle two weeks hence and wished to discuss with me the possibility of my writing a book. Had he been reading my mind?

Entering through the kitchen, where Eileen was making lunch, I held up the epistle. "I think this is it!" I said. She seemed puzzled. "The letter," I said.

"What letter?"

"The *letter*." I waved the document as though it were the paper flag of an impoverished but prideful country. "*The* letter."

Eileen may be excused if she didn't immediately share my excitement. Not everyone has an eye for golden auras.

A fortnight later, Luther Nichols and I met in the coffee shop of the Benjamin Franklin, long since demolished and replaced by the twin corncobs of the high-rise Westin. A lanky, distinguished-looking gentleman, Mr. Nichols ordered a cup of the hot beverage for which Seattle was not yet famous. I -- then, as now, clean and sober when it comes to Sunday school-sanctioned addictive drugs like caffeine (Methodist meth) -- I opted for a dish of ice cream.

Following five or ten minutes of small talk, Nichols cut to the chase. Someone had been sending him (he was stationed in San Francisco) my columns -- *Tom Robbins on the Arts* -- from *Seattle* magazine, and he wanted me to consider writing for Doubleday a book about Northwest art. My disappointment was as hard to conceal as the bride's belly at a shotgun wedding. If he had, indeed, been reading my mind, he needed new glasses.

"Uh," I stammered, "I was, uh, hoping we could discuss me writing a, uh, novel."

Now it was the editor's turn to hide disappointment. How many times during a typical week was he subjected to some delusional hack pitching a novel for which he or she lacked the fortitude much less the talent to pull off. Nichols was a true gentleman, however, scrupulously polite, so he stretched a thin film of interest over his letdown, his ennui, and inquired (yawn) what my novel was about.

I didn't hesitate. I spit it right out. "It's about the mummified body of Jesus Christ, stolen from its secret hiding place in the catacombs under the Vatican, and its subsequent reappearance in a roadside zoo in the Pacific Northwest."

The eyelids of Luther Nichols rolled upward with an almost audible force. His nose twitched, rather like the muzzle of a coyote that has caught the scent of jackrabbit. His spine stiffened. He pushed his

coffee cup aside. "Tell me more," he said, his interest now obviously genuine.

There was one small problem: I didn't know any more. The Corpus Christi germ had infiltrated my brain back in New York, and gradually realizing then that developing it into a novel (answering at last the call I'd been hearing since literally the age of five) was where my true bliss lay, well, that's why I'd not been loath to abandon the diligently researched dual biography of Soutine and Pollock. Alas, for one reason or another, I'd yet to attend to that development, not even in my musings. So, I didn't know any more, no more than what I'd just blurted out. Nichols looked so expectant, so eager, however -- and realizing that this was the opportunity the long-awaited golden letter had finally arrived to present -- I commenced to improvise a plot on the spot.

It was helter skelter and definitely unorthodox, but my impromptu synopsis (from which I would ultimately deviate considerably) held the editor's attention, and when I'd concluded my monologue, he asked, "When can I see it?"

"Well," I said, crossing my fingers, "it's still a bit rough."

We separated with me promising to send Nichols the manuscript as soon as I could make it presentable. And that afternoon I sat Eileen down and announced as solemnly as if I were claiming responsibility for the telltale bulge in the bride's white gown, "I have to write a novel."

distractions

Despite the impetus -- the interest of a major publishing house -- some months were to pass before I began writing the book. To award it the full focus that any good novel demands, I had to extricate myself from both Seattle's art scene and its blossoming psychedelic culture, areas in which I'd become increasingly enmeshed since returning from New York. Superficially at least, the two did not seem to overlap and they were never to really merge, but on a deeper level, each -- modern painting and the psychedelic sacraments -- offered humanity a new way of seeing, an enlarged and deepened definition of reality, a freshened and intensely sensual awareness of what it means to be a cognitive mammal on a tiny planet spinning precariously in the backwash of an infinite universe, a perpetually endangered species kept alive -- and occasionally driven quite mad -- by its capacity to love.

But let's take care not to lose objectivity in a spasm of genuflection or shower of rose petals. Mediocrity is the standard rather than the exception among practicing artists (Sturgeon's rule: 90 percent of everything is shit), and for the past hundred years art has been increasingly more about money and ego than truth and revelation. The periodic discovery, however, of a peach-size diamond in the dung heap of commerce was enough to keep one digging, never mind the fecal matter that accumulated beneath one's nails.

As for psychedelics, too many of the sacraments were contaminated or counterfeit, too many of the imbibers intellectually and spiritually unprepared to learn from or even recognize the gods unmasked in their presence. Still, there were sufficient bolts of wonder

to light up anyone's personal sky, provided one kept his blinds open or didn't run for cover at the first clap of thunder. (Mainstream media were staffed by copious coops of Chicken Littles, while the police state spun paranoia the way Granny Robbins spun wool.)

In any case, I allowed myself to be distracted from what I secretly knew, had always known, to be my true mission in life, dancing instead to the music of the zeitgeist. And what music, literally and figuratively, it was! From the Beatles to the antiwar movement, from Jefferson Airplane to the swelling tide of feminism, anthems of joy and revolution rang.

I reviewed art for several publications in Seattle and beyond, wrote essays included in museum catalogs, organized gallery exhibitions, contributed to shows (under the pseudonym "Max Saint Cherokee") several assemblages of my own making, and was a ringleader in a boisterous neo-Dada gang of guerrilla artists, the Shazam Society, whose raison d'être was to disrupt and poke fun at those uptight elements of the Seattle art community that took itself far too seriously for art's own good. I also participated in "trip festivals" (celebrations of the more external manifestations of the psychedelic experience) for which I created "happenings" (later known as "performance art," an easy, self-indulgent medium that has continued to attract supremely untalented practitioners) with quaint ironic titles such a "Mommy/Daddy/Bow Wow/I Love You."

The happening, bastard baby of Mr. Visual Art and Miss Theater, and by no means a by-product of the psychedelic revolution, can trace its origins, under different names, back to Picasso's Paris in the 1920s. It was reborn, though for years only dedicated avant-gardists heard its squalls, in New York in the late fifties, when serious artists such as Allan Kaprow, Claes Oldenburg, and Jim Dine pushed Pollock's "action painting" to its extreme by eliminating the canvas altogether, moving the action off the wall and off the pedestal, out into the "real" and live space of the room.

By 1966, Seattle's culturati were aware of the hybrid medium, but

few had witnessed an example firsthand, so when the owner of Current Editions, a first-rate print gallery, decided to commission a happening for the entertainment and education of her well-heeled patrons, she turned to me. All too happy to oblige, I created a piece I called "Money Is Stronger Than Dirt." Modest, if sarcastic and satirical in scope, its central element was an amateur banjo picker in blackface and full Uncle Sam costume complete with patriotic top hat. As, seated on a short wooden stool, our personified national symbol picked and sang -- in a voice that sounded as if it had been run over more than once by farm equipment -- corny old folk ballads, a quintet of Shazam Society artists knelt on the floor at his feet cutting one- and five-dollar bills into bits and dropping the scraps into a glass salad bowl. Did I mention that the theme was sarcastic? The staging modest?

After a half hour or so of this, the audience grew restless, as I'd expected it would, but none more discontent than I. I mean, if the spectators were waiting for something to happen, they were not alone. My pièce de résistance was failing to materialize. Literally. It rested, you see, on the shoulders of a young man I knew who'd recently taken a job selling vacuum cleaners door to door in the area around La Conner. The machine Bruce was peddling boasted a shampoo feature which, if its tank was filled to capacity, generated an amazingly voluminous amount of foam. My intent was that at some point, on cue, Bruce would stride out of the storage room in his salesman suit, launch into his pitch, set up his machine, aim its shampoo nozzle and completely engulf Uncle Sam and the money shredders (of which I was one) in a mini-mountain of suds. That was to be the grand finale. By showtime, however, Bruce had yet to show up at the gallery.

It was no problem to start without him, but as time passed and I waited in vain for some signal that he'd arrived, I commenced to fret. Eventually, I left the tableau and went to the storage room to check on him. No Bruce. Ten minutes later, I checked again, wondering if he might be hiding in there, experiencing a bout of stage fright. No Bruce. My anxiety was starting to inch over the panic threshold.

To bide time, and to relieve the awkwardness, the monotony, I found matches and ceremoniously lit on fire the scraps of money in the bowl. The torn bills flared and smoked. The gallery owner looked worried. Welcome to the club. For entirely different reasons, my own brow was so furrowed I could have screwed a hat on. "Money Is Stronger Than Dirt" was experiencing a kind of aesthetic erectile dysfunction for which a Viagra had yet to be invented.

Time passed. Uncle Sam was now on his third raspy rendition of "Oh! Susanna," one of the few tunes in his repertoire. So stressed I could barely breathe, I finally rushed downstairs to the street and searched -- in vain -- for Bruce's van. Arrgh! My impulse was to beat it to my own car and drive away. I felt the need to go home. Or, maybe to Alaska for a month or two, stopping by La Conner on the way to throw a Rotten egg at Bruce Wyman. (Bruce, I was later to learn, had encountered difficulty navigating the streets of Seattle. A small-town lad, he'd become lost in the labyrinth around Pioneer Square. He never did make it to the gallery.)

Reluctantly, I gathered what remained of my integrity and set about to face a roomful of bored, confused, and probably seething art lovers. On my way upstairs, I had a sudden and entirely desperate inspiration. Back in the gallery, where Uncle Sam was playing "Froggie Went A-Courtin'" for the third or fourth time, I stopped at the refreshment table and grabbed the plastic squeeze bottle of honey (a tea sweetener) I'd seen there. Resuming then my place at the feet of the great American icon, and smiling as if nothing was amiss, as if this was just the way things happened at a happening -- and too bad for any philistine who wasn't hip enough to dig it -- I proceeded to squirt honey onto the burned currency in the salad bowl. Next, I scooped up a handful of the now-sticky ashes, stuffing them into my mouth while nodding to the confederates beside me to follow suit. Slowly, one by one, shooting me incredulous glances, they joined in. We ate the money. We just ate it all up. The audience -- presumably unhappily -- got the point. And that was that.

Or, almost. The following night, the conservative commentator on a local TV station devoted his entire on-air editorial to berating me and Shazam, accusing us of a shameful, unpatriotic act every bit as seditious as burning an American flag, suggesting that the scruffy lot of us should face criminal charges for insulting and destroying the currency of the realm.

We were not arrested. And several weeks later, I was commissioned to create a happening at an art center in an affluent Seattle suburb. One more example, I guess, of how nothing sells like controversy.

On August 20, 1966, "A Low-Calorie Human Sacrifice to the Goddess Minnie Mouse" was presented at the Kirkland Arts Center, the opening event of the town's annual summer arts festival. To prepare the prospective audience, and to ensure that I didn't find myself in a situation that might prove as stressful, as embarrassing, as the subversive dude at Current Editions, I included the following disclaimer on the flyer that was circulated to announce the event: "It is not the purpose of this happening to be comic, tragic, satirical, political, social, provocative, poetic, charming, enlightening, artistic, entertaining or even interesting. This happening has one purpose only: to happen."

Well, it happened all right. And while I can't claim it did prove artistic or entertaining, it was evidently provocative. It also -- from my perspective, at least -- got rather interesting. Especially after the cops came.

I fear I cannot take full credit for the police raid. The event got out of hand, true enough, but only because its sponsors had swallowed whole the misconception that a happening was supposed to be some kind of audience participation affair, and in publicity and at the door had, unbeknownst to me, encouraged spectators to become physically involved in the performance. I'd designed the "Low-Calorie Human Sacrifice" as a considerably more elaborate and nuanced presentation

than "Stronger Than Dirt," had recruited and rehearsed more than a dozen Shazam Society members (along with an erotic dancer from Seattle's leading go-go club), and carefully orchestrated the whole show so that it would for all of its unruly appearance unfold in a theatrical procession that even Chekhov could have understood, if not wholeheartedly endorsed. Alas . . .

I'd made a tape loop of Joni James singing "I'm in the Mood for Love," and as the song played over and over, over and over, my dancer was to periodically deliver, in succession, huge trays of fruit, vegetables, and whole raw fish to the assembled Shazamers, posed formally as if for a group portrait and heavily armed with art supplies. Each participant would select a food item, and eat it or decorate it or both as he or she saw fit. (By the way, each time my dancer emerged from the wings she was to have discarded some of her clothing, and she was hardly overdressed to begin with.)

This business had been under way scarcely ten minutes before spectators, apparently signaled by the well-meaning festival director, began lobbing old wooden printing-press type (thoughtfully supplied by the clueless sponsors) at us. Insulted, one of my performers hurled a turnip in retaliation. Taking this as its cue, most of the audience left its seats and merrily stormed the stage. Alas. It was at that point that my happening became a melee.

No punches were exchanged, no bones broken, but chaos reigned, paint and produce filled the air, and the dry-cleaning bills must have been staggering. At one point I encountered the festival director, the attractive wife of a Seattle surgeon, who was wandering about in the fracas, a dazed and helpless expression on her face. Spattered with green paint, her coif undone, she just kept muttering, "Somebody put a fish down my blouse, somebody put a fish down my blouse." And all the while, Joni James kept singing "I'm in the Mood for Love."

I'm unsure how the evening would have ended if the police hadn't come. They'd been called, as it turned out, not by a concerned citizen

reporting a riot at the fine arts center, but by Maxine Cushing Gray, a kind of professional smut-sniffer who wrote a bland, prudish brand of art criticism for an upscale Seattle weekly. Ms. Gray had seen fit to summon law enforcement because my dancer was, in Ms. Gray's opinion, "indecently dressed." In point of fact, the dancer was now hardly dressed at all, unless green paint could be considered clothing.

Police presence brought things to a rather abrupt end. The place cleared out with amazing speed. The dancer and I were detained, but once the cops heard my side of the story -- and got their eyes full of her -- we were released with a warning. And while their warning didn't specifically state that I should refrain from ever staging another happening -- like most of the audience, the cops never really comprehended what a happening was supposed to be -- it didn't need to. I'd already come to that conclusion.

As if I didn't have enough distractions, I agreed in late 1966 to host a weekly show on KRAB-FM, one of the very first listener-supported radio stations in the nation. Called, with a nod to Dostoyevsky, *Notes From the Underground*, the show aired at ten o'clock on Sunday nights, a less than ideal spot for a broadcast; the signal, outside the greater Seattle area, was as weak as baby bird farts; and my voice, as previously stated, was so flat it made that faux "Uncle Sam" sound like Beyoncé. Nevertheless, *Notes From the Underground* had devoted listeners from the start, primarily because it dealt in a positive, even celebratory manner with the three basic food groups of the era: sex, drugs, and rock and roll.

Skating on ice just barely thick enough to keep from plunging the worried station into the punitive waters of the FCC, I delivered audacious bits (often culled from underground newspapers) on such timely topics as civil rights, war resistance, ecology, abortion, police brutality, political corruption, consciousness-expanding chemicals, and alternative lifestyles. Mostly, however, I played recorded music,

the new music shunned by commercial stations from coast to coast.

It happened to be one of those rare times in the course of human history when the popular music of the day was also artistically and socially *important* music, though you'd never know it from listening to AM radio. Wed to a rigid old format that demanded that no song on the air exceed three minutes in length, AM stations stubbornly refused to play album cuts (the majority and best of which had broken free from the three-minute straitjacket), so even as the Beatles, the Stones, the Doors, et al dramatically altered the soundscape of the English-speaking world, commercial radio sugared the airwaves with bubblegum singles.

Inner cities were burning, an unnecessary and immoral war was raging, gender stereotypes were in flux, protesters of many stripes challenged the barricades, an unprecedented generation of ecstatic truth seekers flirted with its neurological destiny, and all the while Seattle's KJR and KOL trotted out a teenybopper sound track of aural fluff. For a couple of hours on Sunday night, *Notes From the Underground* sought to provide a relevant, sympathetic, irreverent refuge from obnoxious advertising, disc jockey prattle, and Top 40 inanities. In fairness, many AM stations did eventually come around, adopting a playlist of songs from higher up the food chain, although, for example, I was playing The Doors' "Light My Fire" a good six months before it aired on KJR. And with that, children, I -- whose voice was the vocal equivalent of week-old roadkill on a Tennessee truck route in mid-July -- with that I made my contribution to radio broadcasting.

I could have made another. One Sunday, as I waited to go on the air, a stranger dropped by KRAB's rather ramshackle one-story wood-frame studio. Thin as a spaghetto, the guy had long, wild black hair, a pointy black beard, and wore a Mexican poncho across which like a bandolier was strapped a cheap guitar. In other words, he looked not unlike a thousand or more other skinny, hairy, ostensibly musical young men then yo-yoing up and down America's West

Coast. He talked like them, as well, scarcely introducing himself (he said his name was Charlie) before treating me to an earful of peace, love, and total liberation. Even as he mouthed the prevailing hippie philosophy, however, he did it with an articulation that was impressive and an intensity that was nothing short of galvanizing.

The more Charlie talked, the more convinced I became that he not only truly believed that philosophy, he, for one, was actually living it. There was a *purity* about him, a blaze in his eyes, that bordered on the charismatic. I also had the sense that hanging out with him would be dangerous: not because he might prove mean, violent, dishonest, or crazier than anybody else I knew, but because he seemed both completely uncompromised and completely uncompromising. As Henry Miller said of Rimbaud, he was "like a man who discovered electricity but knew absolutely nothing about insulation."

At any rate, the dude said he wrote songs and wished to perform a selection of them on *Notes From the Underground*, with which he was somewhat, somehow (he was not a local resident) familiar. Ordinarily, I would have consented, for while my shows were fairly well organized, it would have violated their spirit, the spirit of the times, not to be open to -- even eager for -- change and surprise. The following morning, however, I was leaving on a monthlong jaunt to Arizona and for that show only I'd actually scripted a program with a beginning, middle, and end. Any interruption of the Aristotelian flow would have sabotaged it, completely wrecking the desired cumulative affect. So, I turned Charlie down and sent him on his way.

Visibly disappointed but polite enough about it, he shuffled off into the summer Sunday night and vanished there. Two years would pass before I recognized his picture in the newspaper and realized that for better or for worse, I'd rejected -- and turned down an opportunity to tape a live performance by -- Charles Manson.

the book

Throughout all those diversions -- the art columns, the happenings, the radio show, rock concerts, protest marches, pot parties, etc. -- the old literary pulse continued to throb in my blood. On occasion it would reverberate like a musical saw, but most of the time it beat like tom-toms: distant, faint, mysterious, yet persistent, somehow urgent, prompting my left brain to murmur, "The natives are restless tonight."

A novel had announced itself. It was coming to town. Posters were plastered on every wall in my cerebellum, a vacant lot in that vicinity had been reserved. The date of the first performance, however, was continually postponed. Obviously, annoyingly, there remained issues to be resolved.

I had my center pole, had had it for two years or more. The stolen corpse of Jesus and its reappearance in a funky roadside zoo: those elements could definitely support a literary big top. But a tentpole was not a tent and it certainly wasn't the show itself. I needed wider context, a backdrop, a milieu; needed atmosphere, subplots, and a company of performers. Embedded in it as I was, it took time to recognize that the show I sought was unfolding all around me. Faulkner had his inbred Southern gothic freak show, Hemingway his European battlefields and cafés, Melville his New England with its tall ships: I had, it finally dawned on me, a cultural phenomenon such as the world had not quite seen before, has not seen since; a psychic upheaval, a paradigm shift, a widespread if ultimately unsustainable egalitarian leap in consciousness. And it was all very up close and personal.

Now, not to belabor the circus analogy, but I must mention that I'd also recently found a ringmaster, a music director, a designer to set the overall tone of the show; which is to say, I had at last found my voice. I discovered it very late one night in July 1967, while writing a review of a Doors concert for the *Helix*, Seattle's underground newspaper. My review and the tone I found myself adopting in its composition were not derivative, not specifically influenced by Jim Morrison's blood-dark, leather-winged poetics. Rather, it was that the concert had energized me in a peculiar and powerful way. It had jimmied the lock on my language box and smashed the last of my literary inhibitions. When I read over the paragraphs I'd written that midnight, I detected an ease, a freedom of expression, a syntax simultaneously wild and precise, a rare blending of reckless abandon and tight control; and thought, *Yeah, this is it. This is how I want to sound.* I'd broken on through to the other side.

Even so, writing a novel set in the sixties presented a challenge on at least two fronts: one was immediate and obvious before I even began. The other -- reactive and unforeseen -- inexplicably persists to this day. Of that, more later.

Tom Wolfe, my old schoolmate, has lamented that there has yet to be written a definitive novel of the sixties. Wolfe, of course, is an outspoken advocate of the nineteenth-century approach to the novel, the reportorial approach that amounts to journalism with a thin fictive gloss. I'd instinctively realized, however, that the Dickensian method, while it has its virtues, was simply inappropriate to the material at hand. It could not possibly crack the nut of the period, penetrate its essence; or untangle the multicultural, multicolored web of myth that enwrapped its heart. The sixties, you see, were characterized not by manners but by fantasy.

Fantasy being inscrutable under the microscope of social realism, I (again, instinctively), knew I must compose *Another Roadside Attraction* (I'd recently decided on a title) in a fashion for which there was no satisfactory model. My intent therefore became not so much

to describe the sixties as to *re-create* them on the page, to mirror in style as well as content their mood, their palette, their extremes, their vibrations, their profundity, their silliness and whimsy (for despite the prevailing political turmoil, it was a highly whimsical age). Professor Liam Purdon of Doane College, addressing me personally, has written, "You committed to becoming a novelist during turbulent times. When the blank page offered resistance to the vortex of your imaginative creation, you began, as Burroughs did later in his writing career, simply to alter the novel form itself."

Traditionally, a novel moves from minor climax to minor climax to major climax along a gradually inclined plane. But while 95 percent of all novels are constructed this way, it was not a form that could possibly generate the plexus of effects, let alone evoke the gestalt, necessary to unveil the sixties and make them palpable, to coax them into giving up their secrets great and small. Eventually, it became clear to me that I must construct *Another Roadside Attraction* in short bursts, modeled perhaps on Zen koans, on Abstract Expressionist brushstrokes, and on the little flashes of illumination one experiences under the influence of certain sacraments. My book's goal, then, was not so much to simulate reality as to *become* reality, a reality paradoxically steeped in fantasy.

Needless to say, such a novel -- a novel constructed of zip and zap and zing and zonk, a novel that does its own stunts -- seemed destined to test the mental agility of the critical establishment, but that was hardly my concern, particularly since I'd yet to put a word of it on paper. The tom-toms were nearer, louder now, however, the gong was interrupting my sleep; and the morning after I'd kissed off Charles Manson, as my new girlfriend and I motored down Highway 101 in a 1949 Dodge panel truck (hand-painted silver), the opening lines of *Another Roadside Attraction* were crawling along the screen behind my eyes.

Eileen had decamped a few weeks prior. We had an intense relationship, she and I, a union in which we seemed constantly competing to see who could most successfully blow the other's mind. We each took a fierce delight in introducing the other to some new idea or development, the next amazing artist or record album, always hustling to out-*avant* the other's *garde*. It was exciting, stimulating, but also draining, especially when coupled as it was with mutual romantic jealousy, arguably the dumbest, most useless of human emotions. In the end, Eileen trumped me, captured the flag, by packing up and moving to San Francisco, the epicenter of the new American revolution. *Touché!*

Eileen's car was barely out of the driveway before -- vacillating between heartbreak and relief -- I drove over to the Pizza Haven in the University District and (figuratively speaking) wrapped up the joint's cutest waitress in a checkered napkin and brought her home. Terrie Lunden had been flirting with me outrageously every time·I went in for a pizza. She'd attended a lecture on experimental theater I delivered at Seattle's Free University and had developed a crush on me that evening. I didn't remember her from the class, but at the Pizza Haven she was hard to ignore. Always smiling, constantly cheerful, Terrie was as easygoing and uncomplicated as Eileen was challenging and complex. As an anecdote, a relief package, she struck me as an ideal companion for my projected road trip to the Southwest desert.

We never made it to Arizona. Stopping by San Francisco to pay respects, we remained there for a month, sleeping and eating (tomato sandwiches, naturally) in the back of that old silver panel truck, parked on a side street in the Haight-Ashbury, too mesmerized by the scene thereabouts to any longer consider Tucson or Sedona. We visited museums, City Lights Bookstore, and the waterfront; danced to throbbing amoebas of light at the Fillmore and Avalon ballrooms (children and dogs scampering in and out among the dancers), but mostly we wandered the Haight, where there seemed to be no end to the spectacle, the psychedelic parade, the blossom-choked river

of liberated meat. More than the ubiquitous costumes representing a multitude of periods and exotic lands; more than the relaxed smiles, blatant sexuality, and free-flowing gender-bending tresses, what impressed me most was the genuine spirit of caring and generosity emanating from virtually everyone I met.

Should I admire a passerby's Edwardian waistcoat or Japanese silks, that fellow would insist that I have it, a stranger would literally give you the shirt off his back. If, on a hot street, I'd glance appreciatively at someone's ice cream cone, she'd offer me a lick or else thrust the whole cone in my hand. The Haight was awash in Christian charity. These kids, simultaneously jubilant and introspective, were practicing what their elders preached. The Haight was the New Testament: animated, activated, brought to life in living color. The naïveté was so thick you could cut it with a Popsicle stick -- but so apparently was Christ's. Years later, on a wild African savannah a hundred miles from even the crudest settlement, a pride of lions on one horizon, a solitary giraffe on another, I said to myself, "This is the way the world was meant to be and everything else is a mistake." I'd thought the exact same thing in San Francisco during the Summer of Love.

Oh, and yes, by the way, I did search for at least a glimpse of Eileen in the exultant throngs along the Haight. She never appeared.

When, upon my return to Seattle, I actually sat down and commenced writing that first novel, I set no scenes in Haight-Ashbury. There were no light shows in my narrative, no love-ins, street theater, free clinics, demonstrations, rock festivals, or other public celebrations. My goal, as previously stated, was not to describe the sixties phenomenon as a journalist or historian might, but rather to encapsulate it, privatize and personalize it; boil it down to a reduction, distilling its esoteric yet peculiarly American rapture and uncorking that essence within the confines of a hot-dog-stand-cum-roadside-zoo in rural, rainy Washington state.

To fortify that distillation, I did from time to time make use of a collage technique, whereby I would skim through the underground press, KRAB radio program guides, political and poetry broadsides, concert fliers, even letters from friends, and try to pluck some quaint item or revealing image that, though taken out of context, might add historical weight when pasted into my more intimate, internalized portrait of the period. (In my second novel, the twilight-of-the-sixties' *Cowgirls*, I would continue to collage occasionally, but only in regard to the book's male protagonist, the Chink, who was partially inspired by R. Crumb's crusty old cartoon antihero, Mr. Natural, and partially based on the subject of a prank "news" article that Paul Dorpat anonymously wrote and planted in his Seattle alternative weekly, the *Helix*.)

As Professors Purdon and Torrey suggest in a lengthy interview with me (*Conversations with Tom Robbins*, University of Mississippi Press, 2010), much of the content and style of *Another Roadside Attraction*, as well as of the anthropological and mythological aspects of the age in question, are personified in the novel's two main protagonists, Amanda and John Paul Ziller. Both characters could be considered archetypes: the loinclothed, flute-tooting Ziller an Orpheus figure, using his music, his art to simultaneously charm the world and retaliate against it, all the while identifying with another place, a distant time; Amanda, a manifestation of the universal goddess (maiden, slut, and mother/wife), as connected to the earth as any mushroom, though given to innocently flitting about its posies like a butterfly. She's wise, yet also naive, he's playful yet also dark; and something strangely meaningful seems to cling to them.

All that sixties phantasmagoria was well and good -- fun to write, important to consider -- but remember, the center pole supporting this show, its fulcrum, was to be a certain mummified corpse. Since the very foundation of what many call Western civilization is its faith in the divinity and immortality of the man some call Jesus Christ, what would it say about the future of that civilization, about

its ethics, morality, belief system, history, moods, and general psychic
health if it could be irrefutably demonstrated that Jesus was not im-
mortal, had not risen from the dead, and that the Church of Rome
had been concealing proof of its presumed Savior's fallibility for more
than seventeen hundred years? My goal was to examine the ramifica-
tions of that question, and to incorporate them within a lively narra-
tive constructed of incremental flashes, some which would illuminate
and advance the plot, some which (I hoped) would illuminate and
advance the reader.

Distractions still abounded, but in the autumn of '67 I mailed off
thirty pages to Luther Nichols in California. He read them approv-
ingly and sent them on to New York. I was fishing for a monetary
advance. It was only then that I learned that Doubleday had begun
as a Roman Catholic publishing house. A number of senior editors,
holdovers from that period, were appalled by my manuscript's prem-
ise, baffled by its form. So, no contract, no money. Encouraged by
Mr. Nichols, however, I persisted -- until eventually, sometime in
'68, I had written seventy pages more. These, too, Luther Nichols
forwarded to New York.

This time I was told that the younger editors at Doubleday loved
what and how I'd been writing, but had failed to convince their supe-
riors to spring for it. The elders had softened their initial objections,
but complained that they couldn't tell where the book was going.
Really? Welcome to the club. Except perhaps down in the shadowy
catacombs of my subconscious, I didn't know where it was going ei-
ther. Moreover, I didn't want to know. Discovery was part of the pro-
cess, was what enthralled me, made writing an adventure instead of
a drudgery, a journey instead of a job. It was V. S. Naipaul who said,
"If a writer knows everything that's going to happen, then his book is
dead before he begins it." In any case, my disappointment was offset
by the fact that now, a hundred pages into the book, it had taken over
my life, had assumed a life of its own. I couldn't have stopped it with
an atom bomb.

At this juncture, to move forward, two things were required. I needed to pry myself loose from Seattle's art community and I needed sufficient income to charm the groceries. As if on cue, the gods grinned. First, I landed a weekend gig on the copy desk of the *Seattle Post-Intelligencer*. Then, Terrie's sister offered us cheap living quarters in the little town of South Bend, Washington, a waterfront village physically not unlike La Conner (where I hadn't been able to find a rental I could afford), but almost La Conner's opposite in temperament, the one boasting a concentration of artists and an unusually high level of sophistication; the other quite crimson in the hue of its necks, populated with hard-drinking loggers freighting a logger's sublimated guilt.

On our first night in South Bend, we were kept awake beyond midnight by teenagers driving past the house, honking horns and yelling "Hippies! Hippies! Dirty hippies!" Terrie was quaking, but I calmed her. "Don't worry," I said. "Not a problem. It's the beginning of love."

Sure enough, it wasn't long before kids started dropping by two or three at a time, sheepishly curious; and ere a month passed before our living room was filled virtually every night with teenage boys digging our record collection, questioning us about current events (including the Vietnam War), sex (evasively), drugs (we never gave them any), and rock and roll (through my KRAB connections, I always had the latest albums). We might as well have been the local Boys and Girls Club. I considered requesting funding from United Way.

Terrie took a job waiting tables at a nearby seafood restaurant, from where she would fetch home leftovers off her customer's plates. Indifferent to germs, we dined heartily and happily on slops de la mer. Is it any wonder that I've maintained a soft spot in my heart for waitresses? Many writers subsist on grants from foundations. Mine

have been from the waitresses of American. The Daughters of the Daily Special.

As my contribution, I drove to Seattle and the *P-I* copy desk every Saturday morning, returning to South Bend late Sunday night, except during summer vacation periods or holiday weeks when I would sometimes work three or four days in a row. In the city I'd take a room at the Apex Hotel, located on a dull, pregentrified block of First Avenue. At three dollars a night, the Apex was kind of an upper-story flophouse, but operated by a Japanese couple who kept it orderly and clean. Still, it reeked of cigarette smoke, its mattresses felt like sacks of softballs, the bedsprings squeaked like thickets full of mating chipmunks, and the wallpaper would have given Oscar Wilde a heart attack.

In the Apex's favor, aside from its rates, was the privacy it afforded. I always signed the guest register as "Picasso Triggerfish" (the English name of the neon rainbow-hued fish the Hawaiian's call "humuhumunukunukuapua-a"), and declared my place of residence as "Victoria, BC" (I guess I was Victoria's secret). When friends would come to the Apex looking for me, the owners would claim, "No such person here." A war protester and outspoken critic of U.S. foreign policy, I enjoyed a certain sense of security (as secure as one could feel sleeping on beds that creaked all night like Frankenstein's shoes) to think that even the FBI probably couldn't find me at the Apex Hotel.

In those days, the *P-I* newsroom was as divided as the nation itself. An uneasy truce existed between the old guard of Hearst hirelings and the mostly younger employees who marched to different, more progressive drummers. The latter were tolerated only because we did good work. Weekly prizes were awarded for the best headlines, prizes which Darrell Bob Houston (an unruly genius Blue Moon denizen and Tarzan lookalike) and I won so consistently that other copy editors were inclined to just stop trying. The parent Hearst Corporation

frequently praised the *P-I*'s headlines, which kept the bosses content. Our work, moreover, seemed to suffer not at all when on slow nights between editions Darrell Bob, a couple of others, and I would sneak up on the roof to smoke a joint.

One night, however, a coworker brought in some blond Lebanese hashish, just off the boat, which we felt compelled to go up and sample. Back at the desk, I recall staring at the copy in front of me for an inordinately long time, as if it were the footprint of some alien life-form that I was ill equipped to identify. I don't believe I won any prizes that night.

Which reminds me, I'm always astonished when readers suggest that I must write my novels while high on pot or (God forbid!) LSD. Apparently, there are people who confuse the powers of imagination with the effects of intoxication. Not one word of my oeuvre, not one, has been written while in an artificially altered state. Unlike many authors, I don't even drink coffee when I write. No coffee, no cola, no cigarettes. There was a time when I smoked big Havana cigars while writing, not for the nicotine (I didn't inhale) but as an anchor, something to hold on to, I told myself, to keep from falling over the edge of the earth. Eventually, I began to wonder what it would be like to take that fall. So one day I threw out the cigars and just let go. Falling, I must say, has been exhilarating -- though I may change my mind when I hit bottom.

Indicative of the cultural schism at the newspaper was the response to the death of Jimi Hendrix. When the report of the rocker's untimely demise came over the Associated Press wire, our news editor snarled, "Who cares?" He wadded up the copy and tossed it in a trash can. Incredulous, I retrieved it and carried it into the managing editor's office, explaining that Hendrix was not only an international star, he was a Seattle homeboy. The story ran in a prominent spot.

The *P-I*'s managing editor (he happened, luckily for me, to be Louis R. Guzzo, my former boss in the arts and entertainment department at the *Times*) was adept at keeping peace between the factions. I'd

had an artist friend make me a mouse mask: not just any mouse, not that twit Mickey, but one of the long-nosed secret-agent mice featured in the *Mad Magazine* strip "Spy vs. Spy." One evening I wore the mask to work. As I sat at the copy desk, doing my job, the radically stylized rodent nose protruding a good twenty inches from my face, an undercurrent of murmuring coursed through the newsroom. At one point, the managing editor passed by and, inescapably, noticed my paper proboscis. Guzzo stopped in his tracks. He just stood there staring at me, his hands on his hips. A hush fell over the room. All typing ceased. My cohorts were fearing for my job, my detractors were hoping I'd be summarily sacked. After a long pause, the boss said, "Robbins, you've never looked better." He walked away. And that was that.

A month later, however, I was sent back to the Apex to change when I showed up for work in a gorilla suit.

It was at the *P-I* copy desk that I received the phone call from Luther Nichols telling me Doubleday had accepted *Another Roadside Attraction* for publication. This was around the middle of 1970. I'd finished the novel all ashiver one frigid midnight (we'd run out of heating oil) that January, and over the next six weeks or so slowly retyped the handwritten manuscript on my rackety little Olivetti portable, then paid a professional typist to render an even cleaner copy. This I'd mailed to dear Mr. Nichols, who forwarded it to New York, where, at Doubleday headquarters it was once again the subject of considerable debate. This time the younger editors prevailed.

Subsequently, a contract arrived, offering me an advance of $2,500, modest even for the time, along with a basement-level royalty percentage, standard for a first-time novelist lacking an agent to negotiate for him a sweeter deal. Not that I gave a large rat's poot, understand. My motives for writing fiction -- which, of course, date back to early childhood -- have always been kindled by a runaway imagination and a love of words, rather than any banal craving for

fortune or fame. Believe me, I take no credit for that attitude, and would never attempt to attribute it to strong moral principles. Fate just happened to have wired me that way.

A hardcover edition of *Another Roadside Attraction* was published ("printed" may be a more accurate term) in 1971. Only six thousand copies were run off and there was little in the way of promotion: no signings, book tours, interviews, or public readings. (I just felt grateful there wasn't a public hanging.) Despite acclaim from authors as diverse as Graham Greene and Lawrence Ferlinghetti, the critical establishment either dismissed the book curtly or ignored it altogether. Its first published critique appeared in *Kirkus Reviews*, in whose pages some sage declared that *ARA* wasn't a novel at all but, rather, a lot of record album titles strung together as prose. Is it churlish of me to smirk ever so slightly when I point out that forty-three years later, the book is still in print, continuing to sell?

It was neither surprising nor particularly vexing that the hardcover edition was generally panned or ignored by reviewers: *ARA* was a radical departure in both content and form, operating outside the comfort zone of the typical critic. What *has* been unexpected is that so many members of the academic and journalistic establishment continue to this very day to hang that first novel around my neck like some literary albatross.

Since *ARA*, I've published eight more novels, most of them international bestsellers, and featuring such protagonists as CIA agents, stockbrokers, freelance perfumers, mythological figures, and U.S. airmen missing in Southeast Asia. Not one of these books is set in the sixties. Yet I'm regularly identified in the press as a "counterculture writer." Now, if by "counterculture" they mean "bohemian," that I'm ever reluctant to submit to the constraints of mainstream culture (the mainstream being too often shallow and prescribed), I accept the designation with pride. Alas, in an example of typecasting unprecedented in literary history, they seem always to be referring to the sixties, as if still so threatened, so spooked by that era and its liberties

that they fear, decry, and resent it even when it isn't there. It was an extraordinary, magical, even heroic time, that much I'll never deny, but in my novels and in my life, for better or for worse, I moved on from the sixties decades ago. Wouldn't one think the era's detractors in the media could get over it as well? One can't help but be amused.

I confess I was somewhat surprised and disappointed that not one reviewer had the courage or curiosity to ponder in print the question of what repercussions might be engendered by the proven mortality of Jesus, but my biggest disappointment in the wake of my novelistic debut lay somewhere else. In *ARA,* one of the characters steals a baboon from Seattle's Woodland Park Zoo. Well, three weeks after the novel came out, someone *did* steal a baboon from the Woodland Park Zoo. I'm not kidding. You can look it up in the archives of the *Seattle Times,* it was all over the news. I was totally convinced that my buddy Darrell Bob Houston had snatched the baboon in order to call attention to my book. He was entirely capable, in the name of friendship, of pulling such a caper. However, the animal was recovered unharmed after a couple of days and the thief proved to have no awareness that his life had been imitating art. Now *that* was a letdown.

The hardcover edition of *Another Roadside Attraction* didn't exactly fly off the shelf, but the mass-market paperback enjoyed an enduring and profitable fate, though from an appropriately quirky beginning it traveled a slow and winding path. In those days, major publishing houses produced only hardcover books. Paperback rights of the more successful books would be auctioned off to paperback publishers, who'd bring them out in smaller, cheaper editions once hardcover momentum had flagged. Paperback specialists would also pick up less successful hardcover titles they felt might stand a better chance on drugstore and supermarket racks.

Ballantine Books was one such mass-market publisher. One Friday afternoon, an editor there named Leonore Fleischer filled a

shopping bag with orphaned hardcovers to take home and read over the weekend on the chance that she might find something worthy of a Ballantine reprint. That night, Leonore stacked a half dozen or so books on her bedside table. Then she got into bed and smoked a joint. As she shuffled through the books at her side, looking for the most promising read, her eyes -- her now stoned eyes -- became fixed on *Another Roadside Attraction*. Well, if you've ever seen the bizarre hardcover jacket of *ARA* (I designed it personally), and if you've ever been stoned, you will understand completely why Leonore selected my book from the other more conventional candidates.

Championed by Ms. Fleischer -- to her (and perhaps to marijuana) I owe an undying debt -- Ballantine published *ARA* in 1972. It sold not steadily but in spurts, fueled strictly by word of mouth, the most flattering of all forms of advertising. Just when it would appear to be on the verge of disappearing, I'd receive a note from Leonore advising me that we were going into yet another printing.

Occasionally, I'd get a whiff of the novel's underground reputation. One day in La Conner, where I'd moved soon after completion of the manuscript, a local painter brought by my house a couple, two old friends of his from back east, who'd just driven cross-country in a VW bus and who had a story to tell.

It seemed they had stopped for a few days at a roadside campground in New Mexico. Also camping there was a solitary man in his twenties. This stranger sat at a wooden picnic table most of the day, every day, reading a paperback book with a weird cover. The tome, they eventually noticed, was *Another Roadside Attraction* by someone named Tom Robbins. When, on their last day there, the man finished the book, he slammed it down on the table with a resounding swack. To no one in particular -- to the sky, the pine trees, the jaybirds, and squirrels -- he exclaimed, "Fuck man! The novel is NOT dead!"

With an endorsement like that, who needed *Kirkus Reviews*?

birds of a feather

Smelt-nibbled, duck-dotted, rain-swept, and muse-blessed, La Conner, Washington, is a collection of frontier north-to-Alaska false-fronted stores (interiorly gentrified but externally little changed since the 1890s); most of which are perched over water on pilings, the buildings looking a bit rickety and forlorn in the mist, yet echoing a certain boldness of spirit they seem to share with the gulls that attend them the way bees buzz about a hive. If La Conner sounds like a fishing village, that's what it used to be -- before the Army Corps of Engineers (infamous for turning proud wild rivers into industrial ditches) dredged the Swinomish Slough; before it was discovered that salmon and civilization don't mix.

Hemmed in by estuary water (a cocktail composed of equal parts fresh Skagit River and salty Puget Sound), an Indian reservation, and vast acreage of alluvial farmland so juicy rich you can almost hear it gurgling like the tummy of an overfed infant, La Conner is nevertheless expansive in other, less tangible ways. Amidst the marsh grass and driftwood, the cattails and silt beds (the campus of the Academy of Mud), it's not overly fanciful here to think of blue herons wading in paint jars or poets throwing blackberries at the moon.

Morris Graves was the first artist to settle in La Conner. It was 1937 and Graves was more than a decade away from art-world stardom. He was, in fact, so poor at the time that he lived in a burned-out house, the charred floors of which he'd covered with sand, raking it to resemble the sand gardens of the famous Zen temple in Kyoto. Bearded, gaunt, birdlike, he walked around town with a length of old

rope holding up his pants, an intense but benevolent flame in his eyes. People didn't know what to make of him at first. Unfamiliar with the term "bohemian," and as "beatnik" and "hippie" hadn't been coined yet, some locals -- desperate for a category, a label -- decided he must be a Nazi spy. It wasn't long, however, before Graves (imbued with an almost supernatural presence) won them over.

Single-handedly, Morris Graves raised the consciousness of La Conner, paving the way for other artists (a few themselves on the long road to fame), art lovers, and the usual hangers-on to settle here. Beautiful, peaceful, private, and inexpensive, it became also, thanks to Graves's pioneering, that rarity: a small rural community welcoming to strangers, culturally hip, tolerant of eccentric dress and eccentric behavior. In little La Conner, you could -- and can -- be yourself to the fullest extent of yourself, a freedom you normally would have to go to a large city to enjoy.

There was yet another feature attractive to impecunious creative types. Or maybe just to me. Immediately to the east of town were seemingly endless fields of vegetables: cauliflower, cabbage, spinach, and beets, grown not for the fresh produce markets but for seed, and thus left unharvested for conveniently long periods of time. Convenient, that is, for Terrie and me, who regularly would embark on midnight produce raids. Having quit the *P-I* to concentrate exclusively on my second novel, I'd become, by circumstance, unfamiliar to the cashiers at Thrifty Foods and Safeway. Our pillage, while not really putting a dent in any farmer's crop, provided needed nourishment and even a taste of romantic adventure, the ever-present risk of apprehension offset by the almost surreal beauty of the fields, where long rows upon rows of cabbage, rotund and silvery in the moonlight, suggested the marbles in a game of Chinese checkers set up for the amusement of the Jolly Green Giant.

Keith and Maxine Wyman, the older couple who'd introduced me to the pleasures of the mushroom hunt, the bird watch, and the bacchanalian salmon barbecue, and who'd become in a sense my sur-

rogate parents, had finally found a small but charming house I could rent in La Conner, and Terrie and I moved into it on April 1, 1970. (I recommend that you make all of your major moves on the first of April. Just in case.) That September, as the cabbage went to seed, spelling an end to our surreptitious agricultural subsidies, the *ARA* advance money arrived from Doubleday. For Terrie, I filled a larder with conventionally procured supplies. Then I bought myself an airline ticket to Tokyo.

Ever since my troop ship sailed out of Yokohama Harbor in late 1955, I'd longed to return to Japan. It was that longing that had lured me to Seattle, where, I'd hoped, graduate study at the UW Far East Institute could lead to work as a correspondent in Asia. I'd been waylaid by visual art, a consuming seductress, but now here I was, fifteen years later, buying my own ticket to that weird and exquisite land where jujitsu warriors wrote nature poems, stunningly sexy women kept crickets as pets, and nary a geisha would raise a plucked eyebrow should I decide to chow down on a chrysanthemum. It wasn't merely a rainbow chase, however; I had a legitimate, practical reason for flying to Japan: as research for my second novel, I needed to see some whooping cranes.

Now, you needn't be an ornithologist to know there aren't any whooping cranes in Japan. Ah so. Whoopers -- and there was only one small, imperiled flock of them extant in 1970 -- summer at a remote lake in northern Canada, winter on a protected island off the Texas coast. In neither location was it possible to get close enough to view them in any meaningful way. There is, however, a somewhat compact version of "our" majestic crane that summers in Siberia and spends the rest of the year in northernmost Japan, where, at a park near the city of Kushiro, they can be observed without the aid of binoculars. Known as the *tancho zuru*, this bird has identical markings to its larger North American cousin, which is to say black wing tips

and a bright red "skullcap." (By the time the bird guys got around to naming cranes, I guess "cardinal" had been used up, though for all I know *tancho zuru* means "pope" in Japanese.)

In the novel I'd just begun, whooping cranes were to serve both as hostages and as living inspiration for the illegal occupiers of the largest all-girl ranch in the west, the birds chosen (doubtlessly in a spasm of anthropomorphism) for what I perceived as their conscious, defiant decision to risk extinction rather than conform; rather than alter their ancient patterns of behavior to accommodate the gassy, brassy intrusions of Homo sapiens, an invasive species that is by nature an unnatural animal. In any case, research led me to believe that the *tancho zuru* would serve as an adequate substitute, a visual model, for the more evasive whoopers, so I set out across the Pacific to look them over.

Darrell Bob Houston was already in Japan. He'd landed an Alicia Patterson Foundation journalism grant to study and write regular reports on the subject "Youth in Asia." (When he first told me about it, as I was leaving the *P-I*, I thought he meant "euthanasia," which not only creeped me out but struck me as odd, Japanese being traditionally so well versed in hara-kiri they shouldn't require outside help in ending it all.) Darrell Bob met my flight and after a copious introduction to Asahi beer at a sushi joint, he set me up in the tiny one-room apartment he'd rented as writing-studio-cum-love-nest for trysts with his Japanese paramour, Yoko. (Not *that* Yoko.) My Tarzanesque pal was married, you see, and his Seattle family had recently joined him in Tokyo.

The room was in Otsuka, a working-class district, and it sat above a kind of greasy chopstick restaurant named Ichi-ban. It was in that plain but self-aggrandizing eatery (*ichi-ban* in translation is "number one") that I took my nightly dinner as I waited for D.B. and Yoko (she lived with her parents in an upscale neighborhood) to find

time to accompany me on my hunt for the surrogate whooping crane. After dinner, night after night, as typhoon-season rains drenched Tokyo, I'd sip beer and watch European (including Czech and Yugo-slavian) movies with Japanese subtitles on the Ichi-ban's twenty-four-inch black-and-white TV.

One night the feature film was American. A World War II drama about U.S. airmen flying missions over Germany (Japan's wartime ally), its dialogue had been dubbed so that the American pi-lots were all spouting Japanese. Sitting there by myself amidst a scat-tering of non-English-speaking trolly workers, drinking Asahi and watching a global hodgepodge of a movie while a furious rain lashed the cement-and-rice-paper facade of that dingy building alongside the tracks, I don't think I've ever felt more disoriented and alone. Or more thoroughly, serenely, at home. Every true romantic will know what I mean.

In Japan, my typical ensemble included faded jeans, rodeo shirt, leather vest, black cowboy hat, and a short, stiff lasso with which any suburban New Jersey tenderfoot could have performed ersatz rope tricks. Why? I'd had the dumb idea that the Japanese would be as surprised and delighted to encounter an American cowboy in their midst as an American might be to come across a friendly samurai warrior on the streets of, say, Cheyenne or Little Rock. Wrong! Oh, they were surprised all right, but that turned out to be the problem.

Whenever I met someone on the street, he or she would imme-diately avert their eyes. Occasionally, pedestrians would stop dead in their tracks and turn their back on me until I had safely passed them by. The first time I rode the train, the person I sat down next to rose and moved to the far end of the car. When, with a puzzled expression, I looked to the passenger on my other side for sympathy or at least an explanation, he got up and moved, as well. Such rejection became a regular occurrence. Did the citizens of Tokyo harbor a deep-seated

hatred of cowboys? Did they blame Hopalong Cassidy and Billy the Kid for bombing their city back in the forties? Wasn't the great film director Akira Kurosawa heavily influenced by American westerns?

As I was soon to learn, the Japanese are not a spontaneous people. The Japanese are not fond of surprises. As emotionally fettered by their ancient traditions as they are aesthetically enriched by them, Japanese stoically recoil from any public display of feeling, or any event that might catch them off guard and precipitate a perceived loss of face. They've loosened up noticeably in recent years, but in 1970, loss of face remained a fate next to death. All that legendary politeness? The truth is, when the Japanese bow and mutter, "So sorry, so sorry," what they are really saying is, "Ten thousand curses on me for ever finding myself in a position where I am indebted, however slightly and briefly, to *you*."

The lone place in Tokyo where my cowboy drag was appreciated wasn't the Ichi-ban, where both staff and clientele exhibited persistent indifference, but, rather, a little *okonomiyaki* joint a couple of blocks away, where I usually lunched.

Okonomiyaki is a dish with an identity crisis: it doesn't seem to know if it's an omelet or a pizza. It's round and flat like a pizza, but has the eggy consistency of an omelet, albeit an omelet topped with chicken, shrimp, or octopus (diner's choice) and slathered with a tangy dark brown preparation ("bulldog" in translation) composed of soy sauce, spices, and apple butter. The place in my Otsuka neighborhood served nothing but *okonomiyaki,* which it cooked directly in front of each individual diner on a long narrow grill that ran the length of the counter.

The two countermen had hair almost as long as my own -- a rarity in Japan in 1970 -- and in me seemed to recognize a kindred spirit, grinning like short-order Buddhas when I presented them with color postcards depicting cowboys on horseback and Indian chiefs in full headdress. I signed the cards "Buffalo Silver," the name I decided to travel under in Japan, and when I'd enter the establishment

after a morning of visiting Zen temples and Shinto shrines, they'd shout out in unison, "Buffaro Sirver!" The rest of our discourse, once I selected my choice of topping, consisted entirely of loud and abrupt exchanges of band names. Apropos of nothing beyond camaraderie, I'd suddenly exclaim, "Grateful Dead!" and one of them would yell back, "Rorring Stones!" I'd shout "Beach Boys!" and they'd respond, "Beaters!" As a traveler in a strange land, I don't know that I've ever experienced a more satisfying conversation.

On what haiku master Basho called "the road to the far north," we sorely tested the Japanese tolerance for exuberant public display: "Buffalo Silver" in his dopey cowpoke outfit, six-foot-five Darrell Bob signing inn registers as "Victor Mature Jr." (after an actor he believed -- incorrectly -- he resembled more closely than he did Johnny Weissmuller); and diminutive Yoko, who presented herself in English to her disapproving northern countrymen as "Miss Chocolate Cake," a tribute to the thing she most admired about Western civilization.

On trains, encouraged by quantities of beer, we were as unrestrained in our deportment (having led Yoko egregiously astray) as the Japanese passengers were closed and reserved, believing all the while, as we sang Hank Williams tunes, drummed on Asahi cans with chopsticks, and occasionally exercised in the aisles, that we were setting an example of how less tiresome life can be when people relax their grip on their egos and indulge the innate human capacity for playfulness; though in actual fact we were probably just assuaging any lingering guilt the Japanese might have harbored about Pearl Harbor.

(Hmmm? Remembering Pearl Harbor, I must concede that under certain conditions the Japanese have, indeed, demonstrated an affection for surprise.)

Kushiro proved to be a drab, dog-bitten port city, reeking of urine and fish, and enveloped in a gray air of unspecified danger. It

was as different from Tokyo as Marseille is from Paris; it could have been Palermo to Kyoto's Florence. The fact that its lone movie theater had external speakers and that the sound track blaring for two grimy blocks along the waterfront was that of *Rebel Without a Cause* (it was as if Natalie Wood, my boyhood goddess, my first herald of oceanic love, was once again addressing my heart, lighting my way in this shadowy town) contributed to a municipal ambience that was less cosmopolitan than it was just plain queer.

Thus it seemed only fitting when, the next morning, as we boarded the bus that would take us to the crane sanctuary, five or six kilometers out of town, the bus station sound system was broadcasting an American march, the one with the alternative lyrics that begin "Be kind to your fine-feathered friends . . ." Nor was the park itself any less of a bicultural oddity, for one entered it on foot through a gate in the largest Coca-Cola billboard I have ever seen. On an arch above the billboard were words in Japanese and English. The English read: SACRED CRANES/AKAN NATURALEY PARK. Naturaley.

There wasn't an abundance of cranes in residence, that autumn being sufficiently mild to delay a wholesale migration from Siberia, but we did get a good close look at the early arrivals. Near the plastic chain-link fence that separated the miles of boggy crane habitat from human visitors, park rangers had strewn ears of corn, and the cranes showed no hesitation about approaching us gawkers to peck at their breakfast: like the whooper, the *tancho zuru* is not a meek bird. Its defiant nature, its refusal to compromise its way of life to adjust to human "progress," may be one reason Asians regard the crane as sacred, a veneration American oil drillers and the Army Corps of Engineers fail to share.

While we weren't treated to the cranes' magnificent mating dance, a performance unequaled in all of nature (including John Travolta in *Saturday Night Fever*), the seventeen birds near the fence were no more sedate than we Yanks had been on the train; hopping about on pogo-stick legs, spreading their wings (a span of a

good seven feet), pointing their beaks at the sky, and bellowing, often in duet, a call that resembled an amplified extract of Tokyo traffic. After a voyeuristic couple of hours, I figured I'd absorbed enough direct craneness to complement my library research, so we returned to Kushiro where, as our lumbering, squid-eyed innkeeper (he reminded Darrell Bob and me of Lenny from *Of Mice and Men*) served us a lunch of spiky-crab legs, red caviar, and seaweed, the disembodied voice of Natalie Wood once again came floating over the broken-tiled rooftops and dirty cement, making even the ubiquitous deposits of soot-speckled gull guano seem holy and right. Kushiro *mon amour.*

We parted company at the airport in Sapporo, a larger, brighter city to the southwest, so that Victor Mature Jr. could become Darrell Bob Houston again and attend to his assignment and his family back in Tokyo. We hugged good-bye, an embrace that caused men in the vicinity to turn away in ill-concealed discomfort. Miss Chocolate Cake bowed to me and said, "Up against the wall, motherfucker." Darrell Bob had taught her the phrase, and having no idea what it meant, she said it softly, sweetly, as though it were the most sentimental of endearments.

Alone now, I took a train down the dragon tail of Hokkaido (as spiky as a Kushiro crab leg), from where, on foot, I boarded a ferry to cross the strait that separates Japan's northern and central islands. It was dusk and as the big vessel steamed out of Hakodate harbor, the sun was setting in one quadrant, a full moon was rising in another. On all sides of us, the open water was dotted with tiny wooden boats, each outfitted with luminous paper lanterns whose light was useful for attracting squid. It was as though the gods had plunked me down in the middle of a Hokusai wood-block print from the early nineteenth century. A solitary figure on the uppermost deck was playing a flute, ethereally, wistfully, as if coaxing the stars out of hiding, and,

heart drumming an earthy accompaniment, my deep attraction to Japanese culture was rekindled.

In disdain for grimy Kushiro and the Coca-Cola commercialism of its "naturaley" crane park, I'd lost sight of *wabi-sabi,* the aesthetic of finding beauty in the imperfect and unexpected; the secret, private joy of being ever attuned to the Zen of things. These days, when people refer to Japan's World War II atrocities, to its work-until-you-drop corporate climate, to its incongruent penchant for littering and polluting, and its reprehensible slaughtering of dolphins and whales, I remind myself of that most Zen of counterbalances: a big front has a big back.

On the flight home across the Pacific, I sought refuge from nippophilic brooding by reading a paperback novel. The book was Vonnegut's *Slaughterhouse-Five,* which, though it proved to have nothing to do with that branch of the Jackson family that went into the meatpacking business, succeeded pretty well in diverting me. I would not see Japan again until 2002, at which time I traveled the country on a reading and lecture tour sponsored -- believe it or not -- by the U.S. Department of State. A big back has a big front. Naturaley.

the american way

A foreign visitor can but speculate about what transpires behind the closed shutters and shoji screens of a murky, arcane city such as Kushiro, but someone like me who enjoys living in small American towns (though I've also resided years in metropoli such as Richmond, Omaha, Seattle, and New York) can attest that life in these apple-pie hamlets isn't always reflective of scenes from Norman Rockwell paintings. The face our rural villages present to the world -- freckled, pie-stained, pious, and gullible -- can hide not only political corruption (or pathological ineptitude: often it's hard to tell the difference), meth labs, and steamy surreptitious sexual shenanigans -- but all manner of just plain quirky behavior.

In South Bend, Washington, where I holed up to write my first novel, it was rumored that the mayor could neither read nor write. In any case, whenever he was presented with a document that required his signature, he'd always claim that he'd forgotten his glasses at home and ask someone to read the document to him.

The mayoral position paying little or nothing, His Honor supported himself by selling men's suits -- not from a shop but from his car: a row of suits, predominately black or dark blue, hung from a rod above the backseat of his vintage Oldsmobile. Apparently, they would be purchased by local loggers or oystermen suddenly in need of proper attire to wear to a wedding or funeral. The story around town was that the mayor acquired the suits from unscrupulous undertakers in Seattle and Tacoma, who would disrobe corpses in their caskets

(often dressed in brand-new clothing) once families and friends had had a final look. If the rumor was true, many a Puget Sound gentleman was left to face eternity as buck naked as the day he was born. Unless, that is, they were buried wearing their skivvies. Surely there's no secondary market in drawers of the dead.

South Bend's most noted resident was a real estate agent named Helen Davis. Ms. Davis had written Washington's official state song. She'd also penned a couple of unsuccessful musical plays and fancied herself a concert singer. The mayor and his cronies were decidedly unimpressed with her talents, a fact they took no pains to conceal. The mayor had a hound dog that he'd taught to howl on command. There was a wooden bench on the town's main street where in good weather older gents -- mostly retired loggers or oystermen -- would sit, smoke, chew, and swap tales. From time to time, the mayor, accompanied by his hound dog, would join them. Did I mention that he'd named the dog "Helen Davis"?

At an appropriate moment, the mayor would exclaim, loudly enough to be heard at the real estate office just down the block, "Come on, Helen Davis, sing us a song!" Whereupon the dog would throw back its head and commence to bay in a mournful voice that would have made a wailing banshee sound like Shirley Temple. Meanwhile, the two-legged Helen Davis would stand in the doorway of her office, hands on hips, turning various shades of red, purple, and violet. Some local residents found it more entertaining than television.

When I first started hanging out there, La Conner had a female mayor, somewhat of an anomaly at the time, though the fact that the second floor of its two-story town hall was rented out to a sculptor as an art studio was probably a clue that this rural hamlet was not your typical philistine outpost or vapid little Girl Scout cookieville. The town marshal was a man, however, as was his lone deputy. In

addition to their police duties, the two were also responsible, due to budget constraints, for maintaining and repairing the sidewalks, gutters, and streets.

One unusually warm summer day, the marshal and his deputy were spreading fresh asphalt over a weather-beaten patch of pavement at the end of First Street when they commenced to argue over something or other. I'd like to believe the disagreement was metaphysical in nature but it likely concerned politics or sports. The topic most assuredly was not religion: to this day, when its population has swelled to approximately a thousand, there are only two churches in La Conner and except for the very occasional wedding or funeral, each is in use only for about an hour on Sunday mornings. In Warsaw, Virginia -- as an example of one of the towns Down South where I grew up -- there were four churches for white people, one for colored, to serve a mere four hundred souls, and at the Baptist house of worship there was something going on virtually every night of the week, week in and week out, though I cannot say that Warsaw was any more righteous than La Conner. At any rate, whatever the subject, the difference of opinion escalated, and before long it became physical. The two men -- marshal and deputy -- commenced to grapple, whereupon they toppled down onto the hot, sticky asphalt, and as a crowd of citizens and tourists gathered, they wrestled there. Within a minute, they resembled tar babies out of an Uncle Remus story. Or creatures from the Black Lagoon.

Since nobody dared step in and pull them apart (it would have required a sacrifice worthy of a Nobel Prize), they tussled in the tar until they exhausted themselves and, to a round of cautious applause (speaking of homegrown entertainment trumping TV), sheepishly, separately, slinked away, leaving gummy black footprints downtown that remained until the autumn rains.

Madame Mayor was not amused. Or, maybe she was and just stifled her laughter. Whatever her private reaction, she suspended both combatants for six weeks. And for six weeks there was no law

in La Conner. According to full-time residents, the town has never been more peaceful.

In the early 1970s, La Conner, Washington, was the dwarf capital of America. Perhaps of the world. To be sure, there was a greater number of little people in both Sarasota and Gibsonton, Florida (circus and carnival winter quarters, respectively), but Sarasota was a city of nearly forty thousand, whereas even Gibsonton was three times the size of La Conner, whose title -- unofficial and unrecognized -- was predicated on a per capita basis: approximately seven hundred citizens, three of them dwarves. Nothing in either the water or the gene pool accounted for the ratio, however, because none of the three -- not the hippie dwarf, not the straight dwarf, not the Native American dwarf -- was related or had been born in La Conner. There was, in fact, nothing one could point to that might explain this small phenomenon, and it's uncertain that anyone but me paid it any mind. I was predisposed, I guess, having resided my teen years in Warsaw, Virginia, with its magical family of world-class midgets.

The Indian dwarf lived on the Swinomish Reservation and rarely crossed the bridge into town. He was not even Swinomish, I was told, but on loan from another tribe for reasons never explained. On the other hand, the hippie dwarf and the straight dwarf were regular habitués of La Conner's nightlife circuit, often enlivening the scene by demonstratively trading insults at the 1890s Tavern and the cocktail lounge of the Lighthouse Inn (it was a short circuit). The straight dwarf was Hollywood handsome, clean-shaven, sported a swept-back Michael Douglas haircut, and wore neatly pressed wool trousers and nice button-down-collar dress shirts. The hippie dwarf looked like a Hobbit. His graying hair hung down below his butt, while in front, the tip of his beard preceded his shoes in and out of rooms. The straight dwarf was incensed by the hippie dwarf's appearance, accusing him almost nightly (after one or two full-size libations) of

giving dwarves a bad name, only to be berated in turn for denying his offbeat birthright -- his congenitally issued passport to a life of individualism and dissent -- and selling out to "the man."

As befitting his haircut, the straight dwarf was, indeed, involved in filmmaking, although on the production side, and after a time he moved to Utah to work on a series of wholesome nature movies financed by the Mormons. The hipster's name was Maury Heald, and he possessed a heart, a spirit, a life force, and a résumé that would have dwarfed most men twice his size. In the fifties, for example, he'd traveled to Cuba to join the revolution, living with the rebels in the Sierra Maestras alongside Che Guevara and Fidel Castro. A talented commercial artist, Maury worked as a draftsman for NASA at Cape Canaveral before it became Cape Kennedy, and it was while in Florida that he was saved from drowning by Esther Williams. He'd fallen into a pool, and due to the brevity of his legs, was ill equipped for swimming. Ms. Williams, the champion swimmer turned movie star, happened to be walking by and, fully clothed, dove to his rescue. He claimed he repaid her, though he didn't say how.

It was at an advertising agency, in San Francisco if I'm not mistaken, that Maury designed the Frito pack, the same red-and-orange motif the package bears today. Obviously, it was a successful design, but one evening -- admittedly, we'd had a puff or two of pot -- Maury confided that it had wider and deeper implications. He revealed that the design, if scrutinized from a particular angle, held the visual key to the fifth dimension. I assumed he was putting me on, of course, but I must admit that ever since, I've found myself staring at Frito packages longer than good sense might dictate or the munchies require. The reader may be inclined to investigate more thoroughly than I.

"let tom run"

Although I'm unsure of the derivation of the term "banner year," I think I know what it means, and in accordance with that meaning, 1971 was definitely a banner year for me. *Another Roadside Attraction* was published that year, Terrie gave birth to our son Fleetwood, and I met the literary agent Phoebe Larmore, who, more than forty years later, continues to represent me. Back from Japan, I was immersed in the writing of *Even Cowgirls Get the Blues*, and Phoebe's efforts on behalf of that novel would elevate the trajectory of the rest of my life.

My contract for *ARA* gave Doubleday right of first refusal for my next book, stipulating an advance of five thousand dollars should they accept that book for publication. Phoebe, friendly with the young woman who'd been my editor at Doubleday, had had a peek at some early pages of *Even Cowgirls Get the Blues*, and was, she told me later, knocked out by them. Aware that I didn't have an agent, perplexed by my poor contract and Doubleday's seeming indifference, and confident that she could find a more supportive situation for me elsewhere, she wrote to me in La Conner (I couldn't afford a phone) and offered her services. I thought it over for approximately as long as it would take a neutrino to travel through a slice of Swiss cheese at room temperature. And accepted.

By this time, however, I'd received the $5K, and it was keeping Fleetwood in diapers and me out of the fields at night. Operating behind the scenes, Phoebe enticed Ted Solotaroff, one of the last of the old-time hands-on Maxwell Perkins–style editors still working in New York, to read my manuscript-in-progress. Within days, So-

lotaroff privately offered to best Doubleday's offer by a multiple of ten, provided I could somehow terminate my obligation to Doubleday. Up to the challenge, Phoebe now convinced Doubleday that I was blocked, suffering chronic back pain, and too stressed out to finish writing *Cowgirls*. Doubleday, all too cheerfully, agreed to cut me loose if I'd pay back the five grand, whereupon I borrowed that amount, half each from a couple of older friends, and linked up with Solotaroff at Bantam Books, which would remain my publisher for the next thirty-seven years.

Incidentally, Phoebe's nose grew not by so much as a centimeter when she spoke of back pain: I was, indeed, hurting and it was relentless. Because it was so low -- down around the coccyx -- it would have qualified as what our cousins in Merry Olde call "a royal pain in the arse." Many days, I was forced to write standing up. Due to its proximity to the nether regions, and the fact that spinal X-rays weren't revealing anything definitive, my primary care provider eventually referred me to a proctologist.

Driving down to Seattle to have someone peer into, and perhaps probe with metal instruments, my personal allotment of the ancient mysteries was hardly my idea of a merry afternoon; so, as is my custom in unpleasant situations, I decided to squeeze at least a dollop of fun out of the ordeal, or, if nothing else, endeavor to lighten it up. To that end (pardon the pun), I dug out my duck mask.

This was no ordinary duck mask. This was not the ducky-wucky false face any mother would have chosen to enliven festivities at her little one's birthday bash. Molded from hard plastic, thickish and crude, this mask -- a sickly yellow with a smear or two of red -- suggested the countenance of Donald's thuggish cousin: the bad duck who'd done time in Folsom for armed robbery, the one who'd been escorted off the backlot at Disney for sexually molesting Minnie. It was difficult not to picture a hand-rolled cigarette or the stub of a cheap cigar dangling from its beak.

Concealed in an innocuous paper bag, the mask accompanied me

to the proctologist appointment. There, a nurse ordered me to completely disrobe and don one of those embarrassing paper-thin cotton gowns that tie, always awkwardly, in the back. Bidding me sit on the edge of the examination table, she announced that Dr. Medwell would see me soon. The instant she left me alone, I retrieved my bag and put on the duck mask.

Upon entering the examination room, the doctor took one look at me and froze in his tracks. He did not move. He did not smile. He did not speak. Dr. Medwell just stood there for the longest time, staring, seemingly unsure whether to approach me or retreat. Finally, to relieve the tension, I said, "Well, aren't you at least going to refer me to a veterinarian?" That broke the ice, but he still refused to examine me until I took off the mask.

Beginning in 1980, I had season tickets for Seattle Sonics basketball, attending virtually every home game for twenty-six years. A hoop fan as well, Dr. Medwell had purchased season seats in a section near my own, and frequently we'd run into one another entering or exiting the arena. Recently divorced, he was dating various women, and when he was with one I hadn't met, he'd always introduce me, even years later, saying "This is the patient I told you about. The one with the duck mask." Still in my possession, I suppose that mask and I are destined to go down in the annals (or should it be the "anals"?) of Seattle proctology.

The term "legendary," like many another superlative or word denoting singularity or extreme excellence (not to mention wonder or marvel), has been in modern times so excessively and undeservedly employed by advertisers, media hacks, and the barely literate masses that it has lost much of its impact and nearly all of its meaning. When applied to New York's Chelsea Hotel, however, it's truer to its roots than a natural blonde. For many decades the Chelsea was home away from home for countless artists of every discipline, and

its walls have witnessed legendary activities ranging from the sub-
lime to the tawdry, from Bob Dylan composing "Sad-Eyed Lady of
the Lowlands" to Sid Vicious stabbing his girlfriend. For one week
in 1975, I resided in the Chelsea, riding the subway every business
day up to 666 Fifth Avenue, where, at Bantam headquarters, Ted
Solotaroff and I went over the *Even Cowgirls Get the Blues* manu-
script page by page, line by line.

The editing was attentive, it was scrupulous, yet ultimately feath-
erlight, changes and corrections minimal at best. I was surprised. A
notoriously slow writer, a writer in love with language and ideas, I
was confident my prose was well wrought, yet it was also colored by
a "crazy wisdom," *wabi-sabi,* playful yet deadly serious approach not
exactly commonplace in Western literature, and I wasn't sure how
this would fly with an old-school pro such as Solotaroff. At one point
early in the unexpectedly painless process, Ted paused and told me
the following story:

Jim Thorpe, who would go on to become by consensus the great-
est athlete of all time, was in 1911 a student at tiny Carlisle Indian
Institute in Pennsylvania. This was at a time when Harvard was a
national football powerhouse, so fans chuckled when charitable
Harvard deigned to go down to Carlisle and engage the poor board-
ing school Indians on the gridiron. Harvard's team featured an all-
American linebacker known for his strength, vision, and unusual
lateral quickness, and regarded as the best player in the country. On
Carlisle's first play, Thorpe, unable to outmaneuver the linebacker,
was tackled barely beyond the line of scrimmage. The same thing
occurred on the next play. On third down, Thorpe called his number
again. This time, instead of trying to run past Harvard's star, the
Indian from the hills of Oklahoma ran directly at him, knocked him
down, ran over him, and raced eighty yards for a touchdown. Then he
circled, ran back up the field at full speed, picked up the linebacker
(who still lay on the ground), held him in the air, shook him hard,
and said politely but emphatically, "Let Jim run."

Ted allowed this to soak in for a moment. Then he said, "It didn't take me long to conclude that that was the only sensible approach to editing this book of yours. No editor can hope to impose his will on a performance like this one. We've got to let Tom run."

At the time, Bantam Books was a mass-market paperback publisher, buying, at auction, reprint rights to successful hardcover books and reissuing them in inexpensive, small-format, paperback editions. However, Solotaroff and some confederates were scheming to change that business model, and their maneuver began with *Even Cowgirls Get the Blues*. After first buying *Cowgirls*, Bantam then sought to auction off the hardcover rights. This constituted a major turning of the tables, a significant reversal of tradition, and the move met with considerable resistance in the publishing world. Bantam's ploy, the first of its kind in the history of New York publishing, was almost universally scorned. Almost. Eventually, one brave soul at Houghton Mifflin, the venerable Boston house, thumbed a patrician nose at custom, purchasing rights from Bantam in a precedent-shattering deal, and in 1976 introduced simultaneous hardcover and trade paper editions of *Cowgirls*. (Bantam would issue the mass-market paperback a year later.)

By no means an out-of-the-gate galloping success, *Even Cowgirls Get the Blues* did all right for itself. The *New York Times* compared it favorably to Thomas Pynchon, Pynchon himself wrote that it dazzled his brain, calling it "a piece of working magic," and me "a world-class storyteller." The Bantam paperback, when it appeared in '77, did attract a large following, almost entirely via word of mouth, and *Cowgirls* remains my best-known (though not best-executed) novel, doubtlessly because it was filmed (in 1993) and movies, deserving or not, are perceived as sexier than books.

Particularly admired by women, *Cowgirls* was for years the only novel by a male author to be sold in some feminist bookstores. A phi-

losophy professor from Wright State University delivered a paper at
a conference in which she claimed that *Cowgirls* represented the first
work in history in which a female protagonist undertook the classic
hero's journey, passing through all of the stages as outlined by Jo-
seph Campbell in his monumental study, *The Hero With a Thousand
Faces*. While I was flattered by the reference to Campbell and world
mythology, I must confess that the feminist thrust of *Cowgirls* had
simpler origins.

In Appalachia in the thirties, we kids -- free from the intrusion
of wholesale technological entertainment -- amused and grew our-
selves with improvised role-playing games, usually of an adventur-
ous nature. Our backyard exercises in make-believe were varied in
content, and while dominated by masculine examples, were seldom
gender-specific. My beloved cousins Martha and June could assume
the persona of a cowboy, an Indian, a pirate, a pilot, a cop, a robber,
or a soldier as readily as Johnny or Georgie or I. It wasn't until many
years later that it occurred to me that while any of us boys could ac-
tually, theoretically, grow up to be a soldier, an explorer, a cowhand,
or a detective, those opportunities, particularly in the South at that
time, were simply out of the question for Martha and June. Their as-
pirations, exposed to the harsh beam of reality, would have been both
more limited and more tame.

Thus it was in sympathetic retaliation that I peopled my second
book -- a language-driven seriocomic novel that raised the flag of
physical, psychological, sexual, and spiritual freedom -- not only with
a female hitchhiker whose exploits on the road surpassed those of Jack
Kerouac and pals, but with young women who, determined to finally
realize their cowgirl fantasies, take over a ranch by force. This action
costs one of them, their leader, her life -- but one should never operate
under the illusion that one can always live out one's wildest fantasies
with impunity. One must be willing to be charged a high price.

Yesterday, while examining for the first time in many years, a first edition of *Cowgirls*, I came across excerpts from reviews of its predecessor, *Another Roadside Attraction*, evaluations in which I as a writer was likened to Mark Twain (by the *Los Angeles Times*), James Joyce (*Rolling Stone*), and Nabokov and Borges (*Playboy*). Apparently, the book garnered its share of raves after all. How like an unevolved Cancerian to hold on to his negative notices and forget that there were others that many authors might have killed for.

Since publication of *Cowgirls*, it has been my policy never to read reviews, though people do voluntarily quote them to me, some out of shared pride in my perceived success, others out of malicious glee in what they regard as a well-deserved public scourging. I can't say for certain if my no-read policy has been wise or foolish: who knows what good advice I may have missed? On the other hand, it has shielded me from unnecessary distractions (God knows there is a sufficiency of those already), while the elixir of understanding that every ego, however philosophically downsized, enjoys and at times even craves, is usually supplied -- occasionally by the bucketful -- from other sources.

For example, not long after the publication of my third novel, I received a letter from a young woman, a stranger, that read in part, "Your books make me laugh, they make me think, they make me horny, and they make me aware of all the wonder in the world." I've never forgotten that testimonial because she smacked the nail on the head with a titanium hammer: though I'm oblivious to it during the act of writing, those are precisely the responses I might wish my books to arouse. And is there a higher accomplishment for any novel, any poem, than to awaken some reader's sense of wonder? Probably not.

My most cherished accolade from that period, however, had nothing to do with matters literary, except perhaps in the most indirect way. Terrie and I had split not many months after Fleetwood's birth, our brief marriage another casualty of the turbulent sixties and its libertine mores, but we'd remained close and were sharing, in separate domiciles, the rearing of our son. One day when Fleetwood was

three, Terrie took him shopping with her in a nearby town, La Conner being blissfully bereft of malls, corporate outlets, and franchise stores of any category. There, she fell into conversation with a fellow shopper, an older woman who at one point turned to Fleet and asked, "And what does your daddy do, little boy?"

Pausing not a second for reflection, Fleet answered immediately and forthrightly, "My daddy's a mad magician."

What??? Wow! I'd no idea Fleetwood knew either the word "mad" or "magician," let alone how to juxtapose them in a coherent sentence: as I said, he was three years old. And though I quizzed him on numerous occasions and at some length, even bribed him with potato burgers at the Mount Vernon Chuck Wagon, he would never expound upon his idea of his father's job description. Suffice to say, I guess, that I took it as the highest of compliments, then and now, and were the epitaph "Mad Magician" to be chiseled on my tombstone, I know I would rest in peace -- even were some immoral funeral director to sell off my burial clothes. Including my undershorts.

Speaking of nonliterary or extraliterary endorsements, my other son Rip, whom I'd fathered with Peggy back in the Age of Feeling Horny But Knowing Nothing, and whom I'd not seen since he was a babe, came back into my life during this period. His mother had married a well-to-do gentleman in Delaware and throughout Rip's childhood she had told him what a no-good beatnik bum his biological father was. Not surprisingly, as soon as he turned eighteen, he came looking for me and spent a few weeks checking me out. A year or so later he returned to La Conner and has resided nearby ever since. Evidently, some lads like a bit of "mad magician" or "beatnik bum" in their papas.

hollywood, hollywouldn't

I'd been in Shelley Duvall's kitchen merely seconds before I noticed the ants. Not that the room was crawling with them, the ants were concentrated in one place -- along the windowsill above the sink -- but they teemed there in numbers that might have inspired the Vatican to consider the historical context of that ominous biblical directive to "go forth, be fruitful, multiply, and replenish the earth."

What was I doing in Shelley Duvall's kitchen? I'd gone in there to fetch a beer from the refrigerator, and mission accomplished, returned to the living room, where I gave Shelley the bad news that a plague of ants was descending upon her kitchen. I advised her to call an exterminator. "Oh, no," the actress said cheerfully. "They're just having lunch."

Before I could take a sip of beer she led me back into the kitchen, showed me a squeeze bottle of honey, and demonstrated how around noon every day she would squeeze a line of honey onto the sill, opening the window just a crack so that the ants on her property might come in and dine.

Well, that was Shelley for you, in real life as so often on-screen: completely loopy in a big-eyed, long-lashed, childlike, and endearing sort of way. She gave a more traditional performance in *The Shining*, but while others around me in the theater were transfixed by Kubrick's creepy masterpiece, by Jack Nicholson's escalating homicidal madness, I could not look at Shelley, even in the more terrifying scenes, without smiling and thinking, *That woman feeds ants in her kitchen.*

I'd gone to Shelley's home to take a meeting with a couple of young screenwriters. There had been Hollywood interest in *Even Cowgirls Get the Blues* throughout the late seventies; the book had been optioned several times, and two adaptations had been written, both by experienced screenwriters, but the scripts hadn't worked. The writers just hadn't gotten it. Now Shelley Duvall was wanting to produce and star in *Cowgirls,* and to that end was interviewing writers. I was encouraged that the pair she'd invited to her house that Sunday were young, less crimped by tradition, but we hadn't conversed very long before it became apparent to me that they weren't going to get it either.

What was it none of these guys were getting? Why, the tendency for the serious and the comic to commingle, sometimes almost seamlessly, in life generally and in my novel particularly. Oh they were aware, surely, that comedy, especially slapstick comedy, has an underlying element of desperation, but finding and acknowledging the comedic that can infiltrate everyday sober circumstance was foreign to them, as was the broader notion that human reality is often simultaneously somber and funny. I, on the other hand, have always looked at life that way, and reading Hesse, Nietzsche, and Alfred Jarry (not to mention forays into Eastern philosophic systems and psychedelics) had reinforced my sense that this is just the way our world is ordered. Convincing a screenwriter that such a perspective should be or could be the secret spice that flavored any successful adaptation of *Cowgirls* was proving futile, however. The writers were frankly incapable of thinking that way. Humorous in one scene, serious in the next: that they could manage, but both in the same scene . . . ? Not happening.

Did Shelley Duvall get it? Maybe, maybe not. In any case, she didn't hire the two writers we interviewed at her free-form ant farm. And a month or so later she phoned (I'd finally gone telephonic) to

say that she had written a script herself. Really? Yes, and she wanted me to come back to L.A. and meet with a director to whom she was going to pitch her screenplay. I hadn't heard of Alan Rudolph at that time, but the fact that he'd come recommended by Robert Altman was good enough for me.

We met at a German restaurant on Sunset Boulevard. I'd glanced over Shelley's "script" right before Rudolph arrived -- and couldn't believe what I was seeing. Only twenty-three pages in length (the average script is a hundred pages longer), single-spaced, no paragraphs, no separated passages of dialogue, it gave the impression of having been written by a delusional senior in a North Dakota nursing home, someone who'd not only never seen a film script in her entire life, but had neglected to consult an instruction manual. Rudolph, I was certain, would take one look at this debacle, shake his head in disbelief, and flee the restaurant before we could order a schnitzel.

Astonishingly, the director who, I was to learn, had made invaluable and largely uncredited contributions to Altman classics such as *Nashville* and the sadly underrated *Buffalo Bill and the Indians*, skimmed through Shelley's nonscript (it didn't take long), nodded, and said matter-of-factly, "Sure. Good. I can make this."

And he meant it. He wasn't being facetious. What's more, he really *could* have made it. As he was to demonstrate repeatedly in ensuing years, if ever there was an American director capable of extracting diamond dust from Shelley's lumpy little sack of charcoal, who could have successfully straddled that *Cowgirly* borderline between the edgy and the sweet, it would have been Alan Rudolph. His smoky, neon-bathed romances have seldom shied from directing our eyes to the poignant goofiness that can infect the most sophisticated of modern relationships. His lens charts the wobble in the orbit of the heart, his absurdist wit lends existential wisdom to film noir scenes that from another director might be only violent and banal.

For the knowing and confident way in which he agreed to take on that dopey script, I developed a kind of instant man crush on

Rudolph, but Shelley was unable to get the project funded and eight years would pass before another actress would hook me up with him again. In 1987, my friend Debra Winger talked Rudolph into casting me as a toymaker in *Made in Heaven*, a studio movie being shot in Charleston and Atlanta, and during the shoot Alan and I developed a lasting friendship, despite the fact that he cut the single best line I'd written for my character: "Toys are made in heaven -- but the batteries come from hell."

One of the perks of associating with celebrities is that you get to experience firsthand the state of invisibility. Step out in public with any rock star or Hollywood actress and *poof!* -- you disappear. People look right through you. It's a kind of enchantment, more effective than the graduate program at Hogwarts. Once during the filming of *Made in Heaven*, however, the tables turned and the cloak of invisibility unexpectedly fell about unaccustomed shoulders.

There had been a small but lively dinner party at the house in Charleston provided to Debra Winger and Timothy Hutton for the duration of the shoot. The house was in an upscale neighborhood a good distance from the downtown hotel where most of the cast and crew were lodged. At the end of the evening, I caught a ride back to the hotel with Neil Young and his manager. In the conversation that ensued, Neil learned for the first time that the guy in the backseat was a novelist. He'd never heard of me or my books, assuming all evening that I was an assistant producer or some other functionary connected to Lorimar Studios. He was mildly surprised, I suppose, but didn't seem particularly impressed.

It was well past midnight and the hotel lobby was deserted. To retrieve our room keys, Neil and I approached the front desk more or less in tandem. When we got closer to the desk, the night clerk -- a pretty woman in her early twenties -- suddenly lit up like a ballpark, clutched her chest, and made an audible sound that resembled a mix-

ture of a sigh, a squeal, and a purr. Naturally, Neil thought the excitement was for him.

"You're Tom Robbins, aren't you?!" the girl gushed. "I heard you were staying with us." She went on to tell me how wonderful my books were, how much they meant to her, while the great Neil Young (and he truly *is* great) waited impatiently -- invisibly -- for his key. The human ego is a treacherous apparatus, best kept at a safe distance from the self, but I confess I took a small measure of pleasure in making a star play the transparent ghost for a change.

woodpecker rising

Prior to the publication of *Still Life With Woodpecker*, I had trouble referring to myself as a "novelist" without feeling like a fraud, an attitude engendered less by modesty or insecurity than a respect for the profession, for the craft, for language itself, a reverence that in today's world may have gone the way of the "vine-ripened" tomato. But, when in 1980 Bantam Books, after paying me a substantial advance, brought out *Woodpecker* as its very first hardcover publication; and when the large-format trade paper edition -- issued simultaneously -- shot to number one on the *New York Times* bestseller list and I found myself on one of those coast-to-coast book tours, violating flyleaves with my nasty scrawl and fielding questions from the press, well, I could at last look in a mirror and believe that a genuine, full-fledged, full-time *author* might be staring back at me. It was cool, I can't deny it, but I also possessed just enough good sense to remind myself that whom the gods would destroy they first make popular.

My initial personal buffeting by the gale of glory, the fickle gusts of literary fame, occurred in Austin, Texas. My appearance for a signing there attracted such an unexpected throng that the bookstore, to accommodate the crowd, set up my signing table in the beer garden next door, and I sat there, without once getting up to stretch or pee, and signed and signed and signed -- for five whole hours. It was, as I said, a beer garden, and people were imbibing while they waited in line. Toward the end of the evening, many of those who approached my table, those who'd been far back in the line, were more than a lit-

tle sloshed, a condition that inspired some interesting conversations. And behavior . . .

We were about four hours into the event when a young lady, emboldened by alcohol, and perhaps *Woodpecker*'s audacious male protagonist (she'd been leafing through a copy of the book as she waited her turn), unbuttoned her blouse as she neared the table and requested that I autograph not only her book but *her*. Always willing, when possible, to accommodate a reader, and suspecting that John Hancock might well have preferred this opportunity to the Declaration of Independence, I brandished my Sharpie and in a jiggling jiffy my signature was emblazoned across two well-formed lumps of what -- with the possible exception of mayonnaise and butterscotch cream pie -- is the highest known usage of fat: a perfectly matched pair of baby snow pups, or what some of us are inclined to think of as "the twin moons of paradise."

Well, this fair damsel proved to be a trendsetter. She was a student at the University of Texas, and we know how susceptible college kids are to fads. From that point on, at least four of every ten females in line bared her breasts when she reached the table, asking to be suitably inscribed. Ah, Texas! (A big back has a big front, in more ways than one.) At the conclusion of the event, one of the adorned girls was still hanging around the table, signaling with her eyes that she wished to take me home, perhaps to obtain my endorsement on other parts of her anatomy, but as drained by then as a hemophiliac on a blind date with a vampire, all I could manage was a weak wave as my handlers practically carried me to a waiting car.

On our way to the hotel, Bantam's regional sales representative, smiling and shaking his head, drawled to no one in particular, "Man, we sure moved some product tonight." That was, believe it or not, the first time that I ever entertained the notion that novels, especially my novels, could be categorized as "product." Obviously, I knew that works of fiction were bought and sold, but like goods, like merchan-

dise? The concept so jarred my sensibilities that it wiped much of the shine off the previous five hours, leading me to the unhappy realization, as I fell into bed, that to some people -- people who worked for, say *Playboy* magazine or Hooters -- even the "moons of paradise" might be considered "product."

Terry Bromberg, the Bantam publicist who accompanied me on the *Woodpecker* tour, shared my enthusiasm for culinary exploration. In every city we visited, we made it a point to sample the local specialties. In Austin, we'd relished a fine, authentic Mexican breakfast late on the morning after the marathon signing, and we were walking back to the hotel to check out when it occurred to us that we'd failed, so far, to experience the pecan pie for which that region of Texas is somewhat renowned. We consulted our watches. It was very nearly noon, our flight didn't depart until two, and we were already packed. Impulsively, we ducked into a downtown restaurant intent on crossing pecan pie off our "to eat" list.

Spacious, almost cavernous, the restaurant was just starting to fill up with the lunch crowd; lawyers, retailers, businessmen, trickling in a few at a time. A waitress took our order almost immediately, and as we sat awaiting our slices of pie, a different waitress waved to us from the far end of the large room. She left her station and rushed over to our table, where, smiling ever so sweetly, she undid the top buttons of her brown, dotted swiss uniform, and after apologizing, "It got wore off a little during the night, but you can still read it," revealed to me, Terry, nearby diners, and God himself, my name -- slightly smeared but readable as advertised -- across her bare and Texas-proud mammaries.

After that, the pecan pie, while delicious, was kind of an anticlimax. And Terry and I left Texas agreeing that the Beach Boys may have been misled in wishing they all could be "California girls."

Two nights later, my "product" and I again attracted an overflow crowd. This event was in Los Angeles at Papa Bach's, a popular independent bookstore on Santa Monica Boulevard, and there actually were searchlights. That's right: searchlights for a book signing. And a line that stretched all the way around the block. The aisles in Papa Bach's were quite narrow, so once more my signing table was set up outdoors, this time in an alley, more appropriate than they could have known for someone who once lectured on "alley culture." A flatbed truck was parked a few yards behind me, and atop it a country-rock band was playing. Did I mention that this signing was in L.A.?

The table and chair the bookshop had provided was from its children's section, comfortable enough but quite low to the ground. The employee managing the line had decreed that the line stop six feet from where I sat. People with copies of *Woodpecker* to be signed were only permitted to approach me one at a time, or two if it was a couple. Because almost everyone wanted a bit of conversation as well as a signature, and because in order to make eye contact with me in my kiddie chair they were forced to squat, it gave the impression that they were kneeling before me.

The bookstore was on my right. On my left was a gas station, in whose parking lot, separated from the alleyway by a high chain-link fence, two or three Mexicans, attracted by the music and those luminous astro tortillas sweeping the sky, were watching with considerable interest. It wasn't long before there were five or six Mexicans there, and then more than a dozen (the signing lasted four hours), staring at what they must have believed was some sort of high religious figure receiving homage from hundreds of the faithful. But what kind of bishop or saint was this, youngish, with long hair, a big lopsided mustache, wearing a flashy red-and-yellow sweater and fin-

gers full of rings? To compound their perplexity, I would, from time to time, turn, raise my hand to them and genuflect in what by all appearances must have seemed the most heartfelt of blessings. They shook their heads and murmured to one another. Their bewilderment was almost palpable.

Toward the end of the evening, when I turned to "bless" the Hispanic gawkers one last time (by now there must have been twenty of them), I saw, standing in their midst with a grin that could have set off fire alarms all over town, Dr. Timothy Leary.

I'd met Tim Leary briefly during my sojourn in New York fifteen years earlier, but he didn't recall it and there was no reason why he should: I'd been just a face in the group congratulating him after a lecture at Cooper Union. When he was incarcerated in Folsom, however, a fellow inmate -- Sonny Barger, president of the notorious Northern California chapter of the Hells Angels -- had pressed a copy of *Another Roadside Attraction* in his hands, saying, "This is the Angels' favorite book." (So who needs *Kirkus Reviews*?) Tim had also become a fan. I rendezvoused with him that night after the gig at Papa Bach's and we became friends.

There are those who have condemned Leary as a liar, a sellout, an opportunist, and most of all, a raging egomaniac; but the truth is, he was simply Irish. Like Ken Kesey and Robert Anton Wilson, two other iconically loquacious luminaries of the counterculture, Leary was Irish. *Irish!* He'd kissed the Blarney Stone. He'd French-kissed it, felt it up, rolled with it in the soft grass on the moonlit banks of the River Shannon. Figuratively speaking. Personally, I found him a generous, stimulating, entertaining, always upbeat companion, as full of challenging ideas, sincere flattery, and surprises as blarney. I never once heard him speak ill of anyone, including those who'd set him up and sent him to prison. No, I take that back. He was merciless in his condemnation of Abraham Lin-

coln, blaming Honest Abe for the rise of Wall Street and corporate fascism in America.

Sitting in his home one afternoon, not long after Tim and his wife Barbara had adopted a huge shaggy dog, I noticed on the coffee table a book entitled *There Are No Bad Dogs, Only Bad Masters*. When Tim was summoned to the phone, I picked up the book and was idly leafing through it, noticing that everywhere it said "no bad dogs," Tim, with a black pen, had crossed out "dogs" and written in "drugs." As in there are no bad drugs, only bad users.

Like many of Tim's more playful pronouncements, this one needed to be rinsed for a while in the suds of sober reason. Certainly, the downfall of the sixties, that era of such promise and hope, was due in no small part to the misuse of potentially "good" drugs -- such as LSD, psilocybin, and mescaline -- by "bad" imbibers. When *Time* magazine published its cover story on the burgeoning psychedelic revolution, kids from Michigan, Illinois, and New Jersey, from all over blue-collar America; dissatisfied, rebellious kids from broken homes, inept schools, and boring communities, kids who heretofore would have been stealing hubcaps, cadging beers, crashing cars, and getting one another pregnant, flocked to the Haight-Ashbury to become hippies. Their guide to achieving hippiedom, to fitting into this youth-oriented utopia of unbridled freedom and joy, came (usually second- or thirdhand) from *Time* -- and the *Time* article, although generally positive, got it wrong.

For example, one of the ways the early vanguard of psychedelica -- predominately middle class, in its twenties, with at least some college education -- expressed its freedom from social norms, its desire for a more natural lifestyle, was to go barefoot. Well, when you tread city sidewalks without your shoes, your feet get dirty pretty fast. *Time*'s reporters noticed the grimy feet and deduced that these young people, like the beatniks before them, scorned bathing, whereas in point of fact the cliché "your body is your temple" was mouthed consistently in this milieu, whose members bathed ceremoniously, anointed them-

selves with perfumes and oils, and spent an inordinate amount of time
dressing up, choosing their eclectic -- and clean -- costumes with as
much care as a debutante selects her ball gowns. The new wave of Rust
Belt and breadbasket kids, however, oblivious to the philosophical un
derpinnings of this movement they were naively embracing, took *Time*
magazine at its word and thus the myth of the "dirty hippie" became
a reality.

It should go without saying, then, that those same boys and girls
lacked completely the intellectual, spiritual, and emotional maturity
to gain much beyond anxiety and confusion from psychedelics, and
Time was apparently incapable of even suggesting (as its older sister
Life once had) that in the right circumstances and with proper prepa-
ration the experience might have been ecstatically revelatory instead.
"Good drugs" perhaps, but "bad masters" all around.

On the other hand, friend Timothy to the contrary, I'd submit
that there are some drugs that are intrinsically "bad." There are, as
far as I can see, no hidden virtues, no positive potential whatsoever
in methamphetamines or crack, and I'd be inclined to include regular
cocaine on the cur list, despite the sorry fact that I extolled the vir-
tues of coke, my biggest regret as a novelist, in *Still Life With Wood-
pecker*. Saturday nights in 1978–1979, my beautiful, smart, witty, and
thoroughly mendacious girlfriend Ginny Rose and I would sit at her
dining room table in La Conner playing cribbage or Scrabble -- and
tooting lines of coke -- until ten-thirty or eleven, then head to the
1890's Tavern to dance to live music until closing time. I suppose it
was because I only tooted once a week, and almost never at parties
or in groups, that it took me so long to recognize the hairy truth that
cocaine makes smart people stupid and stupid people dangerous. Bad.

Of course, Indians in the Andes have for centuries chewed coca
leaves, the mother of cocaine, to relieve hunger pangs and give them
needed energy for long treks and hard labor; one example, it seems, of
good masters training a bad drug to wag its tail, guard the premises,
and refrain from peeing on the rug.

Remembering Timothy Leary now, I'll contend that even were he wrong about the neutrality of drugs (which sounds uncomfortably close to "Guns don't kill people, people kill people"), even were he guilty of the character flaws attributed to him by his detractors, he still stacks up quite well when compared to those shallow, deluded, boring, self-righteous, and often self-appointed watchdogs who are all too willing, especially if there's a buck involved, to stand guard at the gates of unauthorized mischief.

Still Life With Woodpecker caused me to be investigated by the FBI. Not right away, however, and certainly not for the rosy picture that I (in my own naïveté) painted of cocaine: it's the substances that enlarge consciousness and open the mind's eye that worry our government, not the ones that draw down the blinds. No, fifteen years after the publication of *Woodpecker* -- a novel that examines the difference between outlaws and criminals, between redheads and the rest of us, but whose primary focus is the transitory nature of romantic love and what might be done about love's vagaries -- fifteen years after its debut, the book led me to be considered a suspect in the Unibomber case.

When someone from the Seattle office of the FBI telephoned one Thursday in 1995 to say that the agency wished to question me, I knew immediately, though no reason was given, what it was about. I knew because a month earlier, a newspaper reporter in Connecticut had contacted me to report that a college professor in that state was telling law enforcement agencies that it was obvious, from what Tom Robbins had written in *Still Life With Woodpecker* -- the anti-authoritarian sentiments, the warnings against overdependence on technology, the romanticizing of outlaws, and, most tellingly, authentic recipes for homemade bombs -- that he (me) was the Unibomber, subject of a nationwide manhunt. The journalist thought it amusing, considering both the humor and passionate reverence for

life that also permeate the novel, and I myself paid it little mind
until the Bureau phoned. Even then I wasn't troubled, and pleas-
antly agreed to receive an agent at my La Conner home on the fol-
lowing Tuesday. But then . . .

But then, the very next morning, as synchronicity (that boundary-
busting logic-mocking clown) would have it, Susan Paynter, a colum-
nist for the *Seattle Post-Intelligencer,* published in her Friday column
the widely circulated drawing of the Unibomber in his hooded sweat-
shirt and dark glasses, juxtaposed with a recent head shot of me -- in
a hooded sweatshirt and dark glasses. The resemblance was hard to
miss. "Could our Tom Robbins," she wrote, "who wouldn't hurt a fly,
be the infamous Unibomber?" Susan, who knew me, meant it as a
joke, but I assumed they weren't laughing very hard down at the FBI.

My assumption was correct. All that weekend, day and night, an
unfamiliar dark sedan was parked in the one spot that would have
permitted its occupant an unobscured view of both the front and rear
exits of my house. Had I emerged with a suitcase or a backpack, it
wouldn't have been long before some guy in black shoes was reading
me my Miranda rights, and not smiling when I asked if those rights
granted me permission to wear fruit on my head like Carmen. Sur-
veillance can be boring, however, for both observer and observed, and
by Monday I wasn't even checking to see if I was still being watched.

On Tuesday, without once asking for directions, the agents ar-
rived at my door. Two of them. Young. Female. Attractive. The FBI
isn't stupid, they knew my weakness. And the agents knew I now
knew they knew. That established, we settled in for a lengthy chat,
during which they never once intimated that I, myself, was under
suspicion, but were only hoping that I could provide them with leads
to follow up on. Leads such as any fan mail I might have received
from a reader who'd professed, perhaps in the Unibomber's prose
style (he'd published extremely long missives in the *New York Times),*
an inordinate admiration for my Woodpecker character and his habit
of punctuating social commentary with dynamite. Leads such as my

source for those unusual explosive recipes (the bomb made from kiddie breakfast cereal, for example) that I'd included in the novel.

Entirely professional, the women raised not a pretty eyebrow when I answered that, alas, I'd hauled an accumulation of answered fan mail to the county landfill only a week before, and that, sorry, I couldn't remember the name of the Seattle sound-system engineer who through an intermediary (also forgotten) had passed along those instructions for turning common household products into things that go boom in the night. I was certain, however, that I could detect something subtle, unspoken, pass between them when I unwittingly volunteered that I'd physically demolished the electric typewriter on which I'd begun composing *Still Life With Woodpecker* and had gone back to writing with a pen, an obvious Unibomber-like retaliation against technology. And then when I asked them where they were from and they both said Chicago, I'd blurted out that I'd spent time in the Chicago area myself. True enough, it was where I'd once attended weather school, but it was also where the Unibomber posted most of his deadly packages.

For whatever Tommy Rotten reason, I was doing a pretty good job of incriminating myself, in addition to which I caught the agents on several occasions eyeing the nutty, cartoonish assemblage of sticks and twine I'd constructed to support a tall, spindly yucca plant in my studio, a contraption that could have led a suspicious mind to equate it with the jerry-built devices the Unibomber mailed to his intended victims. When the fed femmes left that day, I was convinced I'd not seen the last of them, and something perverse in me was actually excited by the prospect, by the drama of it all.

When months passed without a word from my agents, I went so far as to telephone their office in Seattle to inquire how the investigation was going. I just couldn't help it. A dead-robotic voice informed me that the agent I sought did not work there. I asked for the other woman and got a similar response. No explanation was offered. Curious. Very curious, indeed. Who were those women, then?

Who was their actual employer? What did they really want from me? My imagination, that infernal pinball machine, lit up and I had a truckload of quarters.

Then, around Christmas, I received a holiday card from one of the agents, the one with whom I would have flirted more openly had it not seemed somehow in poor taste. She wrote that she and her sister investigator had been transferred to Oklahoma City to work on the federal-building bombing case there. I wrote back but she never responded -- and eventually the Unibomber was caught and I ran out of quarters.

a fool for wonder

In the years since the selling of *Still Life With Woodpecker*, I've finally had the wherewithal to indulge, pretty much at will and in relative comfort, those urges kindled by that world atlas I bought at age eight. When I wasn't absorbed with writing (including research, editing, and some publisher-generated promotion); and/or extracurricular activities such as reading for pleasure, attending movies, following the Sonics, playing organized volleyball, practicing yoga and Pilates, and periodically running away with Cupid's circus (knowing full well I'd probably end up selling peanuts or watering the elephants), I was off to foreign lands in pursuit of fresh experiences: cultural, culinary, or simply thrilling (such as the African treks or the white-water rafting I've enjoyed on three continents).

My wife Alexa, the wisest person I know, says that all those pursuits of mine, including the love of words and the loving of women -- and certainly not excluding my involvement with psychedelic drugs and Tibetan/Zen "crazy wisdom" philosophies -- have been part and parcel of the same overriding compulsion: a lifelong quest to personally interface with the Great Mystery (which may or may not be God) or, at the very least, to further expose myself to wonder. I'm prepared neither to argue with that observation nor advance it; any reader who's so motivated can draw his or her own conclusion. My immediate intention is to say a little something about Cuba.

I traveled to Cuba in 1978, partly because it was forbidden (no American had legally set foot there in about twenty years), partly because I wished to see for myself how much of the official picture

the U.S. painted of our small island neighbor was just Cold War propaganda. (A fair amount, as it turned out.) I could not honestly say that the Great Mystery was in any way involved, although I did, after an evening of dancing at the fabled Tropicana nightclub, make love with a vacationing French Canadian schoolteacher during a ferocious Caribbean storm, and there was definitely a transcendent presence in the room. Forget Barry White, Percy Sledge, Mantovani, and Sinatra; forget romantic mood music of any genre: nothing surpasses crackling lightning, apocalyptic thunder, thrashing palm fronds (Aphrodite fanning the ozone), and hard-driving torrents of rain as inspirational background audio for a night of tropical love.

Upon learning that there were regular flights from Canada to Cuba, I'd phoned my friend James Lee Stanley and convinced him to join in the escapade. He canceled a few gigs (James Lee is a singer/songwriter), we booked a fifteen-day excursion, and a month later flew from Montreal to Havana on a Russian airliner. On the hour-long bus ride from José Martí Airport to the small, funky seaside resort which was to be our headquarters during our visit, our hosts passed around bottles of rum, and it wasn't long before James Lee had his guitar out and we all -- Cubans, Canadians, and us two Americans -- were singing "Guantanamera." We were already having fun, and I hadn't met the schoolteacher yet.

James Lee and I, in fact, had rambunctious fun the entire time we spent in Cuba, which set us apart from the many Russians there and endeared us to the natives. In those years, Cuba was the Soviet Union's Hawaii. If, for example, Ivan's section of a Russian tractor factory met or exceeded its production quota, Ivan and his family might be awarded a holiday in a tropical paradise. Just how paradisiacal Ivan found Cuba, however, was open to question. The Russians would not even attempt Latin dances, they eschewed local rum in favor of their own vodka, and when besotted would sit around teary-eyed, singing old mournful nationalistic songs. You'd see a busload of them on their way to the beach and from their expressions you'd

think they were being shipped to a gulag. In private, Cubans -- a warm, ebullient people who love love love to dance -- mocked the Russians, referring to them as "square heads."

What became apparent during our visit is that ordinary Cubans were deeply grateful to the Soviet government for its assistance in a time of need, but were somewhat contemptuous of the Russian people. Conversely, they despised the American government but maintained a genuine fondness for individual Americans. That dichotomy is easy to understand if you know anything about Cuban history and America's long record of oppressive behavior toward the island, but I shan't get into that here. I will say that while I came away with sympathy, even admiration for Cuba, my favorable impression did not extend to its socialist economy, whose austerity and uniformity was itself oppressive. The conspicuous consumption in capitalist countries such as ours is deadening to the soul, but an absence of variety and choice can be psychically impoverishing, as well.

The lone pizza parlor in Havana did not sell beer, although it would have been entirely legal to do so. In no beer garden could you buy a snack. When you hailed a taxi, the driver would pick you up only if he happened to be going in the direction you wished to go. The cabbie earned the same amount each day regardless of how many fares he picked up, the merchant's profits increased not a peso when he moved more product than expected. Was the average citizen happy with this rigid and prescribed arrangement? Despite his or her fierce (and understandable) pride in the 1959 revolution that overthrew the brutal dictator Fulgencio Batista and evicted the U.S. businessmen and Mafia dons who supported him, I suspected not. Secretly, when they felt they could trust James Lee and me, the Cubans we'd befriended would plead with us to somehow get them cassette players, radios, rock albums, or blue jeans.

There are things in this world -- even material things -- that supersede politics, exhilarating things that support a personal liberation

of the spirit; and on a crude, unevolved level may even represent a longing to connect to the Mystery.

Suzette from Quebec notwithstanding, my most cherished memory of Cuba stems from an occasion of mechanical and linguistic miscarriage. A party from the gringo resort was off on a day trip to the Bay of Pigs when our vintage bus stalled near the center of a small town. It was midday, hotter than the fiddles of hell, and having no luck in restarting the engine, our driver urged us to get off the bus and find a place, if we could, in the shade. We huddled beneath a lone tree in the square, preparing for a long wait as he tinkered with the engine. We should have known there would be bad juju associated with the Bay of Pigs.

James Lee retrieved his guitar and commenced to strum, even to quietly sing a little. Up to that point, the town had seemed unoccupied. There wasn't a soul or a sole in the square, the surrounding houses showed no sign of current human habitation. Someone suggested that Castro had drafted the entire population to go cut sugarcane, someone else dismissed that as U.S. propaganda. James Lee continued to play. And slowly, very slowly, one by one -- kids first, then adults -- people came out of their homes and drifted into the square. It was as if James Lee was an immobile Pied Piper.

James played louder. People drew closer. And before long there was an impromptu fiesta in progress: literally dozens of people singing along, mostly to interminable renditions of "Guantanamera," the one song to which all present knew the words. Obviously, we weren't Russian, but it took a while before James and I were identified as Americans, for many, if not most of them, had never encountered an American. They knew some rock and roll, however, having listened clandestinely and at considerable risk to Miami radio stations. And they knew Chiclets. Man, did they know Chiclets. Somewhere -- if only in their mythology -- they'd come into contact with the tiny

pellets of candy-coated chewing gum and automatically associated them with America. The land of the free and the home of the Chiclets. Chiclets and stripes forever!

Hesitant to interrupt James Lee -- in Cuba you don't mess with the music -- kids surrounded me, just pleading for Chiclets. Now I knew practically no Spanish, and much of what I did know was from a Tex-Mex idiom not widely understood in Cuba -- but I'd seen handmade signs in California shop windows that read *SE HABLA ESPANOL*, a statement I always took to mean "We have Spanish," as in "We have command of the Spanish language." For years, I'd been confusing *habla* with the verb *haber*, "to have," when in actuality, *habla* is the verb "to speak." So when I kept protesting to the young Cubans, enunciating clearly so they wouldn't misinterpret, *"No habla Chiclets,"* what I was really saying was "I don't speak Chiclets."

Well, it was an honest statement: I did not speak Chiclets. Later, however, when I came to realize why the Cubans had been regarding me as if I were some kind of Yankee nut job, I had to ask myself, "Why not?" Trying to imagine what Chiclets might sound like, I began to teach myself a basic Chiclet lexicon. You know, the essential phrases. I still recall a few (they sound like passages from *Beowulf* being recited by cartoon mice), but can only pronounce them after I've consumed four or more Cuba libres.

Linguistically versatile if far from fluent, I can goof up any number of languages and with varying results. The first time I dined alone in Paris, for instance, I made a mistake that conceivably could have gone in my favor.

Perusing the menu at Polidor, my favorite affordable restaurant in that city of magnificent and expensive places to eat, I thought that the veal in a cream sauce sounded good. However, when the drastically cute waitress came to take my order, I mistakenly asked

not for *veau en crème* but *vous en crème,* and it took me a moment before I understood that I'd told her that I wanted *her* in cream.

Of course, that was what I really wanted. Like *no habla Chiclets,* it was a truthful statement, and Freud, bless his heart, would have immediately recognized it as such. The waitress, being French, simply took it in stride. With neither a giggle nor a blush, she wrote down my order and brought me the veal. It was delicious, but having now comprehended my error and fantasized about the potential result, I couldn't help but feel a wee bit cheated.

Linguistic malfunctions involving chewable and edible substances are not limited to peasants such as I. Consider John F. Kennedy on a historic day in Germany in 1963.

Among the confections favored by sweet-toothed *Deutschen* is a jelly-filled pastry they call the Berliner. Now, in the German language, articles of speech (such as "a," "an," "the," etc.) are never placed in front of nationalities or other nouns that identify persons according to their place of origin, although articles, quite naturally, are placed in front of pastries. Thus, there are waggish grammarians who insist that when President Kennedy -- shod in hand-tooled leather shoes, a fine Harvard cravat about his neck -- buttoned himself into a heavy black cashmere-and-wool topcoat, stepped from a bulletproof limousine onto a privileged podium, and with dignity, passion, and compassion announced his solidarity with a beleaguered city by intoning, *"Ich bin ein Berliner,"* what he actually said was, "I am a jelly doughnut."

There are others -- mostly earnest liberals -- who argue that this interpretation is merely an attempt to besmirch the reputation of a great statesman. I contend it's nothing of the sort. From my perspective, in fact, the opposite is true. I've had occasion now to lug my taste buds all over the planet, exposing them to dishes ranging from the sublime -- foie gras mousse in a brown morel sauce

(Paris), and warm zabaglione with fresh wild strawberries (Rome), to the challenging -- snow-frog fat in custard (Hong Kong), and red ant larva (northern Thailand). In all my gastronomic globe-trotting, however, I cannot honestly say that any food item, with the possible exception of a perfect tomato sandwich, has had a greater impact on my palate and my eye or generated richer, more varied imagerial associations than the jelly doughnut, that plump pastry Pantheon, that unbroken circle, that holy tondo, that doughy dome of heaven, that female breast swollen with sweetness, that globe of glorious goo, that secret round nest of the scarlet-throated calorie warbler, that sun whose rays so ignite the proletariat palate, that hub of the wheel of sustenance, that vampire cookie gorged with gore, that clown in an army overcoat, that fat fried egg with a crimson yoke, that breakfast moon, that bulging pocket, that strawberry alarm clock, that unicorn turd, that jewel pried from the head of a greasy idol (a ruby as big as the Ritz), that Homeric oculus (blind yet all-seeing), that orb, that pod, that crown, that womb, that knob, that bulb, that bowl, that grail, that . . . well, you get the picture.

Whether consciously or subliminally, JFK could not have identified himself with a more wide-ranging, democratically inclusive sustenance than a jelly doughnut. How might it have affected his legacy, not to mention world peace, had he proclaimed *"Ich bin ein Kraut"* (I am a cabbage) or *"Ich bin ein Kartoffelpuffer"* (I am a potato pancake) instead?

As I may have made clear in these confessions (luckily for the reader, and me, as well, Chiclets isn't a written language), I've never been accused of gastronomic timidity. In recent years, I have become increasingly disinclined to partake of morsels intimately connected to deceased members of the animal kingdom, but I can recall only once in my travels when I shied away from an opportunity to sample exotic fare in an exotic setting. That occurred when I was invited to sup with

my subjects (that's right, *subjects*) on the day I reigned (I'm not joking) as King of the Cannibals.

I was in northwestern Sumatra with a small group -- eight paying river rafters, four guides from Sobek/Mountain Travel (the California-based adventure company), and an English-speaking Indonesian forest ranger who spent his downtime reading Louis L'Amour cowboy novels -- intent on becoming the second party to ever run the Alas, a remote river that cuts through the largest expanse of tropical rain forest left in Asia; a dense jungle, home to orangutans, rhinos, and tigers, and perpetually threatened by Japanese timber companies.

Adventure travel is by definition unpredictable, and in the steamy dawn, as we set out from Berstagi aboard a snub-nosed bus-like vehicle of unknown manufacture, hoping to put our inflatable boats in the water before the sun became more ornery than any L'Amour gunslinger, we found ourselves on a fortuitous anthropological detour. At a pee stop in the leafy hills not far from where the pavement runs out, we met a surprisingly sensitive field geologist from Mobil Oil, who informed us with genuine excitement that a rare daylong exhumation ceremony was about to transpire in an isolated village of the Karo Batak, a tribe of former (?) cannibals, and though disappointed that he wouldn't be able to join us there, he drew us a crude map to the place in case we were intrigued. We were. Following the oilman's directions, we drove an abusive dirt road to its dead end, then hiked five miles (this had better be good) into a *National Geographic* wet dream.

Aside from the occasional oil explorer, timber cruiser, or misguided Christian missionary, the Karo Batak had never been exposed to blue-eyed devils. Yet, when -- blue eyes as wide as poker chips -- our foreign mob suddenly appeared out of nowhere, we were received as honored guests. So gracious was their hospitality, in fact, that after a confab, tribal leaders declared that a pair from our group would be crowned their king and queen for the day.

Being obviously strong and demonstratively sweet-natured, Beth,

a veteran Colorado River guide, was a logical choice for queen. Why they chose me as their king I haven't a clue. Certainly it had nothing to do with my literary reputation, although some novelists are known to practice *verbal* cannibalism, biting and gnawing on one another insatiably at cocktail parties or in reviews. At any rate, our hosts escorted Beth and me to sexually segregated longhouses where they wrapped us in regal sarongs and other colorful raiments and hung about thirty pounds of solid gold ornaments -- the village treasury -- from our respective necks and appendages. (They must have figured we were too weighted down to skip town.)

There was then a royal procession back to the principal longhouse, where now on display were the remains of seven persons recently exhumed from the graves where they'd lain for seven years while their families saved enough money to fund the ceremony that would finally usher their spirits into the Karo Batak version of heaven. The bones were lovingly washed, dried, and stacked in seven neat piles, a skull atop each pile like a bleached cherry on a Halloween sundae. Then the celebration began.

Squatting along the sidelines, several older women, grandmother types, were chewing betel nut, and though readers may find this hard to believe, I felt it only polite to join in. The grannies, with big toothless grins, obliged me. Well, as I soon discovered, betel nut ain't Chiclets, baby. Wrapped in a leaf coated with a paste of mineral lime (the stuff with which we used to line ball fields and tennis courts), betel nut numbed my mouth, stained my teeth and lips the color of a matador's hankie, and left sores on my gums that didn't heal for days, but it gave me the energy to keep pace with my "subjects" as the lot of us danced ritualistically around and around and around those graveyard sundaes.

The steps were repetitive, fairly easy to learn, and in a kind of conga line that jerked rhythmically to music provided by two groups of drummers and snake-charmer flute-tooters, we literally danced the day away. The relatives of the deceased, having sacrificed for years to

finance this ritual, at the conclusion of which the remains were to be permanently reburied, weren't about to waste a minute of it.

Afternoon was beginning to purple like the best English prose when the music abruptly stopped, dancers relaxed, and the entire tribe seemed to utter an extended sigh of accomplishment and release. Queen Beth now emerged from a dark corner of the longhouse, where she'd sequestered herself most of the day, afraid perhaps that she might be pressed to dance, chew betel nut (though only the elderly -- and I -- so indulged), or, worse, allow her royal spouse his conjugal rights. Members of our rafting party exchanged glances now, wondering if it wasn't time to take our leave. It was then that our eyes were directed to a voluminous cauldron resting on live coals at the center of the longhouse, and in which there bubbled a stew more gray in color than that shade of gray that separates the eater from the eaten. It was din-din time in the cannibal village. Definitely time to go.

Now, in fairness, the Karo Batak seemed much too innocent, too tame to be practicing man-eaters, and despite periodic reports to the contrary (rumors spread by neighboring tribes), were said by the Indonesian government not to have lunched on their fellows in about four generations. Some were converted Christians (leading me to wonder if they didn't especially enjoy Holy Communion), and the Karo Batak mind is so inexplicably disposed to the game of chess that within a year after being instructed in its intricacies, members were said to be playing on a par with European masters. Go figure. Nevertheless, one look at that ghoulish gray stew and we were moved to excuse ourselves. Beth and I changed out of our sarongs, surrendered our gold trappings (the headpieces alone could have financed a Las Vegas pawnshop), and as abdicating monarchs, shook every hand in the village before taking the long muddy trek back to our bus.

Now, at the very worst, that stew meat was dog. Or monkey. More than likely it was only chicken. Be that as it may, I shall never cease to insist that once upon a time, in the tiger-haunted hills of Sumatra, I wielded the savage scepter of the King of the Cannibals.

And at those who might dispute that claim, I'm fully prepared to hurl the ancient and traditional curse of the Karo Batak: "I pick the flesh of your relatives from between my teeth."

Two days before we hobnobbed with the Karo Batak, we'd visited an orangutan rehabilitation center. It's true, but lest anyone think that in some Darwinian fluke the big red apes might be distantly related to Lindsay Lohan, let me assure you that what plagues orangutans isn't drugs or booze. These primates were addicted to something far more dangerous: human beings. Imagine a Betty Ford Clinic where the demon to be exorcised was Betty Ford.

Baby orangutans were said to make wonderful pets. Beautiful in a sort of goofy way -- resembling a cross between Homer Simpson, Lucille Ball, and the Gerber Baby -- they look like a creature you might expect to speak Chiclets. Instead, they jabber primate nursery noises, and gurgling and cooing, become very attached to their human owners, upon whom they bestow bountiful hugs and kisses. They remain affectionate as they grow older, but by the time they're half grown, they've become so strong they're breaking ribs with their embraces and furniture with their playfulness. Among affluent Indonesians, it has long been a fad, a status symbol, to keep a young orangutan as a house pet -- that is, until it reaches an age when, innocently enough, it becomes a house wrecker.

There's a law in Sumatra against harboring an orangutan, but the Dutch, who controlled the island until 1949, devised a program whereby a wealthy violator could "donate" his rowdy juvenile ape to the government. The owner would thereby avoid punishment and save face (important in that society), the ape would go into rehab. At the forest compound east of the capital, Medan, pet apes would be weaned from human dependence, made wary, even fearful, of men; and gradually reconditioned so that theoretically they could function independently in the wild. A high platform had been erected in the

jungle about a half mile from the compound proper, and very early each morning, bananas and milk would be set out atop it, on the presumption that the surrendered apes hadn't yet learned to sufficiently fend for themselves. Visitors like us, who'd hiked into the feeding station, would start to hear branches snapping as one by one, young orangutans would come swinging through the trees to receive their government handout: a simian food bank, you might say.

As implied, the rehab compound was quite a ways in the boondocks. In order to make that sunup hike to the feeding platform, our rafting group had to spend the night at the compound. The Dutch had built two Western-style houses on the grounds, one of which was occupied by resident rangers, the other left empty for visitors; and by empty, I mean completely unfurnished. We were to lay out our sleeping bags on the bare floors of the two main rooms. There was, however, a tiny room in the rear, off the kitchen and near the edge of the jungle, that had a separate entrance -- and a cot. Now, I'd hurt my back on the volleyball court shortly before leaving home, so I petitioned our Sobek guides to allow me, for my spine's sake, to sleep in that room. To be honest, sore back or no sore back, the main reason I coveted those isolated accommodations was that I'm an almost pathologically light sleeper: should a moth land on my windowpane or somebody strike a paper match within forty yards of my bed, I snap instantly awake. You might as well set off fireworks next to my bed as snore in my vicinity, and I knew that Big Jim Pleyte, with whom I'd previously camped in Africa, was, for one, a world-class snorer.

When, however, our guides asked permission for me to sleep in the little room, it was denied. We were told that it was reserved for rangers. As bedtime arrived and the room showed no sign of occupancy, Beth petitioned again on my behalf. And when refused, she persisted. Beth wouldn't give up. She just badgered. Finally, the ranger in charge reluctantly caved in. I unfolded my sleeping bag on the cot's bare mattress and enjoyed a restful slumber there.

Okay, fast-forward a week. We'd set up camp on the banks of

the Alas after a long day on the river, and were heating our evening repast over an open fire when two forest rangers passed by in a motorized canoe. Following a friendly exchange, during which we inquired about wildlife in the vicinity (I, for one, was hot to see a tiger), we invited the rangers to eat with us. After dinner, they inquired what we'd seen of Sumatra since our arrival in the country (our personal ranger, temporarily setting Louis L'Amour aside, was interpreting). When we related that prior to putting into the river we'd spent a day and night at the orangutan rehab center, they nodded approval. Then one of them asked, "Did you happen to see the haunted room there?"

The "haunted room"? Hello! Instantly, we knew the room to which they referred, and as the rangers elaborated, all eyes swung back and forth between them and me. That small room off the kitchen is left empty, they said, nobody will sleep there anymore. Why? Because on several occasions in the past, a beautiful naked woman with very long black hair has appeared in the narrow clearing at the rear of the house, called to the ranger who happened to be staying in that room, and beckoned him to follow her into the jungle. Those who did were never seen again.

The account was told with sober conviction, and in that setting -- in Sumatra, generally -- it was easier to accept as truth than it would have been in Seattle, or even Appalachia. There is something a little spooky about the Indonesian hinterlands, a dark undercurrent, a sense that preternatural forces are at play there, generating in foreign visitors skin-prickling sensations that cannot be easily dismissed as mere susceptibility to the primitive fears of superstitious locals. As the rangers talked about the haunted room, there was around our campfire an epidemic of goose bumps, and people kept looking at me as if I, a survivor, might have something to add. I did not.

I did not. But why not? Why hadn't the jungle girl, this unexpected manifestation of my boyhood Sheena fantasies, come for me? Under scrutiny, I developed several on-the-spot theories to explain why I could have been rejected. First, I had an aching back, not a

promising attribute in a prospective lover. Moreover, for that back pain I'd swallowed at bedtime a Percocet, an opiate that renders one sleepy, dopey, and limp. I could have been so drugged that I hadn't heard her call, or she might have sensed that I wouldn't have been of any use to her anyway and let me be.

Then there were the mushrooms. In Sumatra, Borneo, and a few other places in that part of the world, there grows a phosphorescent shelf fungus, a mushroom that literally glows in the dark. That afternoon, on a short impromptu venture into the jungle, I'd come across an outcropping of that luminiferous species attached to a fallen limb, a dead branch about the length and circumference of a baseball bat. On impulse, I brought it back to the house, where I stationed it in the doorway of what I was hoping to be my room, thinking it could serve as a kind of organic night-light. It appealed to my romantic sensibility, but for some arcane arboreal and/or mycological reason, it might have signaled the lethal nymph to keep her distance.

There was one other possibility, one, that is, if I discount the possibility that she simply found me physically unattractive. Pinned to the otherwise bare wall of the little room was a page torn from a missionary tract or some Sunday school pamphlet, a color picture (no words) of a solitary Jesus kneeling in prayer in a wide shaft of moonlight. Drawing upon my Baptist upbringing, I recognized the scene as the Garden of Gethsemane, where Jesus went to pray alone on the night before his crucifixion. Someone with a pen dipped in or filled with silver ink had elaborately outlined all of the contours in the picture, paying special attention to the beam of moonlight, energizing it with a heavy sprinkling of silver dots. From an artistic perspective, the effect of these embellishments was quite interesting. They added aesthetic and emotional weight to an otherwise rather hackneyed illustration, and I removed the picture from the wall, intending to take it home as a souvenir.

Later that evening, however, I'd begun to feel increasingly uneasy about confiscating the picture, and just before retiring, I'd retrieved it

from my pack and tacked it once more to the wall. Now, around the campfire on the Alas, I found myself wondering if that picture had been placed in the "haunted" room for the specific purpose of keeping the female demon at bay. If so, the doctored image of Jesus may have saved my scrawny white butt.

Lest anyone presume that this incident had motivated me to end my estrangement from organized religion, I hasten to explain that while I'm obviously aware that he is the figurehead of a vast rich and powerful theological institution, I'm disinclined to think of Yeshua bin Miriam, the man we call Jesus, as a religious figure, at least not in any theological sense. What he was, rather, was a wandering Jewish zealot whose philosophical axioms and behavioral advice (assuming they hadn't been put in his mouth decades after his death by evangelists hustling a new dogma, as some scholars contend) differed not appreciably from the pronouncements of other great spiritual teachers operating in China, India, and Persia at about that same time. That said, could his visual image, so creatively enhanced by a believer's silver ink, have been powerful enough to repel the enchantress? It's irrational on the face of it, of course, but in some transdimensional interchange to the left of space and to the right of time (where was the Frito pack when I really needed it?), might the souped-up aura of the Savior archetype have produced a divine spark that checkmated the bewitchery of the universal seductress? I had to wonder.

As for the woman herself, I've since had second thoughts. The rehabilitation compound existed for the purpose of teaching domesticated orangutans how to be wild again. Maybe she called men back to the forest to teach them the very same thing.

Despite the bone-gnawed, marrow-sucked skeletons allegedly in their metaphoric closet, the Karo Batak were Harvard-educated Park Avenue socialites compared to the Yellow Leaf People, an elusive nomadic tribe that needs (if it even still exists) no lesson in wildness; so

primitive, in fact, it hasn't even a name for itself. My bride Alexa and I and some fellow travelers (another Sobek excursion) learned of its existence during an overnight stay in the Hmong village of Ban Huai Yuak deep in the hills of northern Thailand, circa 1995.

Fairly primitive itself (no electricity, running water, or motor vehicles), this contingent of Hmong, however, did possess knowledge of the outside world and was warmly hospitable. On the first of our two nights with them, the Hmong staged a welcoming ceremony for us, a production that involved a great deal of very slow, very mannered dancing around a large bonfire, at the conclusion of which they attempted, without much success, to teach us one of the dances. Feeling we should reciprocate, Alexa and I tried to teach them the simplest Western dances we could think of: the Mexican hat dance, and the bunny hop. The result was not pretty. Mentally and physically unable to fit the movements into their frame of reference, they were even more inept at our dances than we'd been at theirs, and that's why, should you visit the Thai hills today, you're not likely to find anybody doing the bunny hop.

Early the next morning, a scout arrived in the village with the news that he'd seen a plume of smoke rising from a distant, normally uninhabited valley, a sign, the Hmong believed, that Yellow Leaf People could be in the vicinity. Hurriedly, we formed an expedition that included a villager who'd had some previous success in communicating with the little tribe. How little -- it was estimated that fewer than 150 members were left alive, including two or three groups in Thailand and one in Laos -- it was hard to know. They lived in the forest in temporary lean-tos that they fashioned from sticks and green leaves. When the plucked leaves began to turn yellow -- which normally takes about two weeks -- they would move immediately to a new location and build new shelters, believing it terribly bad luck to sleep beneath dying vegetation. Hence their name.

The Thai government had tried unsuccessfully to assimilate them, Christian missionaries had thrown up their hands and despaired of

ever converting them, a resistance that naturally earned my initial respect, although once we were among them (after an arduous hike of several miles up and down a major hill), it was difficult to find much to admire -- except their skill at climbing trees, an activity they performed literally with the speed and agility of monkeys. Despite my interest in mycology, the fungus growing in patches here and there on their bodies held such a minimum of fascination for me I didn't bother to inquire if it glowed in the dark.

There were perhaps thirty people in this group, only one of whom ever conversed with our guide. We had brought them a slaughtered piglet, which they summarily hacked up with a machete, wrapping the pieces in leaves and tossing them into the fire. When they deemed the meat sufficiently cooked, the pieces were retrieved from the flames and distributed among the members. They offered us none. Neither, in fact, had they thanked us, not even with smiles or gestures, for the gift. They, in fact, had failed to greet us or show surprise when we turned up unannounced, and they did not say goodbye when we departed. I had the impression that once we were out of sight, they would maintain no particular memory of our ever having been there. It was as if they were night clerks at a Charleston hotel and we were all Neil Young.

Because they possessed and utilized those two machetes (gifts from compassionate Hmong), and wore odd pieces of clothing (a faded shirt here, ripped shorts there, foisted on them, surely, by missionaries traumatized by their casual attitude toward nudity), the Yellow Leaf People could not technically qualify as a Stone Age tribe. In all other respects, however, you'd have difficulty picking them out in a Neanderthal lineup. Having neither clocks nor calendars, having no names for the seasons, they live outside of time (though presumably not in a chemically or mystically altered state), a disposition all the more pronounced by their lack of a functional numerical system:

they count only up to three. And not only do they not have a name for their tribe, individual members have no names either. Moreover, in their language there are no words for "I," "me," "my," or "mine," which puts them in bold, stark, dramatic contrast to another tribe with which I'd mingled at the Academy Awards in Hollywood four years earlier.

In 1991, I'd escorted Debra Winger to the Oscars. Debra was a presenter that year, so we had privileged seats; one row, in fact, behind Kevin Costner, who won the '91 Best Actor award for *Dances With Wolves*; and afterward we made the rounds of the parties, including Swifty Lazar's "A-list" shindig at Spago. It was wall-to-wall celebrities (I've never been so hard to see), but while a big ego may be as necessary for a film star as a space suit for an astronaut, in comparing Hollywood actors unfavorably to Yellow Leaf People regarding their usage of the first-person singular, I hadn't meant to imply that the players with whom I socialized that long, long evening were all annoying narcissists. In truth, I had engaging conversations with the likes of Sean Penn (whom I'd met previously) and Michael J. Fox; and as it turned out, it was my own ego that caused me difficulty, put me in some danger, and nearly spoiled my night among the stars.

Following the ceremony, there was a dinner backstage for the nominees, presenters, and entertainers. Ranks of tables had been set up in the surprisingly voluminous space, each table accommodating six persons. At my table there was seated, besides Debra and me, Al Pacino and his date (a British fashion model), and the character actor Danny Aiello (a lovely man) and his wife. The dinner was sponsored by Revlon, and at each place setting there was a gift: Revlon cosmetics for the women, Revlon cologne for the men. There was a considerable amount of table hopping: "Schmooze More, Eat Less" seemed the slogan for the dinner. Being invisible in this milieu, I remained seated, though, alas, not entirely subdued.

At one point, only Pacino, his date, and I were left at the table. Either because he was bored, wished to amuse his date, or both, Pa-

cino, who'd removed his tuxedo jacket, sprinkled some cologne onto his hand and began dabbing it demonstratively in his armpits. Reacting as if this were a challenge, and not to be upstaged by Al Pacino (never mind that he was among the finest actors of his generation), I poured a finger of cologne into my water glass, toasted him and gulped it down. I failed to register Pacino's reaction. I was too busy dying.

Seriously, I thought I'd killed myself. Unable to breathe, let alone utter so much as a gasp or a squeak, I sat there frozen, tears streaming, waiting in terror for everything to fade to black. How long I remained immobilized in airless panic, I cannot say; it was probably no more than ten or twelve seconds, but it seemed the length of an Ingmar Bergman double feature in Swedish without subtitles. When finally I could breathe again (thank you, God!), I tried to act blasé, not even glancing around, after wiping my eyes, to see who, aside from Pacino and friend, might have witnessed my performance.

As I look back on the scene, it seems a reenactment of those early episodes in which young Tommy Rotten would drink ink, topical antiseptic, and stringent household products intended for scouring. I've joked that I was born thirsty, but (not to put too fine a point on it), I think in reality I was born *curious*. It's likely that many, if not most, of my adventures and misadventures, on the page and off, have been simply an attempt to feel more fully the sensation of being alive. Ironically, the quest for aliveness can sometimes put one in closer proximity to death, whether one is barreling down a crocodile-infested African river or asphyxiating in glittery Hollywood on a mouthful of Revlon cologne.

the good, the bad & the goofy

There are, as I've suggested, sticky situations, particularly those for which one has volunteered, that, for all the risk involved, are ultimately exhilarating, even life-enhancing. Then there are others, usually unbidden, that are merely creepy, and although one survives them, one feels violated by them, they leave a nasty taste in one's mouth, and I'm not referring to cologne. Here are examples of both.

One night in Namibia, twenty or so wild elephants wandered into our camp. More specifically, they commenced to mill about in the clump of acacia trees in which Alexa and I (hoping to keep a quiet distance from Big Jim Pleyte and his snores) had pitched our little tan tent. Our guide assured us that if we'd just slip ever so quietly into the tent and go to sleep, we'd be safe. Well, after dinner we did manage to get into the tent unnoticed, crawling ever so stealthily the last few yards on our hands and knees. Sleeping, however, was another matter entirely.

"Elephants," the guide told us, "have tender feet. If you notice the way they walk, especially on unfamiliar terrain, they set each foot down very, very carefully. They're wary of stepping on a sharp stone or a sharp stick or thorns or something, so they're not gonna want to step on your tent." Well and good. What he neglected to tell us was that elephants feed sixteen hours a day (which is two hours more than I feed). All night long, separated from us only by a thin sheet of canvas, the big beasts tore limbs off of trees, munched loudly on bunches of acacia leaves, snorted, belched, and expelled big boom-boom pachyderm farts. (Yes, children, elephants do it, too.) Sleep?

Moreover, while the guide didn't exactly dwell on it, it was made lucidly clear that should either of us venture outside the tent -- say, to take a photograph or a pee -- our too, too mortal flesh would likely be resembling the payload of fifty jelly doughnuts. And yet . . . and yet, rather than fret or bitch about our sleepless and potential fatal situation, we lay there in a state of prolonged elation, feeling more alive, more attuned to the rise and fall of the cosmic pumpkin (so to speak), than we'd ever felt at, say, a rock concert, a Fellini film, a New Year's Eve celebration in Times Square, or (it should go without saying) a political rally. We were intoxicated on what Thoreau called "the tonic of wildness," the base yet mysterious rightness of the natural world.

I'd experienced something similar a couple of years earlier when, during two weeks on the Rufiji River in Tanzania, our rubber rafts survived twelve separate charges by twelve different hippos, believed to be the most dangerous animal in Africa. The hippopotamus is a vegetarian but ferociously territorial (you might find that true of certain vegans you know), and will flip a raft or bite it in half: once one is in the water, the crocodiles show up like a bunch of starving hobos descending on a boxcar full of fried chicken.

When a hippo charged a raft, a guide who, except in a rapids, always stood in the rear of the craft, would slap the water with his oar, and since that area of Tanzania was totally devoid of human habitation, the unfamiliar sound of an oar *swack!* would startle the beast and momentarily slow it down. Meanwhile, we six paddlers, three on each side, would dig in and paddle as if our lives depended on it, which was certainly not out of the question. Once we had safely exited that particular hippo's domain, we would relax, wipe our brows, and panting, revel in the primeval drama of it all. Occasionally, though, we'd leave the riverine realm of one nasty hippo and before we'd had a moment to rejoice or reflect, immediately intrude on the territory of an equally possessive fierce fat boy. But that's another story.

There's a sense in which Hollywood Boulevard is a river, too: and until fairly recently it was a river of celebrity, make-believe, neon, and

sleaze; infested with tourists, hustlers, weirdos, petty crooks -- and the LAPD. One early evening in the mid-1980s, my agent, Phoebe Larmore, and I were traveling along this Mississippi of misfits (by then the only stars there were the bronze ones embedded in the sidewalk), when as we paused for a red light, a young man came rushing out of nowhere and tried to yank open the door of the passenger side, my side, of our car. I managed to hold the door shut and lock it, but when the light went green and we pulled slowly away (there was traffic), the guy ran alongside the car, yelling and pounding on the door.

I suggested, rather pointedly, to Phoebe that she turn at the next corner, which she did, taking a right, driving a block, then turning left on Yucca Street, a quieter street that runs parallel to Hollywood. Looking back, we saw that our assailant was gone, we'd lost him. But then . . . but then we heard sirens, close by, and suddenly all around us there began to flash the frantic, no-nonsense red lights of crisis and alarm: authority's monochrome rainbow. A police car was blocking our progress now, and two more squad cars were right on our tail, blaring and blinking. When we stopped, an amplified voice ordered us both out of the vehicle, ordered us each to raise our arms, ordered us to place our hands on our heads. Hello?

In less than a minute, we were literally up against a wall with three revolvers and a shotgun pointed at us by cops with their fingers on the triggers. There is no beast in any jungle, no rapids on any river (including the lower Zambezi in Zimbabwe, where some of the troughs were so deep and the waves so high that there were moments when the river was actually *above* our raft), no outdoor adventure that could come close to generating this level of fear.

The cops took turns firing questions -- and insults -- at us (preferable to bullets, obviously) and at some point in the tone-tough verbal barrage, we learned that two men matching our description (Phoebe had recently gotten an unusually short haircut and the cops were in doubt about her sex, an honest mistake on Hollywood Boulevard), two men had grabbed a woman's handbag outside a bar and

driven away with it. Apparently, the guy who attacked our car was a self-appointed vigilante, trying to recover the purse and apprehend the thieves. I guess he hadn't had time to duck into a phone booth and change into his superhero suit.

We tried to explain to the cops that I was a well-known author, she my agent, but it was a story they were reluctant to buy. "In that fuckin' jalopy?" Phoebe's nice car was in her neighborhood repair shop, the owner of which had loaned her a vehicle, a bit of a beater, for a day or two. The three pistols and the shotgun (it must take a lot of firepower to bring down a purse snatcher) remained leveled at us. Then, slower than a bullet but sufficiently speedy to alter the ambience, something occurred to me. "I'm in *People* magazine this week," I blurted, not really meaning to boast.

Not only was it the truth, but the issue had just come out: we'd picked up a copy at a pharmacy that very afternoon. And, it was lying on the front seat of the car. I convinced the gendarmes to allow me, covered every step of the way, to open the door and produce the magazine. Voilà! They surveyed the article, a three-page feature, as meticulously as if it were a crime scene, comparing the photos to my in-person countenance and the name in the story to my personal ID. Finally, with what seemed like genuine disappointment (I almost felt sorry for them), they lowered their guns.

At no time, however, did they apologize for needlessly endangering our lives (one slip of a trigger finger . . .), although they did grow rather jocular once the cops-and-robbers game was over. "We saw Uncle Milty earlier this evening," announced one, referring to Milton Berle and what for him was now a two-celebrity shift; not bad for a patrolman who'd missed out on the Beverly Hills and Malibu beats.

I have friends and acquaintances who sneer at *People* magazine, ridiculing the sensationalized attention the publication pays to the heartbreaks and high jinks of film starlets and television actors: the comely, the callow, the craven, and the confused. Perhaps, but *People* has not only been kind to me and my books, it saved me from a still

more prolonged interaction with gunmen of the LAPD, a most direful prospect already proven to offer none of the romantic nor transcendental rewards one receives when outrunning angry hippos or bedding down amidst a herd of wild elephants.

There are highlights and low points in the book-flogging arena, as well. An example of the high was the day I was mobbed by teenage girls in Sydney, Australia. Of the low: the night I laid an egg on the Jon Stewart show.

More of my novels are sold in Australia (*Villa Incognito* was number one on the bestseller list there) than in any country outside of the U.S., including Canada. My impression is that the Australian sensibility is generally more Americanized than is Canada's, which, if true, must suit Canadians just fine. At any rate, I'd been dispatched Down Under (where the sesame seeds are all on the *other* side of the crackers), and one of my reading and signing events was a midday affair at the main branch of the Sydney Public Library. There was a girls' school nearby and a contingent of thirty or forty juniors and seniors with a chaperone or two showed up to hear me read.

After the reading, I was escorted to a somewhat smaller first-floor room at the rear of the library and seated behind a long, very heavy wooden table. My mission there was to wallop with my barbaric scribble the flyleaves of purchased copies of my oeuvre. Normally, readers wishing signatures will line up and approach the author one or two at a time. These girls, however, were as wild as dingos. They rushed the table in a disorganized pack, waving books in the air like Meryl Streep's Outback baby. It was hectic but rather entertaining in its way, and it went well enough until my handler from Bantam signaled that I needed to depart for the radio station where she'd scheduled an "important" interview. There was, in fact, a taxi, its motor running, waiting for me right outside the back door.

When I stood and the girls realized that I was preparing to leave

them, all hell broke loose. Waving unsigned books or autograph pads in the air -- some had nothing to sign and seemed only to want to touch me -- they surged forward with such force that I was literally pinned to the wall by that hefty table. It felt as if the table edge was obstructing my air supply and cutting me in half. I glanced around the room for help, but none was forthcoming. Even Alexa, my loving wife, only grinned and rolled her eyes. Well, I thought, there are worse ways to die.

Summoning all my strength, I managed to shove back the table far enough so that I could wriggle up onto it, where I stood for an instant before taking a deep breath and jumping down into the roiling mass of girl flesh. Grabbing first one girl and then another, I kissed them (sometimes on the cheek, sometimes on the nose, sometimes on the top of the head: it was all very scattershot); and hugging and kissing, made my way to the door and escaped to the taxi. As we pulled away, I waved good-bye, then sat back in a daze. I felt as if I'd awakened from a particularly crazy, bed-rumpling dream. I felt like a Beatle. I felt like the Beatles, all five of them, including Mr. Epstein. I felt like the luckiest writer in the world.

The Jon Stewart show was, as the saying goes, a horse of a different feather, although there was nobody and nothing to blame but me and my naïveté. In my foolish innocence, I hadn't realized that the banter between hosts and guests on late-night TV -- *all* late-night TV -- is to some degree scripted. The day prior to my appearance on the show, its producer had interviewed me for nearly ninety minutes via telephone in my New York hotel room. Mainly, she quizzed me about my LSD experiences and, as also reported in *USA Today* that week, my "habit" of buying tattoos for female acquaintances. (True, I'd purchased tattoos for several women including an Olympic athlete, but this was before tattoos had become so trendy that every girl next door and her baby sister were inked up like Chinese scrolls; and besides, I was only encouraging their rebellious spirit, not branding them.) My misguided impression was that the producer was just feel-

ing me out, trying to get a sense of my style and personality.

The next night, I went on the show percolating with uncharacter-
istic confidence. Man, I was *feeling* it! I was loaded for the proverbial
bear, ready to match Stewart ad lib for ad lib, wit for wit. And, of
course, to talk at some length about my new novel. This was the old
Jon Stewart show, the one on CBS, the network that had recently
canceled *Pee-wee's Playhouse* and fired its star for the sort of intimate
in-the-dark activity that no child alive would fail to identify with or
understand. A fan of Mr. Herman, I, as soon as I walked onstage,
embarked on a monologue defending Pee-wee and lightheartedly
scolding CBS. It got a good laugh from the studio audience, but Jon
Stewart, a celebrated iconoclast, looked a trifle perplexed.

Once I was seated in the hot seat, Stewart commenced to question
me. He asked about my LSD experiences. He asked about tattooing
girls. Hello? The questions obviously had been fed to him by the pro-
ducer. I answered briefly, almost tersely, hoping to move right along
to a discussion of my novel, which was, as far as I was concerned, my
reason for being on the show. Well, it never happened. Dissatisfied
(and who can blame them?) with my short, less than pithy responses,
they not only politely ushered me off the set at the next commercial
break, they never paid me the modest union minimum stipend that
all guests customarily receive for appearing on shows of this type.

Friends who have appeared on *David Letterman* and *The Tonight
Show* tell me it's standard procedure for a TV host to be briefed in
some detail by his producers regarding topics for on-air conversation.
It makes sense, I see that now, but it's a little late. I'm not likely to
turn up on another such program. Unless, maybe, it's hosted by teen-
age girls from Australia.

it's a small world

Cuba, fine. Sumatra, fine. Namibia, Tanzania, Botswana, and Zimbabwe, fine. But what about Disneyland?

I've journeyed through Mexico and Guatemala with the esteemed scholar Joseph Campbell, exploring ancient ceremonial sites by day, and at night sipping gin-and-tonics on the verandas of tropical hotels while Campbell took what we'd learned that day in the field and weaved it into the whole glorious, fantastic tapestry of world history and mythology. I've traveled in Greece and Sicily with the laureate of the labyrinth and gladly grim Grimm Brothers gadfly Robert Bly, visiting the ruined temples of the gods and finding in the godly stories revealing insights into familiar human affairs. For sheer fulfillment, however, neither of those enlightening trips surpassed taking my son Fleetwood to Disneyland.

Don't get me wrong, I'm aware that the Mickey Mouse myth is just that, mickey mouse. And the Magic Kingdom is to the Pyramid of the Magicians at Uxmal what Kool-Aid is to French champagne: deficient in cosmological sparkle and psychological depth. Seen through the eyes of a seven-year-old, Disneyland does present a vibrant, fanciful contrast to the mundane monotonies of everyday existence, and some of the rides are undeniably fun, yet even young Fleet became quickly aware that the trumped-up wonders inside the theme park paled beside the genuine working miracle to which he was introduced in our nearby hotel. I'm referring here to room service.

It might not surpass the wheel, the matchstick, kissing, or quantum physics, but room service definitely ranks near the top of the list

of humankind's greatest inventions; and while Fleetwood was hardly immune to the thrill of Space Mountain and the dizzy charm of the Mad Hatter's Tea Party ride, hotel room service was the white rabbit that led his imagination into fabulous new territory. We'd arrived in Anaheim late in the day, so I'd ordered dinner sent to our room. So enthralled was he at how that process worked, I let him call in our breakfast order. After that, we took all of our meals in the room and Fleet did the ordering. He always ordered far too much and none too healthily, but what the hell? We were on vacation.

By the third day, he had waiters knocking at our door every half hour or so, and our room was a wasteland of half-eaten cheeseburgers and melting chocolate sundaes. On our last day (though unintentional, I suppose it was his grand finale), two waiters showed up at our door with an extra-large cart and began setting out so many silver-domed plates and platters it resembled an aerial view of an old Russian city. Uncovered, the vast assortment of dips and canapés could have quelled the munchie madness of eight or nine stoners after a night at a hemp fest. Fleet had unwittingly ordered the hospitality menu, meant for in-room meetings or private parties during conventions.

Needless to say, the two of us made not a furrow in that fulgent field of finger food, and Fleet, eventually bored with the largess, elected to put pieces of it to a more captivating purpose. Playing bombardier, he began with much delight to drop pieces of the banquet on people in the parking lot below. Since we were on the eighth floor, I quickly drew the line at cheese balls and ice cubes, but didn't restrain him from discharging peanuts or olives, and shared in his glee when he scored the infrequent direct hit. A victim's reaction, in its bewilderment, topped any expression we'd observed in Disneyland proper, including at the Haunted Castle. The high point occurred when he bounced a slice of dill pickle off the yarmulke of a dark-bearded gentleman, who, after picking up the pickle that had struck him, stared skyward for what seemed like several minutes, and while

from that distance his words were not exactly clear, I could swear he exclaimed, "Nosh from heaven!"

Ah, but the fun wasn't quite over. The following morning, our last there, we were joined by a young woman with whom I'd been corresponding but had never met. Katherine was a pine-tree heiress and gifted psychic from East Texas, who was living in England (where a year later she would guide Fleet and me on a tour of Stonehenge, Silbury Hill, the Avebury Circle, and other Anglo-astro landmarks of the pre-Arthurian occult) but was back in the U.S. visiting family. After our farewell swing through the Magic Kingdom, I, flush with my *Woodpecker* advance, bought her a ticket so she could accompany us on our flight home. For better or for worse, I was done with hitch-hiking and the Greyhound bus (and there really was a lingering sense of loss, the loss of a special brand of freedom, a freedom never known by the materially ambitious or those to the manor born).

Down in the Caribbean I once heard a guy proclaim, "Lookin' good is da main ting, mon," and we were looking pretty good when we boarded that Seattle-bound plane: Fleetwood sporting a spotless white T-shirt and his new Mickey Mouse wristwatch, advising us of the time every six or eight minutes; Katherine in a billowy summer dress of polar white, me in the white linen suit I'd worn in Havana, the three of us radiating such an aura of dove-down whiteness we might have been created on the spot by God's own breath (though that watch, like all timepieces, was surely the Devil's doing).

In the air, we petitioned the flight attendant for a deck of cards, which we put to use in a three-handed round of crazy eights, a favorite of Fleet's as well as a diversion made all the more pleasant for us adults by the readily refillable glasses of red wine. It was an idyllic scene (Katherine in the window seat, me on the aisle, Fleet in the middle) that, were it not for the vino, it might have made a commercial for a family-oriented travel agency, and who would have noticed that neither Katherine nor I wore wedding rings? Now, crazy eights is not a game that demands a hefty expenditure of intellectual capital,

but there is a wee bit of strategy involved and any game worth a tick of one's time, including croquet and Scrabble, is worth playing with fervor, so each of us made a serious if manufactured effort to beat the pants off the others.

The first game went down to the wire, with Katherine eventually prevailing. Luck was on my side in game two. In the third game, Fleet dominated all the way -- until the end, when with the very last card I beat him out. Yes, I know, I should have just let my young son win, but as reported, we were playing as if the personal stakes were high and my competitive spirit momentarily trumped my paternal fidelity.

In disappointment and disgust at losing by what in basketball would have been termed a "buzzer beater," Fleet smacked the folding tray, our card table, with his fist. As everybody knows, those airline trays are rickety. Most of the cards stayed on the tray but Katherine's recently filled glass of red wine flew off and emptied itself up and down her Easter-white dress, while the other glass and its entire contents landed with a small but portentous splash in my lap.

We sat there momentarily stunned, Katherine and me, soaked with a mediocre merlot, until a flight attendant, after surveying in horror what must have looked like the aftermath of an ax attack, hurried back with a comforting smile -- and four bottles (two for each of us) of club soda. Speaking from experience, she assured us that if we immediately doused our garments with the soda water, the wine would not leave a stain. Taking her at her word and having no real alternative, we hustled with the bottles of seltzer to the toilet at the rear of the plane and, squeezing in together, set about resoaking ourselves, skeptically but with determination. And it worked.

It worked. The seltzer actually absorbed the merlot and did it far more quickly than an old wino's liver might, but it still took a long time. By Fleet's Mickey Mouse watch, we were jammed in that compartment, scrubbing, for at least twenty minutes. Meanwhile, a line had formed outside the toilet, for it was at that stage in a flight when

all the passengers' bladders seemed to reach flood stage in unison, a renal symphony in P sharp. People began first to sheepishly rap, then to bang with some urgency on the door.

Imagine the looks on their faces when the toilet door finally opened and out stepped two people, a well-dressed man and woman, both sopping wet, especially below the waist. It makes me smile even now to recall their expressions (children bewildered, adults outraged or maybe envious) as they tried to picture -- or tried *not* to picture -- what sort of kinky business might have just transpired in that cramped cubbyhole of a public loo (aware, if only intuitively, that Eros, though a plump little bugger, has been known to unfold his salty wings in some very tight quarters); and wondering if it would be hygienic, or even morally permissible to go in there now.

russia with love

Although I'd found my first three books to be generally satisfying from an artistic perspective, and though they'd attracted a loyal following among readers who'd discovered a slice of Tibetan peach pie to be their just dessert after far too many predictable potlucks of good old meat-and-potatoes American social realism (how many protagonists can one watch come painfully of age, how many bad marriages resolve or dissolve; and after a while who really gives a damn if the butler did it?); despite those early successes, I don't think I hit my stride as a novelist until *Jitterbug Perfume*. Published in 1984, it remains, aside from *Still Life With Woodpecker*, my most popular novel, perhaps because it explores from a fresh perspective the pervasive human yearning to somehow nullify that death sentence that each of us is handed at birth, and dramatizes without sentimentality the possibility of an eternal romantic love.

Jitterbug Perfume was followed in 1990 by *Skinny Legs and All*, a novel inspired not by the Joe Tex tune from which I took the title but by a fascination with the biblical bad girls: Delilah, Jezebel, Bathsheba, Lot's horny daughters, and most especially Salome, upon whose so-called Dance of the Seven Veils the book is systematically structured, the dropping of each veil signifying the casting off of one of the illusions that limit human advancement. Set in modern times against a backdrop of the New York art world, *Skinny Legs and All* explores the Jewish/Arab conflict from both an interpersonal and a mythological perspective, and shoves so many pies in the collective face of fundamentalist/apocalyptic Christianity that, considering the

violent nature of some true believers, I thought it might be a good idea to accept the invitation I received that June to travel to Moscow with a high school marching band.

The opportunity was provided by my friend Lee Frederick, a basketball star at Bradley University who went on to coach in college and with the Detroit Pistons. Lee had given up coaching to form Sports Tours International, a specialized travel company that organizes tournaments and takes U.S. collegiate sports teams to play and soak up a little culture in Latin America, the Caribbean, and Europe. His clients are mostly basketball and volleyball programs, but he once organized an overseas tour for a chess team, and now he'd been hired to take to Russia a champion high school marching band from New Richmond, Wisconsin. He wondered if I'd like to come along. Well, yeah.

Lee and I hooked up in Amsterdam, where I sometimes go to take the waters, and flew to Moscow together on Aeroflot. His staff had been in Russia for some weeks and everything was organized. The Wisconsin group arrived in Moscow the same day as Lee and I, and all of us were quartered at a quite large and quite bleak (Soviet chic) hotel on the outskirts of the city. That evening, in a dining room nearly the size of Stalin's paranoia, Lee spoke to the assembly and introduced his staff to the band, its directors, and its entourage: there were seventy-five kids in the New Richmond Marching Tigers and it seemed as if every other one of them had a chaperone. At one point, I stood and was introduced simply as "an American writer" with no hint that I might be on the run from Jerry Falwell.

The following day, the band -- all seventy-five uniformed members -- assembled on the hotel grounds for a brief rehearsal. It was at that point that I noticed the drum majorette. She was hard to miss: very tall, very blond, striking in her white boots, plumed cap, and short skirt; commanding in the way she twirled, tossed, and caught a baton. She was obviously the prettiest girl in school, the reigning social queen of New Richmond High. As I admired

her teen queen confidence, her regal bearing, her polished moves, I decided to have a little fun.

During a break, I sidled up to her, and with a stern expression said softly, "I know I was introduced last night as a writer, but" -- lowering my voice another octave now and glancing furtively over my shoulder -- "but I'm actually with the Central Intelligence Agency. My assignment here in Moscow is to protect *you*." I paused for her to take that in. "In public you'll be on my radar at all times. In private, should you ever detect anything even vaguely threatening, my room number here is 804."

Her blue eyes, naturally large, seemed to widen to the circumference of Frisbees, but before she could utter a word I turned on my heel and strode away. All that week, as the band marched through Red Square, Gorky Park, and along Moscow's broader boulevards, toodling, tooting, trumpeting, and generally blasting "Jesus Christ Superstar," its signature number (amazing, baffling, and sometimes obviously disgusting the Russians, who'd never seen or heard anything remotely like it), I, too, marched along -- off to the side, over in the gutter -- but staying always abreast of the drum majorette, careful to match her stride for stride. From time to time, I'd catch her eye and nod ever so discreetly, indicating that the situation was under control, that I had her back, and by the second day, she would acknowledge me with her schoolgirl version of a conspiratorial smile.

Our "relationship," if it could be called that (it was as much a prank as a flirtation), progressed no further, as well as it shouldn't have: I was in my fifties, she eighteen and surrounded at all times by a battalion of such sturdy, cheese-fed, vigilant Wisconsin chaperones they could have prevented King Kong from getting within an arm's length of Fay Wray. (Potential hanky-panky was also thwarted due to my having met in 1987 the love of my life, a milepost encounter about which I'll have more to say later.)

So nothing came of it -- except that for years now, somewhere in Middle America, a former drum majorette has been reminding her

husband and her children that in Russia she had her own CIA agent. "Is that for real, Mom?" one of the kids will ask, and she'll slowly crank up that old clandestine smile and answer, "Yes, it's true. He had a beard and was kinda cute. His name was Tom, and I guess he also wrote books on the side." And in his English-lit class, her oldest son will tell the teacher, "My mom used to be guarded by Tom Clancy."

Sometime in 1986, I performed a wedding ceremony for a couple in Seattle. Am I legally qualified to officiate at weddings? Yes, in a sense, and so are you, but let's not get into that here. Suffice to say that of the five couples I've joined in holy matrimony, only one has been torn asunder, a record even a Roman Catholic priest would be hard-pressed to equal. In any event, weddings always seem to make me amorous (funerals, as well, but that's another subject we should skip for now), and once the vows had been exchanged and pronounced that afternoon, I started looking around for female companionship.

Having spotted a cute little blonde who appeared unattached, I introduced myself, and there being no food at this rite except wedding cake, I suggested she and I repair to some venue de victuals for a bite to eat. She not only agreed but volunteered that she was night manager at a large restaurant on Lake Union, where we might dine well and for free. We did enjoy a reasonably good meal, and though I ended up paying the bill after all, I had no complaints. Not that night, at any rate. However, in the weeks that followed, Kathleen commenced to pursue me, sending me cards, flowers, and fine cigars. I didn't encourage this behavior but neither did I strongly object: flowers are pretty and as the firm of Twain, Kipling & Freud has seen fit to remind us, a good cigar is a smoke.

When one Tuesday late in the year, Kathleen telephoned to report that she would be traveling up to San Juan Island for a long

weekend and would like to stop off in La Conner on Friday night and take me to dinner, I agreed. I had no plans for Friday and as the saying goes, "Give me liberty or give me dinner." Kathleen neglected to mention that she would be accompanied by a young woman she had recently befriended, one Alexa d'Avalon, an actress who'd been attracting quite a following for her insightful tarot readings at a Seattle cabaret called the Pink Door. Neither did she disclose that she'd shown Alexa an article about me in *People* magazine (once again, *People* was to influence my life), declaring, "I'm going to marry Tom Robbins and have his babies."

On the drive north, Kathleen warned Alexa, "If Tom and I get something going romantically tonight, you'll have to sleep in the car." Never mind that she'd made the all too common error of using "romantic" as a synonym for "sexual"; never mind that vocabulary malfunction, it was December, the car in question happened to belong to Alexa -- and it was a VW Bug.

We spent a pleasant evening. Alexa was as tall and jet of hair as Kathleen was petite and fair, and sitting between them at dinner I felt as if I was sandwiched between the dual aspects -- the dark and the light, the life-giver and the destroyer -- of the universal goddess, though admittedly that notion didn't occur to me until midway through my third Bloody Mary. After dinner -- for which I paid, Kathleen making no demonstrable move for the check -- we repaired to my nearby house for a toke and further conversation. There, Alexa and I had a lengthy discussion about my mineral collection, with me arguing that I admired rock crystals for their physical beauty alone, regarding their alleged healing properties to be even more suspect than those of certain TV evangelists, who, I'm convinced, are more likely to cause indigestion, anal strictures, and nervous breakdowns than to cure them. Impatient with this two-way discussion and sensing that she and I weren't going to be making any babies that evening, Kathleen announced it was time to go.

At the door, Kathleen and I exchanged a brief good-bye kiss.

Then Alexa, who'd been following behind, turned up her face in kiss mode, too. Now, while I'd certainly liked Alexa well enough, I hadn't felt any strong attraction to her. In preparation for a rustic weekend on San Juan, she was dressed, boots to cap, like a boy. I'd actually been unsure of her sex when she'd first arrived. But with that kiss . . . It was chaste, not so much as a bubble of saliva or flicker of tongue tip, yet it was somehow magnetically charged to a degree that for reasons beyond our intent or control -- an instinctive reaction, an automatic, involuntary response -- we kissed a second time, just as briefly but with just as much voltage. (What was that about?) Then the boy/girl departed and that was that.

No, not quite. Feeling bad that Kathleen had conned me out of another meal (apparently her modus operandi), Alexa sent me a letter the following week apologizing for her friend and thanking me for dinner. I responded with a note of my own, assuring her that conning food and drink was all part of Kathleen's Irish charm, to which I had no particular objection. I thanked Alexa for her concern, and in regard to an upcoming theatrical audition to which she'd alluded, wished her multiple fractures in the lower appendage of her choice. And that, I once again assumed, was that.

I ought to explain that I was living alone at the time, an unusual arrangement for me, and for once I was thoroughly content with domestic solitude. Surely I'd long been aware that one can never hope to live harmoniously with another until one has learned to live contentedly with oneself, but such was my deep appreciation of female companionship that I'd seldom put that awareness into practice. Now, however, since the amiable termination a few years earlier of a torrid relationship with savory Donna Davis, a union defined most markedly by the size, scope, and frequency of the blips we made on each other's bedroom radar, I'd been traveling alone and finding the company most satisfactory. Yes, I was dating the prominent sculptor Ginny Ruffner, an extraordinarily talented, intelligent, and delightful individual, but both of us being Southern, Cancerian, art-

oriented, and fiercely independent, we were simply too much alike to suit Cupid. So I'd been semi-reclusive for a while and enjoying it to the point of being almost prideful about it. In other words, ripe for a fall.

Christmas -- that old pagan holiday that seems to come once every ten years when one is a child and once every ten days when one grows up -- was again bearing down on an ill-prepared populace; and Alexa, still feeling a tad guilty about Kathleen's little con, decided to send me a token gift. The present she chose was a key chain, one of those "magic wand" affairs in which the chain itself is attached to a clear plastic cylinder filled with a viscous fluid in which is suspended a churning galaxy of tiny colored stars. As she prepared to wrap this trinket (which I still possess, by the way), her gay housemate Eddie scolded her for the impropriety of giving someone a key chain without a key attached, whereupon he removed from his own chain a key which he claimed unlocked the door to "some drag queen's apartment." As befitting its history, I suppose, they made the key more festive by painting it with purple nail polish.

A week or two after Christmas, I mailed Alexa a note, thanking her for the magic wand. As much out of politeness as any burning curiosity, I also inquired as to what lock might be opened with that small purple key. She responded directly and succinctly, "It's the key to your heart." (Now what could she mean by that?) She also happened to include, as if an afterthought, her telephone number. Later, she was to profess that she'd never before been so forward or so bold.

So yes, I did call her but not right away and it wasn't until I heard her speak -- Alexa has a phone voice that if properly channeled could defrost Lapland and half of Siberia -- that I decided to invite her (sans Kathleen) to dinner. Even so, my invitation was contingent upon her driving the sixty-five miles to La Conner. (So self-contained was I, so disinterested in anything remotely resembling a relationship, that I wouldn't even make the effort to meet her in Seattle.) She agreed,

and it was on January 17, 1987, that she rapped on my door -- stood there in high heels and a tight chic dress, lips rouged, hair beautifully coiffed, looking no more like a boy than a Ferrari looks like an oxcart -- stood there radiating a level of vivacity that caused the ink to run on my personal Declaration of Independence.

Surely Oscar Wilde was pulling our leg when he advised us to choose our friends for their beauty and our enemies for their intelligence, yet it can undeniably heighten the pleasure of a meal if the diner across the table surpasses in his or her good looks the sesame bread sticks or the mustard jar. On the other hand, unless one is oneself a shallow twit, ennui is bound to set in long before the dessert course should the personality of one's dinner date prove less substantial than the odd sprig of parsley, if they have nothing stimulating or at least colorful to say. Based on our first meeting, I was reasonably certain that Alexa would not buckle under the weight of conversation, but just in case the professional psychic should turn out to be a New Age airhead after all, I had the proprietor/chef of La Conner's best restaurant procure a bottle of Cristal champagne (normally not on the wine list) and have it chilling in a bucket of ice at our table. This most blissful of beverages was my insurance policy against a dull or disappointing evening. Sure, Cristal is expensive, but so is Blue Cross and Mutual of Omaha.

As heavenly as the champagne was, and as well equipped to compensate for any tedium in our interaction, it proved no more necessary than lace on a lily or paint on a rose. Alexa explained that she used the tarot deck and its symbols, refined over centuries to trigger subtle responses in the collective unconscious, primarily as a focusing device. What she actually and actively did in a reading was to tune herself to a frequency that could register subtle signals from the client's emotional and/or intellectual state, signals that were often as clear to her as if they emanated from a radio transmitter.

She'd had this gift since she was a teenager, she said. Certain other members of her family had it as well, though a little spooked

by it, they'd chosen not to develop it, whereas Alexa had embraced
it and learned to harness it during a long convalescence following a
skiing accident. She took pains to point out that while her sensitiv-
ity to patterns of behavior allowed her readings to appear predictive,
neither she nor any other psychic could "see" the future. In recent
weeks, she'd begun to read my novels, and casually, matter-of-factly
offered keen psychological insights into several of my characters, il-
luminating qualities and motives which I'd developed instinctively
rather than analytically during the writing process. Her training as
an actress may have contributed to her prowess as an analyst of char-
acter, but it didn't matter: I was impressed. She was not only prettier
than I expected, she was smarter.

After dinner, on the short walk from the restaurant to my house,
we paused under a streetlamp and impulsively kissed. Instantly, the
light blinked out. Scoff if you must but I'm willing to submit to a
polygraph test. Once home, we kissed some more, and while these
kisses were not as electrified, they were sweeter, deeper, positively
nectariferous. At her lips I felt like a drunken bee at the open tap of
an orchid. I suggested we take a soak in the hot tub.

The tub was kept clean and heated for my volleyball team. Fol-
lowing a tournament or games against a rival, the Fighting Vege-
tables would pick up some beer and gather at my house for a tub
party. We were a coed team, the Fighting Vegetables, and though
the female members all had boyfriends or husbands, those guys were
not included. Naturally they weren't pleased, but our girls, especially
those whose mates were sports fans, appeared to get a kick out of
this small show of defiance, and the exclusionary tradition persisted;
though I should point out that while we were all buck naked, there
was never any conspicuous hanky-panky. Bathing together proved
great for team spirit, for camaraderie, although I don't necessarily
recommend it for your office staff, your marching band, or your Bible
study group.

At any rate, Alexa concurred that getting in the hot tub, minus a gang of sweaty volleyballers, was a reasonable idea. And here, reader, good turn th cates that we fade to black.

The next morning, I took Alexa to breakfast at a Mount Vernon truck stop. Conditioned by my boyhood in economically contrastive Blowing Rock, I've always been attracted to both sides of the tracks, equally disposed to the high life and the low life. My date had handled the white-tablecloth dining, the Cristal champagne, with good-mannered aplomb; now I wanted to see how she dealt with biscuits-and-gravy, longneck Budweisers (no glasses), and a jukebox loaded with country music, some of it recorded before she was born. My motives for testing her? Damned if I knew. Fortunately, there was someone present who was privy to my subconscious intentions, and whatever my ulterior objective, she seemed as much at home in this Bubbaesque mise-en-scène as if she'd grown up in a trailer park somewhere south of Big Cherry Holler. It was *I* who behaved like a goon.

It might have been the first time the subject of the tarot had ever been broached in Crane's Truck City, but as we waited for our second round of Buds I suggested rather nonchalantly that maybe Alexa ought to read the cards for me someday. She smiled. It was a small yet knowing smile. There was a cryptic light in her green eyes. "I already have," she said quietly.

"Oh yeah?" I was curious but not overly so. I was mainly making small talk. "So what did they say?"

She smiled again. "They said," she answered matter-of-factly, "they said you were going to lose your heart."

I raised my eyebrows. I straightened my back. I might even have puffed out my chest a little. (Don't you hate overconfidence in a man?) "Oh yeah?" I scoffed "*Really*. To whom?" At least my gram-

mar was correct because otherwise . . . well, that's how ridiculously
cocky I was, how smugly inviolable in my reconfirmed bachelorhood.
Alexa, still gently smiling, did not reply. She just looked at me and
shook her head ever so slightly, as if to say, "You fool. You poor, silly
fool. You don't know what's happening to you, do you?"

She was right. I was a fool. A stubborn goon of a fool. And I had
only the dimmest notion that something significant might be hap-
pening to me. But something was. And I lost my heart, all right; lost
it so completely that after twenty-six years and counting, I've yet to
get it back. From that weekend forward, Alexa and I have been virtu-
ally inseparable, at one another's side day and night, to Timbuktu and
back. Literally.

the curse of timbuktu

"Where is Timbuktu?" I've posed that question to a good many people over quite a few years, and the most common response -- I'd say 95 percent of the time -- has been "Timbuktu? Is that a real place?" Even after Islamic jihadists invaded the city in 2012, setting fire to its treasure trove of ancient manuscripts and bouncing Timbuktu night after night onto the evening news, most of the people I've queried have had no idea where -- or even if -- the place actually exists.

Once a center of caravan trade (gold, salt, ivory, slaves) and learning both sacred and secular, it has become through the centuries such a metaphor for "the middle of nowhere" that metaphor has overtaken and supplanted reality. Veiled in sandy layers of fable and mystery, Timbuktu is the farthest of which there is no farther this side of Shangri-la and Mars, it's our global absolute elsewhere. Is it any wonder then that it was to burn like a danger-scented candle in the daydreams of a romantic such as I?

For most of my life I was content to let Timbuktu glimmer in the recesses of my imagination: after all, few if any of the poets and lyricists who've rhapsodized about the moon have actually expressed a desire to board a space shuttle and go up there. In 1991, however, I was practically picked up and swept to Timbuktu by a confluence of esoteric facts and literary ideas, a juncture where, in my mind, the ongoing worldwide disappearance of frogs coincided with and mirrored a simultaneous dwindling of the middle class; amphibious frogs being a living bridge between water and land, between fish and rep-

tiles, and maybe, if the lore of Dogon and Bozo tribes, whose villages lie just to the south of Timbuktu, can be believed, between planet Earth and the stars; much as the middle class, despite its addiction to flaccid jolly ho-ho bourgeois inanities, constitutes a vital bridge between scarcity and abundance, between the pampered lives of the rich and the miserable lives of the poor. One thing every totalitarian state has in common is the absence of a middle class, one thing all of the world's arid landscapes (whether due to industrial pollution or natural forces) have in common is an absence of frogs.

There are things for which science has no explanation. One such mystery is how the Dogon and Bozo peoples of northwestern Africa were able, with naked eyes, to determine that Sirius is a binary star system, and did so some five hundred years before European astronomers confirmed it with the invention of the telescope. Furthermore, the lensless Dogon went so far as to accurately describe the size, length, and shape of the Sirius sister star's orbit, which lends a perplexing air of credibility to Dogon cosmology, based as it is on a chronicled visitation from a planet in the Sirius system by a party of amphibious humanoids. (Do I hear the tinkling notes of *Twilight Zone*?)

The Dogon experience, inexplicable as it is, seems to dovetail (or frog-leg) intriguingly with the commonly ignored fact that we land-stranded primates are essentially, ultimately (from the primordial soup to the waters of the womb) aquatic, a detail upon which I riff from time to time in the novel that resulted from the aforementioned confluence of weird data and creative ideas; its title, *Half Asleep in Frog Pajamas*, referring to the current state of human development as we oh so slowly proceed along our evolutionary path.

I elected to set *Frog Pajamas*, perhaps my most ambitious book, against a backdrop of the financial markets, a configuration of smoke and mirrors that if deconstructed makes scarcely more sense than a tradition based on a social call by amphibians from outer space. So how does Timbuktu fit into the picture? First, as I've said, Timbuktu

is so close to Dogon and Bozo territory -- which research for my novel demanded I visit -- that it would have been unthinkable not to include it in my itinerary. Then there is this comparison, this projection: Timbuktu, once (primarily between in the twelfth through sixteen centuries) a wheeling and dealing center of enormous wealth, is now impoverished, suffering from depopulation, and is gradually being buried beneath the advancing Sahara Desert. One need not be a visionary to conclude that in time Wall Street, too, will be desolate and wasted, victim of a failed system, covered not by sand but by water as a poisoned, overheated ocean steals in to bear us oxygen junkies back to "the cradle we all rocked out of."

There was one other reason, a bonus enticement, for going to Timbuktu: Alexa and I had been warned -- twice -- by the U.S. State Department not to go there, almost always a good indication that a destination will prove lively enough to suit the tastes of those who haven't confused travel with tourism or adventure with shopping.

So where is Timbuktu? Geographically, it's located in the upper reaches of Mali, a nation in northwestern Africa, that vast continent that Sarah Palin thought was a country. Even today, the town is not particularly easy to get to: were it more readily accessible it wouldn't be Timbuktu. Alexa and I had to fly first to Paris (not exactly a hardship) and wait a few days (loving every minute of the delay) for an Air France flight to Bamako, the capital of Mali. Paris in the morning, Bamako in the afternoon: talk about culture shock. Bamako's earth was red and dense, it's air smoky, humid, and thick; and with its slow-moving jitneys, its sprawl of single-story shacks bursting with produce and cheap goods, the city seemed weighted down beneath a heritage of juju. When we deplaned, we'd had to be cleared by security. The Bamako airport had an X-ray machine, and although it was broken and inoperative, we'd been made to load our bags onto its conveyor belt and run them through anyway. Was

that senseless protocol -- or was it juju? Who needed X-rays or tele-
scopes? Welcome to Mali.

From our hotel, I booked, by phone, reservations on one of Air
Mali's twice-weekly flights to the city of Gao, a transaction con-
ducted entirely in French, a language I cannot profess to actually
speak. (Gao-bound flights, I learned, would land briefly in Mopti
or Timbuktu if there happened to be passengers aboard so inclined.)
Our plane, Russian built and rather decrepit, flew at an altitude of
no more than a thousand feet, which seemed okay because the land
beneath us was one giant sandbox, flat except for the occasional dune.
The plane's interior had been painted with a green household enamel,
and I mean all of it: the cabin walls, the ceiling, the floor, even the
seats; every square inch (I wondered about the instrument panel),
green, green, green. It could have been Muammar Gaddafi's private
jet. Our fellow passengers included four or five Tuareg males, each,
as is customary among these non-negroid nomads, with a full-length
sword in his sash. Swords apparently don't set off alarms in juju se-
curity.

Upon landing in Timbuktu, I saw through our conveniently un-
painted window dozens of eager-seeming men (not Taureg but black
Malians) lined up against the wire fence that separated the terminal
area from the tarmac. I'd been in Mali long enough to know that
each and every one of them wished to be hired as our guide, and that
we'd be practically pulled limb from limb as they competed in a near
frenzy for our business. What I didn't know was that ten tourists had
been killed in Timbuktu in December (it was now February), caught
in cross fire between Malian government troops and separatist Tau-
regs (which would have explained the State Department warning), or
that for the next eight days we would be the only Westerners, which
is to say the only source of income, in the city.

At any rate, I told Alexa that we'd be wise to choose a particular
guide even before we left the tarmac, zero in on one guy and walk
straight up to him as if it had been prearranged. She agreed, and sur-

veying the throng, I settled on a twentysomething individual, selecting him because he looked exactly like Magic Johnson: shorter, to be sure, but with the same happy eyes and a grin so wide and so bright it could have turned a night shift in a lead mine into a three-week vacation. Now, as a Seattle Sonics fan I despised the Los Angeles Lakers, but I wanted this Magic look-alike on my team, loyalty be damned, and as it turned out, Pasquale was to serve us splendidly, above and beyond the call of duty.

Tawny, low, and organic; hermetic, bare, crumbling in places, Timbuktu seemed made of cookie dough and starlight; rising like rough ginger popovers out of the magmatic ovens of the underworld, open only to the incandescent carousel of the whirly night, a city simultaneously earthy and unearthly. Antique races had fashioned it from the very desert they'd dreamed upon, enriched it with gold and salt, elevated it with wisdom (holy and astronomic) from near and far -- and now must look on silently from beyond the grave as the desert takes it back.

Down narrow, unmarked, sandy streets, devoid of neon or billboards; past closed doors and shuttered windows, past an outdoor community oven whose bread, never entirely free of sand, crackless -- and sometimes sparks -- when bitten into, Pasquale and his entourage of teenage boys led Alexa and me to a Western-style, single-story hotel. Clean and comfortable (which is not to say it wasn't sandy), the hotel had forty rooms, thirty-nine of which would remain unoccupied throughout our stay.

Why Pasquale had a posse was never explained. Perhaps the teenagers were apprentices of a sort, interns trying to learn the guide business; perhaps they were just attracted to the older fellow's knowledge, his cheery personality. Or maybe it was because he had us in tow and we were the only action in town. In any case, the boys were intelligent, sweet, and thoughtful. They followed us everywhere we went

and helped protect us from the constant -- *constant* -- onslaught of ambulatory entrepreneurs (mostly Tuareg) trying to sell us "ancient" artifacts that I suspected (and Pasquale, with some embarrassment, confirmed) had been made no earlier than the day before yesterday. Like Pasquale, the boys spoke -- in addition to French (Mali's official tongue) and native Koyra Chiini -- a fair amount of English, as well as a smattering of Italian, Spanish, German, and even Japanese. They'd become multilingual not in school but at the movies.

The Timbuktu cinema, we soon discovered, was a thirty-six-inch TV set that rested atop a table in the sandy (obviously) courtyard of a private residence. The owner charged patrons a small fee to sit on wooden benches before the set, which had no antenna, no satellite dish: broadcast signals didn't know the way to Timbuktu. What it did boast was a VCR player, and its owner had a connection in Bamako who had a connection in Paris, so periodically a rented batch of taped films in various languages would make its way there via Air Mali to be exchanged for an earlier batch that, by the time of the exchange, had been watched multiple times by our boys, picking up foreign words and phrases all the while.

Cinema's influence on one of our boys was both amusing and touching: he was known to everyone in town by his preferred name, "John Travolta." Slight and black, he looked nothing at all like his actor namesake, but he did own a leather jacket with the skyline of New York City painted on its back. He wore that heavy jacket all day, every day despite temperatures that routinely reached 110 degrees, a heat so dry it could cause the body to lose two quarts of water just sitting still in the shade. This "John Travolta's" ambition was to go to medical school and I love to think he might have made it.

Despite the December gunfight in Timbuktu, despite being the only people in town genetically disposed to sunstroke, we felt safe enough with Pasquale, "John Travolta" (who, had he any inclination toward

Scientology, must have expressed it in Koyra Chiini), and the gang as we trudged slowly from ancient mosque to ancient library; and one day to the bank, where the manager, once he'd reluctantly agreed to redeem my traveler's check, opened a cabinet loaded with shoes and tried hard to sell Alexa a pair of sandals. On our last full day, however, something occurred that put the lot of us to the test.

In the relative cool of morning, Alexa and I had expressed casual interest in an offer of a camel ride to a Tuareg encampment a mile or two beyond the town. The nomadic Tuareg, who are related to Berbers, do not reside in Timbuktu or any other city, but from their temporary camps out in the desert, certain members will not hesitate to venture into town on matters of financial interest. Well, as the day progressed and the heat intensified; we came to realize that if the Tuareg got us two pigeons in their sun-broiled camp, we would not be let go until they'd plucked every last one of our feathers: we'd be charged for the camel ride, for food, water, entertainment (dancing girls), and every week-old "ancient" artifact they could foist upon us. So, as we heated up and wised up, we changed our minds. The Tuareg camel wrangler, however, had taken our offhand interest as a binding contract. When he returned later in the day with an extra camel, only to be spurned, he became furious.

Tuareg men wear blue veils, a unique fashion statement that adds considerably to their mystique (their women go unveiled, though are rarely seen in public), and this gentleman was so worked up that his veil was fluttering like the spastic wing of a dying jay. Finally, to shut him up, I just paid him the price of a camel ride. He took the money and stomped away, only to come back a second time as we were finishing our hotel dining room supper of Niger River perch and sand-crackly bread, and this time his anger had been jacked up so high all four legs were off the ground. Though it was growing dark, he was insisting, demanding, that we accompany him to his camp. Alarmed, we sent for Pasquale.

As indicated, perhaps, by which sex wears the veils, the animistic

Tuareg, alone in that part of the world where three aggressively pa-
triarchal religions were born, are a matriarchal society, and Pasquale's
assessment was that when our emissary returned to camp a second
time without the two rich infidels in tow (for the fleecing of which
the women had been preparing all afternoon), the ladies had prom-
ised to deprive him of certain rights and maybe cut his balls off if
he didn't go back and fetch us. Whatever the threat, it left an im-
pression, because the fellow remained outside of our hotel room all
night long -- all night! -- ranting and raving (in French and Hassan-
iya Arabic), pacing back and forth and brandishing his long sword.
There were several pieces of heavy old French colonial furniture in
our room, and we used them to barricade our door.

Even barricaded, we didn't get much rest -- and neither did
poor Pasquale. When sometime after dawn I opened the door just
a crack, I saw that the raging assailant had finally departed and that
our game-saving "Magic Johnson," having stood guard through the
night, lay fast asleep (at least his head was attached and I didn't no-
tice any blood) on a narrow wooden bench. It was enough to temper,
however briefly, my hatred of the Lakers.

Due to depart later that morning, we packed and left for the little
airport right away, partially for fear that the sword-wielding solicitor
would stage another encore, but also to ascertain if someone from the
airfield would remember to go out on the runway and flag down our
plane, as the scheduled flight from Gao to Bamako would only stop
in Timbuktu if the pilot could spot someone below waving his arms.

In what passed for the waiting room, we were soon joined by a
half-dozen Tuareg, resolutely intent on selling us more souvenirs (I'd
previously purchased a hunk of desert rock salt and a carved gourd)
before we got away. They hustled, hassled, and harangued, interfer-
ing with our attempt to hold a farewell conversation with Pasquale,
to copy correctly a postal address where we might send him a pair

of Nike athletic shoes like my own. Finally, annoyed to a level of inspiration, I stood up and announced in a loud voice, "I don't want souvenirs. I want hashish."

The Tuareg looked stunned, so I said it again. "No, no," they cried, "Hashish bad. Hashish bad." Plainly, my request had rattled them, so pushing the envelope, I now commenced to dance around wildly, like a mandrill with its butt on fire, waggling my arms as if I were one of those extraneously limbed Hindu gods directing the orchestra of the spheres or the traffic in downtown Calcutta. The hawkers moved away. In Mali, it's considered very bad juju to make eye contact with the mentally ill, and the more I carried on, the more distance they put between themselves and me; until finally, in the middle of a particularly paroxysmic pirouette -- "Hashish! Hashish!" -- they bagged their imitation artifacts, slipped out of the terminal, and did not return.

Successfully signaled, an Air Mali plane did eventually land and take us aboard. We'd get off in Mopti, from where we'd call on the Sirius-minded Dogon and Bozo, but we were done with Timbuktu. Alas, as it turned out, Timbuktu was not done with us.

The first symptoms tagged us in Paris, where we'd stopped for a few days of joie de vivre before traveling on to the U.S. We were dining in an Alsatian restaurant on rue de Buci when both Alexa and I experienced a simultaneous hot flash. I say "flash," but the feeling that we were standing against our will before the open door of a blast furnace lasted for ten or fifteen minutes. No one else in the room appeared similarly affected, and the source of the heat seemed definitely internal. The next day on the plane home we experienced an identical episode. Our faces turned strawberry red and the jet might have borrowed our plasma for extra fuel.

Back in Seattle, we were tested for malaria. The results were negative, but our relief was short-lived. During the next ten months -- that's how long we were ill -- we would be host to a peculiar panoply

of symptoms, including chronic fatigue and spontaneous panic attacks, often coming on in the middle of the night. The hot flashes continued periodically, Alexa experienced hair loss, her ovaries hurt and so did my testicles. The most persistent and unsettling feature, however, was the ache that racked every joint in our bodies and led us to be temporarily diagnosed with dengue, an ailment known colloquially for that very reason as "bonebreak fever." However, when the tropical disease unit at the University of Washington Hospital, where we'd become familiar faces, sent samples of our blood to the Center for Tropical Diseases in San Juan, Puerto Rico, the experts there found no evidence of dengue. Stumped, the UW even tested us for HIV.

Katharine Hepburn said once, "Men and women weren't meant to live together. They should live across the street from one another." For the first few years of our relationship, before we bit the sugar-coated bullet of matrimony, Alexa and I did exactly that. In the late eighties and early nineties, I had an apartment adjacent to Seattle's famed Pike Place Market (spending just two days a week at my house in La Conner). Alexa lived a clam's throw away on Western. Our symptoms were sporadic yet remained strangely coordinated. When an episode would visit me, I'd ring up Alexa across the street and ask, "Are you feeling . . . ?" Invariably, she'd respond, "Yeah, it just started." It was like synchronized swimming in a pool of pathology.

About six months into the disease, I consulted the pope's doctor. The offices of Dr. Kevin Cahill were in Manhattan, where he served the health needs of the cardinals, bishops, priests, and lay holy mackerels of the New York Diocese, and had been medical consultant to John Paul during the pontiff's visit to America. Dr. Cahill also happened to be the world's leading authority on West African diseases. Although I was never examined or diagnosed by Cahill, he informed me during a telephone conversation that "We have names and medical profiles for only about one-eighth of the viruses one can contract in West Africa." Since Alexa and I apparently had one of the

anonymous seven-eighths, I decided to name it, christening it "djig-giebombo" after the village where we had rested, half dead from heat exhaustion, before climbing down the Bandiagara escarpment into Dogon country. Once named, the virus was a bit easier to deal with: I could talk to it, flatter it, encourage it to take a hike of its own.

Djiggiebombo lingered on, nevertheless, and three more months would pass before another phone conversation with another New Yorker led to a startling resolution. This time I'd been speaking with Jonathan Cott, a senior writer for *Rolling Stone.* Jon had recently returned from Niger, a neighboring country to Mali, where he'd been reporting on the location filming of *The Sheltering Sky,* Bernardo Bertolucci's big-screen adaptation of Paul Bowles's harrowing novel. While in Niger, Jon had unintentionally offended a local witch doctor, who cast a spell that caused him -- a gentle, sophisticated, worldly fellow -- to roll around in the hot sand off and on for three days, begging Tuareg extras to chop off his head with one of their long swords: big bad juju. Jon assured me that in West Africa black magic is a flourishing reality at which only fools scoffed, and encouraged me to consider it as a possible cause of our so-called djiggiebombo.

Consider I did, and at one point in the deliberation my memory bank, like a constipated slot machine, expelled a single tarnished but negotiable coin. I turned it over and over and slowly the hairs on the back of my neck stood in their follicles and looked around in vain for an exit. A particular occurrence in Timbuktu, previously filed under the label "Interesting but Insignificant Local Color," was now petitioning for a front-page headline in my mnemonic tabloid.

The moon had been full that night -- and believe me, Timbuktu under a full moon lives up to its billing as a metropolis of mystery. All around us the mystique was so thick you could have sliced it with a Tuareg sword. With nary a mountain, a skyscraper or even a tree to impede its ascent, the desert moon seemed to pop up fast, like a flat-

faced rabbit some magician has pulled from a hat, and earth's phantom lover was already high-beaming its sweet, fey mischief when Pasquale and the boys interrupted our early supper to invite us to a dance. On such a night, only a wimp would have refused.

As the moon would have it, the dance was an open-air affair, the dance floor itself a concrete slab the size and shape of a tennis court. On its right side, a band of musicians was warming up, their instruments consisting of a couple of Western-style acoustic guitars and an array of strange African contraptions, both wind and percussive; made from gourds, goat bones, wires, bottles, and sticks; all polished, painted, played with expertise and accorded utmost respect. Next to the band there sat on wooden benches the eligible bachelors of Timbuktu. Across the court from the men, twenty or twenty-five young women had gathered, exuding all the poise and assurance the males appeared to lack. Tall, stately, fine-featured, garbed head to toe in those West African fabrics that could make a rainbow blush, the women looked like fashion models, each and every one. Small wonder the men were intimidated.

Once the band commenced to play in earnest, a number of women, impatient with the time it was taking the men to get up their nerve, took to the court and began dancing with one another. It reminded me of my junior prom in rural Virginia. We rubberneckers were huddled at one end of the slab, just taking it all in, when one of those statuesque beauties approached us and beckoned me onto the floor. When I looked to Pasquale for guidance, he indicated that I should oblige. So, I danced with her for a while, and then a second woman cut in and took her place. After that, a third. The band just played continuously, there being no individual numbers as such. I asked my third partner why the other women were laughing at us -- I thought maybe my moves were awkward, too Western, too white -- but she replied that Partner Number 2 had announced that she was going to marry me. (Alexa! Help!)

By this time, the men had overcome their shyness, the floor was

packed, and all the while an elderly female was weaving in and out among the couples, not dancing, just wandering zigzagging -- and looking quite mad. No one acknowledged her presence, not even when she got in their way. The dancers behaved as if she were totally invisible. Which, of course, was standard in that part of the world. They just pretended bizarre behavior was not happening. If someone acted nuts, everybody else hit the delete button.

Eventually, I managed to excuse myself from the frolic and made to rejoin my little group of onlookers. As I sat down beside Alexa, I noticed that the old crone had followed me to the end of the court. Regarding the two of us crazily for an instant, she then hissed and made a swift, cryptic gesture with both hands before turning and disappearing into the swaying, swinging throng.

Neither Alexa nor I thought much about it at the time, but we did start to feel increasingly uncomfortable, sensing that we outsiders had intruded long enough on another culture's private rituals, and when we suggested to Pasquale, "John Travolta," and the posse that it might be time for us to leave, they concurred. Just as children like to scare themselves, we imagined all sorts of exotic menace -- genies, lions, kidnappers, jilted Tuareg promoters, ghosts of long-dead slavers astride pale camels -- as we passed through the velvet shadows cast by those ancient clay mosques and libraries in the still more ancient moonlight. We did not, however, think of the gesturing crone, nor would she really come to mind again until the day nine months later when Jonathan Cott had to go and bring up juju.

Since in all those months our disease had gone undiagnosed, since Western medicine had failed to relieve its symptoms, and since we had, indeed, been somewhat vulnerable in a culture where juju was a fact of life, where things occurred that caused science to look the other way (the Dogon's detailed knowledge of the Sirius star system, for example), it did not seem wholly unreasonable to consider that

our "djiggiebombo" might be, in fact, a curse. If so, then how did one proceed in neutralizing it, in getting it lifted?

As Jun's seed sprouted, and after hours of reflection, I devised a plan of action. Every day, sometimes twice or thrice a day, I would lie down on the earth. In La Conner, I would recline in my backyard, when in Seattle, I'd find a patch of bare soil in Myrtle Edwards Park. Once I'd established what would have to pass for a connection to the earth, once I'd cleared my thoughts of the customary daily debris, I'd close my eyes and focus on the old witch woman. In my mind, I'd try to picture her as a little girl growing up in Timbuktu, imagining her life back then. Next, I'd picture her as a young woman, maybe going to dances such as the one on which we'd intruded, maybe falling in love at such a soiree. I'd picture her as a bride, perhaps a mother, and then I'd try to imagine what turn of events might have wounded her, caused her to begin practicing the black arts. Had she embraced juju only after she'd become mentally unstable? Or, had the juju itself deranged her?

Next, I'd apologize, begging her forgiveness if our presence at the dance had offended her. I'd tell her that my dancing with the women had been all in good fun, conducted with respect, and that the tittering over a potential marriage was just some girlish joke. I'd express admiration for her city and its people, and romantic that I am, this praise was not insincere. I'd congratulate her on Timbuktu's rich history and express hope for a restorative future. All this I did day after day, and although I must confess I sometimes felt more than a little foolish, none of my séances were in jest. We were a trifle desperate. Djiggiebombo was peeing in our punch bowl. Djiggiebombo was plucking our bluebird.

So what happened? It may have been a result of the macrobiotic diet we'd temporarily but rigorously embraced, it may have been due to the shiatsu treatments we were receiving from a remarkable Seattle healer named Yasuo Mori, the crone in far Mali may actually have sensed somehow my daily appeals and responded favorably thereto;

or maybe the damned disease just finally ran out of gas, as viruses, named or unnamed, sometimes do; but for whatever reason, within weeks of my having first launched my psychic missives toward north-west Africa, our symptoms, mine and Alexa's (in perfect tandem, of course), began to ebb, to fade. And then one fine day -- after nearly a year of wreaking havoc in our twin corporal oases -- djiggiebombo saddled its dromedary and rode off into the sunset, never to return. Au revoir, motherfucker! And God bless Timbuktu.

two bunch, too

Looking back on my life, as I've been doing in these pages, I'm reminded again of my great good fortune to have been a writer during the golden age of American publishing. On second thought, I suppose publishing's golden age actually was the twenties through the forties; when Maxwell Perkins was bringing out Fitzgerald, Wolfe, and Hemingway, not to mention James Jones, Faulkner popping over the horizon; you know, back before television would do to reading what panty hose would do to heavy petting. My period of peak production -- the late seventies through the nineties -- might more accurately be described as "the golden age of expense accounts."

During those years, my novels and those of many other authors were launched with elaborate parties in New York clubs. On tour, I was lodged in spacious suites in the best hotels; fed in fine restaurants, where, when I traveled with Terry Bromberg and Barry Dennenberg from the promotion department, we'd sometimes order every dessert on the menu. Barry would read off the desserts to us, one by one, in tones and with emotions that rivaled James Earl Jones reciting the Emancipation Proclamation. (We called it "The Barrysburg Address.")

I'm still not sure where my agent Phoebe and I got the nerve or how we managed to pull this off, but we somehow convinced Bantam Books that I was dead set against shipping manuscript pages of a book-in-progress to New York for approval. Phoebe would hand-deliver an opening chapter or two, on the strength of which

I'd usually receive a contract and a monetary advance against future royalties. After that, when the company felt the need to check on my progress, one or more editors had to travel to *me;* had to meet me in some location of my choosing, where, once they'd settled down and divested themselves of their New York buzz, then and only then they'd be shown fresh pages to read. They'd make notes, ask questions, and we'd discuss any suggestions they might propose, after which they'd return the pages. It was called an "editorial conference," and two or more would be scheduled for each novel.

Should this strike you as rather presumptuous on my part, you're probably not just whistling Sinatra. On the other hand, the halls of publishing houses were not sufficiently insulated from the ongoing amphetamine pace of Manhattan, and while the prevailing physical and psychological hubbub, the busyness of it all, might actually be a fitting accompaniment to the contemplation of fast-paced thrillers, or for that matter, tomes a-twitch with Jewish, Irish, or Episcopalian angst, a meaningful assessment of my sentences, quirky in ways different from Eastern Seaboard quirkiness, required of an editor, if not exactly a West Coast sensibility, at least a mind relaxed enough to follow the charmer's pipes out of the familiar, well-paved neighborhoods of syntax and story line and into a kind of wild, neo-druidic grove, emblazoned with poppies, woodpeckers, spotted toadstools, and a painted pagoda where the Language Wheel is banged like a gong and no Ivy League creative-writing professor would ever have been caught smiling let alone dead.

The location I selected for almost all of those editorial conferences was Two Bunch Palms, a health spa near Desert Hot Springs, a hundred miles east of Los Angeles. Like Timbuktu, Two Bunch is an oasis. Unlike the potable spring around which Timbuktu had sprung up, the spring at Two Bunch is hot, laced with minerals, and continually gurgles up what tests have shown to be the second most therapeutic waters on earth, second only to Baden Baden. The natural mineral pool lies in a rustic grotto, lushly surrounded by palm trees

and other semitropical foliage, and by moonlight verges on the genu-
inely magical.

Early in its history, Two Bunch Palms was the desert hideaway
of the gangster Al Capone, who operated a private casino there. The
small rooms beneath the former casino, where nowadays the finest
massage practitioners in America perform their restorative rub-a-dub-
dub, were, during Capone's tenure, cribs for prostitutes. This history
lends a faint air of naughtiness to the otherwise relentlessly whole-
some place and acts as a defense against forebodings of woo-woo.

If one can't relax at Two Bunch Palms, one can't relax anywhere,
but in the beginning my editors from Bantam put up a valiant re-
sistance. The evening that Steve Rubin and Matthew Shear arrived
there, for instance, they were not only almost audibly crackling with
New York intensity, they broadcast ill-concealed vectors of resent-
ment: not exactly thrilled about being lured into that all-too-alien
environment. Despite having fortified themselves with martinis on
the plane, they were poised to get right to work. I, however, refused
to allow them even a peek at my pages until they'd had at least one
massage and a soak in the pool.

The editors somewhat begrudgingly complied, and by the sec-
ond day, each of them was walking around about two inches off the
ground, hanging from a smile. In their central nervous systems you
could have heard a pin drop. Steve, who had never before been mas-
saged and who was initially suspicious of the very idea, would go back
to New York and hire a masseuse to work on him twice a week. Our
editorial sessions progressed as smoothly as massage oil, and there-
after I never had to petition for a meeting at the spa. Word spread
at Bantam, creating some jealousy, and periodically I'd receive calls
from Matthew, Steve, or a successor, asking how the book was com-
ing along and, almost plaintively, if it wasn't about time for another
conference at Two Bunch.

Bear in mind that Bantam was picking up the tab for those ses-
sions, including transportation, lodging, meals, and spa treatments

(usually two daily), for the editor or editors, for me, my agent, and whatever wife or girlfriend I might have invited along. It's safe to say that in today's economy such lovely expense-account indulgence is a thing of the past, especially since that upstart pair of dinky little digits -- the insubstantial *0* and the barely substantial *1* -- rode the e-train into the publishing world, with its alphabets and vocabularies, its warehouses of wood pulp and reservoirs of ink, and turned it sideways if not upside down.

When in 2000 it came time to edit *Fierce Invalids Home from Hot Climates* -- my novel about the CIA, the Virgin Mary, and the maverick operative who loves, hates, and redefines them both -- well, things having already changed, I shipped all the pages to New York via FedEx, massaged my wife's neck, and ran myself a bath in our tub. *Tibetan Peach Pie?* When I'm convinced that it's finished, I'll hit the send key on the computer and, both wistfully and with some trepidation, leave it up to the *0* and the *1*.

swan song

For decades, I've handwritten (yellow legal pad, ballpoint pen) my manuscripts, and this one is no exception. At week's end, I dictate the accumulated paragraphs to my assistant, Julie, and she transcribes them onto the computer. Thus, it is Julie's hand that hovers now above the send key, awaiting the signal that I'm through swinging this monkey by its tail, that *Tibetan Peach Pie* is done. Hold on, Julie. Not yet. As you know, I write slowly -- despite the comic overtones in my fiction, I'm no less conscientious about my craft than James Joyce, Virginia Woolf, or any other literary obsessive one might name -- and there are a couple more stories I want to tell.

In the early eighties, I had a little crush on Linda Ronstadt. I didn't know Linda Ronstadt, understand, I'd never met her or even seen her in concert. She was awfully cute in photos, though (this was before the combined forces of enchilada and Wiener schnitzel escalated her dress size), and I was particularly enamored of the way she sang certain words and phrases: "sweetie pie," for example, in her rendition of (appropriately enough) "I've Got a Crush on You."

One day my ex-spouse Terrie said to me, "If you like Linda Ronstadt so much, why don't you manifest her?" So I told her why, told her in effect that they'd be serving liver and onions in every school cafeteria in America before people started actually "manifesting" the objects of their desires; told her that if "manifestation" worked, there'd be world peace and half of the New Age naïfs in California would own peppermint helicopters and million-acre sprout farms; told her that while there was something to be said for the power of

positive thinking, what she was advocating was amateur juju. Nevertheless, I promised to give it a try. And in a half-assed way, I sort of did.

A year passed and it was 1984 when I received an invitation to Joseph Campbell's birthday party. The venerable mythologist, with whom I'd traveled in Latin America, and whose writings had so often turned the spit in my cognitive barbecue, was turning eighty, and there was to be a celebratory dinner in San Francisco. Of course I accepted. My flight was a trifle delayed, so by the time I entered the upstairs banquet room at the waterfront Italian restaurant, many of Campbell's guests were already seated. Checking the place cards, I located my seat at the end of one of the two long tables. The chair to my immediate right was still vacant. When I casually glanced at the place card there to see who would be sitting next to me, I was startled to read, "Linda Ronstadt."

Manifestation? Coincidence? A practical joke? So distracted was I, trying to make sense of it, that I almost didn't hear the man seated directly across from me when he introduced himself. It was George Lucas, who, for an instant seemed to be speaking from a galaxy far, far away. Now, I knew that Joseph Campbell was a scholar fixated exclusively on timeless universals, that he refused to read newspapers or watch TV and that he claimed not to have seen a motion picture in thirty years, so my second big surprise of the evening was learning that Campbell had spent the day -- his eightieth birthday, remember -- at Lucas's Skywalker Ranch, where he'd watched *Star Wars* in the morning, *Return of the Jedi* after lunch, and *The Empire Strikes Back* later in the afternoon. I was so amazed and delighted by this information that it took me a few minutes to make the connection to Linda Ronstadt. She, according to the gossip wire, had been dating George Lucas.

For better or for worse, Ms. Ronstadt never did take her place at the table that evening (I didn't allude to her absence or inquire of her whereabouts, not wishing to embarrass Lucas, with whom

she possibly had quarreled), and I'll submit that it was just as well. What would have been the point? For one thing, the notion that she might ditch a wealthy visionary film tycoon for the likes of me, might start calling *me* "sweetie pie," was ludicrous. For another, I cannot be counted among the tens of millions of Americans who are so gaga over celebrities they'd exchange their soul for a rubber dog biscuit just to be cuddled by -- or better yet, seen in public on the arm of -- a popular star. Beware, folks! Many, if not most, celebrities come with a metric ton of emotional baggage, and neither their talent nor their success will rub off on you in bed.

Having said that, it would be dishonest of me to claim that not once during that very long dinner party (it was close to midnight when Joseph Campbell led the guests in singing a pagan parody of "Gimme That Ol' Time Religion"), that not once did I look to my right and think that if I'd just put a tad more effort into my manifesting, I'd have been sitting next to sexy Linda Ronstadt instead of an empty chair and a dumb little card with her name on it.

I bring up the subject of celebrity primarily because for an offbeat fiction writer out of the North Carolina hills, who has chosen to live his life far from the centers of power and ambition, I've crossed paths with an extraordinary number of famous people (painters, photographers, writers, actors, directors, and rock stars), a few who've become cherished friends; and I know that certain of my readers will be disappointed that I haven't written more about those figures in these pages. Sorry. To tell stories that involved them would run the risk of violating their privacy (perpetually under assault as it is), and if I haven't good stories to tell, simply alluding to them could only be construed as an unseemly exhibition of name-dropping. I've tried to keep it to a minimum.

Not surprisingly, the clear majority of notables I've met has been on or around movie sets -- as I've had small speaking parts in several

Alan Rudolph films, and spent two weeks on location while Gus Van Sant was shooting *Even Cowgirls Get the Blues* -- or else in meetings where potential screen adaptations of various other of my novels were being discussed. Some of the actors with whom I've interacted proved as interesting and as nice as they were gifted, but the Tinseltown individual who made the deepest emotional impact on me was a marginally successful screenwriter whose name I cannot even recall.

Like many Vietnam vets, this guy had come home from that disgraceful and wholly unnecessary war psychologically vulnerable, but he'd convalesced by writing a screenplay about his boyhood. Clint Eastwood bought the script and turned it into a decent film, and now someone else had hired the fellow to adapt *Still Life With Woodpecker*. Unfortunately, he wasn't up to the challenge, but in our meetings I couldn't help but notice that he always had a toothbrush protruding from the left breast pocket of his sports coat.

One day my curiosity got the better of me and I asked him about it, suspecting he might be suffering lingering post-traumatic doubts about where he would be spending his nights. That's when he revealed that his girlfriend had moved out a few months before, and the only thing she'd left behind was her well-used toothbrush. Ever since, everywhere he went he carried that intimate implement of personal hygiene in his pocket next to his heart. I imagined that on particularly lonely nights he might even brush his own teeth with it, its presence in his mouth re-creating the sensation of her kisses. There's not a romance novelist on the planet who could come up with something one-tenth as touching as this. But -- one last time -- I digress.

Aside from the opportunity to explain my general reluctance to write about celebrities, I had an additional motive for recounting my nonmeeting with Linda Ronstadt. To wit: The subject of manifestation offers a fairly smooth segue into the subject of imagination, which, after all, figures prominently in my life, not to mention the title of this tome.

Although at first glance there may appear to be a fairly thin line

between them, there are significant differences between the attempt to somehow magically exert one's will on tangible reality for one's own benefit (manifestation), and the inspiration to imagine entirely new realities (sometimes to add color and bounce to the drab waltz of existence, sometimes to facilitate the recognition of wonder, sometimes just for the hell of it); between an attempt to mentally force fortune to alter its course for one's personal gain (to manifest, say, a winning lottery ticket), and possessing the lightness of spirit and the freedom of mind to live as if such developments would pale in comparison to those one regularly experiences at the piano, the easel, the writing pad, or upon viewing a pattern of fallen leaves in the gutter; to live -- against all evidence -- as if advances in fortune were already here.

Arising late one morning in Washington, D.C., a stop on one of my cross-country book tours, I cleaned up and set out in search of sustenance. I'd walked not much more than a block in the quiet neighborhood around my hotel when I noticed something rather odd. There had been a downpour during the night, and a few yards ahead of me, a man was squatting on the sidewalk staring into a rain puddle. What the . . . ? It couldn't have been a congressman because while many of them are known psychopaths, they're seldom deranged in such an interesting way; and anyhow, this man, I saw as I drew closer, was of a Middle Eastern ethnicity.

I slowed my pace for a better view, and when he noticed my attention on him, the fellow broke into a wide -- and, I thought, conspiratorial -- grin. Pointing into the rain puddle at his feet, he said enthusiastically, "The swan!" I must have looked bewildered, because, still gesturing at the puddle, he said it again. "The swan, the swan, the black swan."

He had a nice face, no shrill in his voice, no hint of madness in his eyes. So what could I do but squat beside him? I squatted. I stared. And I have to say that so convincing was he that I half expected

(maybe *fully* expected) to observe a miniature swan, a waterfowl (he surely wasn't referring to a ballerina), the size and color of a licorice drop swimming around in the puddle on the street.

To his obvious disappointment, I at first saw nothing, however, and when I regarded him quizzically, he regarded me as if I were thick. "The black swan," he repeated. This time his tone was patient, as if speaking to a child. "The swan is dead." Oh? The swan was dead! Maybe that was the problem: the poor swan could have been partially submerged or even floating upside down, not immediately recognizable. I gazed into the puddle again, and this time I actually could see a dark shape, a shadow in the rainwater, could see what could have been the drowned corpse of a tiny swan just below the surface. And the question that came to my mind was not what a teeny-weeny black swan was doing in a rain puddle in Washington, D.C., but what had caused it to die?

It was then that it dawned on me that at the same time the gentleman had been pointing down at the puddle with his right hand, his left had had been pointing upward at the sky. And at that moment -- *bing!* -- something else occurred to me. I suddenly recalled hearing on the news that there was to be a solar eclipse that day. The nice man from Lebanon or Iran or wherever, aware that looking directly at a solar eclipse could permanently damage the eyes, was cleverly watching its reflection, its dark shadow in the puddle. I'd been fooled by his accent. He'd not been saying "swan" at all, but rather, "sun": the black sun. The sun is dead.

We were both relieved that I'd finally understood. As the moon slid on by, though, and the sun reemerged, seeming none the worse for the brief if dramatic interruption, I couldn't help but be somewhat disappointed. There'd been moments, even after I'd become aware of the eclipse, when I'd imagined that I could actually detect a little bitty swan in that puddle. You see, such is my disposition that I could hold both eclipse and swan in my mind at the same time.

If I have been given any gift in this life, it's my ability to live

simultaneously in the rational world and the world of imagination. I'm in my eighties now, and if there is one thing of which I am most proud, it's that I have permitted no authority (neither civilian nor military, neither institutional nor societal) to relieve me -- by means of force, coercion, or ridicule -- of that gift. From the beginning, imagination has been my wild card, my skeleton key, my servant, my master, my bat cave, my home entertainment center, my flotation device, my syrup of wahoo; and I plan to stick with it to the end, whenever and however that end might come, and whether or not there is another act to follow.

The French say that the best part of an affair is walking up the stairs. I say that it's probably better to imagine heaven than to go there.

author's note

For one reason or another, some of my closest, most beloved friends are not mentioned by name in this book. To them I say, "Count your blessings."

Mentioned, although not adequately thanked (it's not that kind of book), are: Louis R. Guzzo, Dr. James Dilley, Luther Nichols, and Ted Solotaroff; men who innocently aided and abetted my literary advancement. To them I say, "It's okay: You could not have foreseen the result."

In addition to the women named herein, there are many others (ranging, alphabetically, from Libby Burke and E. Jean Carroll to Carolyn Watson and Theresa Zoro) who in one way or another have had a significant impact on my life. To them I say, "The gravy would have been damned lumpy, the champagne only dishwater without you."

My little dog, Blini, likewise fails to appear in this tome, although I did dedicate my last novel to her, and anyway she can't read. (I've no idea how she learned to recite those dramatic verses from *Beowulf*.)

I do wish to bow in gratitude before my insightful and certainly courageous editor, Daniel Halpern, for professing to find something flavorful, even nourishing, in these accounts of mine, and for encouraging me to keep spilling the beans.

Tom Robbins
La Conner, Washington
September 2013